HAND TO EARTH
Andy Goldsworthy
Sculpture 1976-1990

Edited by
Terry Friedman and Andy Goldsworthy

With contributions by
Clive Adams
Andrew Causey
Sue Clifford
John Fowles
Terry Friedman
Andy Goldsworthy
Angela King
Fumio Nanjo
Paul Nesbitt
Miranda Strickland-Constable
Hans Vogels

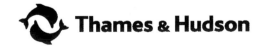 Thames & Hudson

First published in Great Britain in 1990 by
The Henry Moore Centre for the Study of Sculpture

First published in this hardcover edition by
Thames & Hudson Ltd, London in 2004

Graphic design: Peter McGrath, Groundwork, Skipton

This new edition produced by Jill Hollis and Ian Cameron
Cameron & Hollis
PO Box 1, Moffat, Dumfriesshire DG10 9SU, Scotland

Reproduction by Studio Fasoli, Verona

Printed and bound in Italy by
Tipolitografia Petruzzi, Città di Castello, Perugia

Andy Goldsworthy is represented by: Haines Gallery,
San Francisco; Michael Hue-Williams Fine Art, London,
Galerie Lelong, New York and Paris; Galerie S65, Aalst,
Belgium; Springer und Winckler, Berlin

British Library Cataloguing-in-Publication Data
A catalogue record for this book is available
from the British Library

ISBN 0-500-51172-1

Contents

Foreword

Hand to Earth *appeared to accompany the first major retrospective exhibition of Andy Goldsworthy's work, which originated at Leeds City Art Gallery in 1990 and travelled to Inverleith House in the Royal Botanic Garden Edinburgh followed by the Stedelijke Musea, Gouda, Holland, and the Centre Régional d'Art Contemporain Midi-Pyrénées, Labège, Toulouse, France. Since then it has become the standard reference work on the first fourteen years of Goldsworthy's oeuvre, and indispensable for anyone interested in studying his whole career. A chronology of Andy Goldsworthy's work up to 2000 appears in* Time *(Thames & Hudson, 2000). A representative selection of the artist's work and related documentation and publications is held in Leeds City Art Gallery and the Henry Moore Institute, a centre for the study of sculpture, 74 The Headrow, Leeds LS1 3AH. For this new edition of* Hand to Earth, *all the illustrations have been reproduced afresh.*

In 1985 The Henry Moore Centre for the Study of Sculpture at Leeds and Northern Centre for Contemporary Art at Sunderland organised the first major touring exhibition of photoworks by Andy Goldsworthy, *Rain sun snow hail mist calm*. This brought his art, already seen and admired in smaller one-man and group shows, to the attention of a wider audience and went some way towards establishing his national reputation. Since then a number of exhibitions and residencies around Britain, as well as in Belgium, France, Germany, Italy, Japan and the United States, have confirmed him as one of the leading young British sculptors working in nature. It now seems appropriate to present his work again, on this occasion as a more comprehensive retrospective covering the fourteen years between 1976 and 1990 and embracing not only the ephemeral works represented by photographs, including those recently made in France and at the North Pole, but also the less well-known, though equally fascinating, permanent sculptures constructed of stone and earth and leaves, as well as the large-scale drawings for monumental sculpture projects in the landscape.

In offering this second 'look', both the artists and the organiser are acutely aware of the need, in the accompanying publication, to present this body of work in ways which fill gaps in an already considerable Goldsworthy literature; to include illustrations of hitherto unpublished work; to address itself to wider issues than have been presented in previous books and catalogues, with their emphasis on photographs and brief poetic descriptions. How do Goldsworthy's ideas about sculpture originate and develop? How does he work? What is the importance of place, weather, seasons, time of day (or night) and material, of drawing and the photograph, in the making process? What is the distinctive character of his rapport with nature? Is it, as his private sketchbook notes seem to suggest, a tough and, curiously (for an Englishman) unromantic relationship in which the creative act of 'touching' rather than of encroaching on the land is steadfastly asserted and in which both the failures and successes of works are truly grist to the mill?

In the introduction to *Rain sun snow hail mist calm*, the artist has stated: 'A rock is not independent of its

surroundings. The way it sits tells how it came to be there . . . In an effort to understand why the rock is there and where it is going, I do not take it away from the area in which I found it' and 'My sculpture can last for days or a few seconds – what is important to me is the experience of making. I leave all my work outside and often return to watch it decay.' Though he has since made a number of permanent and transportable sculptures, a museum exhibition cannot hope to capture the total experience of his art. Therefore, visits to the site-specific, public sculptures: *Spires* and *Sidewinder* at Grizedale Forest in Cumbria, the *Lambton Earthwork* and *Leadgate Maze* in County Durham and *Entrance* at Hooke Park Wood near Beaminster, Dorset, described so evocatively in these pages, are to be encouraged. Of my own excursions to the village of Penpont in Dumfriesshire, where Andy, his wife Judith, their young son Jamie and daughter Holly live, of their extraordinary hospitality, of weaving among piles of stone and dried leaves and drawings in the indoor studio, of walks and talks in Stone Wood and along Scaur Water, of drives high up in the surrounding craigs to discover the source of the Scaur: of recollections of this personal journey to understanding and friendship, words almost fail.

By a happy coincidence the retrospective could be timed to coincide with both the Leeds Festival and the Edinburgh International Festival, and we are particularly grateful for the interest shown by its respective organisers. Paul Nesbitt, Exhibitions Officer at the Royal Botanic Garden Edinburgh has arranged to display the exhibition in the newly refurbished Inverleith House. Hans Vogels, Curator of the Stedelijke Musea at Gouda, and Alain Mousseigne, Director of the Centre Régional d'Art Contemporain Midi-Pyrénées at Labège, Toulouse, are hosting the exhibition during its 1990-91 European tour.

Many people have helped to make this retrospective and its publication possible, not least of all the artist himself. The Study Centre is especially grateful for the enthusiastic support of the Henry Moore Foundation and Henry Moore Sculpture Trust, and for the deep commitment of Mr Fabian Carlsson of the Fabian Carlsson Gallery and of its artist manager, Catriona Colledge.

Clive Adams, Andrew Causey, Sue Clifford, John Fowles, Angela King, Fumio Nanjo, Paul Nesbitt, Miranda Strickland-Constable, Hans Vogels and others have contributed unstintingly of their knowledge and insight. Galerie Aline Vidal, Paris, Art Now Gallery, Gothenburg, Bradford Art Galleries and Museums (Cartwright Hall), John Dawson, Fabian Carlsson Gallery, Leeds City Art Galleries, Mr and Mrs Kjell Nilsson, William Palmer, Gilles Peyroulet, Professor Colin Renfrew, Christer Salen, Evelyn Silber, Nick Silver, the Whitworth Art Gallery and the artist have generously lent works. Our thanks are also extended to Jill Adams, Julian Andrews, Dr Wendy Baron, Judith Bumpus, James Bustard, Julian Calder, Ian Cameron and Jill Hollis of Cameron Books, Christian Salvesen plc, Stevie Crawford, the Earl and Countess of Dalkeith, Steven Fox, Barry and Audrey Gregson, John Grimshaw, Christine Hopper, Marie-Françoise Lallemant, Leeds Photo Litho, Graham Maney, Steve Manthorpe, Peter and Caroline McGrath, Henry Meyric-Hughes, David Nash, Judith Nesbitt, Northern Arts, Phil Owen, Rees Martin Art Service, The Scottish Arts Council, Joe Smith, Donald Urquhart of Locharbriggs Quarry, Nigel Walsh, Jenny Wilson and the farmers Kirkland, Morton, Campbell, Barbour and Peden, in whose fields many of the Penpont works were made.

Dr Terry Friedman
Principal Keeper, Leeds City Art Gallery and
The Henry Moore Centre for the Study of Sculpture
and the exhibition co-organiser
1990

For Judith, Jamie and Holly

The Photograph

My approach to the photograph is kept simple, almost routine. All work, good and bad, is documented. I use standard film, lenses and no filters. Taking the photograph is not a casual act. It is very demanding and a balance is kept in which documentation does not interrupt the making. Each work grows, stays, decays — integral parts of a cycle which the photograph shows as its height, marking the moment when the work is most alive. There is an intensity about a work at its peak that I hope is expressed in the image. Process and decay are implicit in that moment. A drawing or painting would be too defined. The photographs leave the reason and spirit of the work outside. They are not the purpose but the result of my art. As Yves Klein said of his monochrome paintings: 'They are the left-overs from the creative process, the ashes. My pictures, after all, are only the title deeds to my property which I have to produce when I am asked to prove that I am a proprietor.'

That art should be permanent or impermanent is not the issue. Transience in my work reflects what I find in nature and should not be confused with an attitude towards art generally. I have never been against the well made or long lasting.

The photograph does not need to shrivel and fall to the ground for change to be part of purpose. It is an outdoor experience expressed in an indoor place which uses the conventions of that place to keep its meaning clear. It is appropriate to that space as it would be inappropriate to hang a framed photograph from a tree in a wood.

If the photograph represents the work alive, then work brought indoors becomes its husk. Much of the energy is lost: stones become isolated and leaves dry out . . . yet there is still enough meaning left. Not only does such work explore the relationship between indoor and outdoor alongside the image, it emphasises the physicalness of what I do.

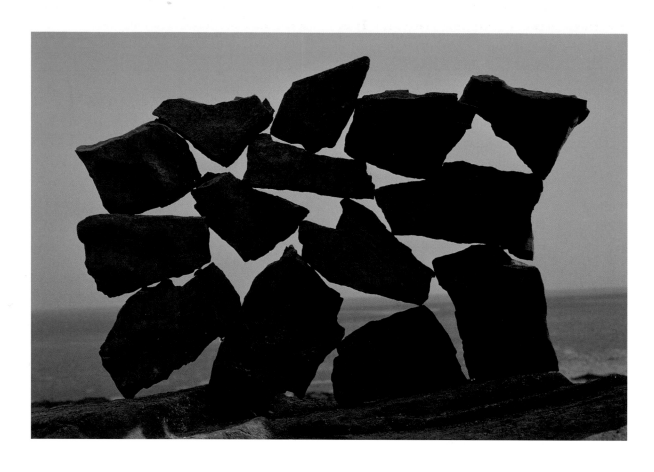

Balanced rocks

BEGINNINGS

Miranda Strickland-Constable

To the north of Leeds there is a small wood surrounded by fields, one of many such in the farming country of Lower Wharfedale between Leeds and Harrogate. It is typical of many planted and managed woods, composed of separate areas of different kinds of tree; pine is succeeded by larch and again by beech. Exploring it involves walking through a series of separate worlds. The way in is through a miniature jungle of sycamore, the ground between the mature trees a tangle of saplings, self-seeded as is the way of sycamore. Then a plunge into pine-trees; beneath these it is dark and quite silent underfoot; the outside can be seen as a bar of light low down in the distance. Up hill and out into a wide space planted with beeches in rows like cathedral aisles; in December it is open and airy above, the ground rusty-gold and crackly with shed leaves. There is green also in the algae covering the tree trunks and the thin wiry grass which is all that will grow under the dense canopy of summer leaves. In the nearby planting of larch it is quiet again; as in the pinewood the floor is blanketed with fallen needles, but since larch is deciduous, in winter there is no darkness and the sound-absorbing carpet is brilliant orange. A small beck borders the wood; the slope down to it is thick with bramble and ferns; its course is broken here and there by a tumble over rocks.

It is in this wood that Andy Goldsworthy made his first outdoor sculptures. It is important to him; he had known it from the age of thirteen, and during his years away at college, he would return to work in it every vacation. In among the trees, you can imagine yourself to be 'miles from anywhere' (that curiously anthropocentric phrase which implies that a place does not exist unless it has people in it). In fact, the very variety of the character of the wood is due to the fact of its being man-made, and the relationship of people with the natural world is of central concern to the artist.

The wood lies not far from the suburban housing estate where Andy Goldsworthy grew up.[7] His parents had moved there from Cheshire when he was seven. Their house was at that time on the edge of the estate, with, as it were, its back to the city and its face to the country: the city with its comforts and restrictions, the country with its open spaces and freezing winds. This part of West Yorkshire is not true mountain country where the cultivated spaces are pockets in a wilderness, nor is it the comfortable pastoral scenery so often thought of as typically English. Instead, industrial cities are side by side with spacious farmland and both are overlooked by wild moorland. The Goldsworthy's house was on the edge of Leeds when they moved into it in 1963; the estate grew, and houses were built on what had been open fields, moving 'the country' further away.

In their teens, Andy and his elder brother found holiday work on a local farm — washing milk bottles, an early introduction to the hard facts of farming, which is an industry, not a rural idyll. It was while working on this farm, where he learnt also to hump straw bales, lift turnips and care for the animals, that he discovered the woods nearby.

He regards these as formative experiences, learning not only the actual workings of a farm but how people who work on the land regard and relate to it. Goldsworthy is sometimes described as working 'in the landscape' but this is only sometimes true. He is not concerned with a view of the land, as we see it, but with the land itself, its substance, the things that live in it and what happens to it.

Andy Goldsworthy's early career was unpromising. He began by failing the 11-plus examination,[8] but did well enough at his secondary school to move on to the Harrogate High School, which 'was more exam-pressured'. There, he says, the Advanced Level Art syllabus put him off making things for a year (his creative energies were diverted into the decoration of motor-bicycles). He then had some difficulty in finding a place at art school, but was eventually accepted for the foundation course at Bradford College of Art, where the atmosphere was more liberating. Experiment was encouraged; there was some energy remaining in the air from the outburst of performance art five years or so earlier; working outside the studio was not seen as so very eccentric (however it may have looked to the passers-by in the streets of Bradford). The art history sessions he found particularly stimulating, with discussions about *avant-garde* artists in Europe and America who were doing just that. By the end of the

year, however, he had not succeeded in gaining entrance to any of the colleges he had applied to for further study, until in the autumn Preston offered him a place on their Fine Art Course.

This, as it happened, turned out to be a fortunate chance. The course itself was based not in Preston but in Lancaster, the ancient and beautiful town overlooking the estuary of the River Lune. Four miles to the north-west is the seaside resort of Morecambe, where students could find accommodation in holiday flats, vacant outside the summer season. The town overlooks Morecambe Bay, a vast stretch of sand some ten or more miles across at the estuaries of two rivers. This was to provide Goldsworthy with a new working place, an alternative to the wood; wide open to the sky where that was secret, offering no shelter from weather or the public view; he was to work here almost daily during term-time for the next three years, with occasional excursions up the coast or inland to the Pennine dales, especially in summer, when the beach became more populous.

Morecambe may be lively enough in season: on a wet winter afternoon it can be grim. South from the centre along the promenade is a seemingly endless parade of darkened boarding houses. The sea, except at the highest point of the tide, cannot be seen; across miles of wet sand the lights of Grange-over-Sands beyond the Kent Estuary can just be made out through the gloom; if the rain lets up, vague shadows may be the lakeland hills. Walk southwards and the Victorian terraces give way to nineteen-twenties' 'semi's'; then the coast changes. On a grassy headland stand the remains of a pre-Conquest chapel; below it the medieval church of St Peter, Heysham is surrounded by tall but windbent trees, and the graveyard slopes downhill towards the sea. Beyond the headland is a bay overlooked by sandstone cliffs, mostly chunky and frowning, though in one place prettily layered like a geology textbook. The rocks on the shore are jagged or flaky and covered with seaweed — at high tide the sea comes right to the cliff foot. Past the next point is a more gently curving shore, stretching down to the industrial estate around Heysham Harbour, which dominates the landscape to the south. The shingle on the beach here includes among the usual multi-

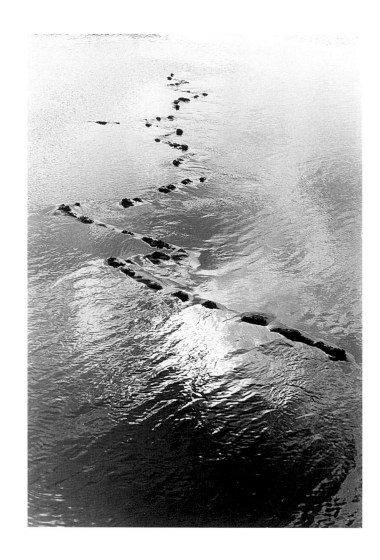

MORECAMBE BAY, LANCASHIRE OCTOBER 1976

coloured assortment of granite, slate, sandstone and the rest, nicely waterworn pebbles of pink domestic brick. Turn your back on the lights and gantries of the port and look north, however, and on a bright day there is a splendid view of the Lake District fells far off over the sands.

'When I began working outside . . . I splashed in water, covered myself in mud, went barefoot and woke with the dawn.'[9] Put less poetically, this means that he took his shoes and socks off and left them off, as a matter of everyday practice, not just on sunny days. This has practical advantages (until the invention of gumboots, all fisher-folk went barefoot as a matter of course) but also it meant that he could feel through his feet as well as his hands. Getting up early is of course essential for an out-

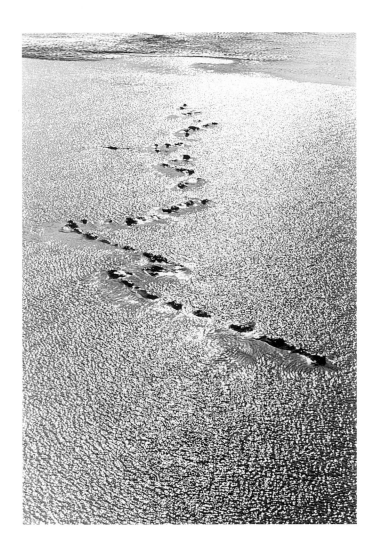

MORECAMBE BAY, LANCASHIRE OCTOBER 1976

same way, but he had gained encouragement from those art history sessions at Bradford, where contemporary art was discussed and books and illustrated journals and catalogues were available. It is an odd but acknowledged fact that, except in some interested circles, British *avant-garde* art was better known abroad than in Britain, in the early seventies; conversely what interest there was here focused on art from America or the European continent. Consequently Goldsworthy in 1974–75 was impressed by the ideas of Yves Klein, excited by a photograph of Robert Smithson's *Spiral Jetty*[10] and 'very moved' by one of Josef Beuys up to his neck in a swamp (in *Bog Action*, 1971)[11] but did not see any work by Richard Long until Long visited Lancaster in 1976. In his second and third years he was encouraged by the sculptor David Nash, who asked him to his studio in north Wales. (He was to return to Wales on several occasions.)

Outside, Goldsworthy began to explore this new place. At first he spent as much if not more time exploring than in 'finished' work; not just the splashing about in mud but photographing the rock structures of the cliff, learning about such marine life as there was on this wind-swept shore, finding out how to deal with the weather (it took a year or two to learn how to work *with* it). To take advantage, for instance, of sun and freezing temperatures to melt and fuse ice. At first he took black-and-white photographs, and discarded most of them. In his second term, he started to take colour slides, keeping them all, try-outs and failures as well as things he thought had 'worked', something which was less easy to do with the black-and-white. Those had had to be enlarged and printed, so involving selection before they could be properly seen. Slides can be projected, and thus enlarged for inspection at no extra expense. This meant that he could be a little more generous in the use of film; since, though the photography department did help out, the cost of film was a major limitation. Another decision he took some time early in 1976 was one of principle, and concerned the forms used in the work. He had experimented with treating the sand as it were as a canvas, super-imposing on its natural texture geometric patterns, over-lapping rectangles for example. He saw this as an imposition on nature; he says the realisation came quite

door worker who needs to make the most of the daylight in an English winter. Goldsworthy soon established a routine of working out of doors most days, going in to college once or perhaps twice a week, to attend the art history classes and to talk to people. He did, at the suggestion of authority, attend the life-class for a time but gave up, not because he did not like it, but because his hands, used to the outdoor wet and cold, would not do what he wanted them to do; they hurt also, in the warmth of the studio.

In choosing to work in the open Goldsworthy was on his own at this time, but it must not be imagined that he was working in a cultural vacuum. It is true that he did not find people around him wanting to work in the

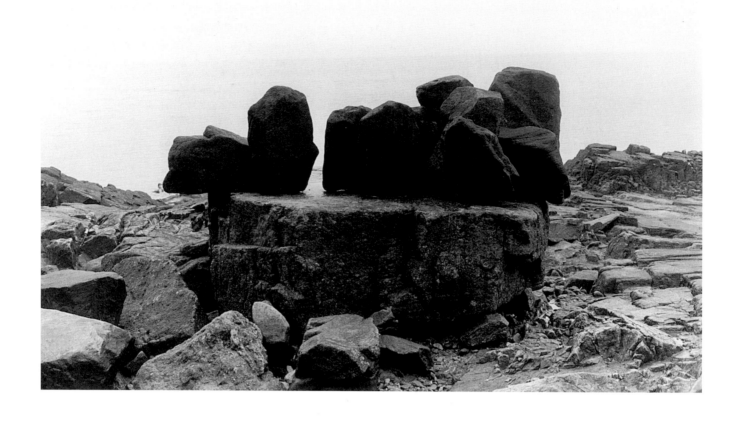

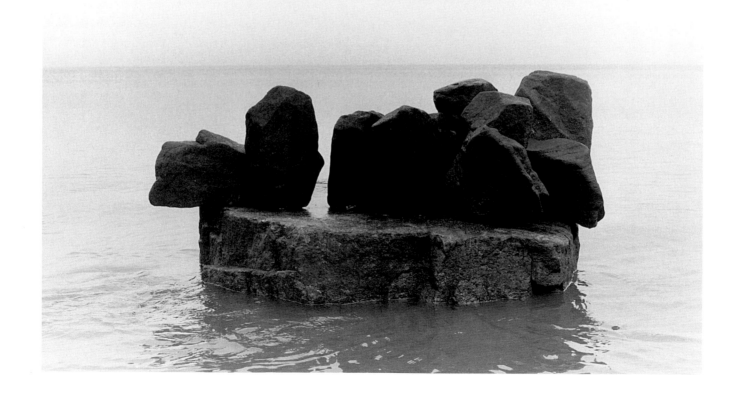

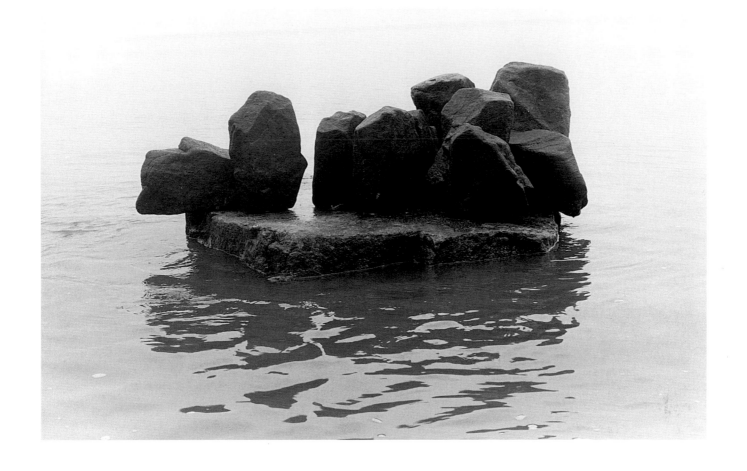

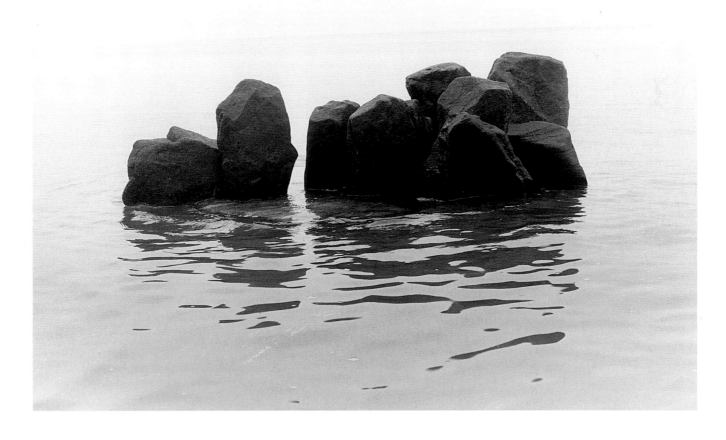

HEYSHAM HEAD, LANCASHIRE MARCH 1977

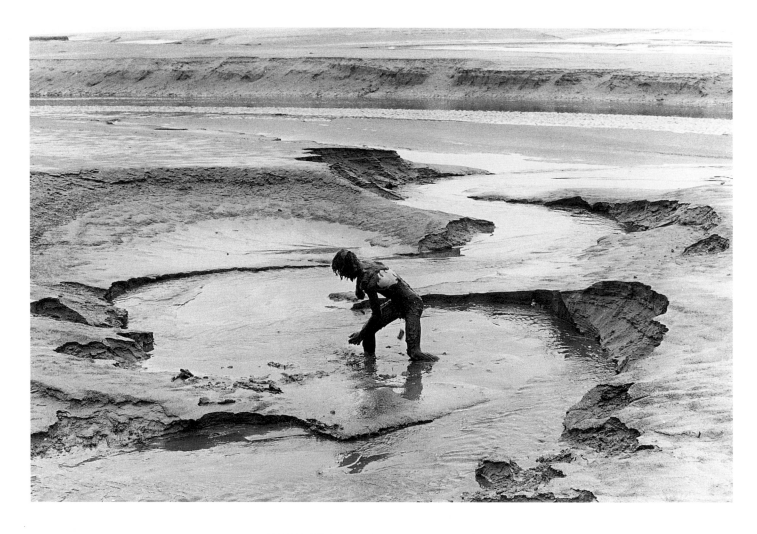

MORECAMBE BAY, LANCASHIRE OCTOBER 1976

suddenly during a train journey, when he was looking through the window at formal rows of trees along the edge of the fields. For some time he confined himself to what he calls 'formless' works, which meant that their shapes were dictated by the materials he was using, were in fact discovered in the process of studying his materials, rather than invented. Many of these studies are tentative; some are distinctly untidy. Looking at a sequence of them gives the impression of trying out something new every day, the only connection being his self-imposed 'rules'; in addition to that just outlined, the refusal to use any kind of tool or to fasten things together in any way; also when working with vegetation (branches, grass stalks, leaves) they were at first always dead or at least fallen, not cut from the living tree. Sculptures were made from everything to hand — or foot — from rocks and sand, branches and mud, even seagulls and sandworms. (The gulls were induced to line up in formation along a row of breadcrusts set out for them; the worms did not actively participate but a number of their casts were grouped together to look as if they had all burrowed simultaneously on the one spot.) The sandworm piece, made in March 1977, is an improvement on some attempts a few weeks earlier at making worm-like forms from wet sand; these looked too man-made. The real worm-casts have that look of the improbable yet not totally impossible which was to become a frequent theme in the next years. Some of the more successful examples

16

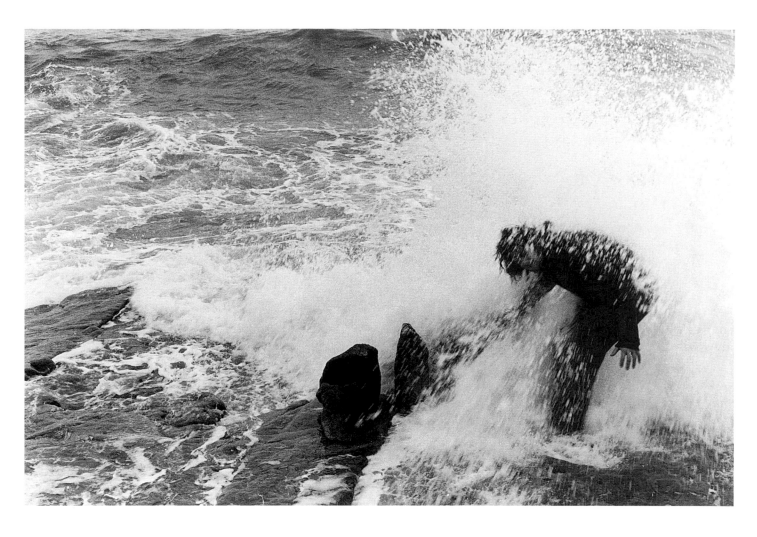

HEYSHAM HEAD, LANCASHIRE FEBRUARY 1977

at this time are to do with rocks apparently defying gravity: a line of stones meandering gently over the curve of a snow bank; a group of boulders floating in the sea (made by standing the stones on a rock below the high-water mark, and photographing them as the tide rose).

Working on a tidal beach gave plenty of opportunity to use water. (It could also produce a sense of urgency, as could an impending storm, though tides have the advantage of being more predictable.) Water has reflective properties, and can be used in combination with light for particular effects. Light, and soon colour, were to play an increasingly important part, with the result that the role of the photographs taken on completion of the work changes slightly. It is not enough simply to record a structure; it has to be done at a precise moment: with a change in the weather the work may alter in character, or be lost altogether.

In the summer of 1977 some of these things come together. In the Easter vacation, working in the Leeds wood, he had photographed a spray of yellow oak leaves held up to the sun, to try out the colour. Back at Morecambe, colour exploration is the theme of a whole sequence of work in which stones are arranged in groups, dark on a light background or vice versa, sometimes altered or shaded by scraping or rubbing; all are photo-graphed from above and close to, producing an image like an abstract painting. They are reminiscent of, for instance, the reliefs of Jean Arp in the 1920s, which is

17

perhaps a reason for not publishing any of them. The outlines which give this impression were actually prescribed by the grain found in the stone itself, but the resemblance — though fortuitous and even pleasing — is distracting.

In these 'painterly' works, and in the ones that follow, the role of the camera is crucial, since it is not being used simply to record a sculpture which may be fragile, transient or inaccessible. More even than those pieces involving illusions of balance, or particular light effects, these works involve using the right angle of view, and relating the image to its frame edges; prescribing for the spectator in the gallery how they should be seen. Given

the artist's preoccupation with physical contact with his materials and the natural world they come from, this makes for a certain tension, even uneasiness. He says he welcomes this, but it may nevertheless lie behind his refusal to allow us to accept the works simply as pleasing abstract patterns, on the one hand, or conjuring tricks, on the other. He habitually de-mystifies the illusion by providing explanatory captions and sometimes also photographs of the site or of work in progress.

Foxglove leaves | split down centre vein | laid around hole (cat. no. 6) is one of the pieces made that summer which are among the earliest the artist chose to show when he began exhibiting three years later. Like the sand and rock pieces made earlier on, it works as an abstract image[12] but is tighter in design and more clearly made up of arranged elements, and moreover these elements have been altered. How it is done is not easy to see without careful looking and the help of the caption. The depth of colour and the darkness of the hole which makes the central patch are fixed by the camera; what cannot be seen are the surrounding trees or the littleness of the piece when seen amongst them, nor what happens when the light changes or the rain comes. As an image it acquires its own scale; the disguising and re-arranging of its components demand that the colours be seen first simply as colours. The dis-orientation is necessary to provoke a response uncluttered by previous knowledge; the information is as essential to persuade us that this colour is, truly, to be found in nature.

This induced 'innocence of eye' is a primary objective. Goldsworthy tells a story of some walkers who had just seen a wonderful bird, with magnificent blue and black in its wings. Told it was a common magpie, they were evidently disappointed. One hopes that they realised afterwards their luck; if they had recognised the bird straight away they might not have given it a second glance, and never have seen those gorgeous feathers. It seems as if many members of our urban, science-orientated culture, even (perhaps especially) those of us genuinely curious about the natural world, go about with our vision blinkered by information, from guidebooks, handbooks, lists of the classification of species. Goldsworthy felt for some time a reluctance to pay much

attention to the names of the flowers, plants and so on that he saw, feeling that he might learn more from his own observation than from looking them up in books. He would not carry this stance too far, however; he does not believe in romantic escapism.

One significant feature of *Foxglove leaves* is that it is centred on a hole in the ground. This hole is not as surprising to the sight as subsequent examples of this motif, perhaps because it does not quite yet register as one. Maybe holes, to be interesting, have to be round. Goldsworthy made his first hole by accident, when scraping through layers of sand: one layer fell in, and he was pleased with the resulting dark space. Using the idea posed problems: it did seem to want to be round, but it must not be perfectly so, or it would have that man-made appearance he had been so studiously avoiding, and might carry unwanted overtones of traditional symbolism. For this reason, when he first began to explore the 'hole' theme, and later in the leaf patches of 1980–84, he did come to use a circular shape ('it is such a fundamental form, you can never get away from it altogether'), it is always unevenly outlined, a little off balance. Besides the circle there are other shapes which will recur in the work. The triangle, as used in a piece made from fragmented ice sheets, *Shallow pond* of 1983 (cat. no. 78), we are accustomed to regarding as taken from abstract geometry. Serpentine lines, on the other hand, remind us of traditional snake imagery. Neither of these identifications is quite correct. The triangle's outlines can be found in the pattern made on the water's surface by a swimming duck; the flightpath of a crow, or the movement along the ground of a snake lie behind the sinuous line, more nearly than any image of the reptile itself. Evading the repetition of familiar icons of this kind was one problem; another was the possibility of getting too close to a similarity to ancient crafts, either fragile or permanent — weaving or building. There was a dangerous edge over which the work might become too decorative, something he was very conscious of when he came to use flower petals for colour.

To say that Goldsworthy eschews symbolism is not to imply that the work is intentionally without meaning, rather that this is something discovered in the course of its making, and then exploited. The holes in the ground are so constructed that no light falls on the inside walls: all that can be seen is perfect darkness, or sometimes a dim twilight, so that the depth of the cavity cannot be guessed: it could be infinite. This gives the artist a sense of the energy contained in the earth, and energy is one of his favourite concepts. It appears in the way he uses colours, manipulating them by re-arrangement to bring out unexpected brilliances; it is the intensity of a found colour, rather than its individual hue which fires his enthusiasm.

During the winter of 1977–78 Goldsworthy made several variations on the 'hole' idea; working with snow he could enhance the contrasts of light and dark, and even create a 'hole into the light'. During a week of hard frost he worked with icicles, sometimes constructing a kind of screen for the light to shine through; sometimes laying them down in a radial pattern, centred on a shadowed hole, like a sunburst with a dark centre. The photographs have these cut off all round the edges, emphasising the flat surface pattern; this is something he would not now do. The feeling of energy implicit in them is better expressed in more recent works, icicles again, or sticks or reeds, fully in the round and 'exploding' outwards from their centres.[13]

During the spring and summer of 1978 the majority of works are not made flat on the ground but freestanding against the open sky. They show the same consistency as the previous summer's work and although upright, many are quite flat. *Balanced Rocks, Morecambe Bay*, May 1978 (cat. no. 14) is composed of fourteen flat stones perched one above the other in a (very) approximately spiral pattern, with wide spaces between them. Peat was used as well as stones: this could have openings pierced in it, or be carved into irregular, spiky shapes looking as if they were growing upwards from the ground. The idea of light seen beyond or through seems to be common to all these: at Morecambe he would work facing across the bay, so that the Lake District mountains could be seen through them across the sands. The openness of construction of the rock pieces especially adds to the sense of infinite space since again they seem to be defying gravity.

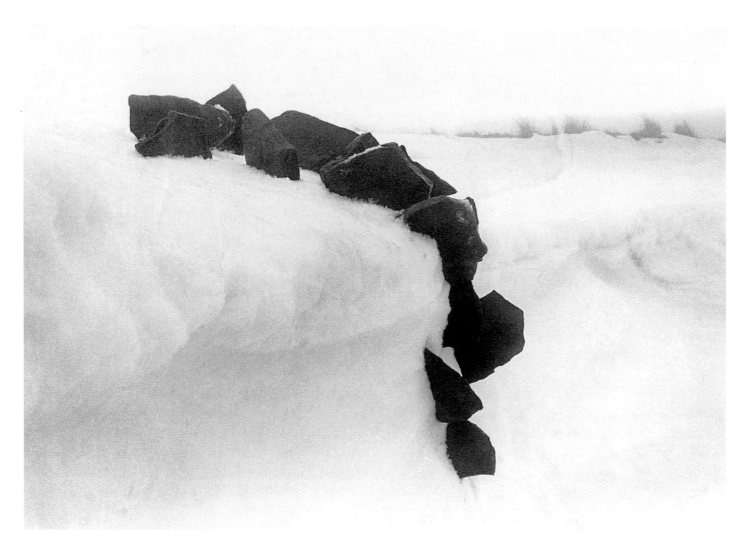

This suspension of probability is exploited often over the next two years, not altogether as an end in itself but as much a device to make the spectator look harder. The shapes, the colours, the feelings they engender, above all the way they have come to take those forms from the properties of the materials used are more important. Late in the summer Goldsworthy was making configurations of groups of sticks placed upright in the ground, attempts at what he calls 'drawing in air'. One or two particularly unsuccessful efforts looked rather too nearly like moving figures; the solution was to ensure that every line came back on itself or to the ground. This was difficult with large and unyielding sticks. Later, he tried again on a smaller scale, using thin stalks or grass.

These had varying degrees of flexibility and could make curves or stiff angles as required. The angles were easier and came first. In *Continuous grass stalk line* of 1983 (cat. no. 83) there are curves as well. Asked whether this was not something like Paul Klee's 'taking a line for a walk' (a phrase quoted at every art student in his first week) Goldsworthy agreed that it is that, 'or — letting a line take you for a walk'. Grass stalks are thin and flexible at the growing end, stiff and prone to bend into sharp angles at the base: they tell the artist what he can do with them.

In the summer of 1978 Goldsworthy left college. The Christmas before, the farmer for whom he had worked near Leeds died, followed soon afterwards by the

20

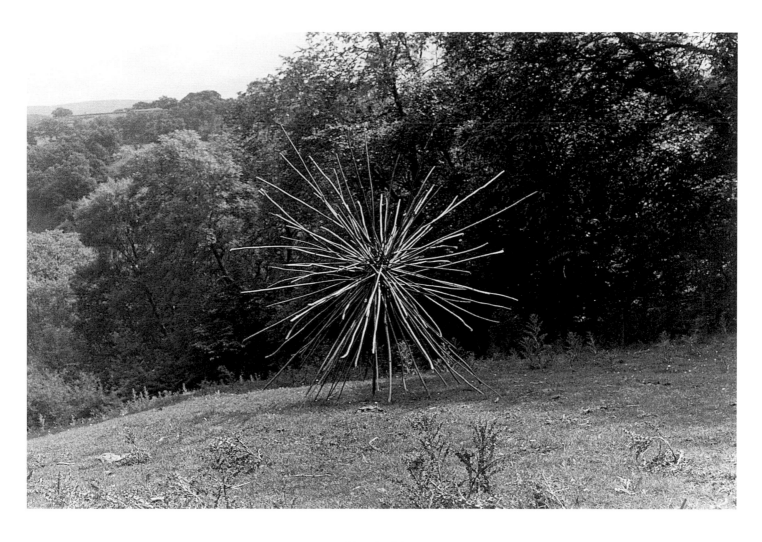

Hazel sticks

LYC MUSEUM, BANKS, CUMBRIA JULY 1980

farmer's wife. He had lost both a steady part-time job which he knew and understood, and the use of the caravan at the back of the farm in which he had been able to live during the vacations. The farm changed hands and he no longer had access to the little wood. He went to live at Bentham, in the Pennine Dales east of Lancaster, in bare, rocky, sheep-farming country. From that time, except for a year in Ilkley (while his future wife, Judith was at college), where he worked on the shores of the River Wharfe and in the woods above the town, he has preferred to live in a country village; before moving to Scotland, he spent some time in Brough, on the Westmorland (now part of Cumbria) – Yorkshire border, working as a gardener to pay the rent. There were

wooded hillsides and open, stony country above the village; he needed both. Often, after a prolonged stint at small-scale, earthbound work, he feels the need to escape from it — like a bird at migration time — and make larger, free-standing works instead, and vice-versa.

Andy Goldsworthy has shown from the beginning a singular determination in the pursuit of one constant goal. Since most of his basic tenets developed during his first years at art school, it seemed worth paying more attention to this stage of his career than is usual. At the start he set himself some very strict rules; these were necessary, at first, in order to concentrate his ideas; with growing experience he is allowing himself to bend, if not absolutely break them.

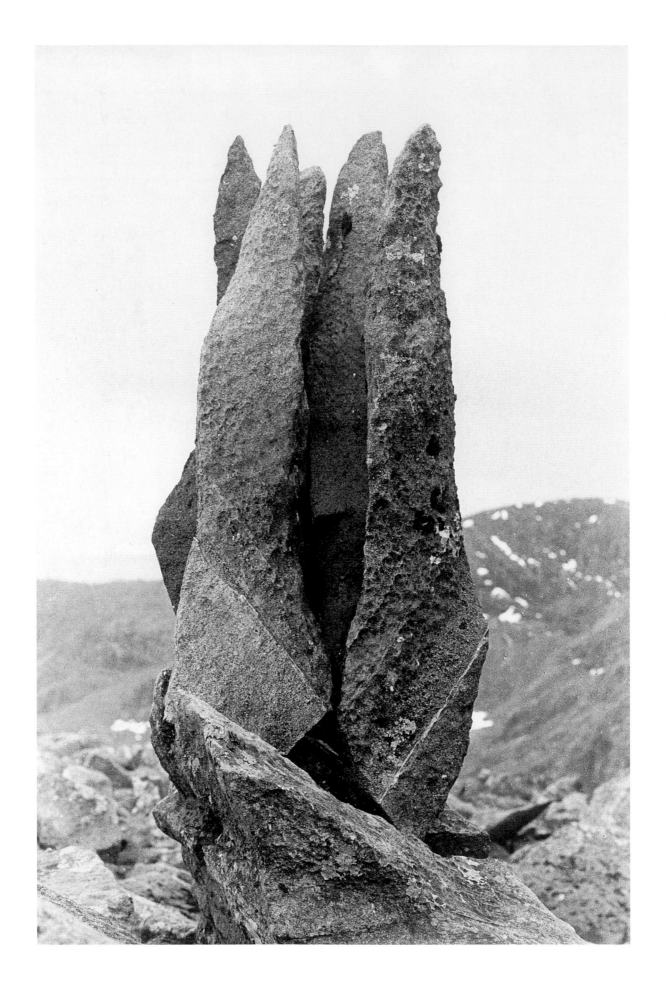

SCAFELL PIKE, CUMBRIA MAY 1977

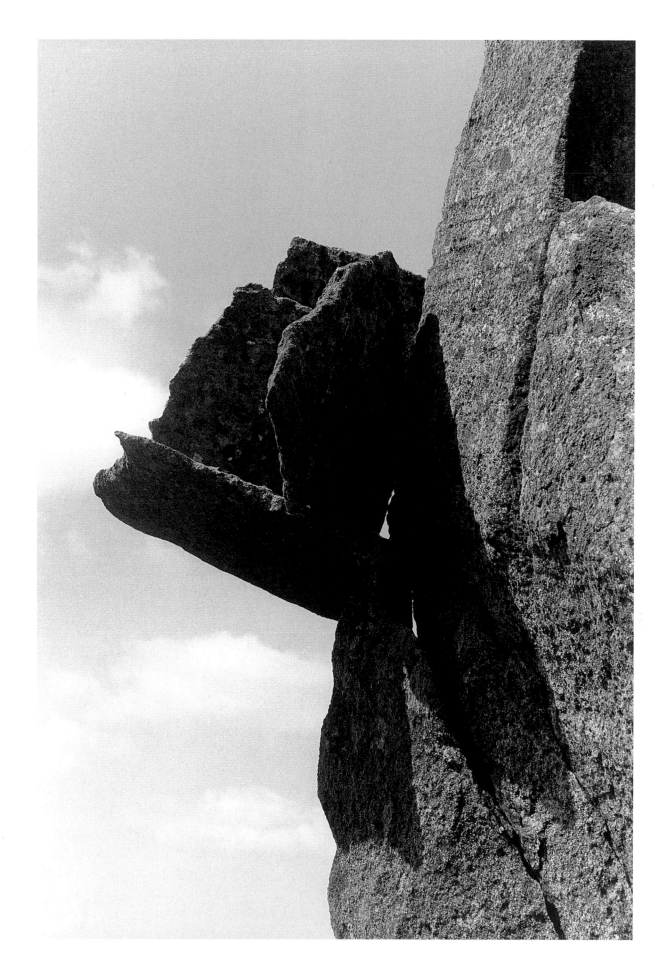

BOW FELL, CUMBRIA MAY 1977

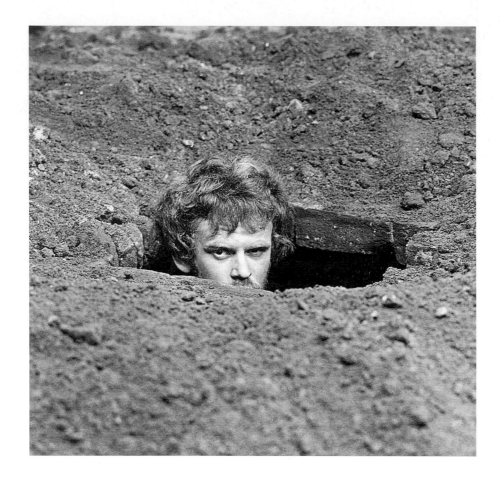

FRANS HALS MUSEUM, HAARLEM AUGUST 1984

HOLES

The black of a hole is like the flame of a fire. The flame makes the energy of fire visible. The black is the earth's flame — its energy. I used to say I will make no more holes. Now I know I will always make them. I am drawn to them with the same urge I have to look over a cliff edge. It is possible that the last work I make will be a hole.

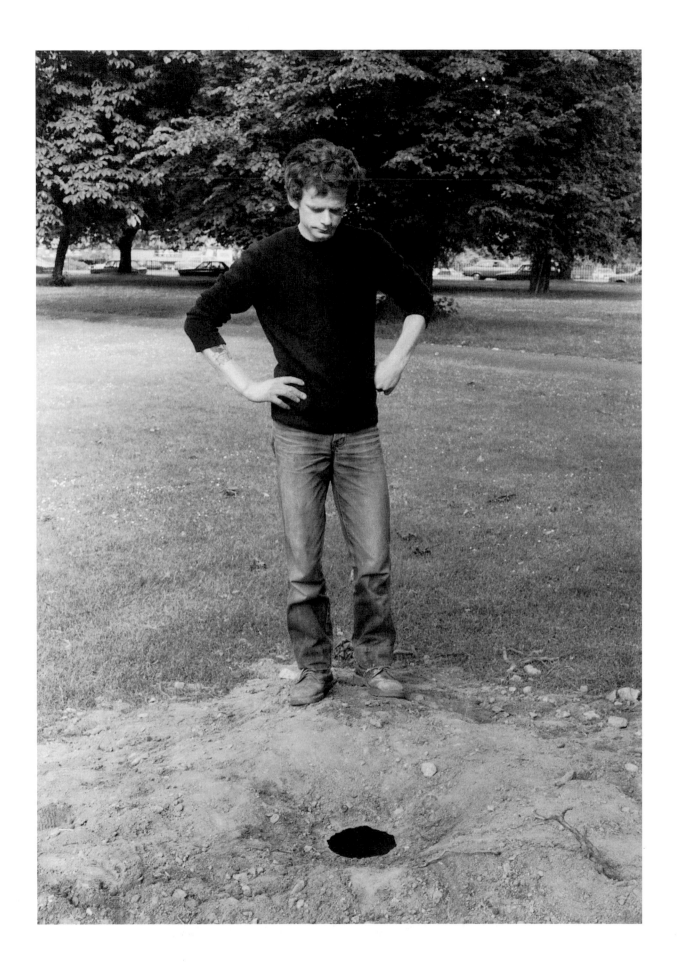

SERPENTINE SUMMER SHOW 1, LONDON JULY–AUGUST 1982

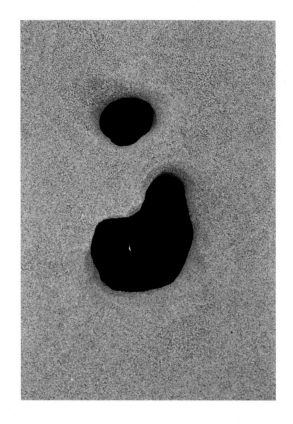

First hole, sand

SOUTHPORT, CHESHIRE JULY 1977

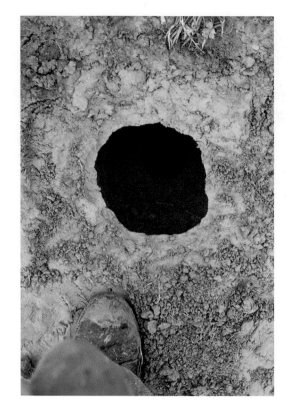

Earth

LYC MUSEUM, BANKS, CUMBRIA AUGUST 1980

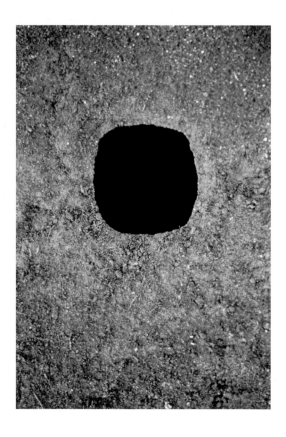

Peat

BLAENAU FFESTINIOG, NORTH WALES JUNE 1980

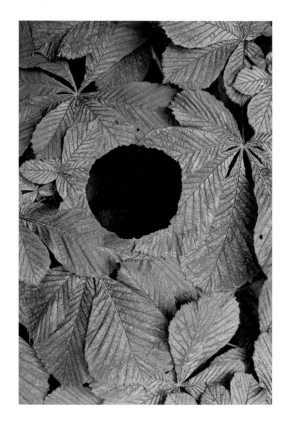

Horse chestnut leaves

CAMBRIDGE, ENGLAND 24 JULY 1986

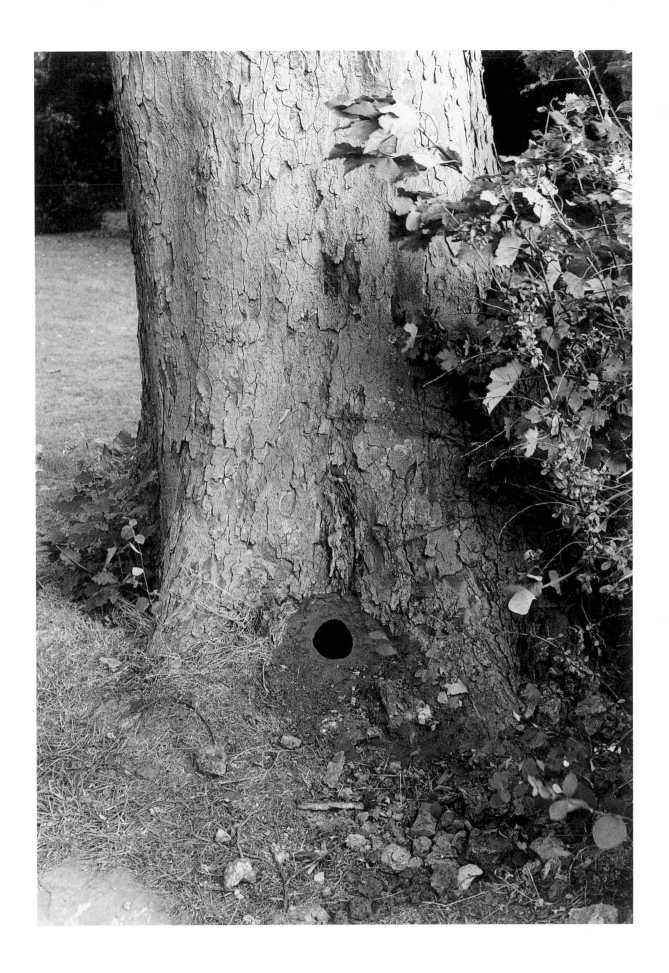

YORKSHIRE SCULPTURE PARK SEPTEMBER 1983

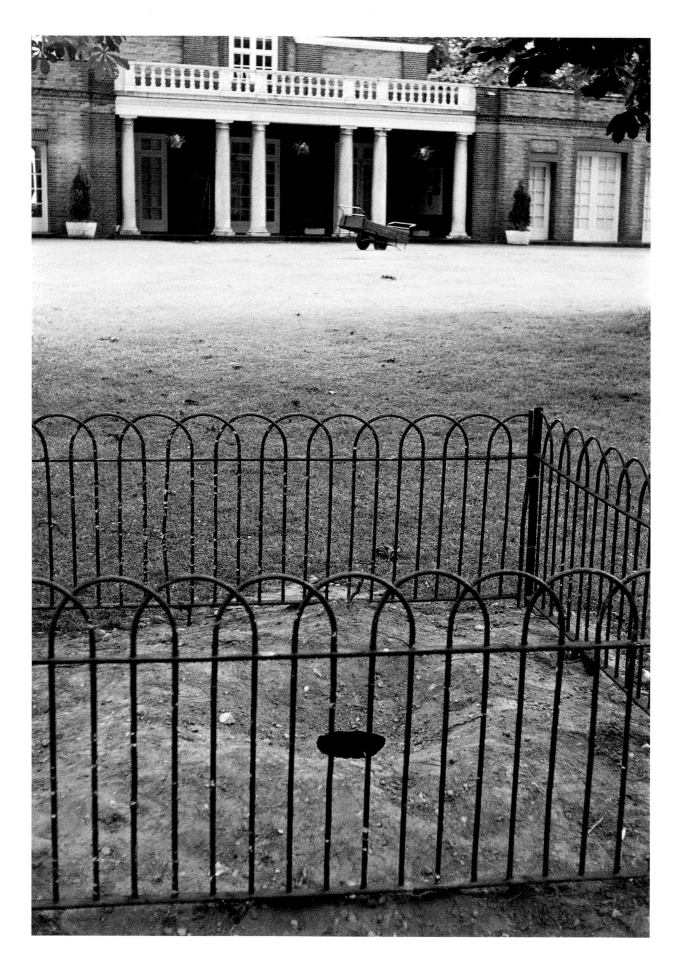

SERPENTINE GALLERY, LONDON 1984

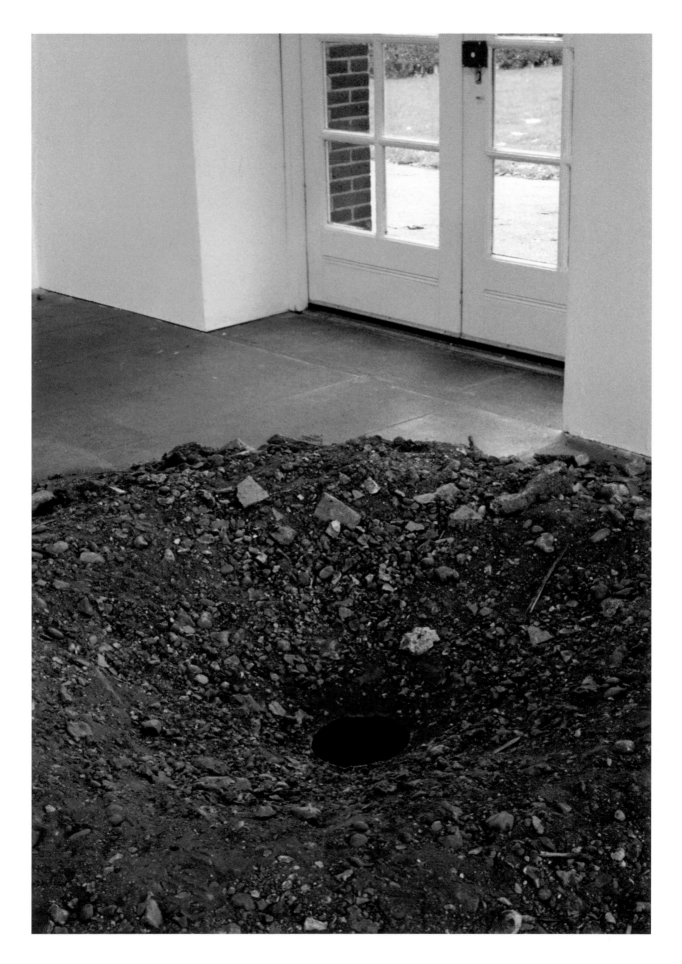

SERPENTINE GALLERY, LONDON 1984

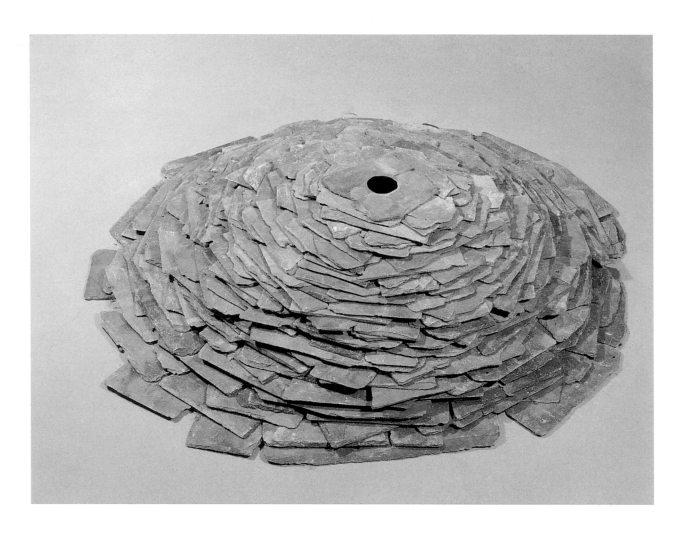

Slate hole

FABIAN CARLSSON GALLERY, LONDON JANUARY 1987

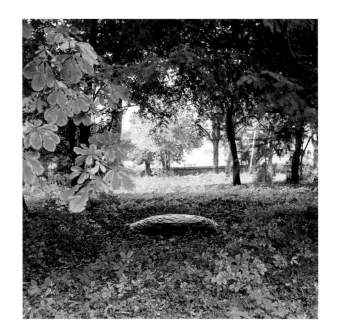 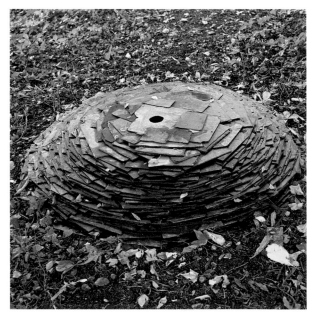

Slate hole

ROUEN, FRANCE 1988

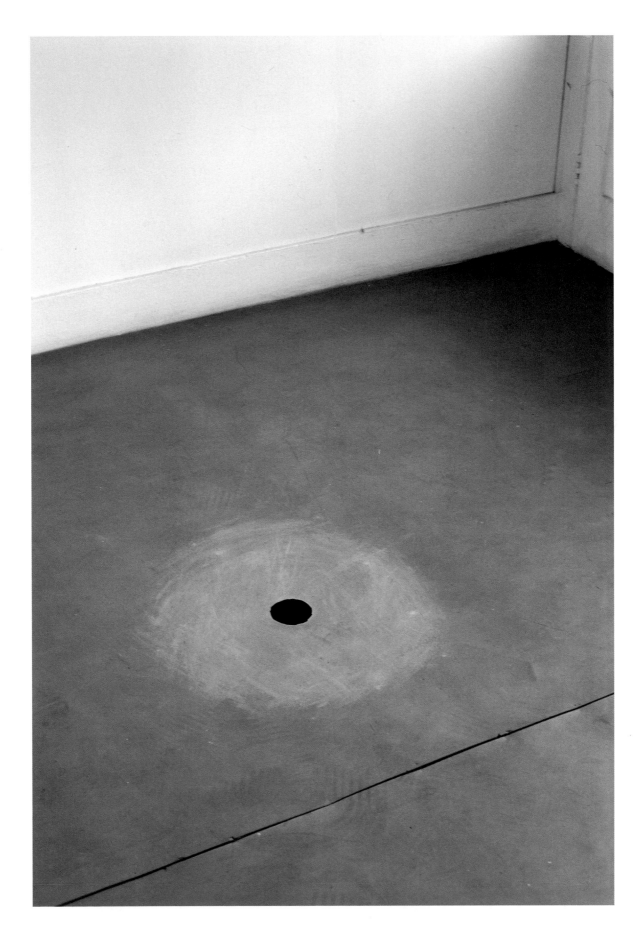

Linoleum hole

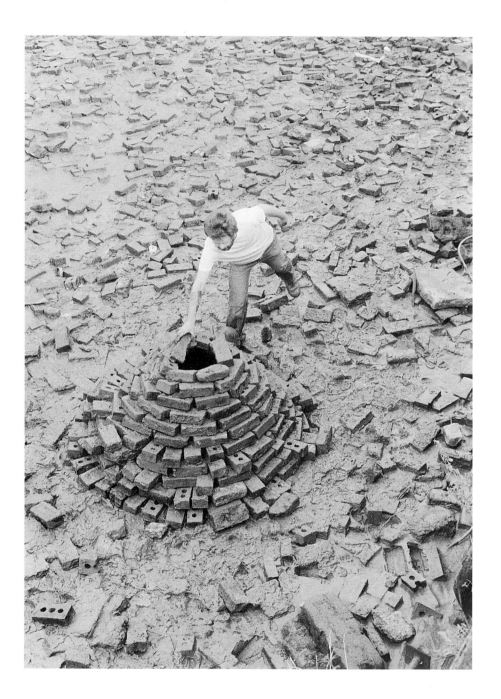

Bricks and river mud
rising tide

RIVER THAMES: THE SOUTH BANK, LONDON 1987

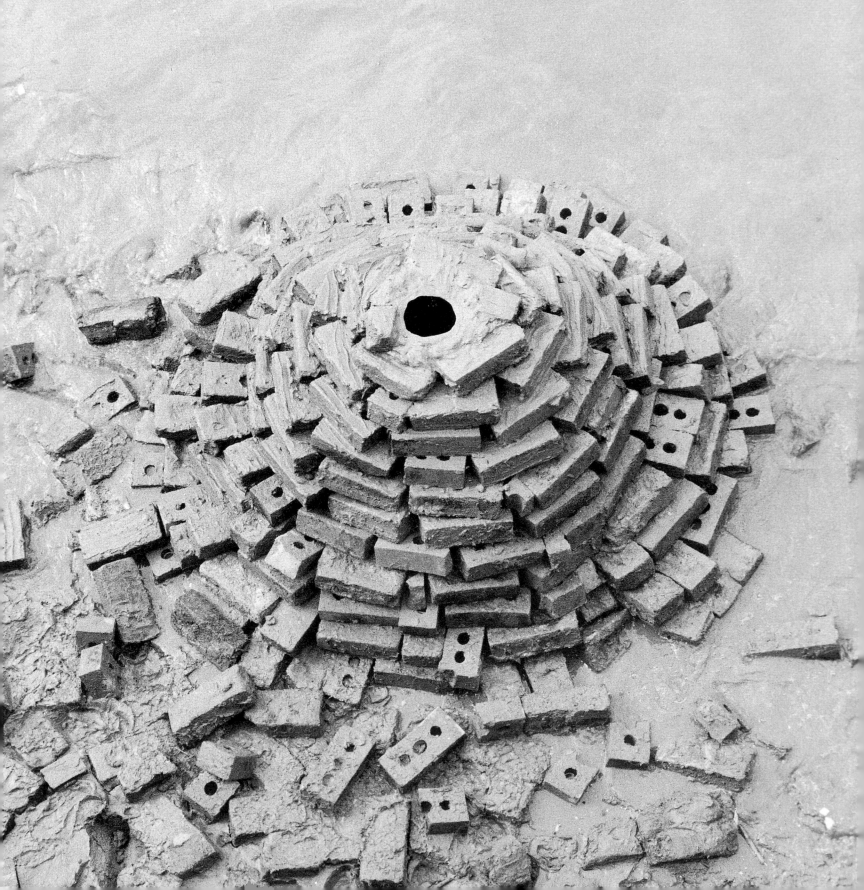

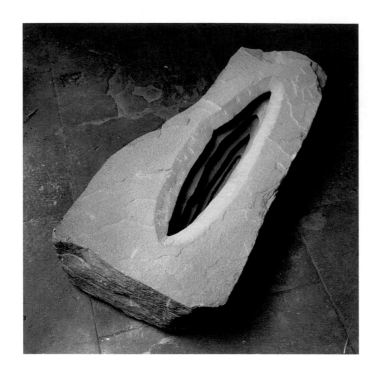
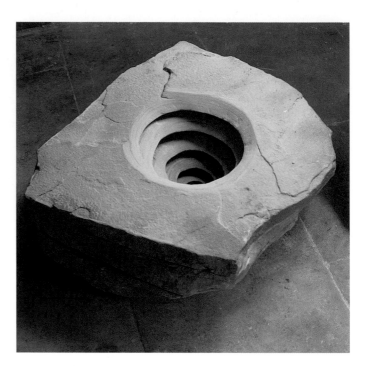

Split and carved sandstone

PENPONT STUDIO, DUMFRIESSHIRE 1987–90

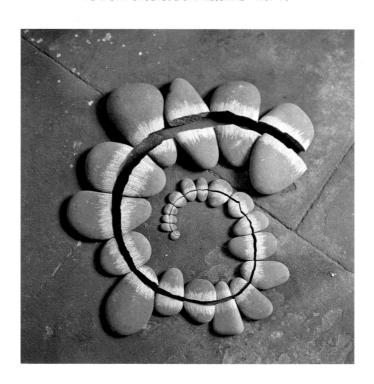

Broken pebbles

PENPONT STUDIO, DUMFRIESSHIRE 1987

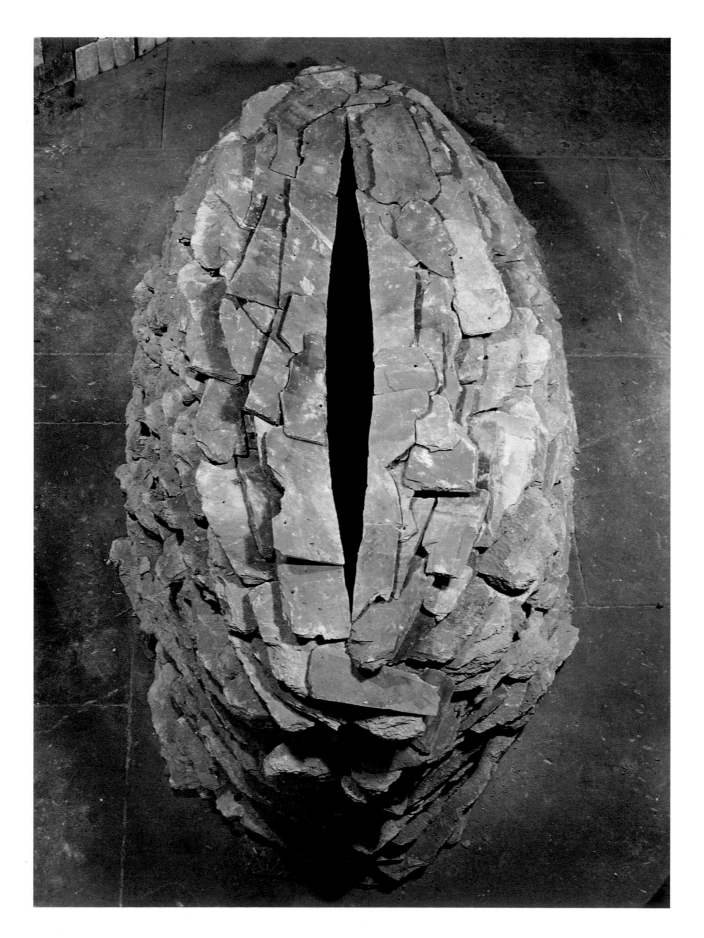

Slate hole

PENPONT STUDIO, DUMFRIESSHIRE 1990

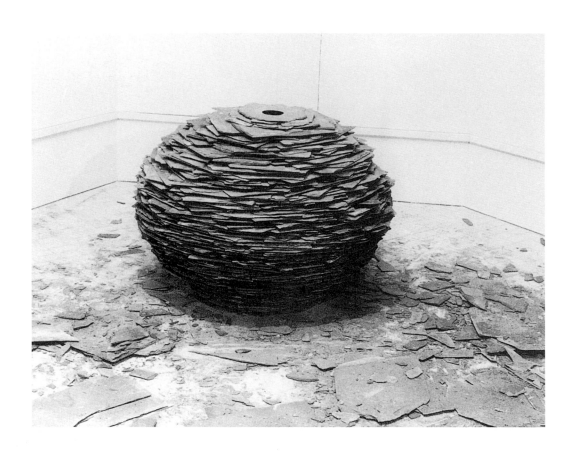

Slate hole

LEEDS CITY ART GALLERY 1987

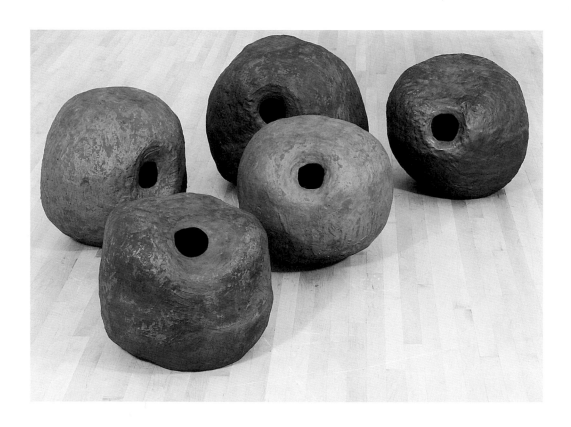

Fired clay holes

FABIAN CARLSSON GALLERY, LONDON 1989

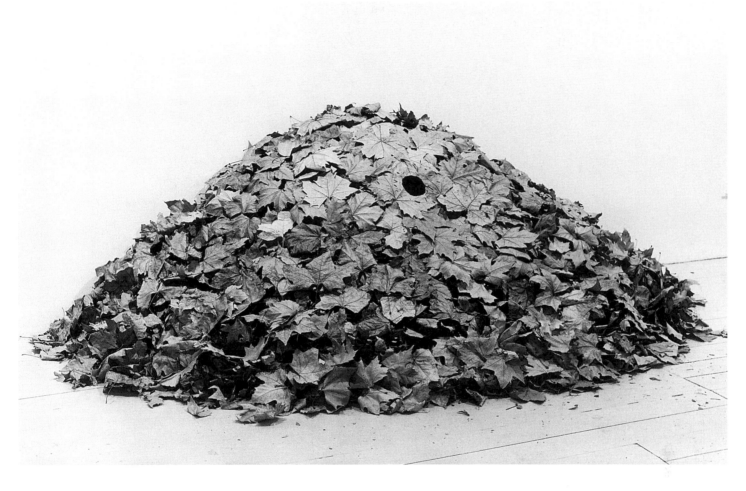

Leaf hole

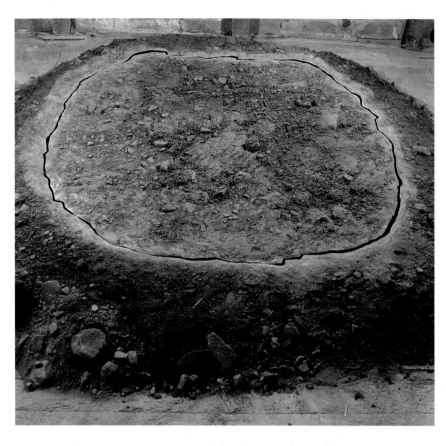

Fired clay and earth

PENPONT STUDIO, DUMFRIESSHIRE 1989

Earth crack line

YORKSHIRE SCULPTURE PARK SEPTEMBER 1983

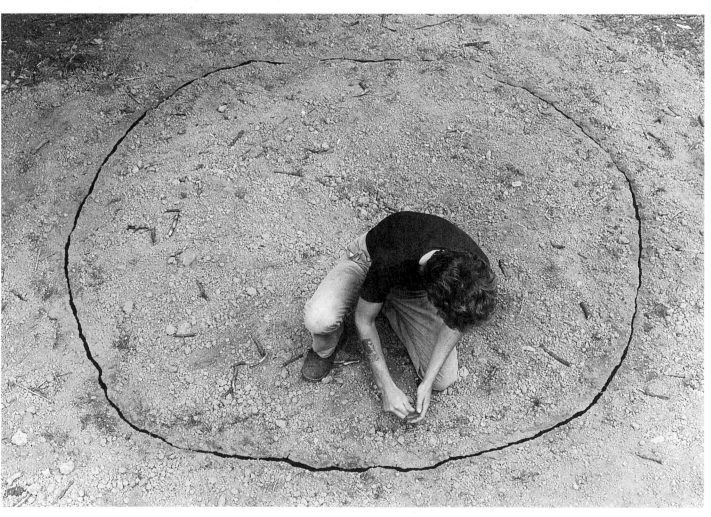

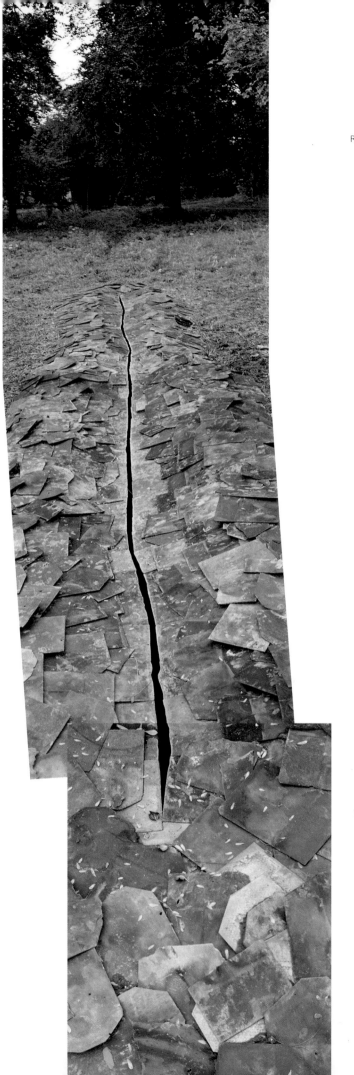

Slate

ROUEN, FRANCE 1988

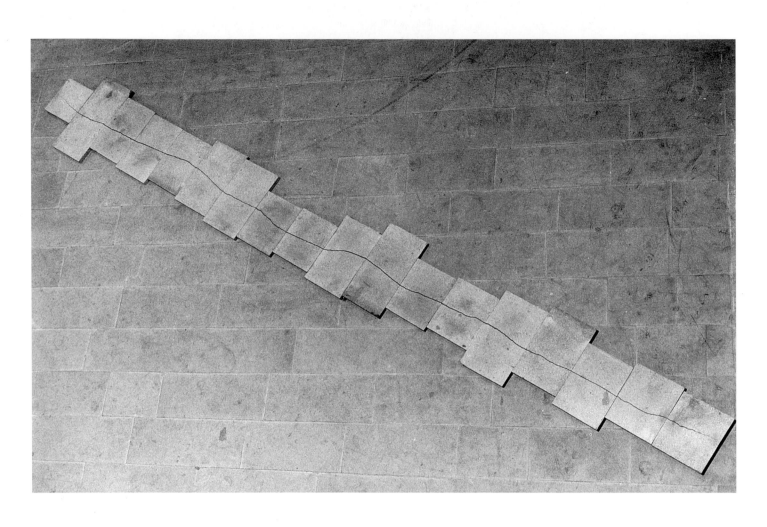

Broken paving stones, versions I and II

APERTO: VENICE BIENNALE 1988

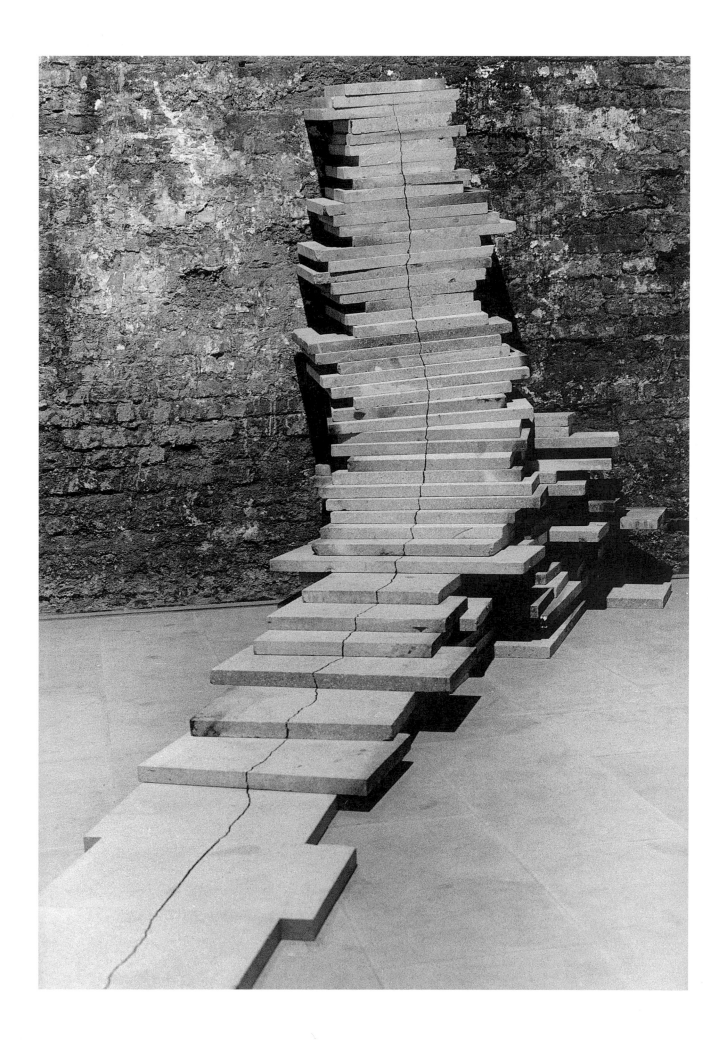

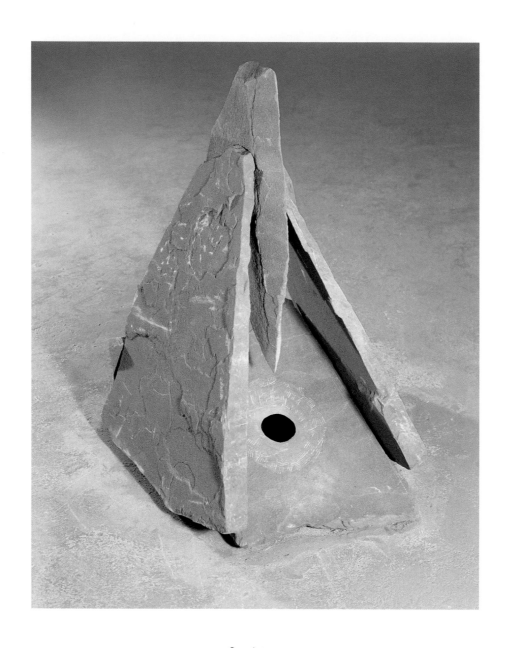

Sandstone

FABIAN CARLSSON GALLERY, LONDON JANUARY 1987

STICK THROWS

STONE THROWS

LEAF THROWS

RAINBOW SPLASHES

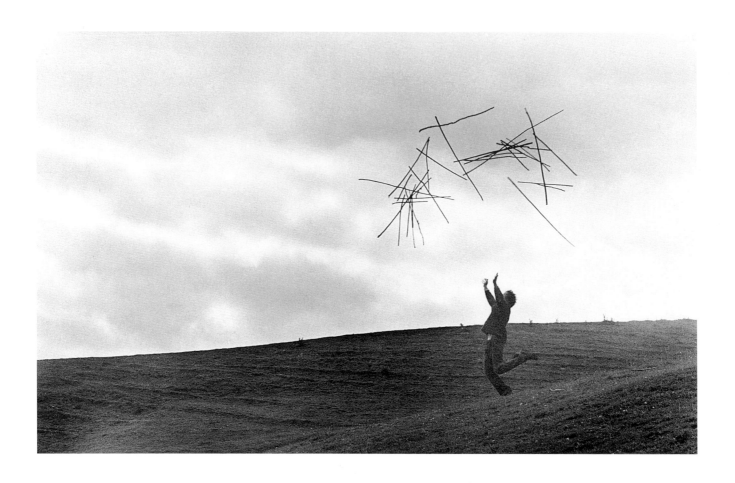

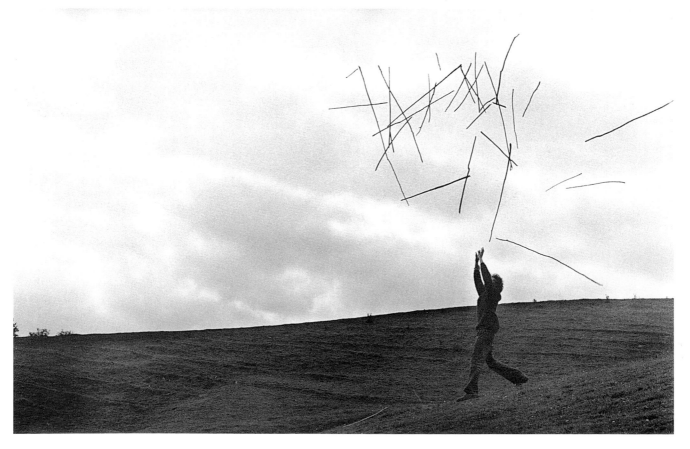

Hazel stick throws

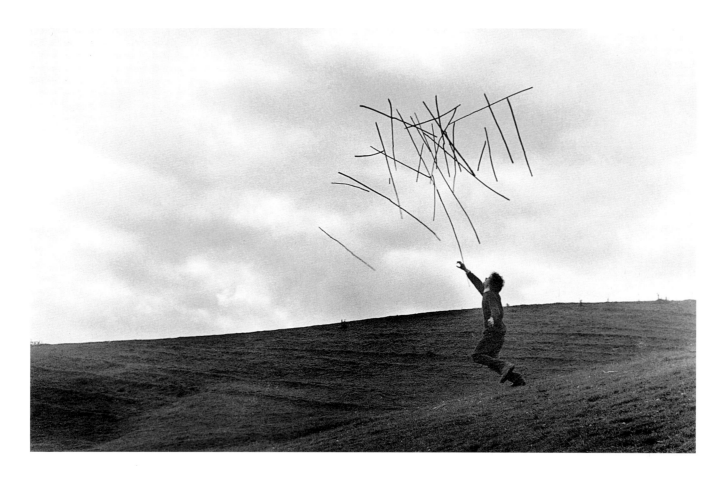

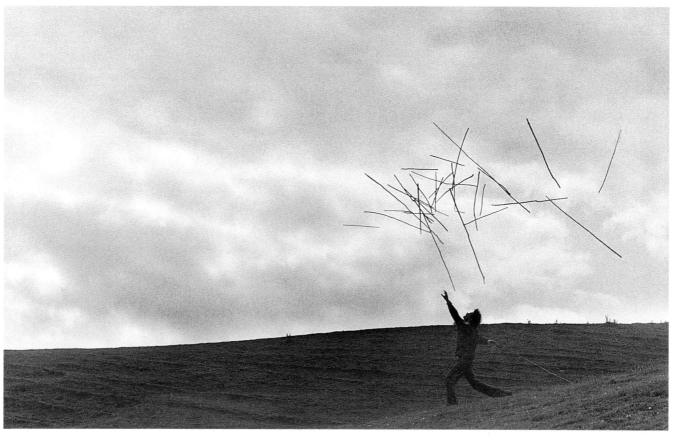

BANKS, CUMBRIA 10 JULY 1980

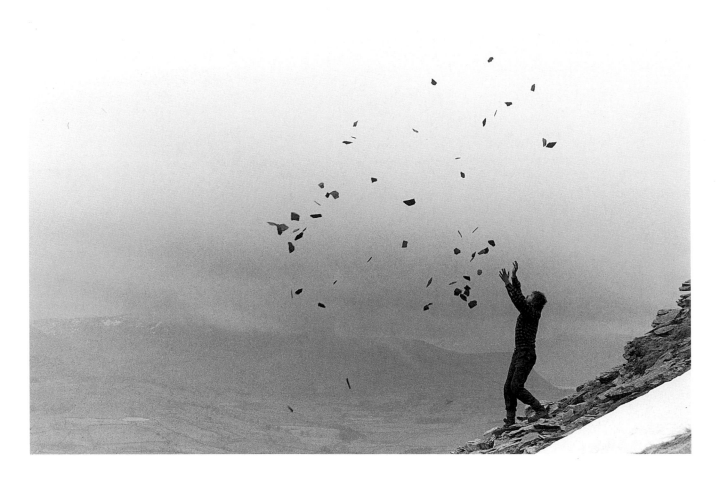

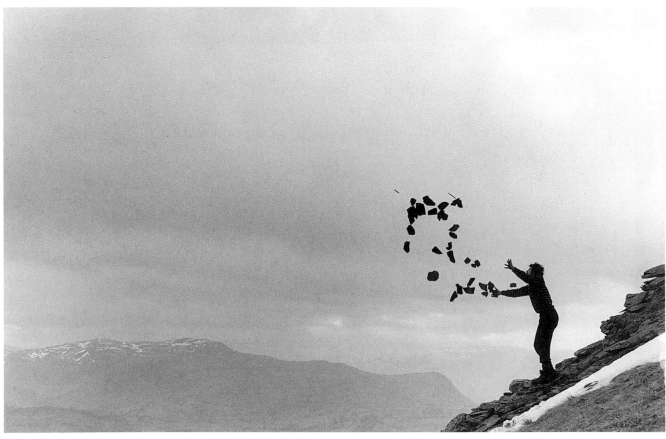

Slate throws

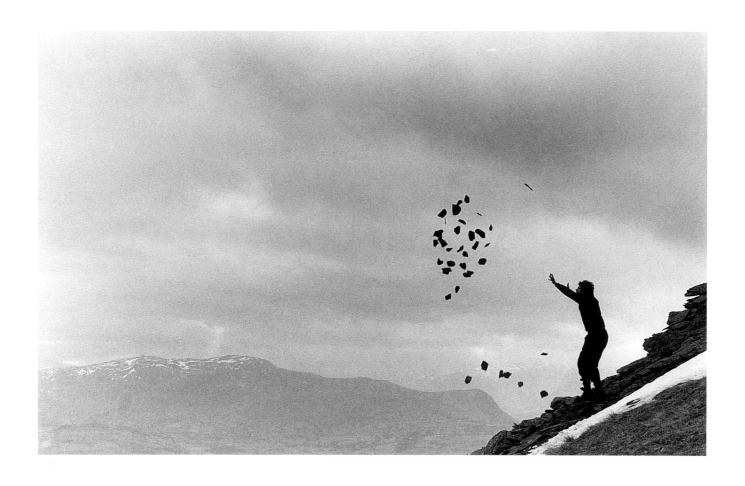

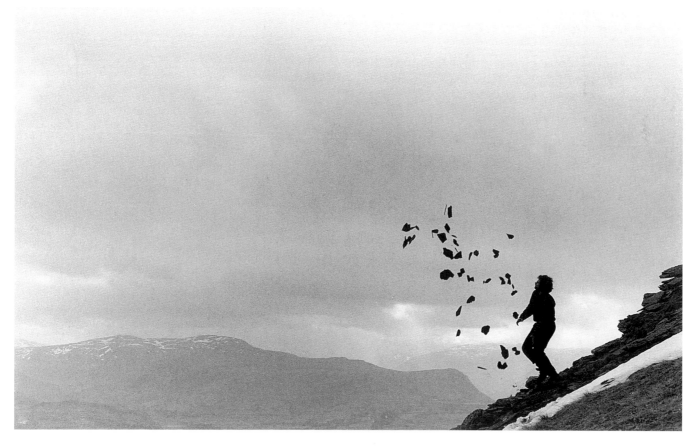

BLENCATHRA MOUNTAIN, CUMBRIA 19 FEBRUARY 1988

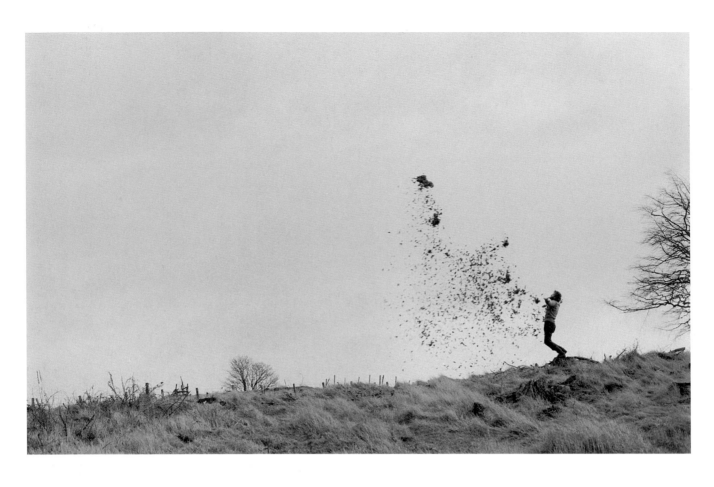

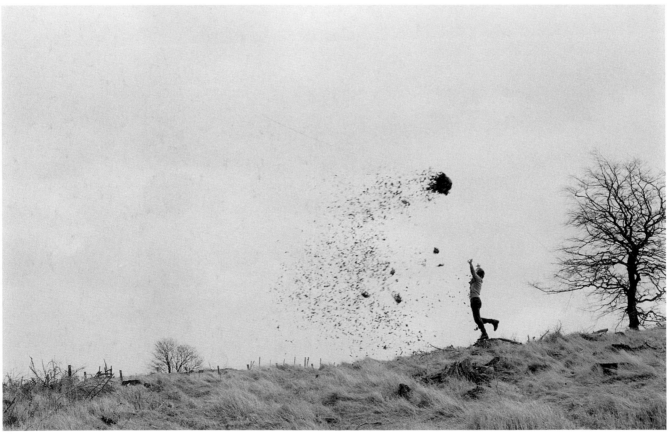

Leaf throws

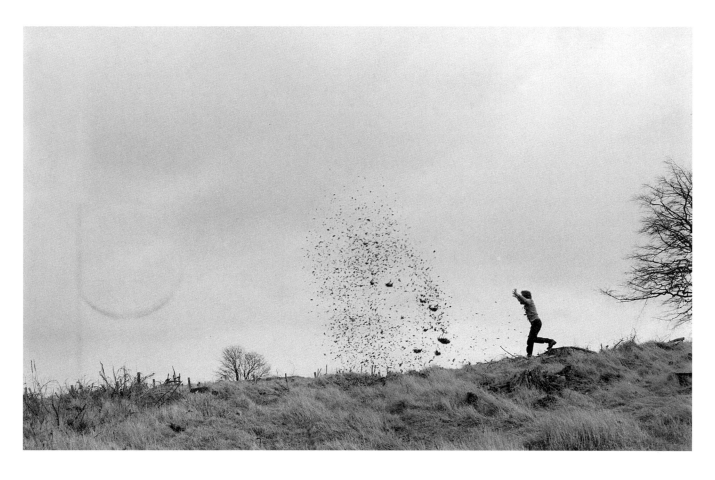

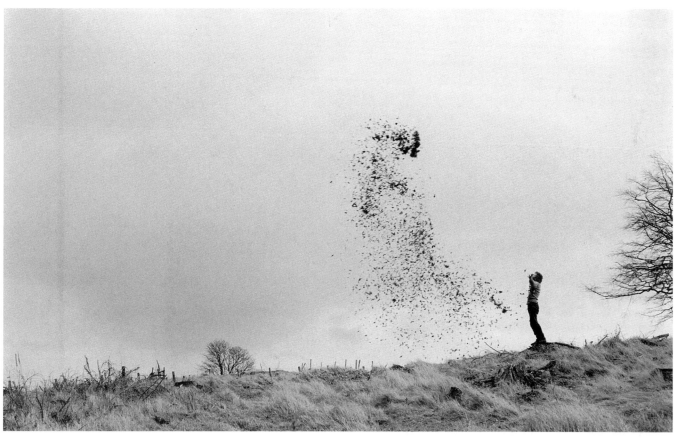

BLAIRGOWRIE, TAYSIDE 3 JANUARY 1989

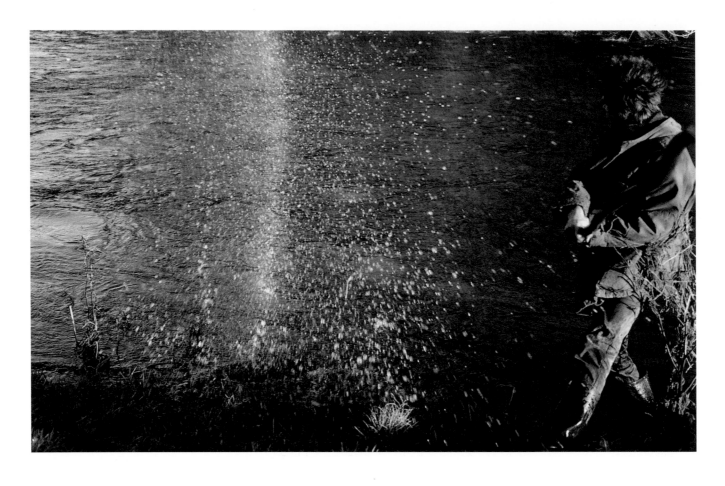

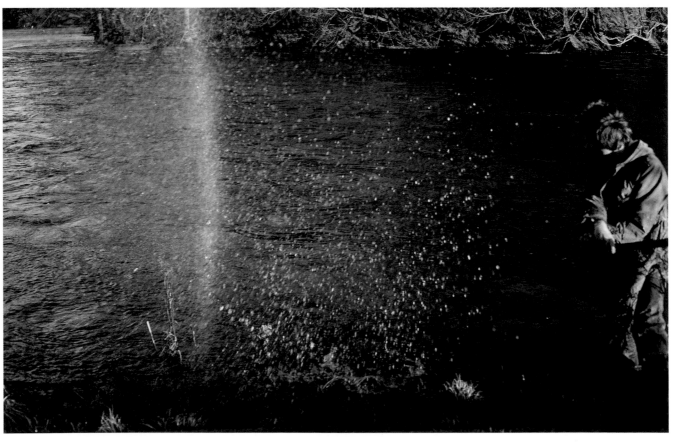

Rainbow splashes

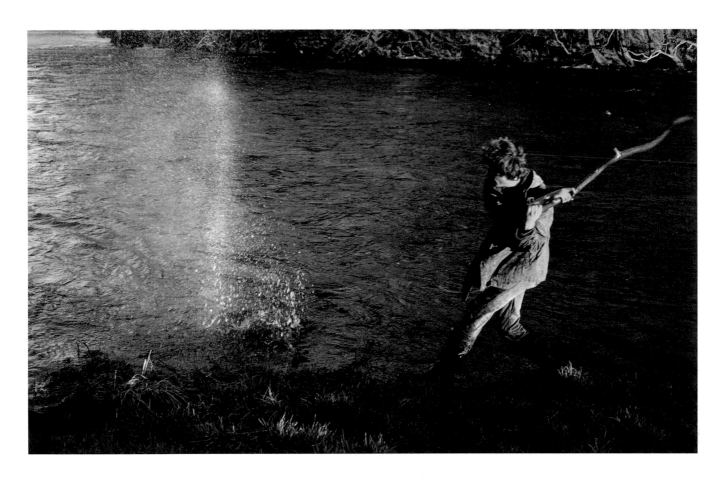

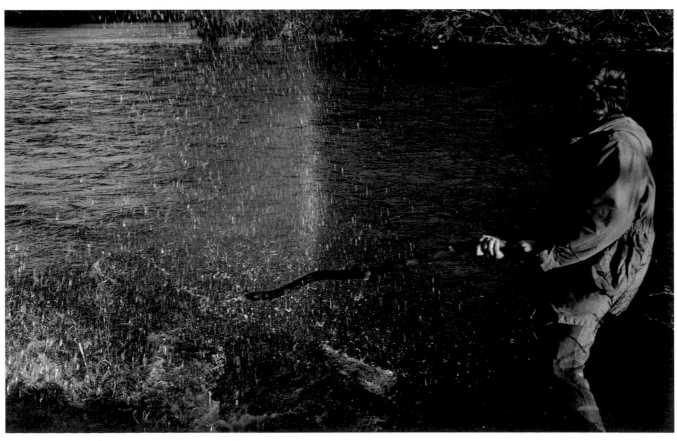

RIVER WHARFE, YORKSHIRE 23 DECEMBER 1980

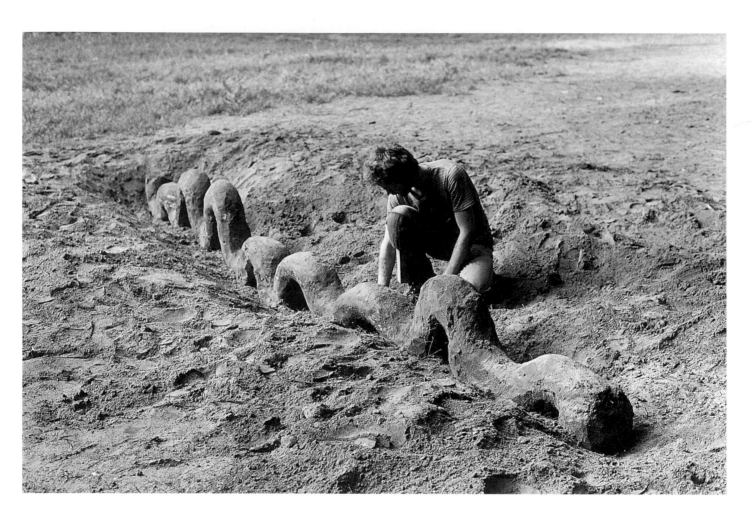

Carved sand

HAARLEMMERHOUT, HOLLAND 13 AUGUST 1984

PROJECTS 1984–1989

HAARLEMMERHOUT 1984

Hans Vogels

In recent years there have been several important contemporary sculpture events in Holland. During the Eighties a number of exhibition organisers, encouraged by the famous Sonsbeek buiten de Perken exhibition (held in the fine country park of Sonsbeek near Arnhem in 1971), offered personal surveys on the state of sculpture. Sometimes these were critical surveys of developments thought to be crucial at that particular moment, but there were also events in which the participating artists worked from some guiding principle: an inspiring location in nature, in a piece of architecture such as a deserted factory with an unusually stunning space, or on a more abstract level, a theme. In the vanguard of these exhibitions was Beelden aan de Linge (Sculptures on the Linge), held in 1984 along the banks of the small River Linge, where some fifty leading Dutch sculptors were invited to work. (Foreign artists have also participated in subsequent years.) The exhibition subtitle, 'sculptures looking for an environment', perfectly illustrated the organiser's intentions and this has become an annual event.

In the same year, 1984, a sculpture show held in Haarlem was distinguished by a somewhat different approach. Situated in western Holland and only a few miles from the sea, Haarlem has a large public park — perhaps even the word forest would be appropriate — known as the Haarlemmerhout. In popular speech called 'de Hout', it is frequented by many strollers, often accompanied by pets. 1984 celebrated the Park's 400th birthday and the municipal commission advising the city council on the festivities recommended holding a contemporary sculpture symposium on themes related to nature and natural materials: 'hout en de Hout'/'wood in the Wood'. Mabel Hoogendonk, curator of modern art at the Frans Hals Museum, was responsible for coordinating the event with the Dutch Ministry of Welfare,

which also gave substantial financial support. Twelve artists were invited (six from Holland and the rest from other European countries), including Andy Goldsworthy.

Three selection categories were established: artists working with wood, using wood as a mark of their respect for nature; artists who gave wood the most prominent place in their work; artists who chose a natural environment as the starting point of their art. Each participant was asked to establish a visual and three-dimensional relationship with the landscape and history of the Hout.

The symposium was held between 5 and 31 August amidst continuously warm and sunny weather. Trees cut down in and around the city since the autumn of 1983 had been stored and were now available to the artists; in addition, five diseased trees in the Haarlemmerhout due for removal in the near future were retained for their use.

For Andy Goldsworthy, working in a municipal park was stimulating; at the end of the symposium he remarked: 'I have enjoyed a month of sand, leaves, sun, shadows, one rainstorm, a lot of people, few sticks and no clay or stone.'[14] He looked for stones, so often present at sites he had worked in Britain, but in vain at Haarlem, where the soil is sandy. This forced him to consider alternative solutions.

On 29 August, at the very onset of a sudden, brief shower, he lay down on the dry soil, then after the downpour stood up, leaving the contour of his body: a light figure against darker, wet sand.[15] For Goldsworthy a work made in the landscape, no matter how modest or fleeting, is a token of man's presence in nature, the equivalent to a signature.

A map of the Haarlemmerhout included in the catalogue issued by the Frans Hals Museum following the symposium shows the sculptor's daily tracks and activities, revealing his working method — a personal exploration of the natural environment — and some of the materials he used: green and purple sycamore leaves, horse chestnut leaves, raspberry leaves, cherry leaves, poppy petals, green beech patches and so forth. The sketchbook diary (No. 10) which he kept at this time records, for example, on his first day of work, 6 August, the sunny weather, the splendid play of clouds above the

Wood and some early experiments with the sandy soil and the abundant sycamore leaves. During these first days he made irregular patterns on the ground with horse chestnut leaves; and, above all, lines, sometimes out of beech leaves, with colours ranging from green to yellow, brown and red-orange, delicate and poetic though transient creations.

Another recurrent motif was the hole: made from leaves arranged in a circle on the ground, leaves hovering over a hole, leaves held together by thorns or twigs, floating on the water's surface, a kind of peep hole into the earth down towards the energy that makes nature live and grow, the essence of our existence. A hole dug in the Serpentine Gallery garden in London in 1981 was repeated in the exhibition hall of the Frans Hals Museum on 10 August 1984 and on Goldsworthy's return to Britain, in the Serpentine Gallery itself: he removed the cobblestones and dug with his hands in to the sandy and soft soil below the foundation a hole the depth of his own body. Even amidst the museum building nature was laid bare.

On 13 August Goldsworthy began working with Hout sand, which proved a revealing activity for him, stimulating his spirit and in a way anticipating his later work in snow and ice at Grise Fiord and on the North Pole in 1988. The sandy paths through the Wood were very hard due to their dryness and the imprint left by a multitude of visitors and dogs, combining to produce a compact, stone-like material, yet far more fragile. Using a sharp knife, he made sculptures: first, an irregular serpentine to explore the possibilities (and impossibilities) of the material; the results were fruitful and attracted a considerable crowd, which he enjoyed. His diary records his nervousness at *working something that has taken many years of walking feet to make* (13 August). He was astonished by the sculpture potentials of hardened sand, though he did not return to working in this way until 23 August.

In the meantime, he experimented further with leaves, finding the making difficult due to the hot weather which dried them too quickly and, therefore, he redirected his attention to the hardier structure of leaves, which stand up to the weather: *The key is in the leaf veins — the leaf architecture — it's amazing how geometric the structure is* (17 August). From horse chestnut leaves he made flat patterns on the ground, partly covered with soil, spires (cat. no. 88) and boxes held together with thorns. Wind and dogs became serious threats to these structures and some were destroyed even before they could be photographed.

The same fate befell a second sand sculpture made on 23 August. Goldsworthy had originally planned to construct an arch but failed because of the heaviness of the sand. The alternative, and more successful, work was made possible by carving the softer sand beneath the hard crust, with the resulting amoeba-like structure consisting of both a light 'positive' form (above ground) and a dark 'negative' form (below ground), echoing each other and both appearing as if hovering above the void. The sculpture was soon destroyed by passing people and their pets (cat. no. 87).

In August it is, of course, still summer and the range of colours in nature is not as great as in autumn. One of the few possibilities of experimenting beyond the many shades of green was offered by the scintillating red of poppy petals. Gathering petals, tearing them into strips and sticking them end-to-end with spit (glues are never used), he made a seven foot long line and hung it vertically on the branches of an elderberry. This was one of the most impressive and poetic works to come out of the Hout, though it survived only long enough to be photographed and was then swept away on the breeze.

At the close of the Haarlemmerhout symposium Andy Goldsworthy remarked: 'It is difficult to articulate clearly an experience that is still very close to me — it will be a long time before I understand what I have made this August.' The myriad works created since that time in Holland reveal that particularly the experience of working with Haarlem sand was of tremendous value; not only the actual making of sculptures in sand, which anticipated some of the Japanese and North Pole works, but also making manifest the sunlight, its changing intensity and warmth through the day; the play of light and shade on the sculpture functioning as though it was a sundial, thereby revealing another aspect of the ever-changing character of nature.

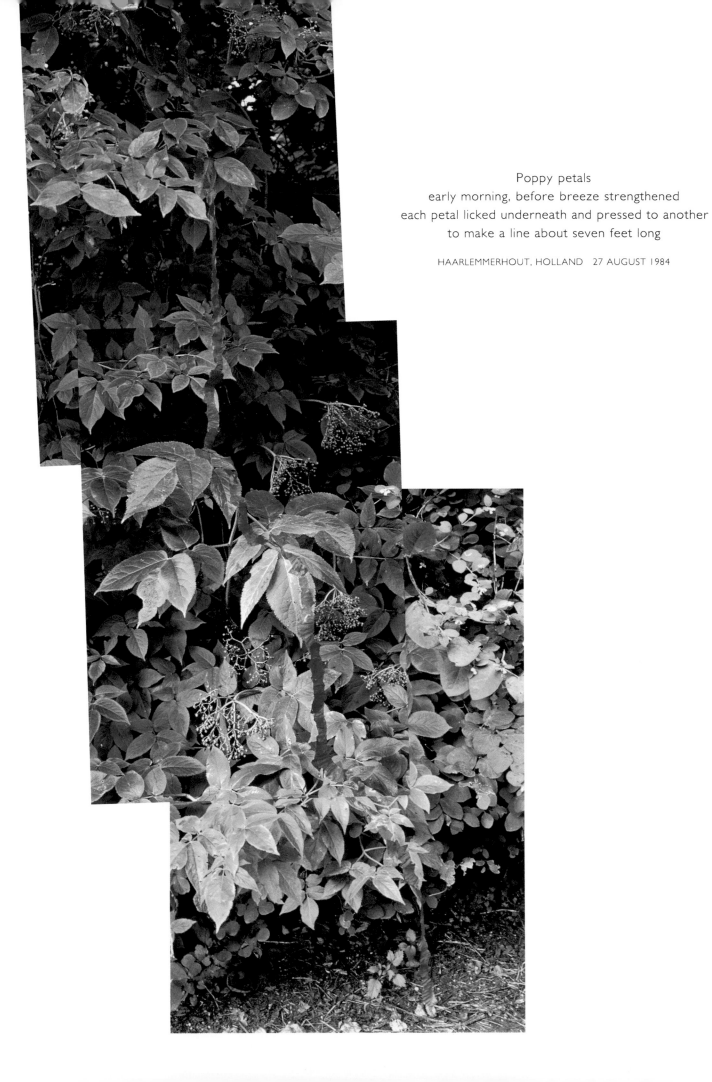

Poppy petals
early morning, before breeze strengthened
each petal licked underneath and pressed to another
to make a line about seven feet long

HAARLEMMERHOUT, HOLLAND 27 AUGUST 1984

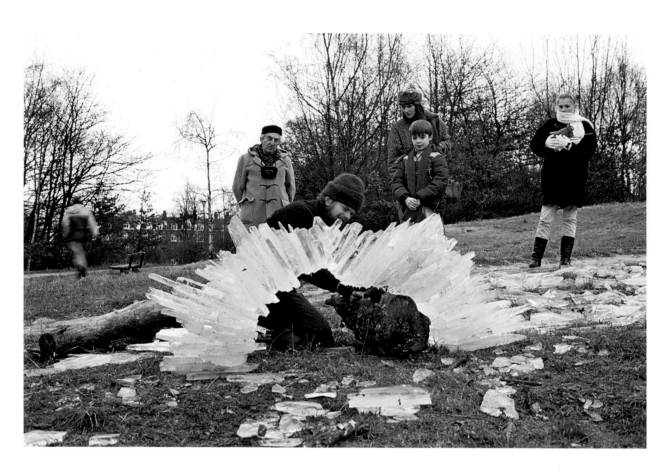

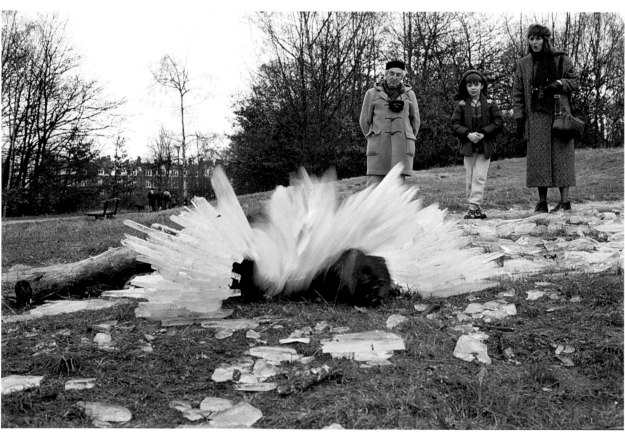

Ice workshop. Collapsing

HAMPSTEAD HEATH, LONDON 30 DECEMBER 1985

HAMPSTEAD HEATH and HOOKE PARK WOOD 1985–86

Sue Clifford and Angela King

'I would not like to think that my work could only take place in the spectacular remote landscape. My work has always been about the area around where I live, whether it be Brough, Langholm, Leeds or London. I enjoy working in a common place with common materials, and through the process of making come to realise how rich and extraordinary these places often are. I have always recognised the importance of green areas within the city.'

Andy Goldsworthy spent six weeks working on Hampstead Heath in central London during the winter of 1985–86. Concurrently, he created a visual diary updated virtually every day alongside his exhibition *Rain sun snow hail mist calm*. Common Ground's aspiration in bringing him together with his exhibition was to help increase people's awareness of their local surroundings and to show that inspiration is to be found in everyday places and materials. Enabling people to talk with and watch this artist going about his work on their home ground might help to reaffirm the imagination and the vitality of the arts in helping us to see the importance of nature and particular places in our everyday culture.

Artangel Trust joined Common Ground in support of the residency and endeavoured to keep people informed of Andy's whereabouts. With the permission of the Greater London Council and the help of the Hampstead Heath workers he began his 'residency' on 12 December.

On his first day, discussion with a sympathetic journalist from the local newspaper, the *Hampstead and Highgate Express*, left Andy in no doubt that the Heath is a precious place to the many people who walk, jog and play there, and that he would be very exposed. As paradox would have it, when he left six weeks later, not only were very many sad to see him go, having claimed him as

their own resident artist, but Andy himself was surprised to discover that his feeling of freedom there far outstripped that of working in 'open country' where the territoriality of land holders and gamekeepers often impose demanding constraints.

He began by saying 'I do hope they will understand it will be a response to the Heath, will be sensitive to the Heath and about the Heath. It will last for a very short time, nothing will be there after I have gone'. Working many hours a day in all kinds of weather, he created works of leaves, snow, ice, coppiced branches, and built the visual diary showing the successes, the failures and the friendships that he developed.

The exhibition (held at the London Ecology Centre), residency and diary succeeded in opening the eyes of a wide range of people, many of whom came to a gallery for the first time after discovering him working in the open. Gallery visitors were lured to the Heath.

In one of three talks he described a variety of encounters while working: 'I made the hairy circle and as soon as I finished it a group of kids came up and took it in turns to jump through. One guy, must have been an actor of some kind, he was shouting out his lines as he went past, paused to look through. A man came up with his pigeon which he was taking for a walk. I was really bracing myself for the "usual response" towards art in public. A jogger running by said, "what's that then?" He didn't stop; it was as though I had 5 seconds to explain my ideas about life. After I'd been on television a couple of times a man said "How do Andy. Saw you on Blue Peter last night. I was so proud of you". In fact, I have aimed the whole thing at the people who use the Heath regularly. For people who just come out for the day to find me it's a bit difficult, because I might just have a pile of ice that has just collapsed. It is very risky, so people who see me everyday get into the problems I have and understand the process behind making something.'

The visual diary records a moment of 'failure':

30.12. Sun. Ice workshop. Made arch over a pile of sticks — waited for it to freeze — temperature going up and down — thawing then freezing — managed to get out most of the sticks — lost concentration for a moment —

all sticks loose but somehow knocked arch and caused its collapse. Not really frozen enough. So close. Photograph of the arch collapsing by my wife Judith — I am under the falling ice.

Earlier in December, the hanging of the exhibition going on all around him, Andy had thorn-pinned a serpent of bracken to the wall of the gallery and then turned to the creation of an arch of slate. Out of the tea chests came some of the essence of Cumbria. Hours of careful work followed, pushing the notion of arch to its limits, further than sensible for barn or house. Late at night the arch collapsed. Sometime the following day a slightly less daring arch stood firm, and warded off the leanings and touchings of thousands of hands for two months.

Always testing and searching, so much of what Andy achieves demands a renewal of our excitement in the discovery of things, of their characteristics and colours, their potential:

24.12. Tues. Holly Ball held together by its own thorns. I've had lots of problems with holly in the past. It's such a tough little leaf and to do something with it has been really difficult. And it's because I haven't got into it, understood it, I don't know enough about it, and it's just a matter of pecking away until I've learnt enough. Then I'll be rewarded with a good piece of work. They are held together with the prickles on the leaves.

'I made a leaf box on the Heath and it became a kind of ritual to bring this box out from behind the holly bush (I keep it in the holly bush) and everybody touches it and passes it around. Until people actually pick it up they just don't understand it. They don't understand how it is made or what it is like. As soon as they touch it they understand. It was very important to me when I discovered that I could actually learn from making art. Instead of it being a means of dumping my feelings or ideas, it acted as a kind of vehicle for getting information. Learning how ice freezes, what the weather's like, how long it takes for the rain to fall before it can leave a shadow.'

Roger Took, Director of Artangel Trust, elegantly summed up popular feeling: 'When Artangel and Common Ground were first talking about Andy's work, I thought heavens this man will not enjoy working in London. I worried about whether he was actually going to be able to cope with the interest of the media that was bound to come, and the crowds who would want to see him work. To work and to be watched working is for some artists a very difficult thing. But Andy you have been teacher and entertainer to all of us. I wish you had been in the office on some occasions when calls have been coming in by their hundreds — people anxious to know where you are, people who felt extremely annoyed and very upset that they had not found you. Your work is a wonderful and beautiful and admirable craft, it is also art because by its intervention in nature it creates new relationships between ourselves and nature. At this time when all of us are getting depressed about the educational cuts and the loss of our teaching institutions we are amazed to find you have under our noses opened a new university in London: The Open University of Hampstead Heath. Those of us who have been lucky enough to watch you and feel the tension of your work really consider ourselves graduates of Hampstead Heath. In the words of one of your spectators, "thank you for showing us what is there".'

Andy had extended our perception of sculpture from the solid and monumental to the delicate and ephemeral. He did not leave empty-handed, apart from the many friends he had made, touched directly or indirectly by his work, and the new lessons learned, the Heath itself had made its mark: 'there are places on the Heath now that are so important to me, that I care desperately about. It's a bit like passing a house that you used to live in. And it is just like any other house, but because you've lived in that house you have some sort of understanding with it. And that's how I feel about the places in which I've worked.'

Later in 1986 Andy Goldsworthy again collaborated with Common Ground in their New Milestones Project, commissioned by the Parham Trust, making *Entrance* at Hooke Park Wood near Beaminster, Dorset.

'The hole/arch was my immediate response to the commission — initially taking its curve from the steep banks — a single sunken ring through which cars and

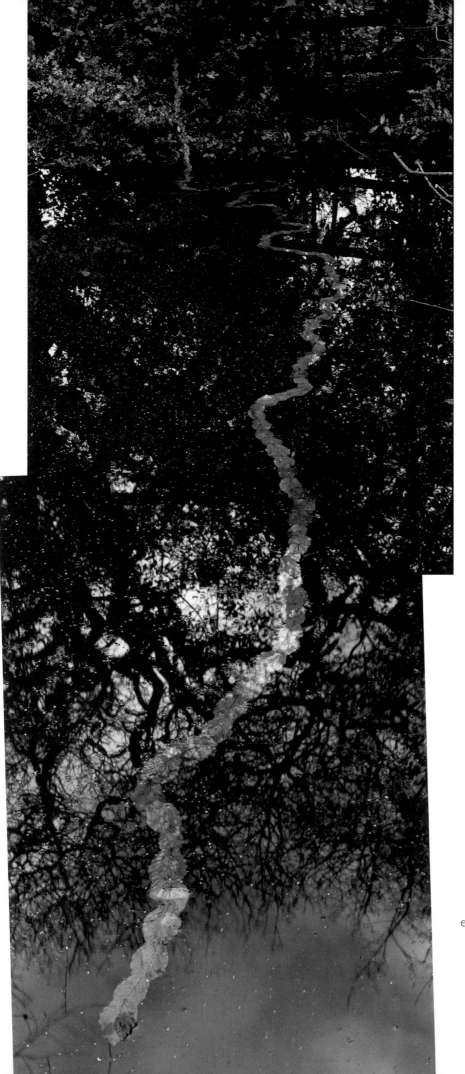

Beech leaves
collected only the deepest orange
from within the undergrowth
protected from sunlight
unfaded
each leaf threaded to the next by its own stalk

HAMPSTEAD HEATH, LONDON 26 DECEMBER 1985

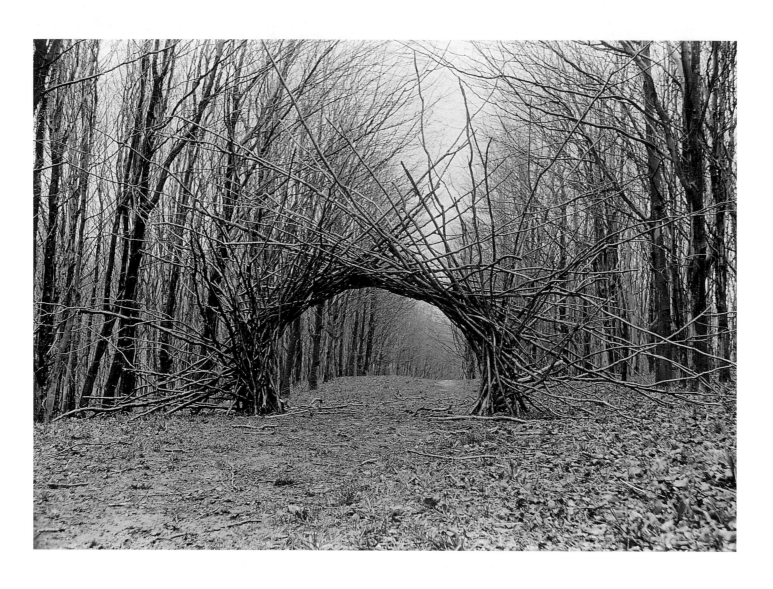

Woven beech

HOOKE ENTRANCE, DORSET APRIL 1986

people would pass. The road width, however, would have meant an entrance out of scale with its surroundings — in response to Department of Transport regulations and not the place itself. The site demanded something smaller. The work became two separate rings at either side of the road — on the more intimate scale of the walker or horse rider. I enjoy the seductiveness of a hole which always makes me want to explore the spaces inside or beyond — a window, opening, invitation, entrance. . . I spent time exploring Hooke Park Wood — looking for openings making entrances in hedgerows, clearings and along paths. Getting a feel for the place. I made drawings — working the space. I had some idea of the form but left the scale and nature of the work to be resolved in the making. I wanted the form to come out of the material and place. I looked for a material that would mould into the entrance space — in the way that a roadside tree forms an arch. A tree is shaped by the space into which it grows and the earth holding its roots. A bent tree is wood, root, growth, wind, snow, boggy ground . . . the energy of the place is caught in the curve. The nature of the work was determined by these curves — a collaboration. Being dependent upon what I found made the process of searching and finding an integral part in establishing a working dialogue with Hooke. Bent pine trees have little use to the forester and usually end up as low value thinnings. It was important that what I took fitted into the ecology of Hooke. The entrance is a meeting point between wood and road. Its form is drawn from the wood within and a landscape beyond that is rich in earthworks, landmarks, paths and roads that occasionally become tunnels through overhanging trees and steep banks. I have left a touch in a landscape steeped in associations between people and land. It is a social landmark — a passing through place that gives a sense of entering without blocking the way — an invitation. A barrier was a requirement of the commission — it will occasionally stop cars but always remain open to the walker'.[16]

Andy Goldsworthy was the third artist to be commissioned for Common Ground's New Milestones Project in Dorset. The project is about what places mean to people who live in them, about how to express that meaning in an imaginative and accessible way through

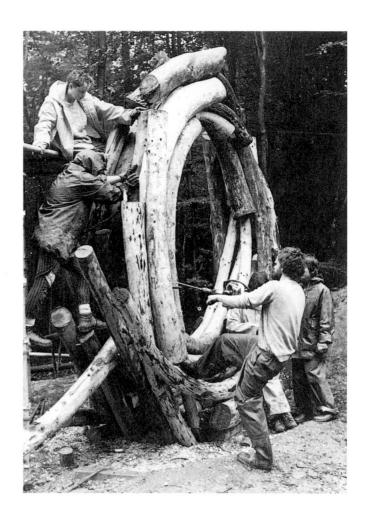

HOOKE ENTRANCE, DORSET 1986

sculpture. In encouraging people, landholders or local communities, to commission craftspeople and sculptors to crystallise feelings about their place in a public and permanent way, we are trying to liberate sculpture into the wild and to give anyone courage to commission art, however modest, to help communicate their caring. We are emphasising that our feelings about our everyday landscapes are important and should be taken seriously; that our moment in history has something to offer and that in setting our imagination free to explore places we can help initiate new cultural touchstones worthy of our time.

In November 1985 we talked with John Makepeace, Director of the Parnham Trust. We were excited by his ideas for the wood they had recently bought. Their plans for a School of Woodland Industry which would explore

commercial uses for small roundwood seemed an excellent way to help save small woodlands throughout the country by finding uses for the timber they provide. Since 1947 over half of our ancient deciduous woodlands, with their rich variety of flowers and creatures, have been destroyed because it has been more profitable to turn them into barley fields or conifer plantations.

Makepeace was keen to explore the philosophy of the 'Working Woodland' with a New Milestones sculpture and together we wrote a brief for a sculptor to make a 'gateway' from the road into the wood, incorporating a barrier which could stop cars from entering the wood at certain times; it was to be an impressive local landmark, a feature which will entice people into the wood and which will say something about the pioneering work in small wood technology being demonstrated at the school. We envisaged a residency of eight to ten weeks and approached South West Arts for matching funding.

Jenny and John Makepeace were impressed, as were we, with the permanent works Andy Goldsworthy had recently made in Grizedale Forest: the *Seven Spires* and *Sidewinder*, and with the support and approval of South West Arts, we offered the commission to him.

In April 1986, Andy spent some time in the woods exploring the place and ideas. Some of his sculptural drawings experimenting with holes and entrances were amazing for their simplicity and inventiveness.[17]

Andy started work on *Entrance* in July 1986. He was helped by his wife Judith and four students — Judith Atkinson, Samantha Rudd, Lynette Charters, John Ogden and Justin Underhill. Two weeks were spent finding naturally curved trees, felling them, dragging them to the forest path, trimming and barking them. It took two more weeks to complete the bulk of the work.

'Each ring was first laid out on the ground as a circle of overlapping trunks, then fixed with one inch diameter pegs turned out of greenheart in John Makepeace's workshop. The rigid ring was then lifted (on the first occasion with a tractor grab, on the second with a hand-winch anchored to a tree) and pegged to slanting timbers sunk into 6-foot foundations filled with preserved timber and concrete. Trunks to build up the skeleton rings were selected from the stock of prepared timber and added individually, each being hauled into position with ropes, drilled and pegged securely in at least two places. Further trunks were chosen and fixed until Andy was satisfied that the right balance had been achieved. The 15-foot barriers which operate on the drop bar principle were the final part of the work to be constructed. The slim, gently curving trunks were designed to cross in the centre of the drive, preventing cars entering when the woods are closed, without deterring walkers or obscuring the lure of the woods beyond. When raised, they lift back and disappear into the structure of the rings to complete the sculpture, visible only as longer spars extending above the others. Counterbalances of hollowed logs weighted with molten lead were added in January 1987, after the wood had dried out for several months. Despite their length and weight, the barriers can be easily lifted by one person, fulfilling the functional requirement of the commission brief. Young holly bushes have been planted which will grow against the rings, softening their junction with the bank. The inner edges of the rings are purposely set at different heights, so that one creates a 3-foot step, while the other rests on the ground with a levelled path beyond, enabling walkers with prams, wheelchairs and pushchairs to enter when the barriers are closed. During 1987 the sculpture was treated with preservative, masking the original golden colour of the wood and setting the rings back visually into the wood. Their shape makes them distinct from the trees behind, the curving timber contrasting with the vertical growth of the living wood.'[18] In March 1987 Goldsworthy described *Entrance* as 'a signpost, gateway, boundary marker and milestone that celebrates the beginning of the wood — just big enough for a horse and rider to jump through. A landmark by which people give directions — "go right at the wooden rings"'.

Knotweed stalks
used angles at offshoots to make a spiral
one end stuck up wider hollow end of another

HOLBECK TRIANGLE, LEEDS 16 MAY 1986

HOLBECK TRIANGLE
1986

17 May Holbeck Triangle — So many ideas!! a backlog of work with the beautiful stalks — just waiting for calm weather to bring them out. Tried working on top but too windy — went in dip — started making scaffolding again but this time more structured — smaller stronger & I think better. Made it to about 3½' tall. left it. Need to be made above when I am fresher. Problem with other loosing concentration will work on it tomorrow.

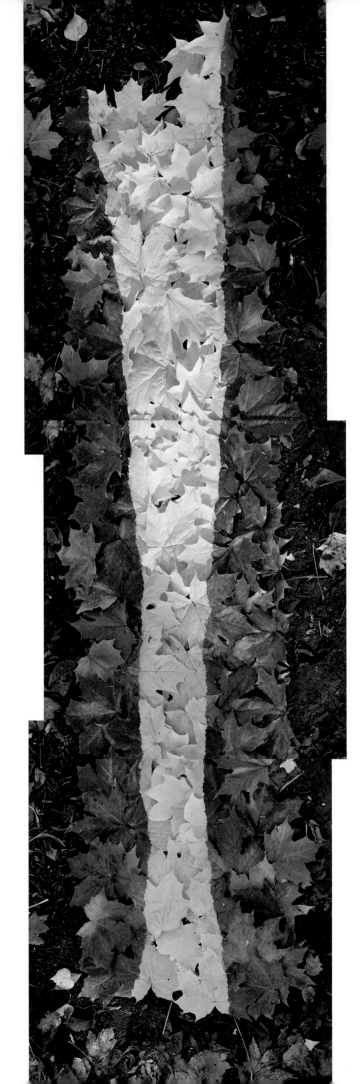

Yellow and ruddy leaves
made edge by finding ruddy and yellow leaf the same size
tore yellow leaf in two, spat underneath one half
pressed it on to the ruddy leaf

POLLOK PARK, GLASGOW 1 NOVEMBER 1986

GLASGOW
1986

The Collins Gallery, University of Strathclyde, commissioned work for the exhibition *Perspectives: Glasgow — A New Look*, 1987.

'I had never been to Glasgow before this commission and I approached the city as I would any new place — a map in one hand, looking for places to work.

I can't really say what my intentions were at the beginning — I wanted to come with open eyes — to see what I could find, especially in a place not readily associated with my work. This was the attraction of the commission and having a free brief allowed my work to develop day to day in response to place, season, weather and materials.

I aimed for the parks and especially the strips of rough ground that often edge them. Although my work is very personal and private it is usually made in a public place. I enjoy the social nature of parks and feel comfortable working amongst the dog-walkers, joggers, children, footballers ... The things I make are left to be discovered.

I arrived during a week of the most intense autumn weather I have experienced and the most extraordinary range of colours in the leaves scattered everywhere — sycamore, elm, chestnut...

I worked with the leaves and a light that changed dramatically each day — from dark overcast to an intense autumn brightness that only comes on a clear day after heavy rain.

Glasgow brought to fruition a crack line and yellow streak through leaves that had been developing over the years — the idea finding the right time, place and material. I broke new ground — a hanging sheet of yellow leaves, one of the best pieces I have ever made — and amongst the rest many starting points — markers for work to be discovered in the future.'[19]

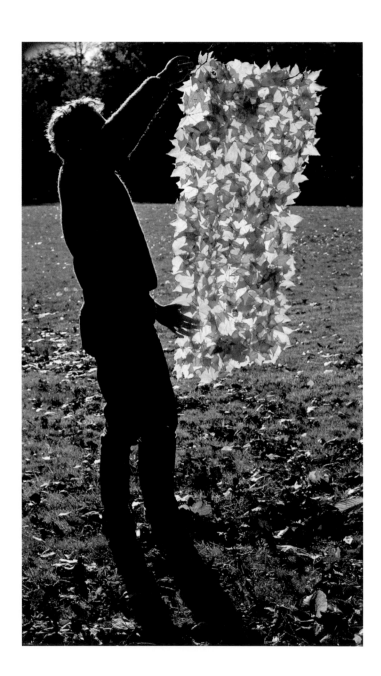

Sycamore leaves
stitched together with stalks
hung from a tree

POLLOK PARK, GLASGOW 31 OCTOBER 1986

Dark dry sand drawing

COMPTON BAY, ISLE OF WIGHT JUNE 1987

Damp sand
hollowed out
soft red stone ground into powder around each rim

COMPTON BAY, ISLE OF WIGHT JUNE 1987

QUAY ART CENTRE
1987

Newport, Isle of Wight

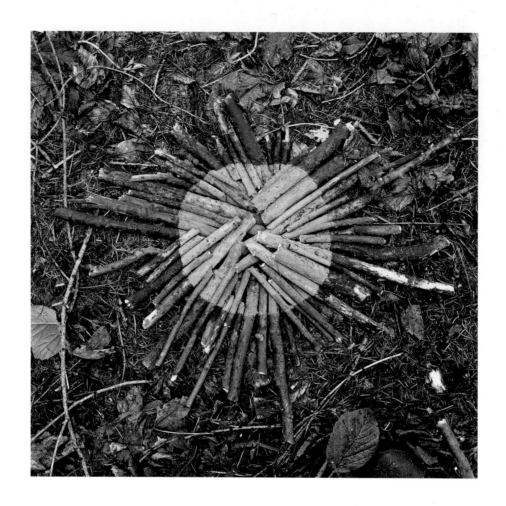

Green sticks
partly scraped and rubbed

YORKSHIRE SCULPTURE PARK 10 FEBRUARY 1987

YORKSHIRE SCULPTURE PARK
1987

WINTER 11–23 FEBRUARY

SPRING 25 APRIL–7 MAY

SUMMER 1 AUGUST–4 SEPTEMBER

AUTUMN 21–28 OCTOBER

Goldsworthy's residency is commemorated in *Parkland Andy Goldsworthy*,
published by the YSP in 1988.

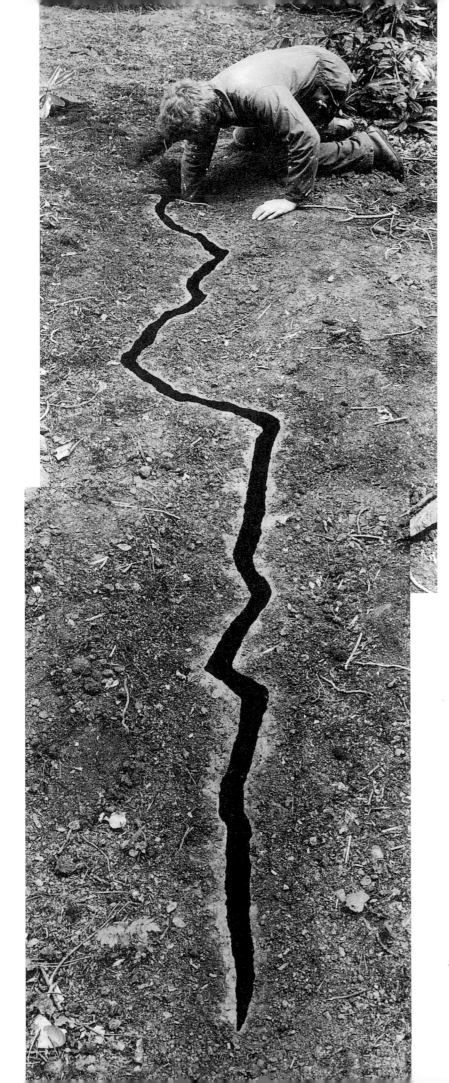

Trench
dug over two days
earth brought to an edge
clay supported with sticks
cold, darkly overcast but no rain
a hot day would have caused the clay to dry out
a wet day would have washed the earth away

YORKSHIRE SCULPTURE PARK 6–7 AUGUST 1987

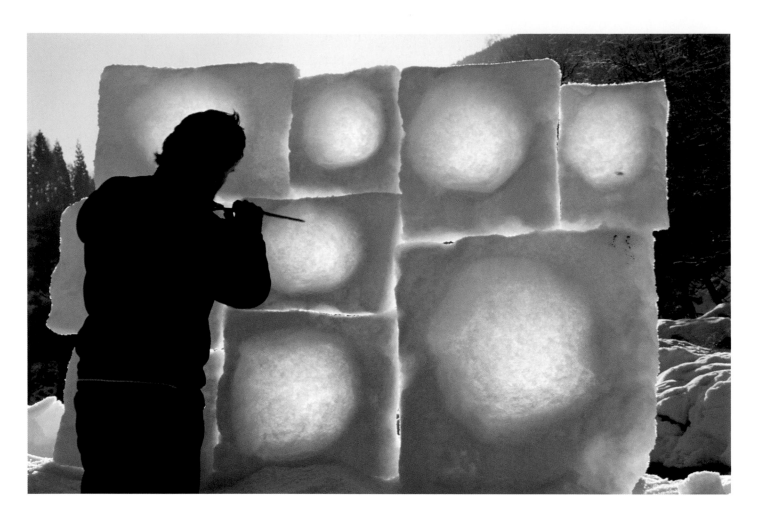

Carving frozen snow

IZUMI-MURA, JAPAN 25 DECEMBER 1987

JAPAN
1987

OUCHIYAMA-MURA 14–24 NOVEMBER

KIINAGASHIMA-CHO 27 NOVEMBER–7 DECEMBER

IZUMI-MURA 19–30 DECEMBER

A conversation between Goldsworthy and Fumio Nanjo concerning work made in Japan in 1987 appears on pages 163–65 of the present publication.

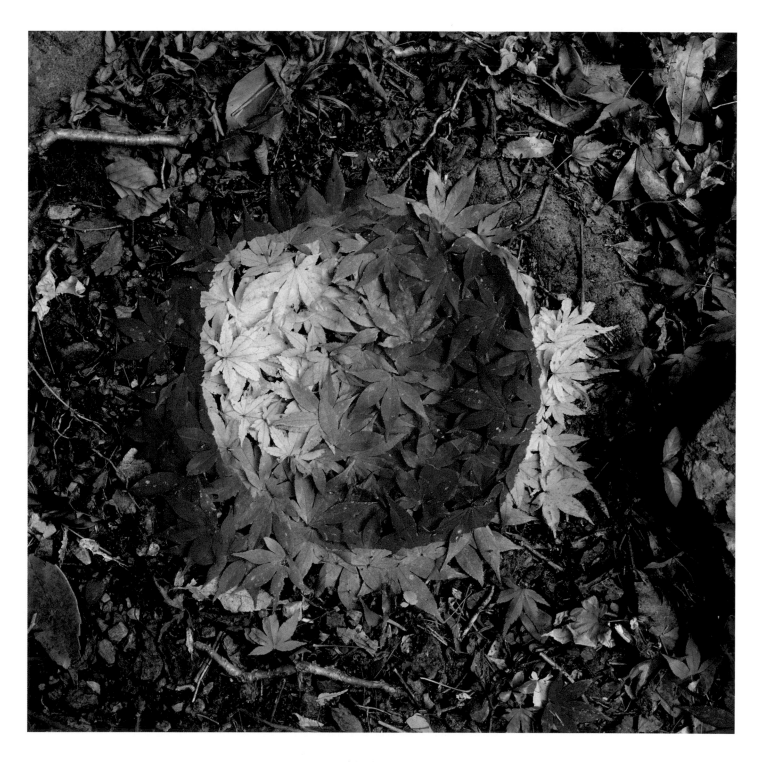

Maple patch
difficult
yellow to orange hard to find
wind, sun
leaves drying out and blowing away

OUCHIYAMA-MURA, JAPAN 22 NOVEMBER 1987

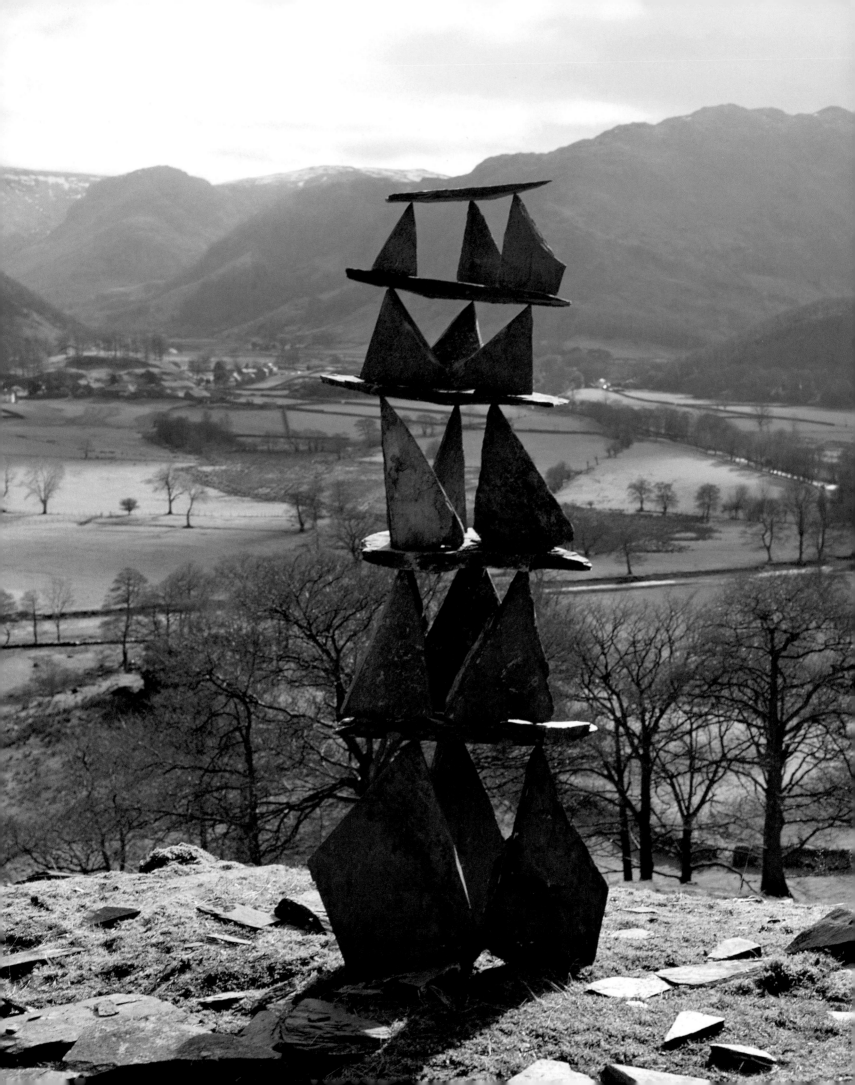

THE LAKE DISTRICT
1988

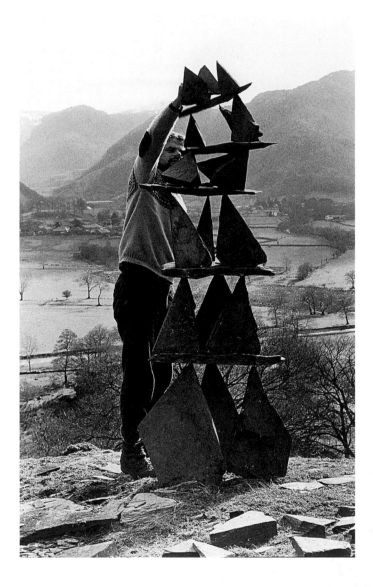

Balanced slates. The moment of collapse

BORROWDALE, CUMBRIA 1988

Work commissioned by Conoco (UK) Ltd, the Department of the Environment and The Victoria and Albert Museum was shown in *Artists in National Parks*, 1988. Goldsworthy wrote in 1985:

'I have lived for most of the time within sight of the Lake District, although this is due more to circumstances than any great wish to be there. The mountains have become important to me not only to visit and work but as a place by which I orientate myself. It has taken on the significance that all mountains, hills, mounds and single trees have to people living nearby. It has become a landmark which creates a sense of presence and location, defining the surrounding landscape.

Many of the early works on Morecambe Bay were made in response to the space over the bay and the distant mountains which enclosed that space. I often made holes in rocks, ice, snow which usually opened out into and examined that space. The mountains were bait for the eye.

When I first visited the Lake District I was impressed by the mass and space — and the things that made that space active. It offered new experiences on a massive scale, being able to walk up into the clouds and touching snow when I thought winter was over. If there is such a thing in my work as a range of locations that have influenced the scale of my work the Lake District must rate as the place most instrumental in causing the largest things I have made.

I think the Lake District is a place where some of my basic interests were formed — a love of the last remaining patch of snow, becoming aware of the mass and energy of a mountain culminating at the peak manifesting itself in many of my works with tapered rocks, icicles and most recently seven 35–47′ tall pine spires at Grizedale Forest in the Lake District — my first permanent work.

Having said all this I have to add that I am still very committed to the common place. My way of working developed in small works on the outskirts of Leeds. I have worked in ever smaller woods since and for a time worked under the Big dipper at Morecambe. I can work anywhere there is growth and I enjoy adapting to different environments — the Lake District is one of several places that are of special importance to me.'[21]

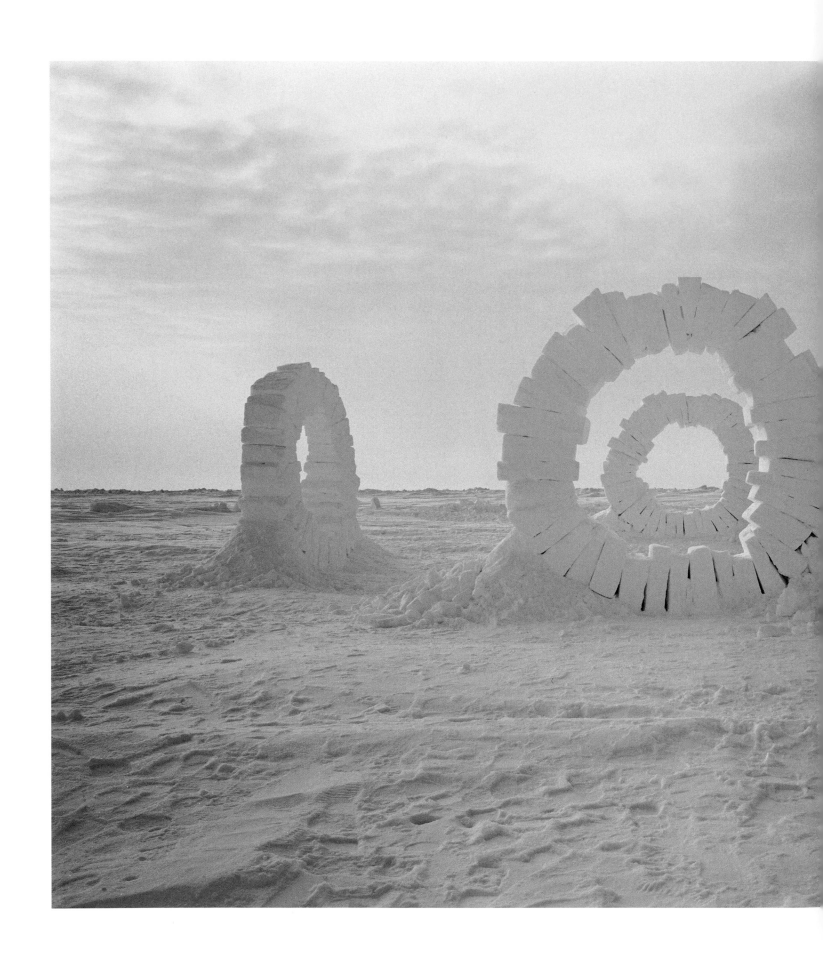

Touching North THE NORTH POLE APRIL 1989

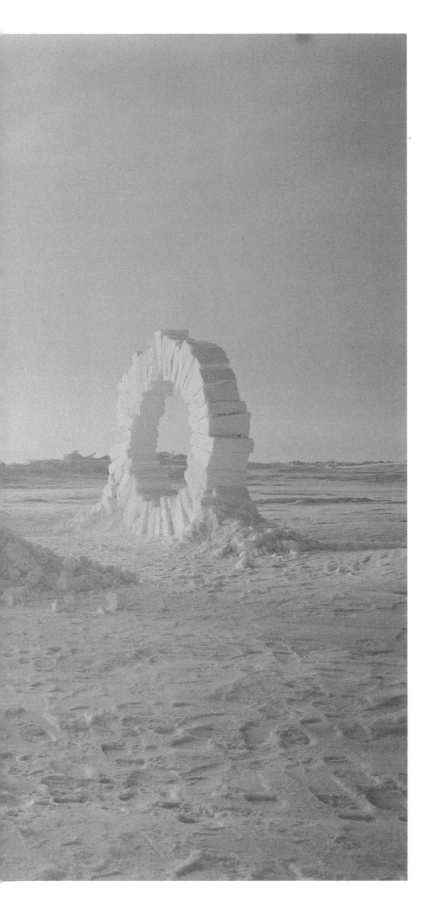

THE NORTH POLE
1989

Goldsworthy worked at Grise Fiord in the Canadian Arctic (22 March–20 April 1989), followed immediately by three days on the North Pole, a project organised by Fabian Carlsson Gallery. Audio-tapes made during these weeks feature in *Touching North Andy Goldsworthy*, 1989. The following statement was written in November 1988, in anticipation of the trip:

'North is an integral part of the landscape that I already work with. I can touch North in the cold shadow of a mountain, the green side of a tree, the mossy side of a rock . . . Its energy is made visible in snow and ice. When I work with winter I work with the North. The further North I go, the stronger its presence. I want to follow North to its source — to try to come to terms with it — in the same way I work with a leaf under the tree from which it fell. I want to understand the nature of North as a whole. Unlike a summit of a mountain, the North Pole itself presents a relatively featureless landscape for there is no land, only snow and ice. It is more of a feeling than a place. It belongs to no one — it is the earth's common — an everchanging landscape in which whatever I make will soon disappear.

Before going to the Pole I will spend one month working in the Northwest Territories of Canada living with the Inuit. I will go in winter when the snow is hard-packed and good for making snow houses. It will be an apprenticeship to the cold — learning from the Inuit not only ways of working with snow and ice but, I hope, something of a way of life that celebrates cold weather in a frozen landscape.

I have never had the luxury of constant freezing; so much that I have made in ice has been frustrated by a rise in temperature. I have held ice to ice seemingly for ages waiting for it to freeze only to let go and see it drop off. I have enormous respect for the weather and am aware of the great demands that intense cold will place upon my work. I also recognise the potential freedoms that the cold will bring — in the same way the Inuit is able to travel by sledge once the ground is frozen over.'

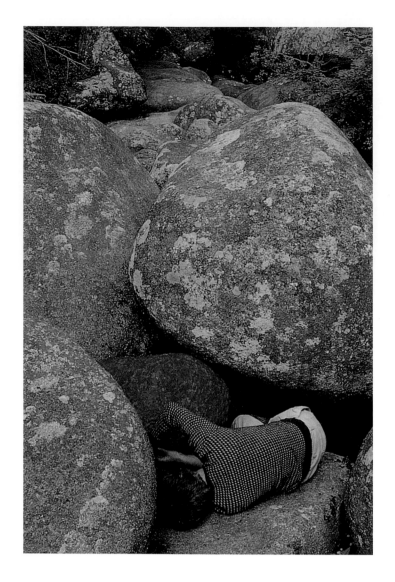

Wrapping poppy petals around a granite boulder

SIDOBRE, FRANCE 6 JUNE 1989

CASTRES AND SIDOBRE
1988–89

Goldsworthy worked as artist-in-residence in the small garden of beech and chestnut and plane of the Centre d'Art Contemporain at Castres (17–26 October 1988) and subsequently (31 May–7 June 1989) among heaps of granite boulders and in the deep woods of the Sidobre. The exhibition *Garden Mountain*, held at Castres, St Fons, Tarbes and Paris, 1989–90, accompanied by a publication of the same title, marked the occasion of his first one-man show in France.

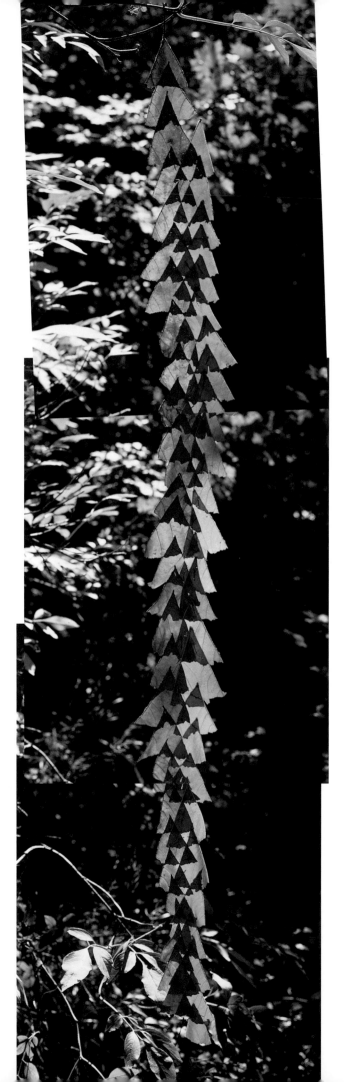

Sycamore leaf sections
pinned together with pine neeedles
hung from a tree

CENTRE D'ART CONTEMPORAIN, CASTRES, FRANCE
21 OCTOBER 1988

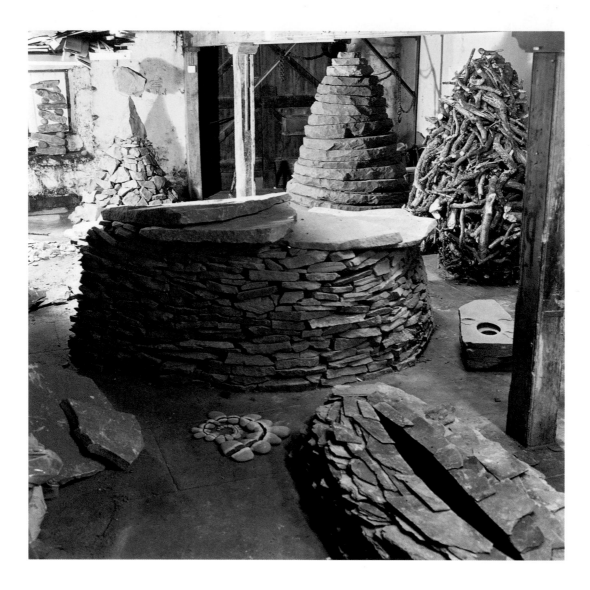

PENPONT STUDIO, DUMFRIESSHIRE 1990

INSTALLATIONS 1985–1990

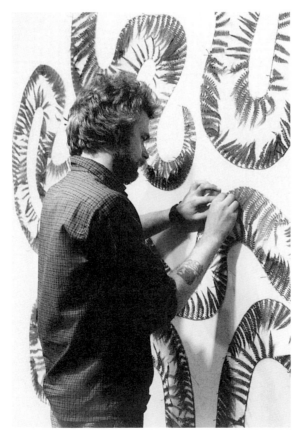
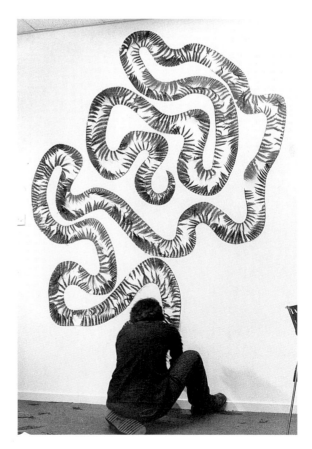

Bracken fronds pinned with thorns

THE ECOLOGY CENTRE, LONDON DECEMBER 1985

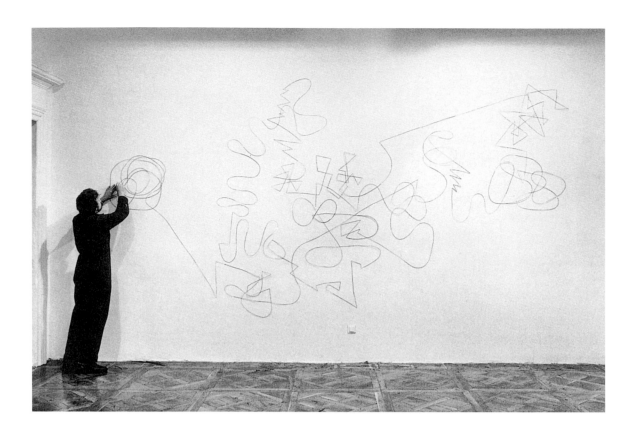

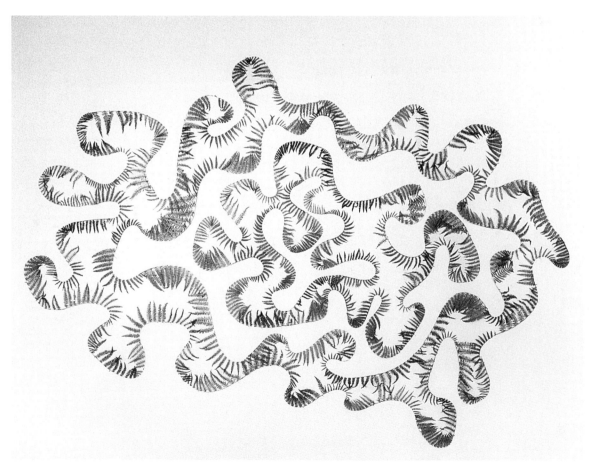

Reeds, bracken and horse chestnut stalks pinned with thorns
CENTRE D'ART CONTEMPORAIN, CASTRES, FRANCE 1989

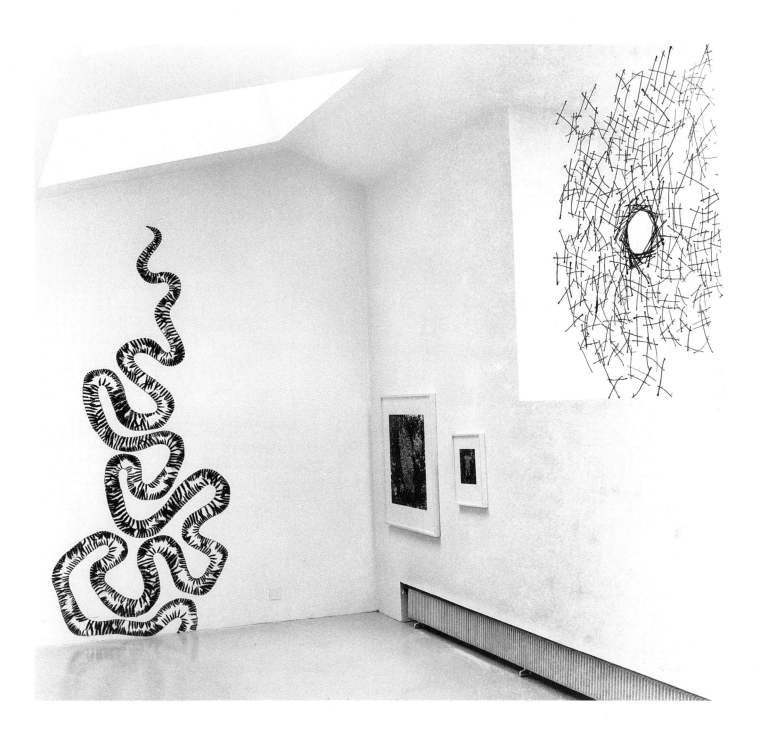

GALERIE ALINE VIDAL, PARIS 1989

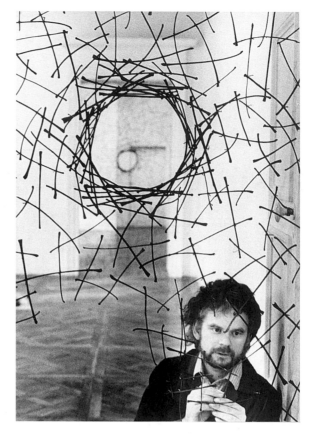
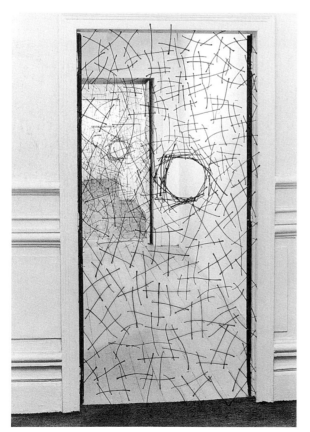
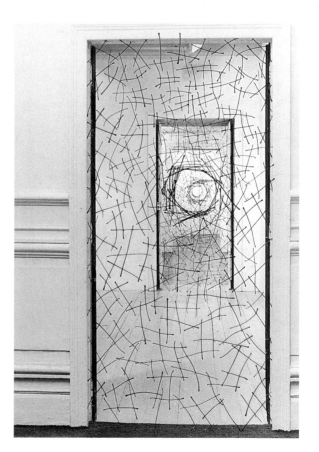

Horse chestnut stalks and thorns

CENTRE D'ART CONTEMPORAIN, CASTRES, FRANCE 1989

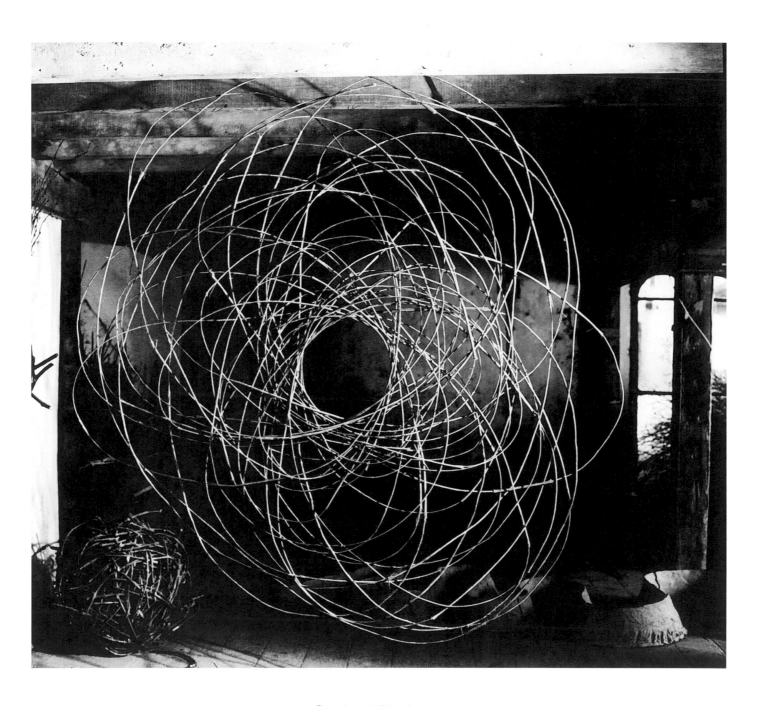

Rosebay Willowherb

PENPONT STUDIO, DUMFRIESSHIRE 1990

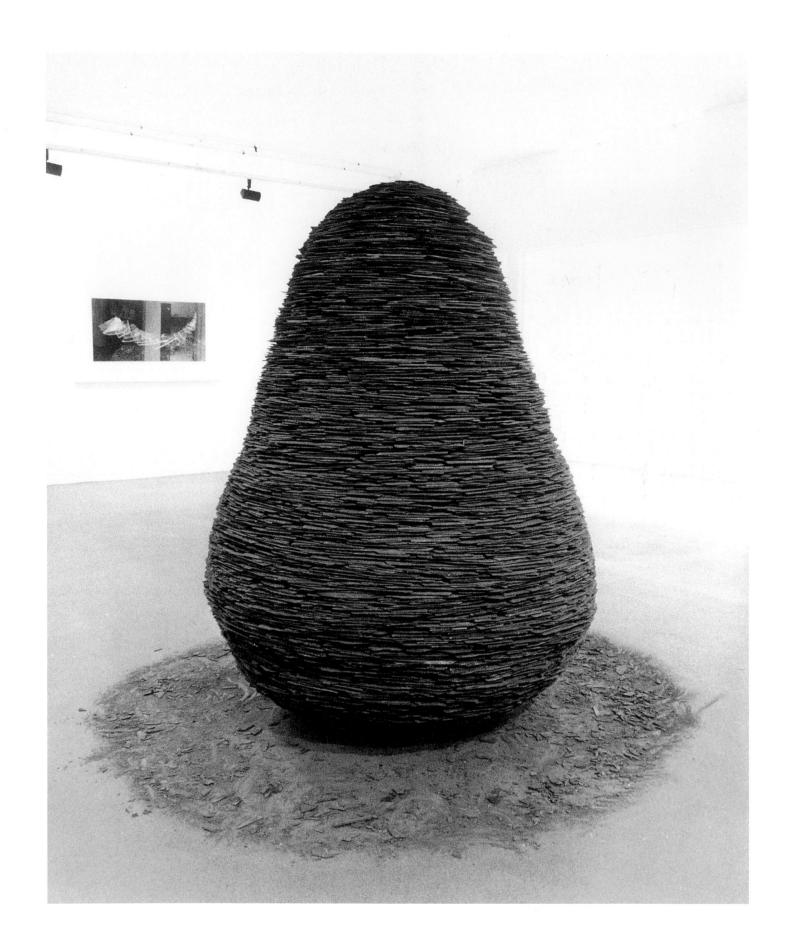

Slate cone

FABIAN CARLSSON GALLERY, LONDON 1987

Government Art Collection, London: installed in the garden of the British Embassy, Copenhagen

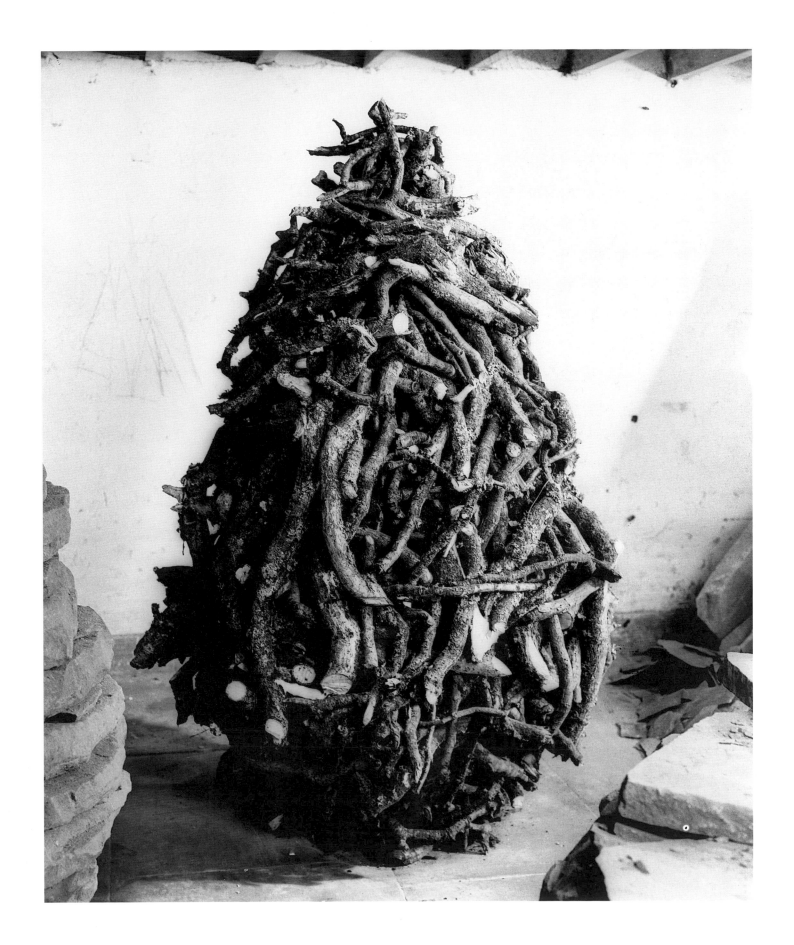

Oak branches

PENPONT, DUMFRIESSHIRE 1990

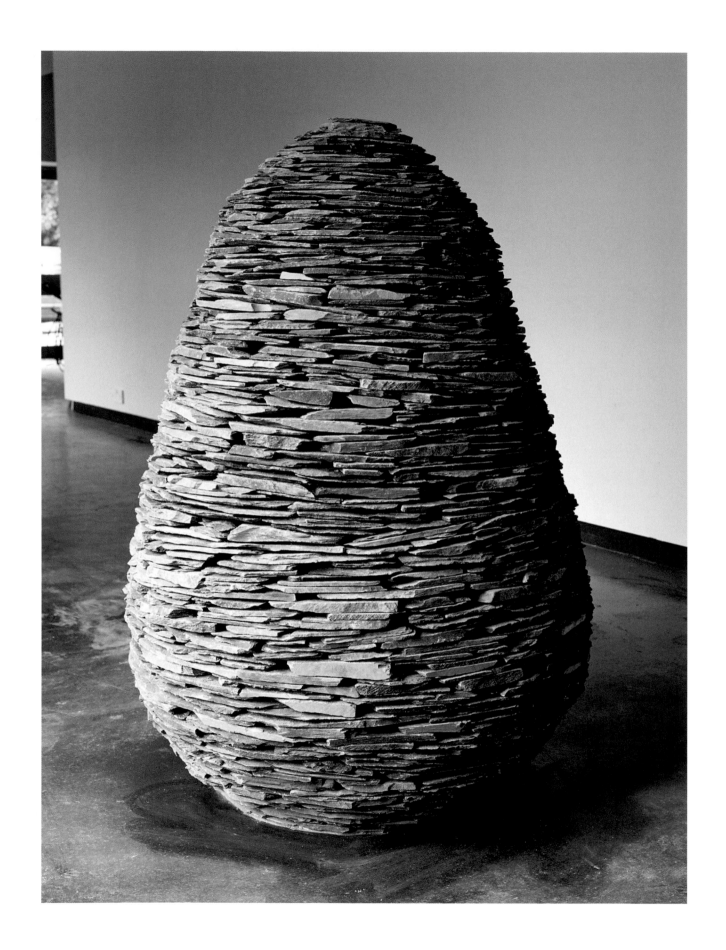

Slate cone

GRIZEDALE GALLERY, CUMBRIA 1988

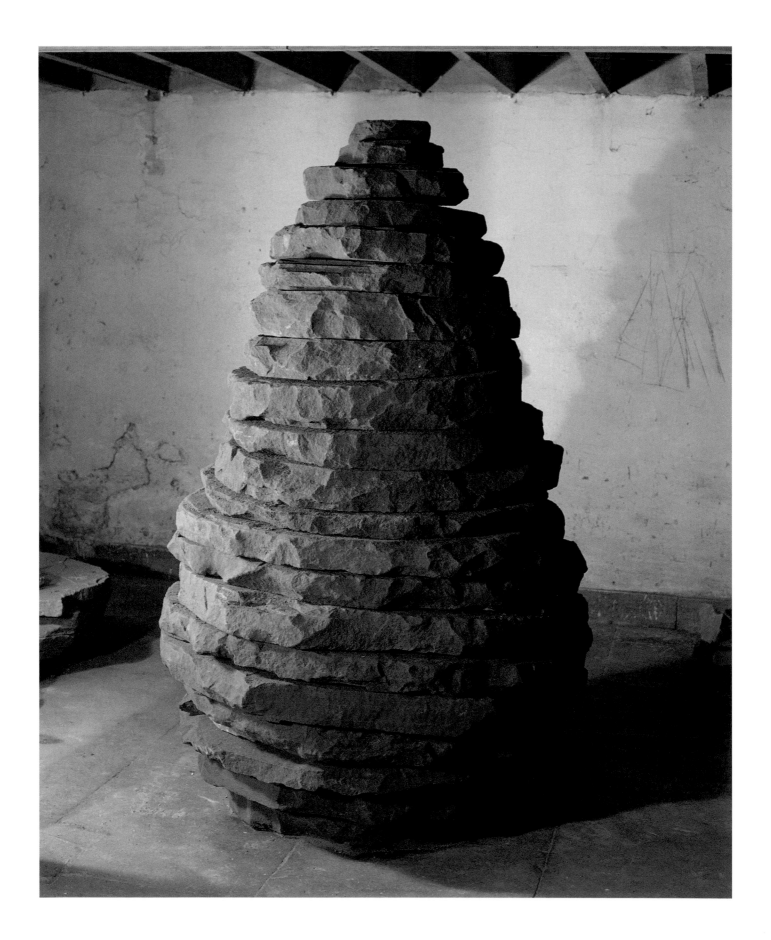

Sandstone

PENPONT STUDIO, DUMFRIESSHIRE 1990

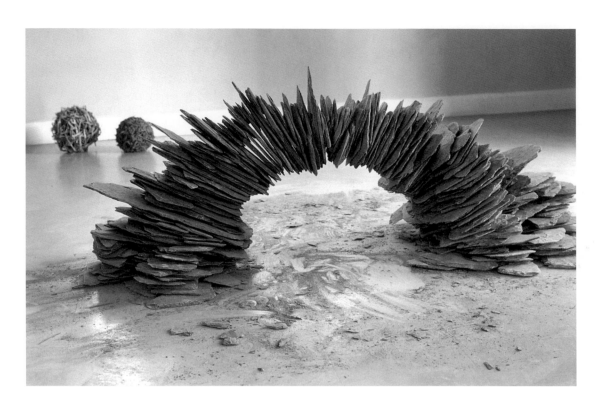

Slate arch

ABBOT HALL, KENDAL, CUMBRIA 1985

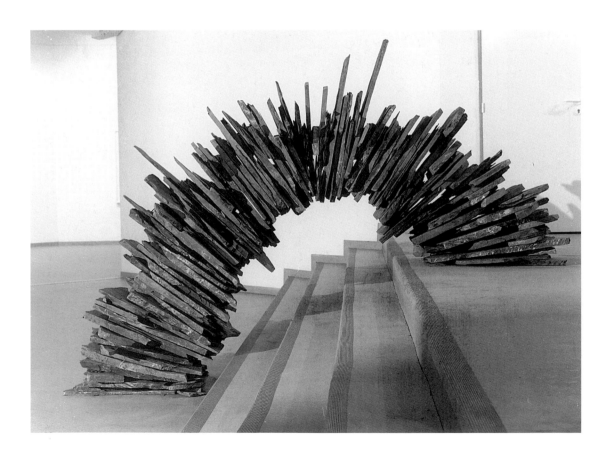

Slate arch

CENTRE DE DEVELOPMENT CULTUREL, TARBES APRIL 1990

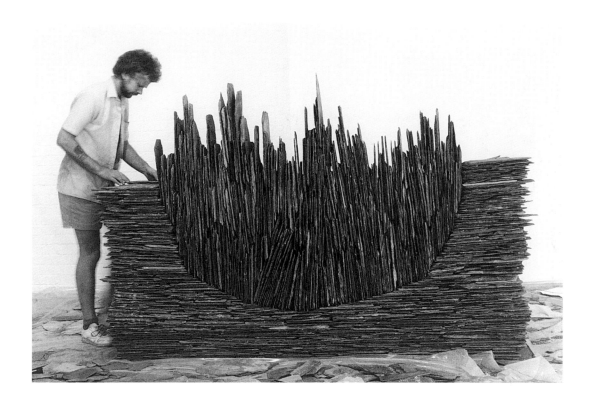

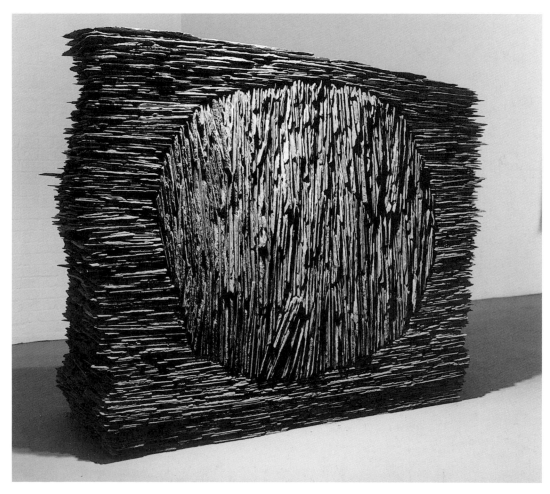

Slate stack

FABIAN CARLSSON GALLERY, LONDON 1989

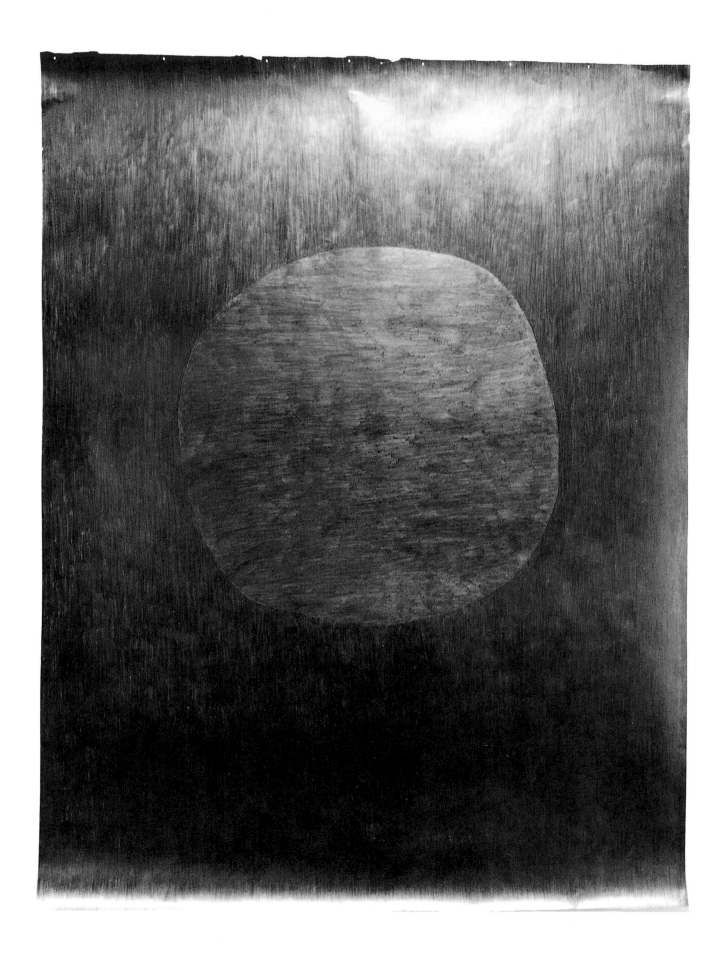

Graphite, I and II, 1988 and 1989

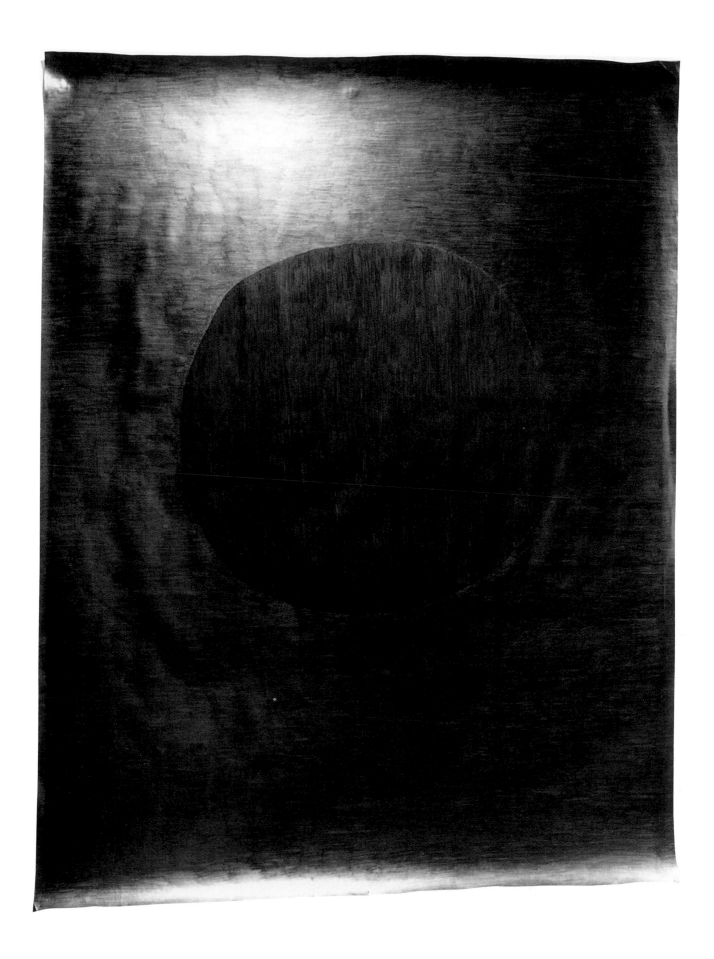

FABIAN CARLSSON GALLERY, LONDON 1989

Graphite

FABIAN CARLSSON GALLERY, LONDON 1989

Touchstone North
Graphite, 1989

FABIAN CARLSSON GALLERY, LONDON 1989

Seal/snow

GRISE FIORD, ELLESMERE ISLAND, CANADA APRIL 1989

Snow/Caribou

GRISE FIORD, ELLESMERE ISLAND, CANADA MARCH 1989

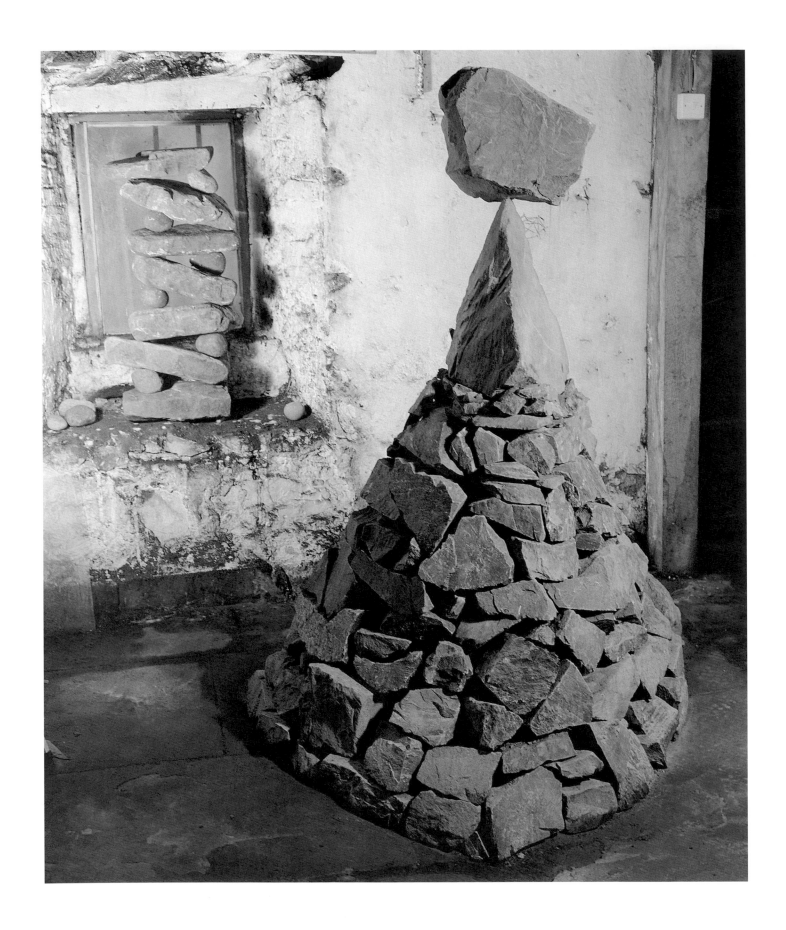

Balanced Winstone

PENPONT STUDIO, DUMFRIESSHIRE 1988–90

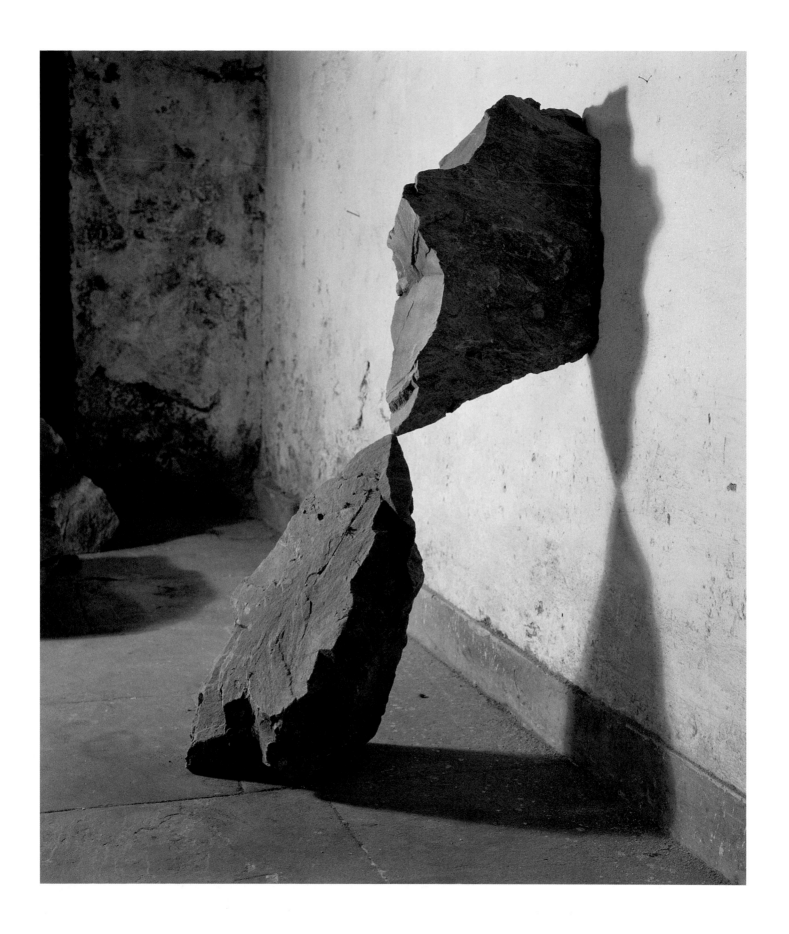

Balanced Winstone

PENPONT STUDIO, DUMFRIESSHIRE 1988

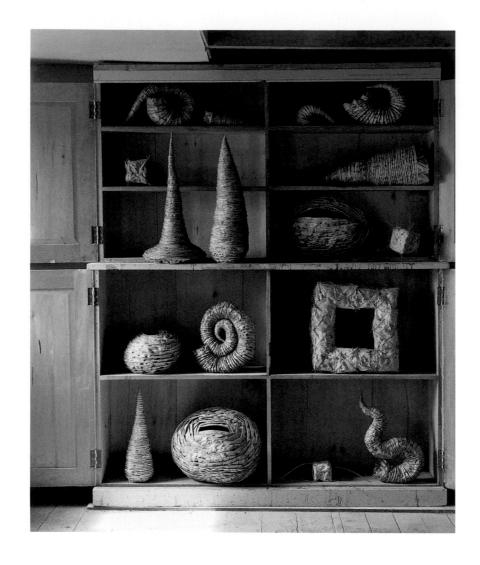

PENPONT STUDIO, DUMFRIESSHIRE 1989

LEAFWORKS

Paul Nesbitt

'At first I used only windfallen leaves, relying on the wind and frost to provide materials. I have been in woods after a hard frost in autumn with trees noisily shedding leaves as the sun rose. There is a strangeness in leaves collapsing to the ground on a calm day, unlike the wind that can rip the leaves away from the tree. The wind that brings down materials to work with causes problems in the making. I have worked in dips, made windbreaks, only to have work that was nearly finished blown away by a sudden gust from an unexpected direction. It took several years to realise the potential of bracken slivers and thorns as a way of securing leaf to earth. The thorn in turn became the means to lift the leaves off the ground.

Gradually I began to use leaves from the trees as well as the wood floor. Not out of impatience but because the leaf on the tree has a different quality. To understand leaves I need to work the dry brittle windblows, the cold, wet frost-fallen and the fresh green growing. I am careful about what I take. A few leaves from each tree.

I have learnt that thick leaves are found on the outer branches where the sun reaches and growth is strong. Towards the trunk the leaves are spring-like and delicate. The largest leaves are found on smaller trees, on trees that have been stooled, with roots that have more vigour than branches. The sycamore has taught me most. The biggest lesson being that so much can be found in something common and ordinary. Its leaf can turn all colours; its stalks can go bright red and within its leaf structure I realised my first leaf construction. By using its architecture I can make forms that grow from the leaf. The sycamore makes boxes, the chestnut makes spirals and horns, an exploration of structure and growth.'[22]

The permanent leafworks described here have grown from those ephemeral arrangements and constructions created in woods, hedgerows, fields and streams and represented only by photographs. By contrast, these works — made outside and inside the studio and exhibited in the gallery — utilise leaf structure so fully that the boxes, horns, spirals and sheets which result retain their integrity and beauty wherever they are placed.

Beginnings

Goldsworthy began documenting work made in landscape on the shores of Morecambe Bay while attending Lancaster College of Art in 1977. At this time he also made many ephemeral leafworks in the very different setting of woodland near Grove House Farm on the outskirts of Leeds, where he worked as a labourer, enjoying the bold contrast between shoreline and wood-edge. 'It was as if each place taught me more about how to use the other.'[23]

The first work to use leaves primarily consisted of a stick, held by Goldsworthy against the light, around which impaled oak leaves glow bright yellow in the sunshine. It marks his fascination with one of nature's primary forces — light, and has the primitive appeal of a leaf throw, stone throw or rainbow splash. More ephemeral work with leaves followed, a high proportion invested with the assurance and distinctiveness with which Goldsworthy is associated in much later work, though remarkable for a young artist still at college.

He began to build up knowledge of leaves through the process of making sculpture. Frequently the unsuccessful works taught him most. A driving desire to investigate and work with the leaf's properties added manipulation in various forms to the early, simple juxtaposition. He began to fold leaves, then fold them along the veins so that the vein structure itself created pattern. He exposed the leaf skeleton by tearing and stripping away the soft tissue between the veins. He also began to make spheres, cubes and towers — not yet from leaves but from branches, twigs and snow. It was not until 1984, seven years after he began working with leaves, that Goldsworthy would develop the skill and encounter the opportunity to make his first permanent leafworks — a cube of leaves pinned together with thorns.

First Leafworks

The opportunity came not in his native Yorkshire nor even in England but in Holland during a residency at Haarlemmerhout in August 1984. However, the leafworks realised there were a direct continuation of the

ephemeral works made one month previously in Brough, Cumbria. It was in Brough that he lifted a horse chestnut leaflet off the ground in a tentative loop, a form which would emerge in the spiral construction of the first leaf cone several years later. And in Brough he used the right-angled vein pattern of the sycamore leaf, pinning pairs together repeatedly to form a simple lattice. This arrangement became the basic building block of the leaf-work cube.

In Holland the simple leaf lattice was extended by repetition in two dimensions, but the leaves were still firmly pinned to the earth with thorns. This, in a matter of days, was to change.

For Goldsworthy the dominant characteristic of Haarlemmerhout was its soft, sandy earth, a substrate which yielded few rocks or stones of any size. This meant that to make three-dimensional sculpture he was forced to use leaves, and the sycamore lattice structure provided the means. Notes in his *Sketchbook* for this period (No. 10) detail the work produced each day leading to the making of the first box:

Getting leaves off the ground — Interesting — hogweed and sycamore — not quite right though (15 August 1984). *re-worked yesterday's piece. stayed more faithful to leaf structure. I am getting somewhere but not quite sorted out* (16 August). *Horsechestnut — best work so far — things stepping out into new territory. I am beginning to get more*

Sycamore

LEEDS, YORKSHIRE AUGUST 1977

structure into leaf work — forced to find structure in leaves — No rocks or branches. The key is in the leaf veins — The leaf architecture. Amazing how geometric the structure is (17 August).

Then, two days later, came the first three leaf boxes using the architecture of sycamore leaves:

Three boxes of Sycamore. Leaves turned inwards. I think this was a good idea that didn't quite lift off. Technically awkward, also leaves always drying up in heat.

Goldsworthy had demonstrated that he could use sixteen sycamore leaves, pinned together with thorns, to make a box. However, he realised also that in order to

Foxgloves

LEEDS, YORKSHIRE AUGUST 1977

100

achieve durability they would need to be built well enough so that the strength of the veins would support the structure during the period when the leaf tissue loses water and wilts. Thereafter, the dried leaves would be rigid enough to hold the box intact. The problem recurred several days later:

Horse Chestnut spire — getting a bit wobbly towards end — Base sank a bit — feel tired after working late yesterday — also drained — yesterday's work became very demanding. Fell down before I photographed it — Went back to lunch hut — made poppy line (24 August). Made leaf spire again — better constructed — still fell down though. But not until after photographing. Taller than yesterday (25 August).[24]

He made four successful leafworks in Haarlemmerhout (collection of the Frans Hals Museum, Haarlem). Almost three years later, in Lancaster in 1987, he constructed a tower of three sycamore boxes joined vertically, which was largely unsuccessful and remains to this day sagging against the window of his studio. A year later he exhibited a wonderful single box of purplish sycamore leaves on top of a wall at the Venice Biennale, as his 'Unofficial' entry.

Modified leaf boxes were made in Cambridge in August 1986 and during a residency in Loughborough in

October 1986, where he repeated the simple box structure but left the sycamore leaves attached to their long stalks to act as legs, lifting the box off the ground. Unfortunately, they sagged in time and it was not until he used the very long stalked leaves of Van Voxlem's Maple (a rare tree growing in the Royal Botanic Garden Edinburgh) in 1988 that he successfully made a box which could be supported by its own stalks. This was exhibited with many other leafworks at The Natural History Museum exhibition, *Leaves*, in 1989–90. One box in particular astonished visitors by its scale.[25] Using the leaves of London plane rather than sycamore, which in leaf structure it resembles quite closely, it is a sixteen-inch cube with no support but its exoskeleton of dried leaves. Since the first leaf box in Haarlem, he had acquired the skill of using not only fresh leaves from the tree but also fallen leaves, and extended the time available to make his constructions by re-wetting them to just the correct moistness to restore their original suppleness. They could now be made anywhere he chose, and this large leaf box was completed while sitting in and near his Land Rover watching progress on the *Lambton Earthwork* in County Durham. Whilst the mechanical digger moved tons of black earth into serpentine mounds, a quarter of a mile long, Goldsworthy was engaged in what he still considers to be a more monumental feat: 'some of the largest works I've ever made have been of leaves; the

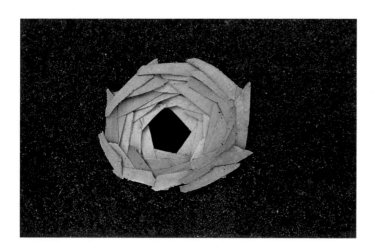

Leaves

LEEDS, YORKSHIRE NOVEMBER 1977

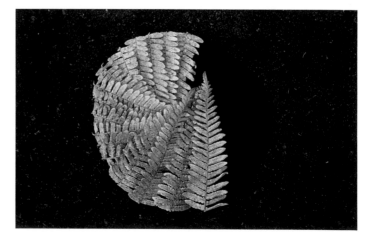

Bracken

LEEDS, YORKSHIRE NOVEMBER 1977

101

surface of a leaf when I am working with it, bending, folding, shaping, pinning together, has a scale which is enormous. True scale is determined by the material I'm working with.'

First Spiral Construction

In the Summer of 1986 Goldsworthy picked up the threads of the first two 'unsuccessful' horse chestnut leaf spires attempted in Haarlem, making a group of successful spires in Cambridge. The horse chestnut leaf is composed of five separate leaflets, each capable of being detached and folded longitudinally down its centre along the prominent main vein. By joining four (or more) leaflets at the top and extending the structure downwards by nesting and pinning further leaflets on to the original ones, rather like following the ribs of an umbrella, a spire is built from the top upwards. The base may be left flat or, as in the development which took place in Bath the following month (September 1986), the many-ribbed spire was concluded with a base made frilly by leaving the lowest leaflets entire and free (variation at the base would be used to good effect when the cones were made). This leafwork and its derivatives (two fat spires lying head-on, joined by thorns at their points) were later made and included in The Natural History Museum exhibition.

Having made boxes from sycamore and spires from horse chestnut, Goldsworthy was about to find the key which would introduce him to the possibilities of a spiral form of construction with which to make cones, horns, snakes and spirals themselves. In October 1986 he went to St Louis, Missouri, to work with a papermaker, the results of which will be discussed later. When his hands weren't immersed in a vat of cold paper pulp, he was outside in the bright sunshine making a leaf spire with a flattened base. However, the real difference between this and the ones made several months previously in Cambridge and Bath was that the structure became slightly twisted in its building, the ribs describing a spiral form.

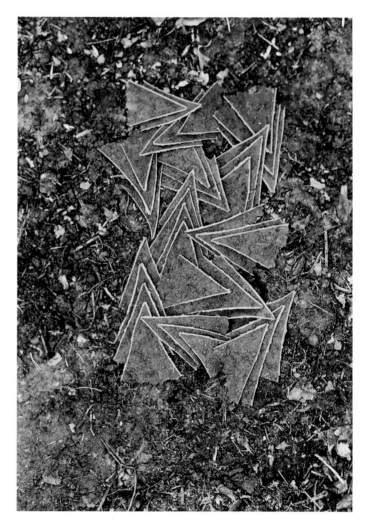

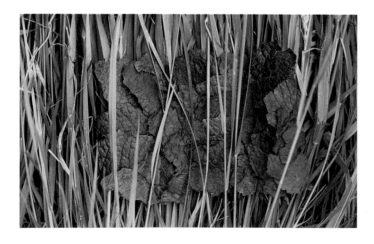

Dock

MORECAMBE, LANCASHIRE 1978

Sycamore

ILKLEY, YORKSHIRE JULY 1979

This fixed in his mind the idea of creating not the flat, two-dimensional leaf spirals which took form in a number of photographs but a three-dimensional spiral construction. This was realised on his return home to Penpont where, using a continuous spiral made from fallen golden-brown sweet chestnut leaves, he created a cone twisted into the shape of a horn in the autumn sunshine. This event was probably more important than even the construction of the first box, although far less arduous. In making that box Goldsworthy recalls a certain doubt: 'When the box began to take shape, I had a feeling that it was somehow unnatural — the angles too sharp, and the cube at first sat uneasily in my mind'. This

feeling was overcome quite quickly however: the cube is found in nature — in rock and ice crystals and in the plant cell itself, which forms the inner architecture of the leaf. But building cubes from leaves, even sycamore and plane leaves, remained a difficult task and the large leaf box is a remarkable feat of skill. No such reservations accompanied the making of the first leaf cones from a continuous spiral. Compared with the cube, the spiral in nature is both more universal and visible. Spiral arrangements and structures are observed in interstellar gases, in air and water flow as eddies, in natural phenomena such as tornados and whirlpools. The spiral is an economic arrangement for structural support in the stems of plants

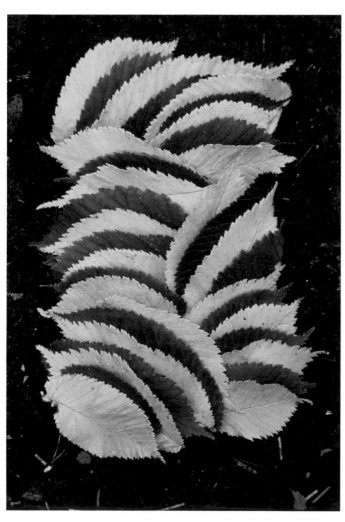

Elm

ILKLEY, YORKSHIRE 1978

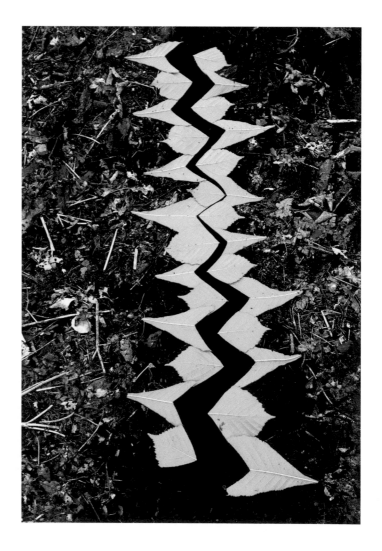

Horse chestnut

ILKLEY, YORKSHIRE SEPTEMBER 1982

103

and shells of molluscs, and an efficient arrangement for the leaves around a plant stem, enabling them to intercept most light by minimising mutual shading. At a more abstract level, it has been used in art for thousands of years by civilisations worldwide as a symbol of growth and life itself, a beginning without end.

Goldsworthy relishes working with the spiral form in leaves because of its leading role in a process as natural as growth itself. The basic method of construction enables an astonishing wealth of forms to emerge in his hands. To date he has mostly used the leaves of sweet chestnut, dark glossy green in summer and rich brown in winter, often collected in parkland at Drumlanrig, six miles from his home. They are large — up to eight inches or more in length — quite tough and remain supple for a long time after being picked. A leaf is folded along its length so that the prominent central vein is uppermost, forming a backbone. This is then shaped into a tight spiral, loosened, and another leaf, similarly folded, is nestled into the fold of the previous one and pinned with thorns. As the process is repeated the spiral grows. A natural cone shape results and grows from the thin end downwards and outwards. Curves and twists are readily introduced by varying the degree of overlap with the layers of the spiral immediately above. Significantly, Goldsworthy's first construction at Penpont was a horn and he proceeded, during the next three years, to create

cones of varying sizes, horns curved successively so that they formed spirals, and cones curved in alternating directions like serpents.

Following the first leaf horn at Penpont, he made other leafworks: a sweet chestnut spire and a sweet chestnut ball with holes in the top, both in Harrogate in December 1986. The leaf ball he found surprisingly easy to make — adapting the cone shape and compressing it into a bulb, and capturing in its hole of intense black the quality also found in his pots of clay and domes of slate. The contrast between, on the one hand, form and detail illuminated all around, and on the other, the absence of light itself, serves to heighten our awareness of the material by this juxtaposition. Later that year, on Christmas Eve in fact, he made an engaging holly ball held together by its own prickles, on Hampstead Heath.[26] Further leaf cones and boxes were made at the Yorkshire Sculpture Park during September and October of 1987. However, it was in 1988 and 1989 that he collected leaves in earnest to create the astonishing collection of leafworks which were to be exhibited at The Natural History Museum in London.

Most of these, exhibited in glass cases reminding one of bizarre homes created by mammals and insects, were made either at or near Penpont, or at Leadgate, County Durham under the circumstances described for the large sycamore leaf box. Penpont sycamore boxes,

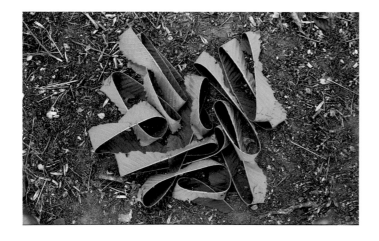

Horse chestnut

HELBECK, CUMBRIA JULY 1984

Sycamore

BROUGH, CUMBRIA JULY 1984

with and without legs, Drumlanrig sweet chestnut horns, balls, spirals, spires (up to 28 inches high) and snakes (one of 51 inches long), were made from fresh green leaves and fallen brown leaves. Joining these were examples made at the Yorkshire Sculpture Park, the garden at the Centre d'Art Contemporain at Castres and Claude Monet's garden at Giverny. Some of the permanent leafworks, while sharing similar principles of construction with those already mentioned, were clearly three-dimensional derivations of ephemeral leafworks. Finally, there is a diverse group, also represented in the *Leaves* exhibition, which stands alone: leaf shields, plates, installations and pulps.

Leaf Shields

Goldsworthy's leafworks are primarily about structure rather than light, which is sometimes best conveyed in

ephemeral works. It is the dried underside of the leaf which we observe when looking at the leafworks. When the leaf is folded in two along its central vein to make the spiral works, it is the underside which faces outwards, and it is the underside which is exposed in the leaf boxes. The translucence of leaves is lost when they dry out — the leaf begins to shrink and it takes on a different, opaque beauty.

In 1986, he was asked to visit Glasgow and make work for a group exhibition at the Collins Gallery. Characteristically, he headed for the largest green space on the map, and in Pollok Park he made a series of leaf shields from the yellow and red autumn colours of Maple. The leaves were held together with their stalks to form large, flat, translucent sheets which were then suspended below the bare trees from which they came. With the bright sun behind they shone like the sun itself against the dark trees

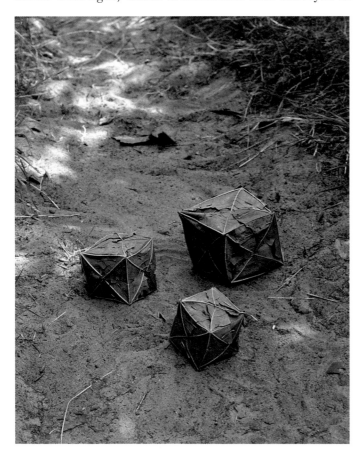

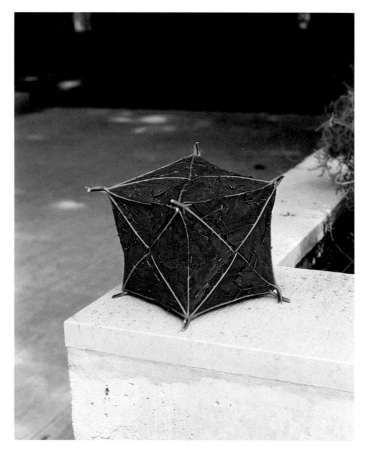

Sycamore

HAARLEMMERHOUT, HOLLAND AUGUST 1984

Sycamore

VENICE BIENNALE 1988

105

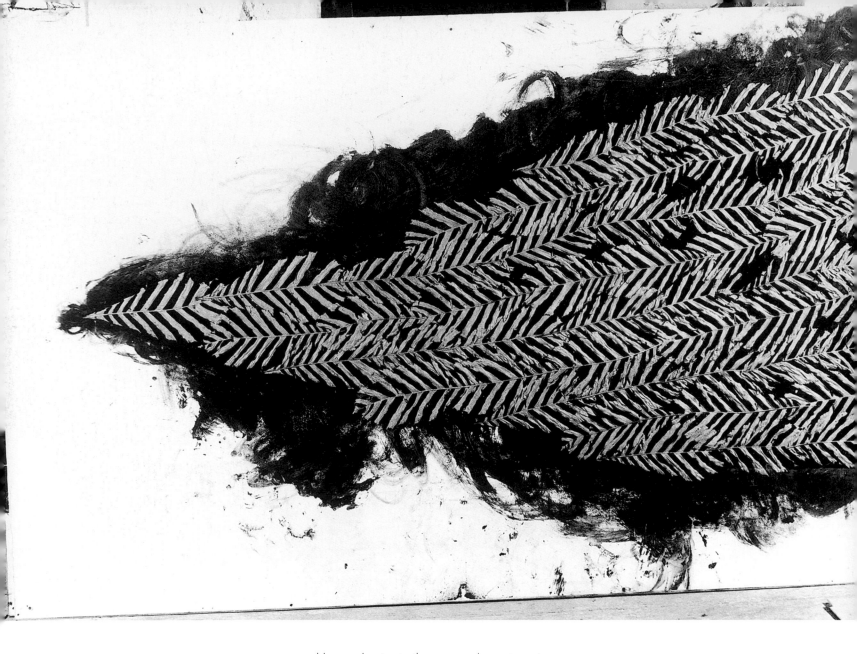

Horse chestnut, thorns, mud, soot, water

beyond. Next spring, at the Yorkshire Sculpture Park, he again made suspended leaf shields, intermingling blades of grass through which the light projected their shapes seen in layers of differing thickness. Later that year, he returned to make a shield of horse chestnut leaflets held together by grass stalks into which he punctured the outline of a circle, made by removing a thin ring of green leaf tissue to reveal only the leaf veins radiating outwards. This work had its beginnings in the first stripped leaf mentioned earlier. Several months later, he travelled to Japan and created two stunning shields of maple inscribed with circles constructed in a similar way, lit by the light reflected from deep snow.

These works are made to capture light, to make it visible and work with it. On opposite sides of the illuminated shield, reflected and transmitted light behaves as in the leaf itself, having a light side and a dark side. However, in their inclusion of stripped leaf sections, these works are also about structure. They work as both permanent leafworks and ephemeral leaf photographs, as the small shield of beech leaves from Giverny, inscribed by a circle of feathery veins, demonstrated when exhibited at The Natural History Museum. Goldsworthy's very first leaf shield from Glasgow coincidentally hangs in his studio window opposite his first ill-fated leaf box tower.

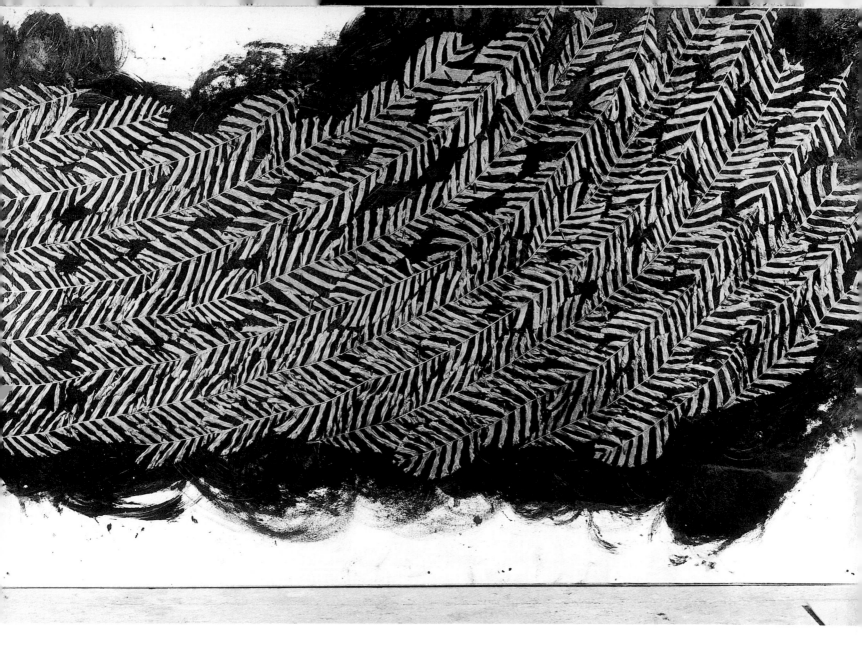

PENPONT STUDIO, DUMFRIESSHIRE 1989

Leaf Plates

Here I'd like to mention the flat, plate-like leafwork which derives not from vertically-hanging shields but those early leaf lattices pinned to the earth (from which the leaf boxes grew) and from the floating rafts of leaves which are known from photographs. A good example of the former is the leafwork made as a study at The Holbeck Triangle in Leeds in 1988.[27] A plate of sycamore leaves pinned together with thorns was made (in a similar fashion to the earth-bound sycamore lattice made in Haarlemmerhout) in the shape of the triangle which forms the Holbeck waste ground, the paler green under-side of the leaves outermost, crossed with prominent veins.

Secondly are the leafworks derived particularly from the pinned rafts of horse chestnut leaflets, floating bright green against sooty black water at Loughborough in 1986. Goldsworthy has remade the work, substituting paper for water, rubbed black with dark mud from the river bank. Against this black he pins the leaflets in the same arrangement as in the raft, the leaf tissue stripped away along alternate veins to create a series of vibrant green and black zebra-striped parallel strips. A water surface frozen in time. It was preceded by only one other, similar work, made in 1986.[28] In such a way,

107

temporary works made in the landscape become permanent leafworks in studio and gallery, each adding to one's perception of the other.

Installations

The use of thorns (blackthorn or occasionally snowberry twigs, grass stalks, or even pine needles in the case of the Giverny beech leafwork) provided the means by which Goldsworthy pushed plates of leaves into the earth, lifted them up into vertical shields and expanded them into boxes and spirals. He has also used them to directly re-create, in studio and gallery, works made in the landscape. In a number of exhibitions in recent years he has included leafworks made by using thorns to pin leaves to walls and secure stalks together to make veils across rooms.

Notably, at the Centre d'Art Contemporain at Castres, he made a stunning installation of serpentine forms using the leaflets of bracken, and mazes of leaf stalks set across gallery entrances (held together by each other's ends and concentrated around a circular patch left bare). These are direct re-creations of bracken serpents represented in photographs. At The Natural History Museum he all but re-created the work made in Japan in 1987,[29] the earth substituted by the wall, and the leaves folded up into transverse ridges to catch the light. Although these installations have a temporary nature and are dealt with elsewhere in this book, they are very much leafworks in subject and composition.

Leaf Pulps

During the last two years Goldsworthy has made several leafworks using lightly pulped bracken — boiled in caustic and beaten with a stone to loosen the fibres, washed and moulded to the desired shape and left to dry. These rough, circular works were made following his visit to St Louis in 1987 to work with Tom Lang. In pulping, more or less of the original external appearance of the leaf is lost (depending upon the treatment) but its inner and outer structure become one in the transformation. The opportunity to work with leaf structure in this new way and to re-present it in a different form is one which appeals to Goldsworthy and future opportunities to develop this theme will undoubtedly be realised.

Two bodies of work were produced in St Louis. In the first, lightly boiled sycamore leaves and stalks were arranged in a pattern before being laid between felts, pressed and dried. In one variation, stalks bent into acute angles (mirrored in several earlier photographs of stalks and leaves pinned on to earth) enclose areas of pulp in a jagged ring; in the other, a mass of leaf pulp encloses bent stalks. The second body of work comprises four variations on a theme: in each variation the pulp is shaped into two adjacent rings or circles, of different shape, size and material. Birch bark and twigs, bracken, iris leaves, plane leaves and stalks, pine needles and horse hair are all used in varying combinations. They seem to share a strength of abstract composition with some of the very earliest ephemeral sculptures made from coloured sandstone at Morecambe Bay ten years previously.

Leaves represent for Andy Goldsworthy 'part of a wider approach to the land — leaf and tree, light and space, all form part of the leaf'. He awaits nature's seasonal events like no one else I know, and he relishes the opportunity (ever more difficult in recent years) to be at home during these times. Although travelling is important, he likes to be at Penpont where he knows the trees best, and looks to leaves emerging in spring, growing and thickening in summer, changing colour in autumn and beginning to fall. 'Through my work I am trying to understand leaves' (he has worked with the Sycamore leaf for fifteen years). The leafworks, in particular, provide the opportunity for him to explore the creative potential of the leaf in different stages of dryness, this involvement extending far beyond the practical significance of their construction. But he also uses leaves to gain a greater understanding of nature's materials and forces (rock and ice, wind and light). Just as working in very different places assists the understanding of the other, 'so leaves teach me about stone and stone about leaves'. As he remarked on our first meeting: 'There is a whole world in a single leaf.'

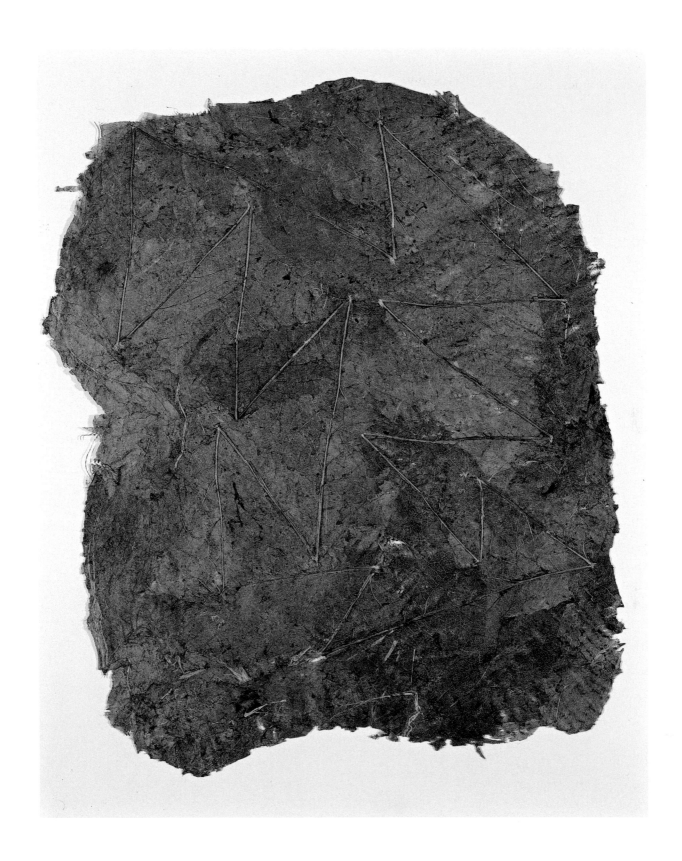

Sycamore leaf paper

PENPONT STUDIO, DUMFRIESSHIRE 1987

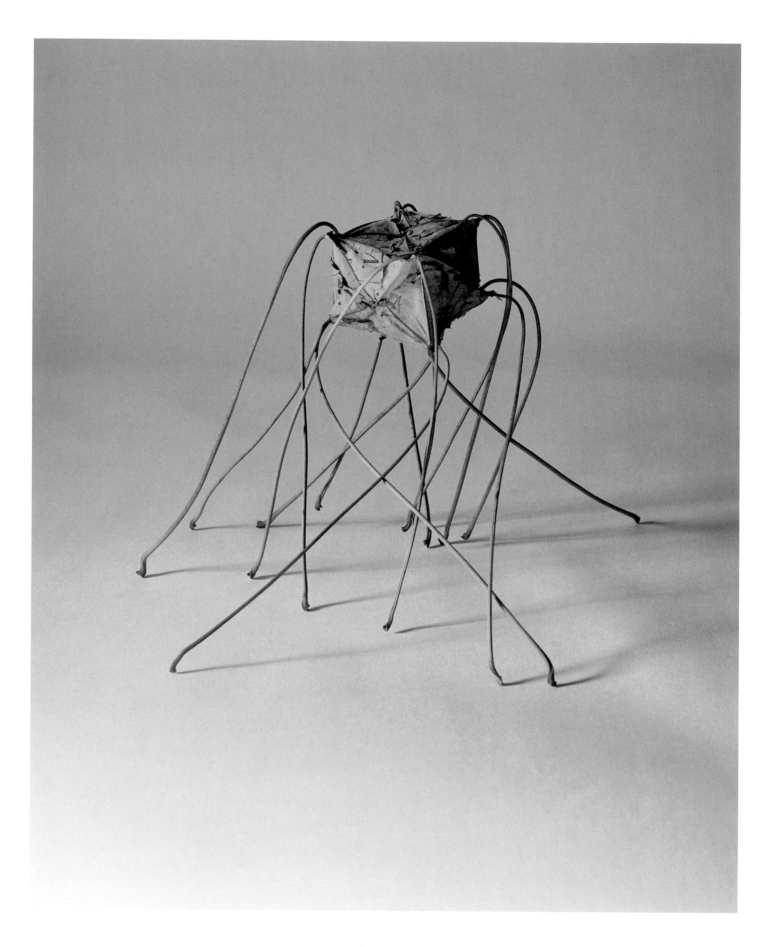

Sycamore

PENPONT, DUMFRIESSHIRE 1989

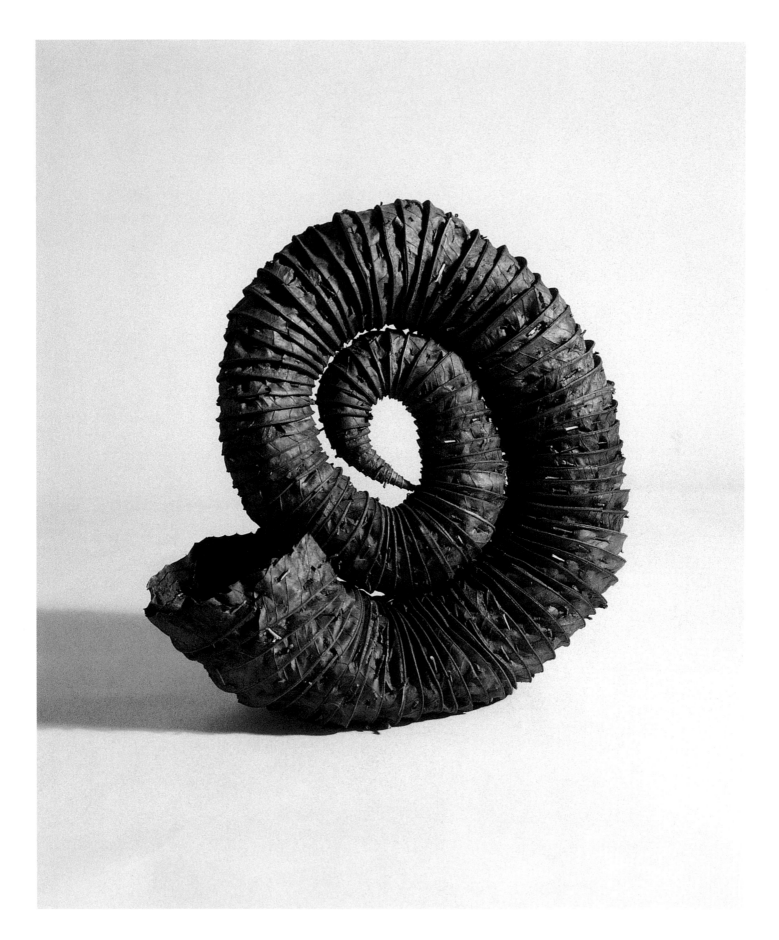

Sweet chestnut

COUNTY DURHAM 1988

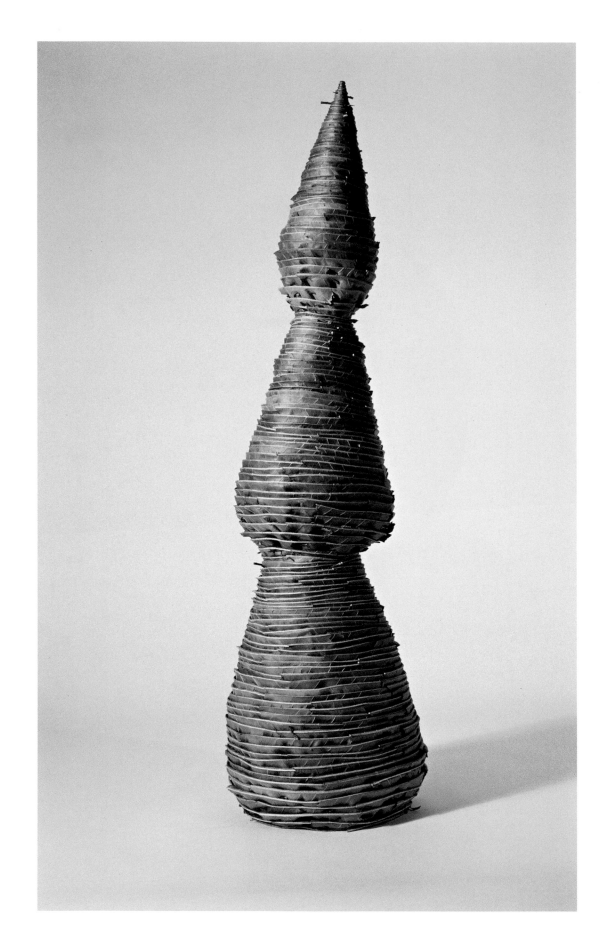

Sweet chestnut

PENPONT, DUMFRIESSHIRE 1989

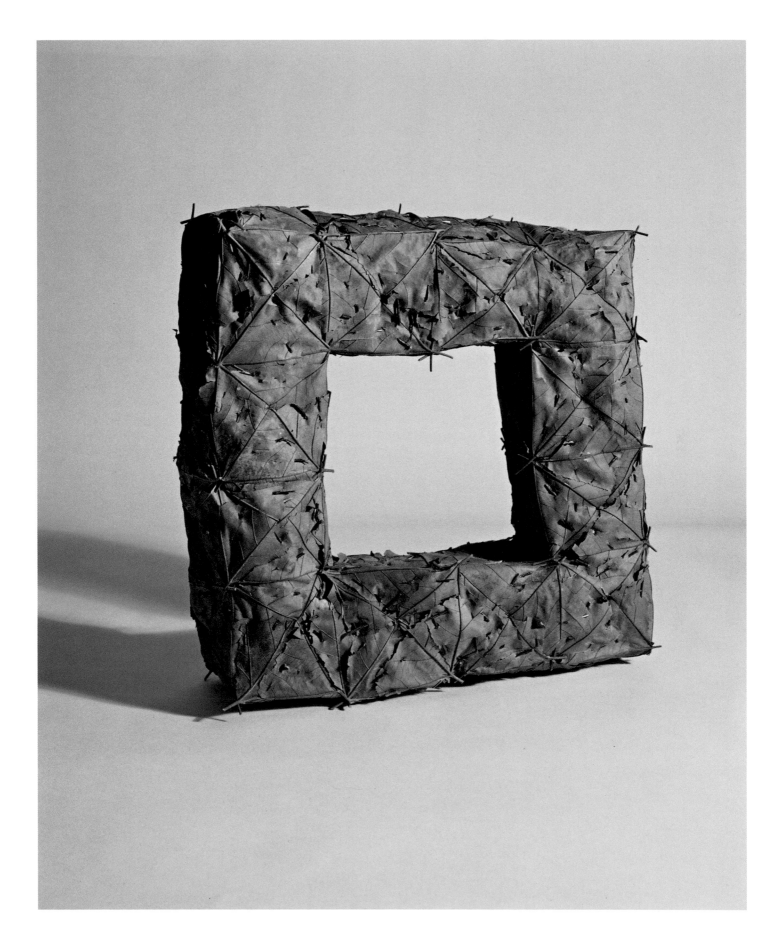

Plane

PENPONT, DUMFRIESSHIRE 1988–89

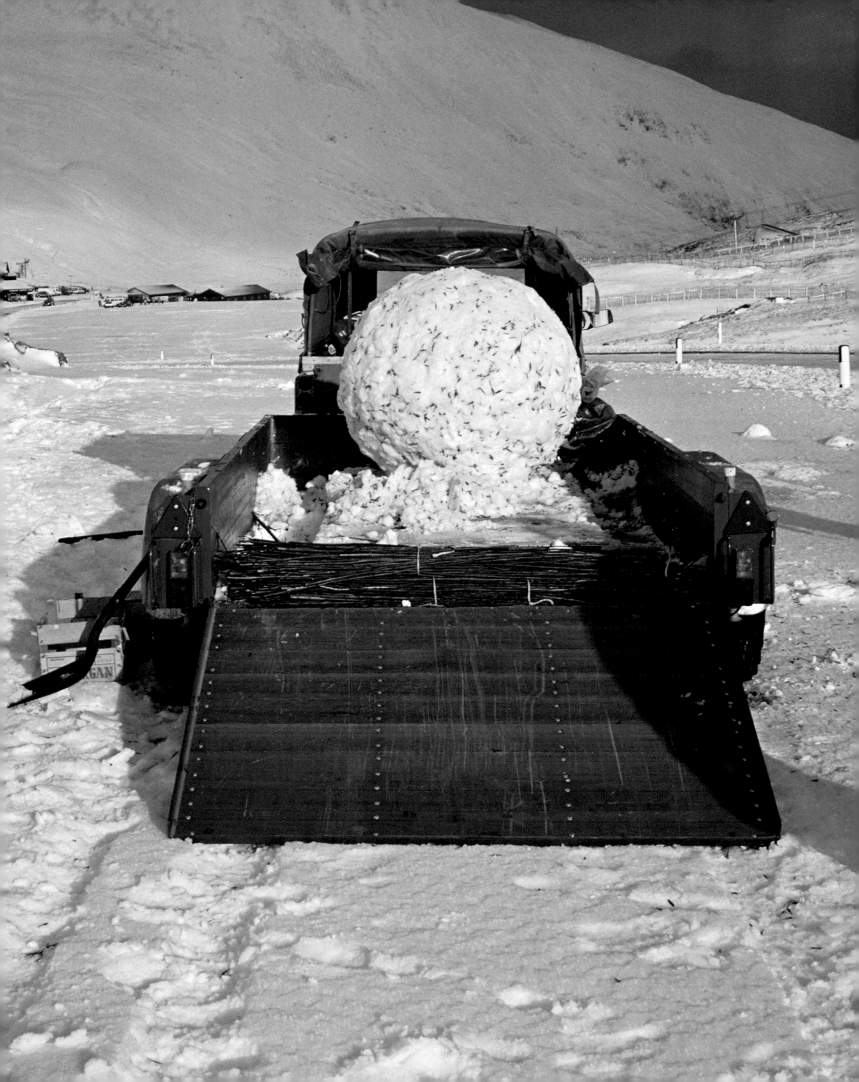

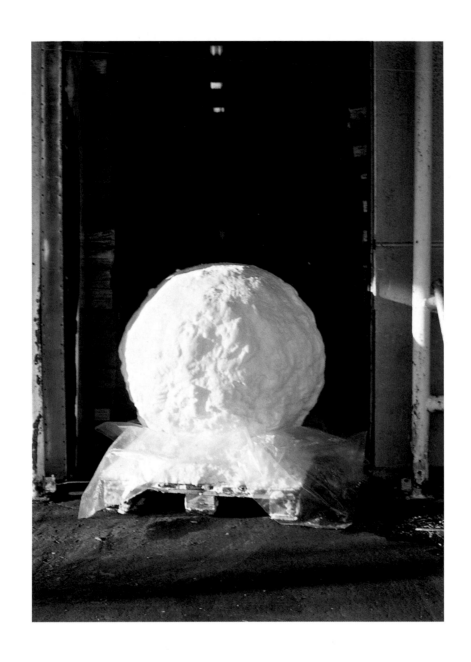

SNOWBALLS IN SUMMER
GLASGOW

Eighteen large snowballs made in Perthshire during the late winter of 1988–89 and then preserved in cold storage, were displayed in the Old Museum of Transport, Albert Road, Glasgow. There, from Friday, 28 July 1989, they began to melt, the process completing itself within five days and leaving only the inners scattered on the floor among pools of water. The installation, sponsored by Christian Salvesen, plc, was the first Visual Art event initiated by Glasgow District Council's Festivals Office in conjunction with the artist, who writes:

'Snow and ice is on a journey — it falls from the sky, forming drifts, thawing into the earth or grinding its way through a valley in the form of a glacier. Movement is a part of its nature. Working with snow and ice is touching a force that has shaped the land.

Understanding it is to learn about rock and earth.

When snow melts things hidden slowly emerge — evidence of time laid on the ground. Rocks carried in avalanches, soil crumbling from an eroded bank, bird droppings, feathers, the remains of a kill, fruit, wind-blown twigs, leaves ... caught up in the fall and the movement of snow. Removed from place and season — suspended in snow and time. Fresh snow falling on old — compressing a layer of debris — to be revealed like fossils in the melt.

The last patch of snow has always held a fascination for me. It is as if all snow has drained and concentrated into that patch — a white hole. There is a place high up in Scotland where there is snow almost all year round. That snow has an intensity and power. It is precious. It is the reason why I am more excited now by the first snowfall than when a child. It is the urge that makes me want to climb up a mountain when capped white — gather snow — bringing it down to the valley — perhaps leaving it in some dark wood to melt. It is why in Blairgowrie when I arrived with snow, children wanted to touch and play with it — taking lumps home.

We have a summer that is long enough to make winter a surprise. Snow always has the quality of the unexpected. If snowballs in summer seems a contradiction then it is in the nature of snow to contradict. It turns the dark earth white — it can fall softly or with a vigour that hurts. It is at the same time tough, gentle, dangerous, delicate, powerful and hard.

Snowballs in summer is an exploration of snow and an expression of my understanding and feelings gathered over the years I have worked with it. It will bring together qualities of time, space, movement, noise, colour and texture forming often the unpredictable that makes up the character of snow. Each snowball will have a different theme and pattern as it melts. Materials will emerge and concentrate on the surface, then fall. Different snows will melt at different rates. I will not fully understand each snowball until it has melted. I am, however, deeply aware of the potentials.

The elements of the melt will be best understood in the quiet stillness of an indoor space. The snowballs will speak louder having been made in the mountains yet melting in the city. Storage, transport, delivery and unloading become part of the making. A recognition that nature is these places also — snow falls on both city and mountain.

The snowballs were made during the warmest January and February on record. I intended to stay at Blairgowrie in Perthshire for two weeks where I would be near to the cold store and have a range of altitudes from sea level to over 2,000 feet which could be reached by road to find workable snow. If the snow had been too dry at 2,000 feet than lower down the snow would be better. I arrived on 28 January with my wife, son, father and mother-in-law. The plan was that my mother-in-law would look after my son whilst the rest of us went snowball making.

We stayed at Craighall near Blairgowrie. The day after we went looking for snow up Glenshee. I had expected to find the remains of the drift — something — but there was no snow at all apart from one or two patches at around 3,000 feet — out of my reach. I spent a week at Craighall working with dock stalks, waterfalls, garlic leaves, beech, sticks ... waiting for snow — listening to weather reports that put Aberdeen as being the warmest place in Britain and ski reports talking of fresh grass beginning to grow on the slopes. I even read in a paper that a strong wind had blown a stack through the

roof of the Old Transport Museum in Glasgow — the venue for the exhibition!

The wait was as important as the making. Sometimes I felt I was coaxing snow out of the sky. When it did snow it released an urgency that gave the snowballs energy.

After waiting one week we had a thin covering — enough to make two snowballs (the limit of how many I could carry on my trailer). Then the snow melted. The realisation that the snow is going creeps up on you slowly, it gradually becomes harder to work and collect. At first you think you are tiring — which you are — but also the distances you have to collect become greater and the snow heavier.

And then the snow was gone.

Another week passed with mild weather and no snow. Making the snowballs seemed unlikely. I decided, however, to stay another week — moving further up the valley so that I would be able to see if snow was falling by looking at the mountain tops and to respond quickly.

On a day that I would never have thought there could be snow I took a trip up to 2,000 feet just to see and came across just enough snow. Over the next week we made 17 snowballs. I tried to keep a diary of snowballs made but some days are vague. It became difficult to distinguish between snowballs made in the mountains and the snowballs made in my mind or in my sleep. It was desperately important that whilst snow lay on the ground snowballs were being made.

Once the process had begun the snowballs exerted their own demands, becoming an independent force that had to be won from the mountains in the same way a quarryman talks of winning a rock. This effort and tension has given the snowballs qualities I never thought of.

I look forward to seeing the shapes and how much the form reflects the day of making. A snowball made in a day when the snow was good, fresh, not thawing, sunny and calm has to differ from one made in the wind, rain and dark with wet thawing snow. Each snowball is an expression of the time it was made.'[30]

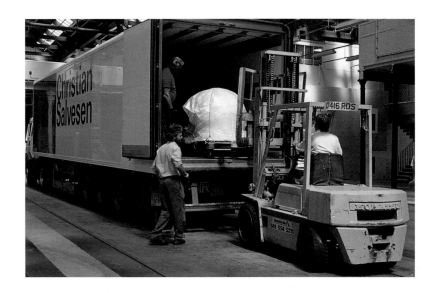

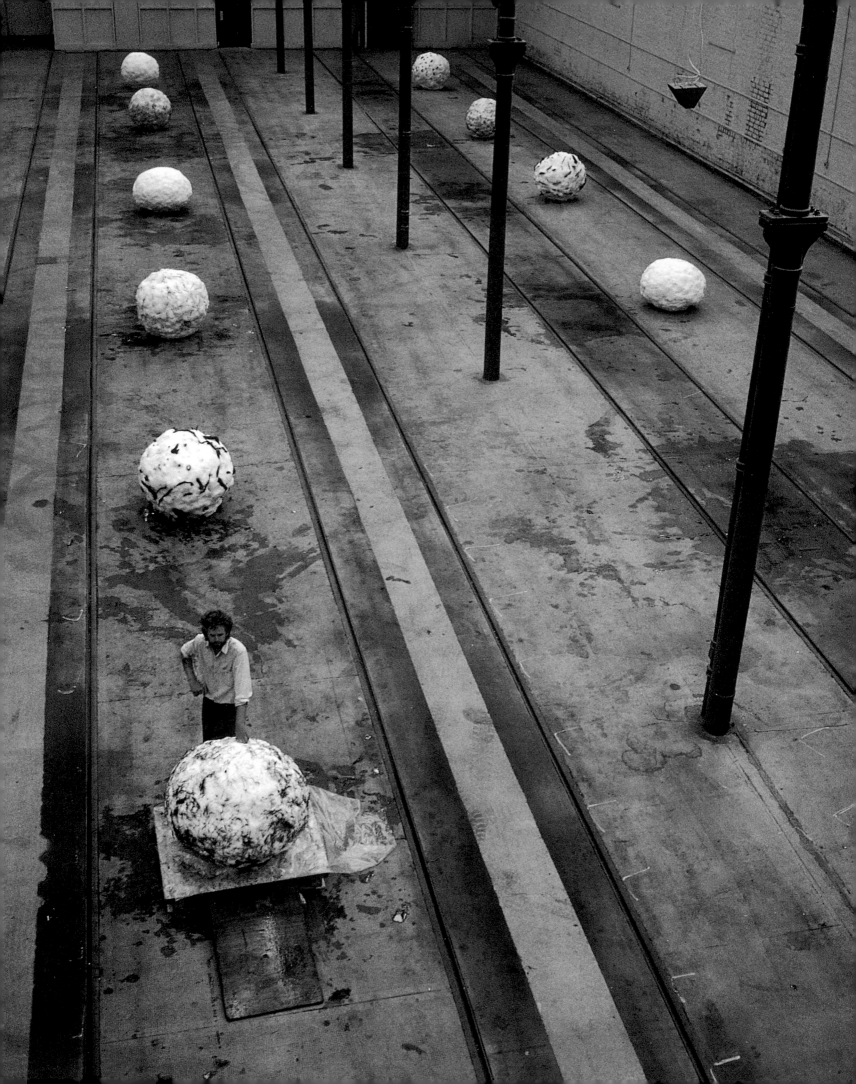

CHALK

OLD PINE NEEDLES

DOGWOOD

REEDS

OAK STICKS

PEBBLES

CHESTNUT STALKS

FRESH PINE NEEDLES

SLATE

CHESTNUT LEAVES

SOIL

ASH WINGS

WILLOWHERB STALKS

DAFFODILS

SNOW

BIRCH TWIGS

STONE

PINE CONES

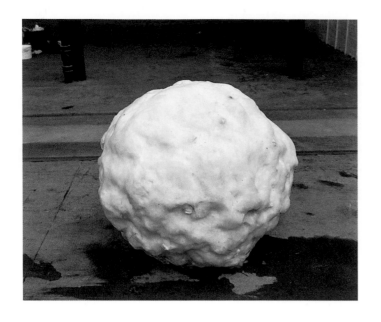
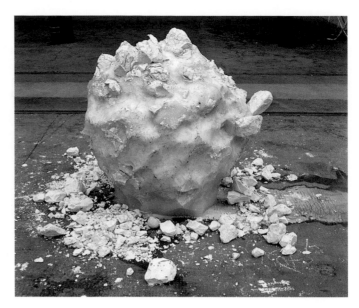
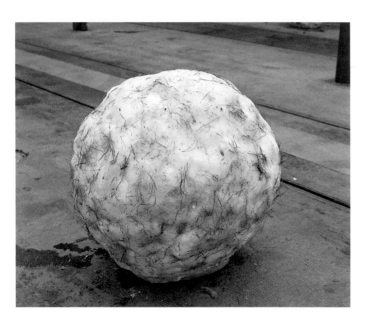
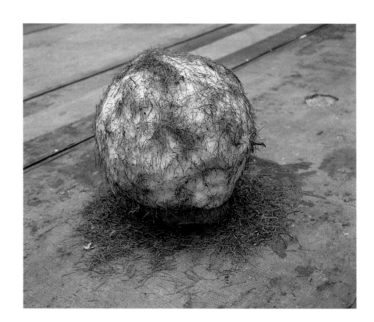
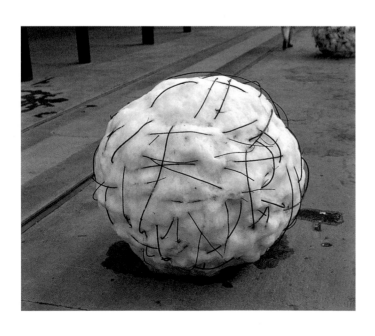
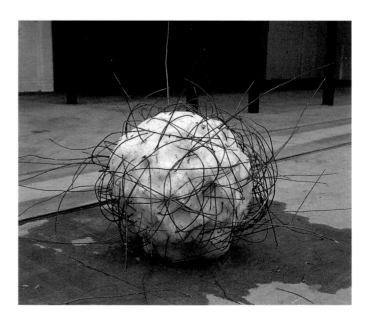

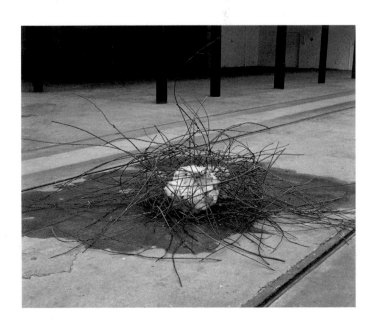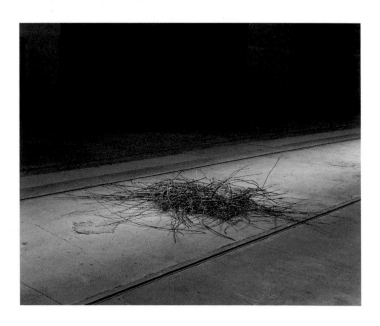

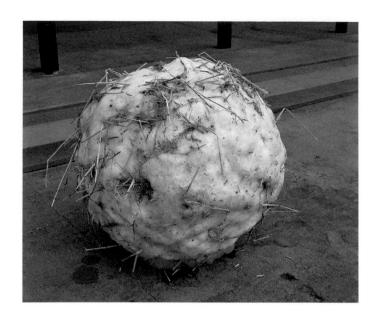
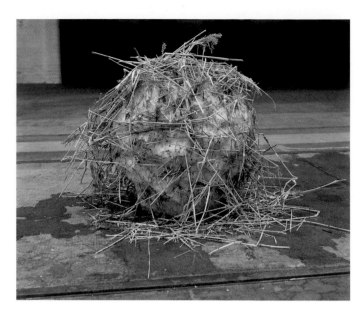

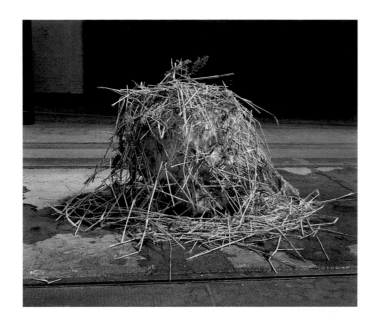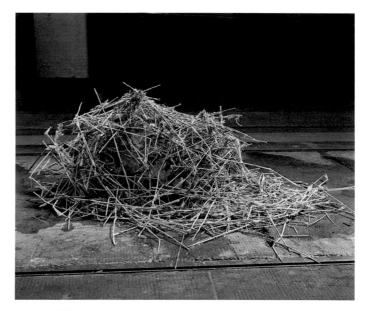
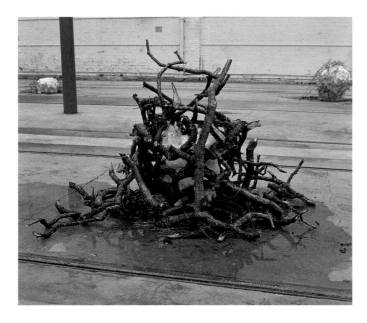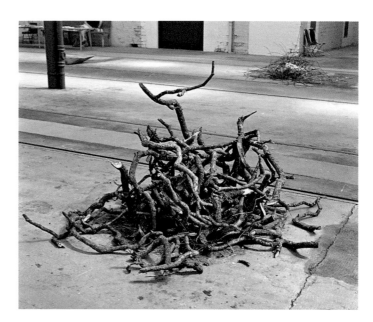
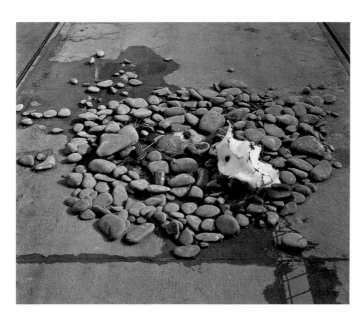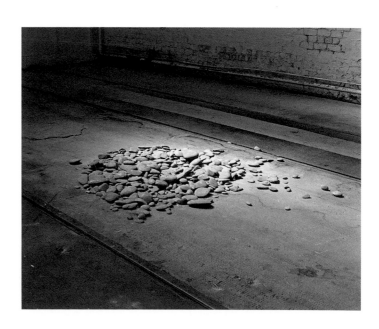

Proposal for Flevoland, Holland

1990

ENVIRONMENTAL SCULPTURES

Andrew Causey

Andy Goldsworthy is best known for his small ephemeral works created *ad hoc* in the landscape and recorded as photographs. Since April 1984, however, when he made *Seven Spires* in Grizedale Forest in the Lake District, he has completed five commissions for large-scale works, and has several more at the planning stage. There have been two projects at Grizedale, another woodland sculpture at Hooke Park in Dorset, and two huge earthworks on the line of an abandoned railway at Lambton near Chester-le-Street and Leadgate near Consett, both in County Durham. Goldsworthy has plans involving the use of stone walls in France and the United States, a series of artificial tree-clad mounds in Holland, and a set of cones made of layers of steel for a site overlooking the Tyne at Gateshead.

Understanding these projects involves both defining them as a category and distinguishing them from Goldsworthy's ephemeral works. Setting the photograph pieces against the larger more permanent projects, Goldsworthy sees himself as two different artists, but does not want the large works' growing demands on his time to draw him away from the photograph pieces, which he sees as the core of his art. The distinctions between the kinds of work are most obviously the contrast of size and the quite different ways they are made. For the large projects to be properly understood, these distinctions need to be refined.

The small works are inspirations of the moment, made intuitively without plans or drawings, the artist's only tool being a knife. Goldsworthy is alone, he photographs the sculpture to preserve it, and a colour print is then available for exhibition in an art gallery. The large works, on the other hand, are commissions, which may have been competed for. Drawings are important here to clarify the project in the artist's mind, support applications and guide fellow workers. These projects involve assistants, art students brought in to dig holes and handle manual winches at Grizedale and Hooke, and the skilled operator of a mechanical excavator, Steve Fox, at Lambton and Leadgate. The early commissions presented financial problems, and all of them confronted the artist with organisational challenges that the small works do not. The brief lives of the photo-graph pieces contrast with the long ones of the large works. Permanence eliminates the need for photographs, so the large projects do not become art works for sale in a gallery.

Beyond these technical distinctions are others that help define the types of work further. The photograph pieces are rearrangements of nature in which, for example, stones, leaves or flowers of a certain colour are brought together, the randomness of nature is removed, and geometrical forms are created that highlight edges, crevices and holes. The works are elegant, refined exhibits of a craftsmanly virtuosity that makes us look at nature more closely. But in the sense that they bring the viewer up short, and surprise with their wit and resource, they are not natural.

Their brilliance lies largely in their artifice, and the illusionism of colour and scale aligns them with painting as much as sculpture. The photograph pieces often stand apart from their natural surroundings which become a form of background or context. Characterised in this way by having distinct boundaries, they work ideally as framed photographs on the wall of a gallery. Without exaggerating the distinctions between the types of project in this respect, it can be said that surprise, illusion, and other characteristics that make the small works immediately arresting and separate from their surroundings are less prominent in the large projects, where continuity with the environment is a part of their identity, and their character is partly defined by the modest, sometimes minimal, difference between the sculpture and the adjacent landscape. Although distinct objects, the environmental works differ from the small ones in that they cannot be removed from the landscape. To photograph one and place it on the wall of a gallery would simply be to document what the artist had done, rather than exhibit a work of art: the life of the large works is there in the landscape and nowhere else.

These points lead back to the question of what sculpture is. Goldsworthy did a sculpture course at Preston Polytechnic, and is called a sculptor. But what is sculpture if, within the work of a single artist, it is a photograph one moment and an earthwork the next?

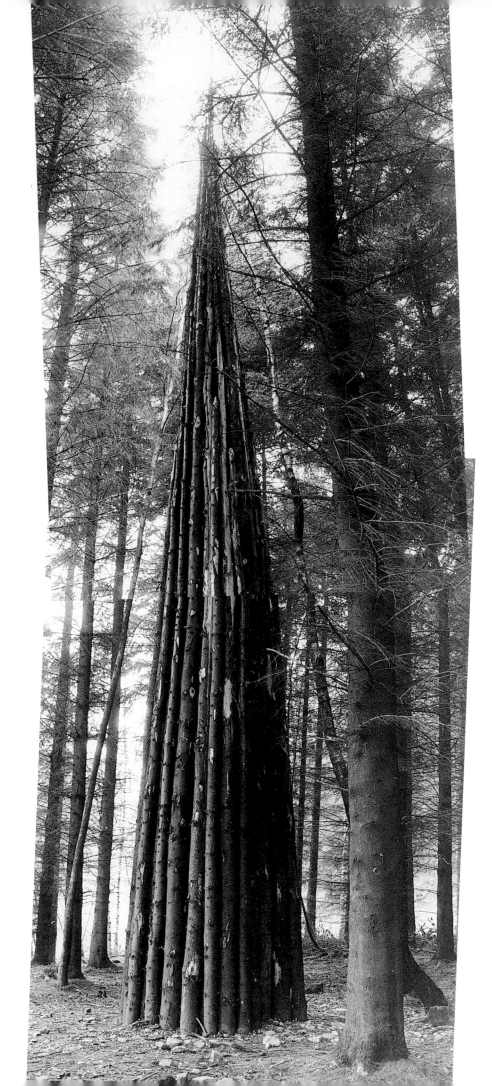

Spires

GRIZEDALE FOREST, CUMBRIA 1984

Understanding Goldsworthy means taking into account the way sculpture has expanded its field in the last twenty-five years, and distinguishing between something that was traditionally to be looked *at* and is now, thinking of the earthworks, something to be walked *over* or cycled *through*. How sculpture related to a particular place was a minor issue when that place was an art gallery; the concern then was the space it needed rather than the place it was in. But for Goldsworthy the character of the place is the core of the brief he gives himself. How then, the issue becomes, can sculpture — thinking of Grizedale — relate to forestry, or — thinking of the 'excavated' look and hill fortress reminiscence of Leadgate — to archaeology? Tying these questions together is another, the relationship of the sculptor today to landscape, which has traditionally been much more the concern of painters than sculptors.

While sculpture has been thought of as permanent and outside time, Goldsworthy's works change: the forest projects gradually decay, while the earthworks will, initially at least, grow, as weeds and undergrowth cover them. Sculpture traditionally represents the imposed will of the maker, but Goldsworthy is a collaborator with nature, interested in the way wind and rain form pools in the folds of his earthworks, the sun and shadow encourage some growth and not other. He is concerned with the way people respond to his sculpture, without trying to influence them. Place is crucial to his art: a work must fit, must draw on its environment and become part of it. But place is distinct from mere space. Places have history and character and exist in time, and Goldsworthy's sculptures, which gather meaning and character from places also exist in time, being subject to natural change and any other changes — of land use, for example — that affect public places as opposed to the protected space of an art gallery.

Grizedale is a working woodland run by the Forestry Commission, and finance for sculptors to work there using its timber has been available since 1977. It is open to the public and a leaflet locates each sculpture on the many miles of forest track. But Grizedale is not a conventional sculpture park, because its main purpose is to grow timber rather than provide the opportunity to view art in

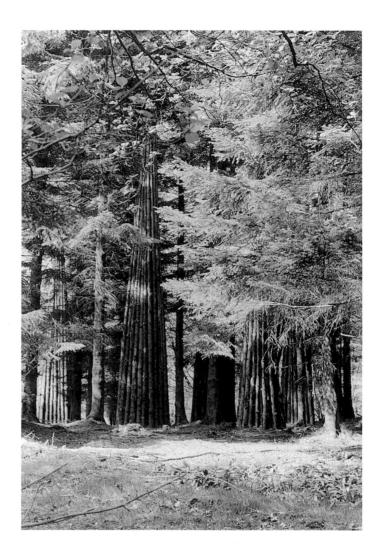

the open air. Goldsworthy's first commission, *Seven Spires*, takes this into account, not just because the seven sets of clustered pine trunks grouped in tall pyramid forms are made from the forest's surplus timber. *Seven Spires* is part of the forest and not, like most sculpture, either distinct from its surroundings or to be looked at only from outside. One spire is easily visible from the track and its prominence signals the presence of the whole work. But to find the other spires and experience the sculpture in its entirety the viewer must leave the track and walk in among the trees.

Goldsworthy's sculpture helps to form a new relationship between spectator and sculptor, because the viewer is inside the sculpture, among the spires and trees. Experienced from the inside, sculpture loses its character as monument, something external to the spectator and

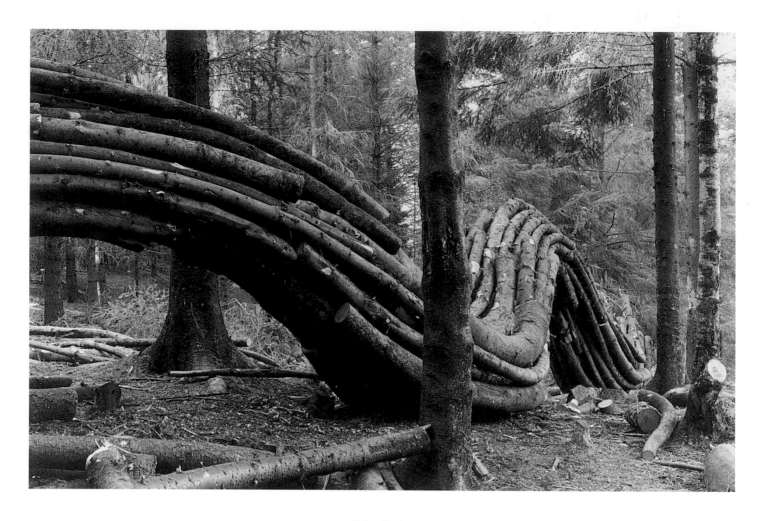

Sidewinder

GRIZEDALE FOREST, CUMBRIA 1985

claiming a kind of superiority because it is special and outside the flow of time. In avoiding monumentality, however, Goldsworthy's sculptures do not forego grandeur.

From the time of the eighteenth-century contemplative garden, furnished with sculpted busts and figures, to the Battersea Park sculpture exhibitions of the 1950s, and the installation in the same decade of the *King and Queen* and other sculptures of Henry Moore on Scottish moors, there has been a tradition in England of using nature as sympathetic background for sculpture. Goldsworthy goes beyond this. When selecting the site for *Seven Spires*, he avoided working in a clearing, which would have been the obvious choice if he had wanted to follow the tradition of giving sculpture its own space within a

picturesque context. Goldsworthy, by contrast, needed *Seven Spires* to work with nature to the extent of becoming all but part of it. He wanted the pine trees to dictate the idea, scale and form of the sculpture, and in this has added a new dimension to the idea of what sculpture can be. With *Seven Spires* there is only modest difference between the trunks that form the spires and those of the live trees. Goldsworthy is interested in what is like nature yet different.

The relation of the sculpture to its surroundings is not a stable one, because, as time passes, living trees grow and are ultimately felled, while dead ones slowly decay away. Most of the *Seven Spires* can be seen properly only close-to, inside the wood, and a possible view is to look up the spires from close to the base, from where

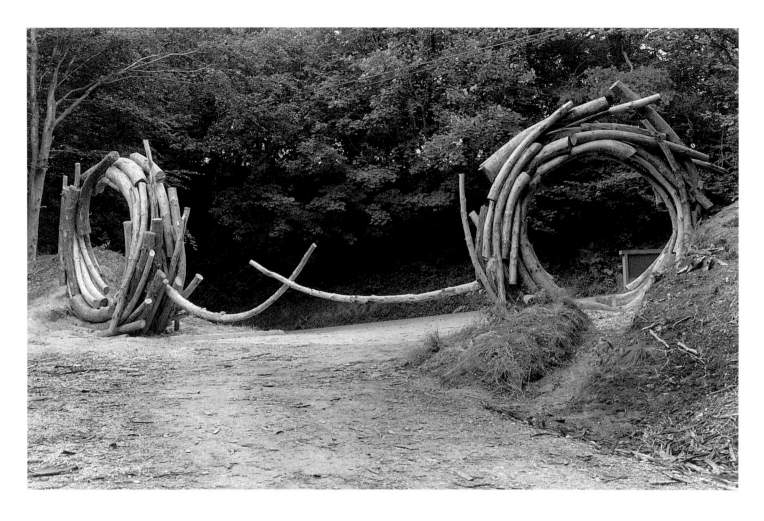

HOOKE ENTRANCE, DORSET 1986

one can share Goldsworthy's sense that there exists 'within a pine wood . . . an almost desperate growth and energy driving upward'.[31] He makes an analogy with Gothic architecture, the surge of energy through columns and the convergence and resolution at the point of the vault, in the way D. H. Lawrence describes his feeling for the inside of Lincoln cathedral in *The Rainbow* ('Here the stone leapt up from the plain of earth, leapt up in a manifold clustered desire each time, up, away from the horizontal earth').[32] Romanticism has commonly associated the Gothic with the forest, and Goldsworthy is in this sense Romantic. He is not, however, a nature mystic searching for some vaguely conceived pannish spirit of the woods, nor a Symbolist in the sense that he sees an image, such as a spire, as the fixed expression of an idea, such as religion.

Richard Long has commented on the way art's changing role in society has made direct comparisons between his own interest in stone circles and ostensibly similar manifestations in the past dangerous: 'Stonehenge and all the circles in Britain . . . came about from a completely different culture. . . . They were social, religious art. I make my work as an individual.'[33] If art is now a matter of individual expression, it cannot be assumed that forms will have the same meaning as in the past, or that a common understanding of forms will exist. Goldsworthy's reactions are instinctive, his sculpture has meaning for *him*, which may or may not be widely shared; what matters is that such analogies should be felt and not imposed.

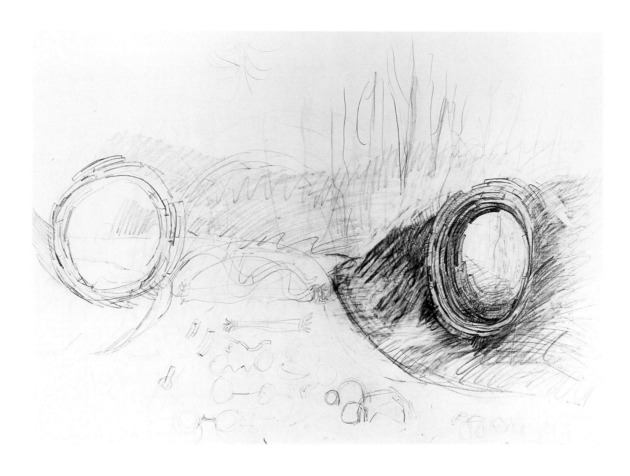

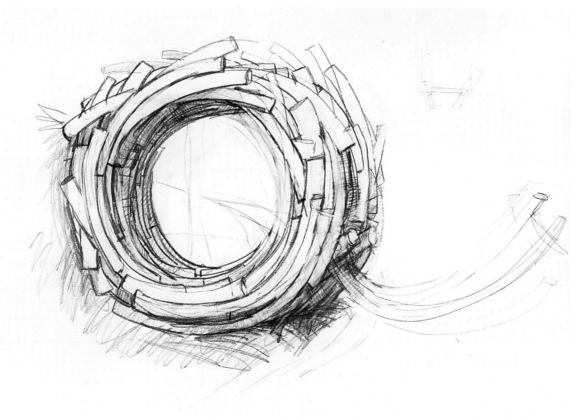

Proposals for Hooke Entrance V and VI

1986

Goldsworthy's second Grizedale project, *Sidewinder*, made in May 1985, and conceived as a contrast to *Seven Spires*, is a horizontal 'serpent'. From being a single log at one end, the body of the sculpture was built up by butting together an increasing number of sections of wood side by side, so that it grows in width down the length of the body. By contrast with *Seven Spires*, *Sidewinder* is close to the ground, and, as against the calm grandeur of the previous work, the rapid succession of arches that form the body of the new one is tense with energy. It has some resemblance to the rise and fall of the old stone walls left from when the forest was moorland and still to be seen among the trees. But individual imaginations, searching for associations, may prefer to see it as serpent, the emblem of the dark energy of the forest encountered in the more remote part of Grizedale that Goldsworthy chose for *Sidewinder*.

Goldsworthy's third large scale project, the two wood circles at the entrance to Hooke Park Wood in Dorset, made in September 1986, arose from an approach to the furniture maker John Makepeace from Common Ground, a group dedicated to heightening awareness of landscape and encouraging local initiatives to commission sculpture in rural places. Makepeace was starting up a School of Woodland Industry there, one of its purposes being to develop economic uses for timber thinnings in the surrounding woods, which had been taken over from the Forestry Commission. Sue Clifford and Angela King of Common Ground describe the project in detail in this book, but something needs to be said about the place of Hooke in Goldsworthy's work as a whole.

Grizedale offers public access, but an element of secrecy surrounds the sculptures there, which are often remote and have to be searched for. The entrance to Hooke Park, from an unclassified road away from the village, is also off the beaten track, but it is a public place and the sculptures are markers, registering passage from one kind of land, a public road, to another, a wood which is privately owned but with public right of access. Entrances and thresholds have symbolic value, acting as focal points and introducing what is beyond. Making the circles out of curved, and therefore commercially low-

value, timber, was a reference to the school inside, part of whose function was to find new ways of using low-grade wood.

Goldsworthy's original proposal, for a single circle enclosing the roadway, involved a fifty-foot span, which would have been out of scale, and would have made the work too dominant over its environment for the sculptor who had brought art and nature into such close liaison at Grizedale. As an artist who, in the course of the eighties, made sculpture varying in length from two feet to a quarter of a mile, Goldsworthy has become aware of problems of size in relation to scale. He has successfully created sculptures of large size by keeping them in scale with people and with their environments. The problem was acute at Hooke where the large span would have created something like a twentieth-century triumphal arch, and Goldsworthy opted for two smaller circles on either side of the road entrance.

Goldsworthy's next public commission, the *Lambton Earthwork* near Chester-le-Street in County Durham, made in December 1988, faced him with a different type of location and size of project. He was commissioned jointly by Northern Arts and Sustrans, a company specialising in finding new uses for abandoned railway tracks, to build an earthwork on a section of the disused line between Consett and Sunderland. His new site was in an area scarred by the decline of heavy industry and marked in particular by the closure in 1980 of the Consett Iron Works and the ending of the town's railway link. With the old iron bridges over the former track left at either end of his chosen site, but a modern housing estate creeping up to one side of the railway embankment, the place has an air of being caught between old and new. Working for the first time in an area neither naturally beautiful nor remote from civilisation, Goldsworthy demonstrated that he was not bound by a specifically Romantic tradition of landscape art.

The *Lambton Earthwork* is a quarter-mile-long earth spiral lying in a wide low cutting, the banks of which are in most places higher than the earthwork, giving it the appearance of an excavated object exposed just below the surface of the land. As with most of Goldsworthy's large works the form had already been

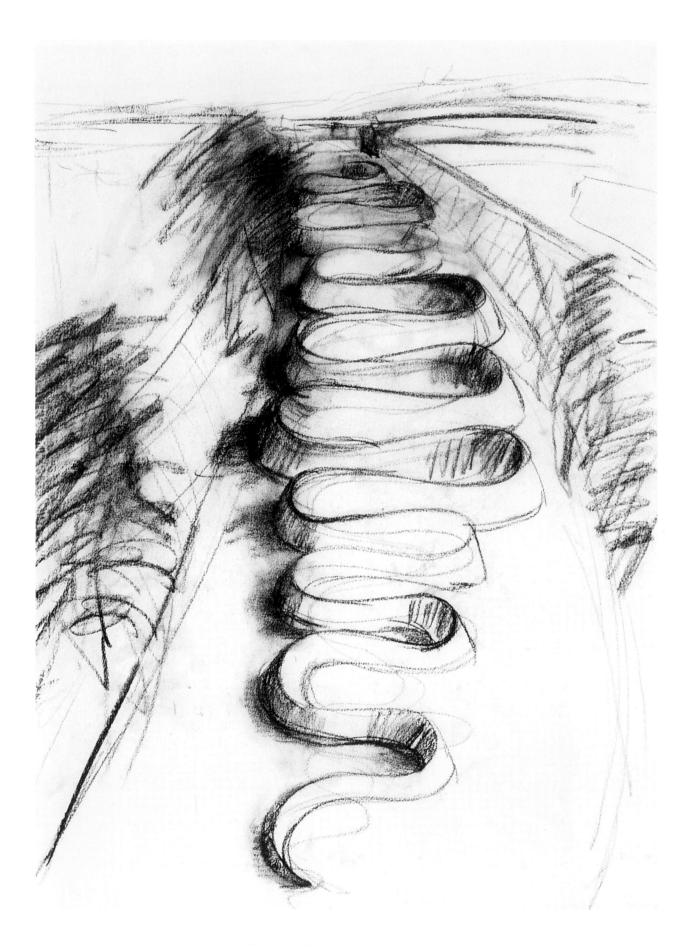

Proposal for Lambton Earthwork III

1988

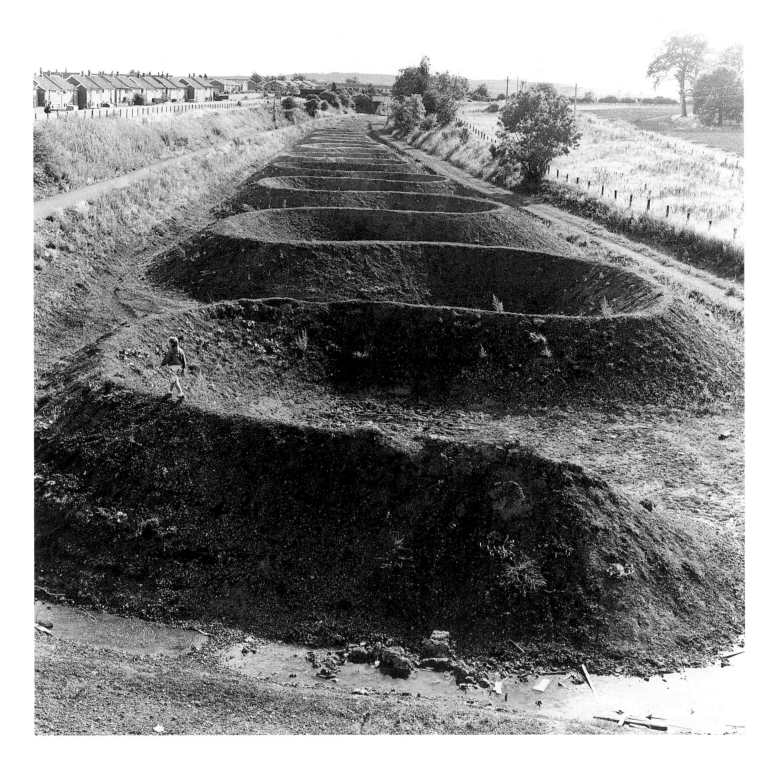

LAMBTON EARTHWORK, COUNTY DURHAM

1988

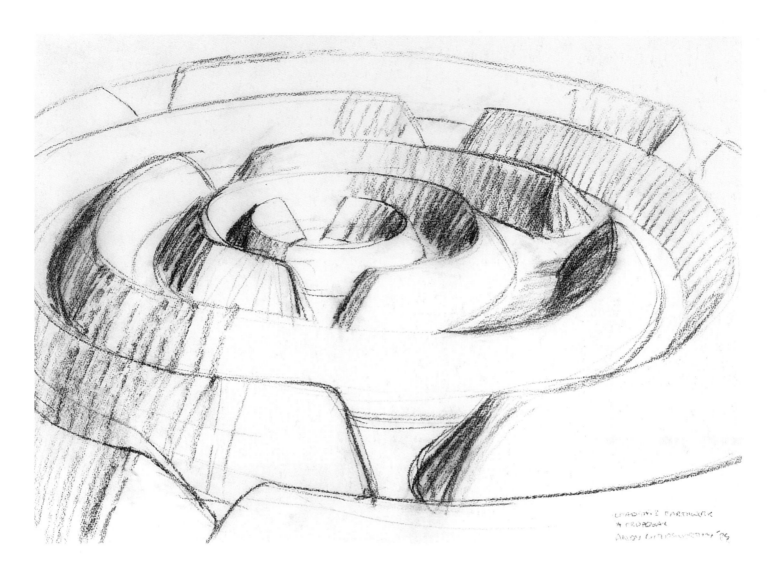

Proposal for Leadgate Maze II

1989

explored in small ephemeral ones, and relates also to *Sidewinder* in the way its coils correspond to the arches of the earlier piece, and its body grows from narrow to wide. Cycle track flanks the sculpture which can be experienced from outside on the tracks, by climbing over it or by attempting the hazardous enterprise of cycling along the top of its narrow curving spine. Alternatively, there is a view from above from the bridges at either end. Exploring its folds, avoiding the puddles that form in wet weather, or climbing on the steep banks are tactile experiences that familiarise the viewer with the physical presence of the work, while the view from above enables

it to be seen, more conventionally for a sculpture, as a whole.

Goldsworthy compares Lambton's serpentine form with natural phenomena to which he would like it to be seen as parallel: 'a river finding its route down a valley, the ridge of a mountain, the root of a tree a feeling of movement — of earth risen up and flowing — a river of earth'. The work is further like a river because it 'starts narrow and ends wide — giving a sense of direction. . . . It has qualities of snaking but is not a snake. The form is shaped through a similar response to environment. The snake evolved through a need to move close to the ground

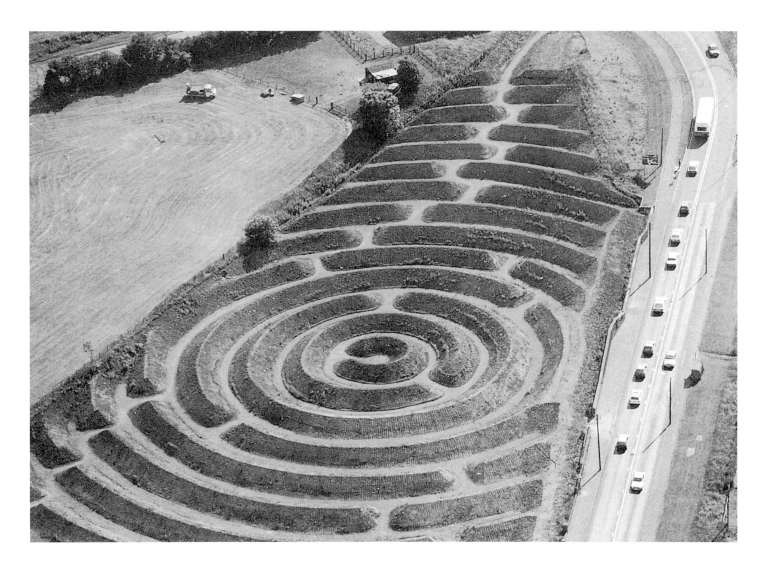

MAZE, LEADGATE, COUNTY DURHAM

1989

— sometimes below and sometimes above — it is an expression of the space it occupies.'[34] Goldsworthy's account stresses the functional origins of natural form, a snake or a river is what it is because of its needs in relation to its environment. As with *Seven Spires* and the cathedral, Goldsworthy has no objection to the work being read symbolically if that is how it is felt, but stresses that it is a matter of individual response. He heard only after he had designed the work the popular legend of the Lambton Worm, a legendary local chthonic power, which people living in the area assume was Goldsworthy's inspiration.

Goldsworthy was attracted to the idea of a disused railway line with its feeling of travel and distance, and though the earthwork is in an enclosed space, bounded by the banks of the cutting at the sides and the bridges at either end, the line of the old track disappearing into the distance at either end is part of the viewer's awareness, and the imagination can envisage the coils of the earthwork as signifying the full course of the railway line or its representation on a map where, in hilly country like this, it twists in and out with the contours. The idea that a sculpture could absorb the surrounding landscape and become an emblem for it was expressed by Henry Moore

135

with reference to his 1938 *Reclining Figure*, now in the Tate but commissioned for a position overlooking the South Downs.[35]

Time, experienced and understood in different ways, is important in all Goldsworthy's large sculptures. In *Seven Spires* time was a property of the sculpture, in the sense that it was about growth and decay, but attached also to the spectator because time passes in experiencing each of the seven spires. Similar ideas apply at Lambton, which will change as nature engrosses it and takes time to experience fully. Lambton also evokes associational time, a feeling of being pulled back into an earlier moment of history. Archaeology, which has been of major importance in American earthwork sculpture, is an issue at Lambton. Goldsworthy is not interested in archaeology as such, but the process of excavation, of burrowing back through time in a landscape that has been formed by centuries of cultivation is stimulating to Goldsworthy who has himself been a part-time farm labourer at various times from the age of thirteen and has a strong sense of landscape having a life which he needs to key into and co-exist with. Lambton is reminiscent of an ancient burial mound, and also bears comparison, as it lies exposed in the cutting slightly below ground level, the earth still fresh and not yet overgrown, with an archaeological discovery, the form of some mammoth exposed by digging. Goldsworthy is interested in the mystery of what is beneath us, but unlike the archaeologist seeking objective truth, the artist is content that things remain ambiguous and inscrutable.

Lambton's future is indeterminate. It is not, like conventional sculpture, protected from change by being in an art gallery never to be de-accessioned. In a possible future when it was decided to reconstruct abandoned railways and the earthwork was lost, Goldsworthy would not be perturbed because change and finiteness are principles of his art.

With the successful completion of Lambton, Goldsworthy was given a second commission on the same cycle track some eight miles east at Leadgate. Here the closure of the railway had been followed by road improvements. Evidence of the railway has all but disappeared and Goldsworthy was left with a larger site than

at Lambton, a triangle of some two acres between two main roads as they approach a roundabout.

The sculpture, completed in September 1989, is formed of concentric walls of earth, somewhat resembling the ramparts of a hill fort, with straight sections at the sides to make the circular shape fit the triangular site. The cycle way passes to one side of the centre through a labyrinthine network of paths, engaging the pedestrian or cyclist more completely in the art work than at Lambton where the path ran alongside. Weaving through the maze one feels close to the earthwork because the banks are steep and high and the pathways narrow. The sense of enclosure is strong, the environment is intimate and tactile, and though the sculpture is huge in size, its scale is human. To see the whole work from outside is not easy as it extends close to the edge of its site and there are no bridges or raised points to give a view from above. As it is sunken there is no outside wall saying keep out, no psychological obstacle to entry. Even more than Lambton, Leadgate is naturally experienced from inside, the viewer is at the core of the sculpture. Goldsworthy is concerned with continuities between art, nature and the human body, and the space created within the sculpture is body space, the projection of the viewer, and not an objective space conceived as if no person was involved.

While earthwork sculptures of the size of Lambton and Leadgate are unique in England, they do resemble the work of certain Americans. Leadgate could be compared with Robert Morris's works involving concentric circles from the seventies. But the likeness is more apparent than real. Some Americans have created structures that are architectural in character and contrast with their environments like interventions in the landscape. Even a sculptor like Robert Smithson, who works close to the ground using materials from the site, operates in a more commanding way than Goldsworthy. In the spacious undifferentiated landscapes of the western deserts Smithson is handling locations that demand a grand-scale response, and the characteristic view of a Smithson environmental sculpture is from the air where its simple form is easily comprehended. Goldsworthy's earthworks are impressive from the air, but sunk in landscapes that are already elaborately worked (a railway cutting is a kind

of earthwork itself) they are like new chapters in the history of an already well established landscape. Their scale is human, not monumental, and the texture, variety and complexity of their surfaces all demand that they are seen close to.

One American with whom Goldsworthy has much in common is Carl Andre, rare among his countrymen in having being influenced by the English landscape when he visited this country in 1954. Andre shares Goldsworthy's sense of the countryside as related to human history, the product of man as worker: 'The English countryside has been literally cultivated, in every sense of that complicated word, and it has been moulded very slowly over at least three thousand years.' The landscape, he said, 'created in one the sense of the value of sculpture as human activity',[36] a belief he has translated into ground-hugging works that his audience are free to walk on. Andre shares with Goldsworthy the sense of sculpture being at your feet, an extension, almost, of the body, and not something objective and apart in a space of its own. Andre's suggestion that the ideal form of sculpture is a road[37] relates more to Long than Goldsworthy, who does not, like Long, make sculpture by walking. But it points in general to a conviction shared by the three that sculpture is an expression of physical activity connected with the ground.

The English tradition of artists working directly with landscape goes back to landscape architecture in the eighteenth century. Mid-eighteenth century aesthetic theory came to regard beauty in nature not just as a visual experience but in terms of physical sensation. For Edmund Burke, for example, beauty was related to smoothness, delicacy of form, and gradual variation. He gave a definition of beauty that could have been founded on the experience of parkland designed by Capability Brown, describing it as the sensation of 'being swiftly drawn in an easy coach on a smooth turf, with gradual ascents and declivities'.[38] Though a direct parallel between the earlier period and the present day would ignore the different origins and purposes of landscape architecture and today's land art, the existence, nonetheless, of an earlier tradition linking aesthetic expression with physical sensation is significant in view of the con-

nection in Goldsworthy's earthworks between sight and touch, the experience of looking at them complemented by that of walking over and through them.

Henry Moore is a key figure in the historical context of Goldsworthy's sculpture. Moore's interest in placing his sculpture out of doors and the presence of the Moore bronzes on the Scottish moors not far from where Goldsworthy lives has been an inspiration to Goldsworthy and many others. But placing sculpture *in* the landscape is not the same as making sculpture *out of* the landscape. The wider relevance of Moore lies in the way his wooden reclining figures from the mid-thirties onwards opened up a new kind of space. On account of the sculptures' openings and the sense of direct access to their interiors, their space is felt as continuous with that of the spectator, inside becomes one with outside as the solidity of more conventional sculpture disappears. The tactility of the natural material adds to the effect of the continuity of space in making the viewer feel one with the sculpture. Goldsworthy's earthworks obviously go much further towards this idea of 'oneness' because he is able to put the spectator literally in the centre of the work.

The affinity between Goldsworthy and Moore extends further. Lambton and, especially, Leadgate, gain a feeling of being special or protected by being cradled within the earth, in the way that Moore, from the forties, develops relationships between inner and outer forms, creating a feeling of the protection of the core by the outer shell. Like Moore, Goldsworthy is concerned not to determine specific relationships and meanings but to arouse in the spectator feelings that respect his sense of sculpture evoking ideas that ultimately remain mysterious.

Goldsworthy's future plans include several involving stone walls, taking up the theme of enclosure and protection that he often comes back to. Bound by contract to construct a wall between land he owned at Stone Wood near his home at Penpont and the neighbouring farmer's, he designed one in 1987 with two loops in it, one to give the farmer a small sheep pen on his own land, the other providing himself with an enclosure for a sculpture on the farmer's. In 1989 he made a proposal to build a curving wall down a hillside at Mossdale Farm in the

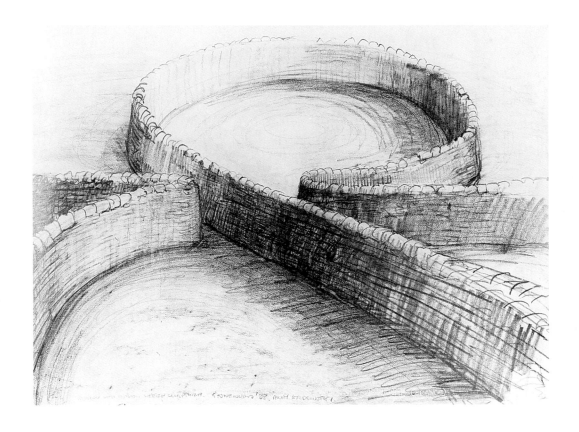

Proposal for The Wall, Penpont, Dumfriesshire

1988

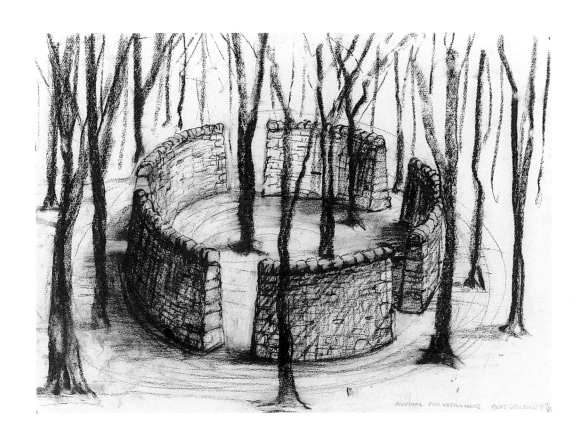

Proposal for Kentuck Knob, Pennsylvania

1989

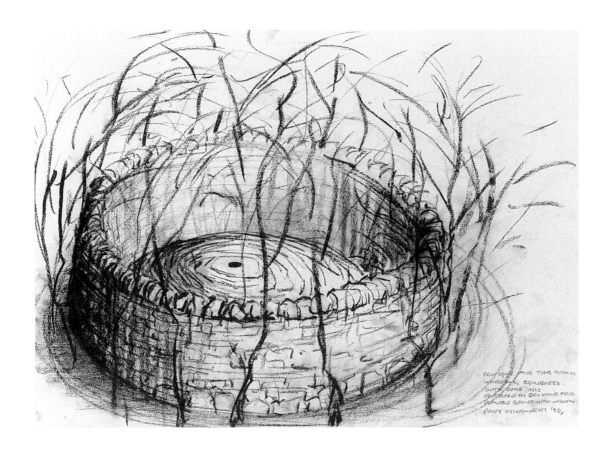

Proposal for the Royal Botanic Garden Edinburgh

1990

Proposal for Labège, France

1989

Yorkshire National Dales. A sycamore planted in each curve would be guarded from the weather by the wall. As at Stone Wood the wall was to be built from the stones of a nearby broken one, recycling materials and giving them a pattern of use and re-use equivalent to the cycle of growth and decay in nature. Plans exist for a stone enclosure for a private house in Pennsylvania, and at Labèrge, a built-up outer suburban area of Toulouse, Goldsworthy plans a high walled enclosure surrounding a boulder, a natural untouched rock acting as a kind of sacred centre or altar protected by encompassing walls from the ravages imposed on nature by suburban civilisation.

A proposal for a series of five conical hills at Flevoland in Holland presents different priorities from the projects involving enclosure. 'Travel, time and distance' Goldsworthy describes as his concerns in this plan for a set of tree-clad, twenty-metre-high, artificial hillocks alongside a road. He was impressed by the simplicity of the flat landscape which the cones will complement while still introducing an element of the unexpected. The hills will be spaced, not close to one another so that they form a row, and not so far apart that no connection is made at all. Goldsworthy plans, for the first time in a large scale work, to work actively with colour, as he does with his photographic pieces. The trees will be chosen for the colour, perhaps red or orange, of their autumn foliage and will be densely planted to form a mat effect. The sculpture will thus be seasonal, perhaps imprinting itself on the motorist's vision only subliminally for most of the year and creating a startling impact for a few weeks in the autumn. Not only colour but light as well will be important, with two hills placed so that they are illuminated, when seen from the road, by the rising or setting sun.

In America Goldsworthy has a project for a sculpture in the garden of Mies van der Rohe's Farnsworth House near Chicago. The house is built just off the ground because it is by a river that regularly floods, and Goldsworthy has chosen a form of sculpture that reflects this: a row of stones, one for each year of the house's existence, the size of the stones governed by the height of the floodwater in each year. It is a more conceptual form of art than usual for him, in the sense that a set of exter-

nal facts, the height of the floods, regulate the art precisely. The facts, however, are ones that also govern the house, its elevation from the ground, and its environment, and are therefore a representation of place in the way all his works are.

At Gateshead Goldsworthy is planning a set of giant cones in the form of two-inch-thick steel plates laid on top of one another in a public park overlooking the Tyne. The cone has long interested Goldsworthy as a shape: his unfulfilled plans include a set of wooden cones for Grizedale and a group for an open moorland setting. Hitherto Goldsworthy has only worked with nature but has no prejudice against man-made materials so long as, like steel, they have a life expressed in changes of colour and texture on the surface. Plastics, which are neutral, textureless and unchanging, do not interest him. Steel cones will act as an emblem of the Newcastle–Gateshead conurbation, which was built in the nineteenth century on heavy iron and steel based industries, like shipbuilding, that are now in decay. When Minimalist sculptors in the sixties adopted new materials, like plastics, and used them for anonymous abstract forms, they were using shapes and materials that seemed urban, progressive and modern.

The American land artist Robert Smithson was among the first to step back from these values, to challenge the link between urbanism and progress, expressing a belief in the centrality of dissipation and decay, to consider once again non-urban locations for sculpture and to point out, appropriately for Goldsworthy's Gateshead project, that one of the fundamental properties of steel is rust. Goldsworthy is different from Smithson, who enjoyed extremes and thought in terms of polar opposites like order–disorder. Goldsworthy is a cool and moderate artist compared with Smithson, but does share the sense that art can be about the downside of things as well as the upside, and the Gateshead cones will be monuments to a decayed industrial environment. They are planned to stand in parkland, late twentieth-century counterparts of the heroic Victorian figures, from royalty to local philanthropic industrialists, who were also memorialised in statues in public parks.

Proposal for Woodland cones, Vassiviere, France

1990

Proposal for stone cones, Penpont, Dumfriesshire

1987

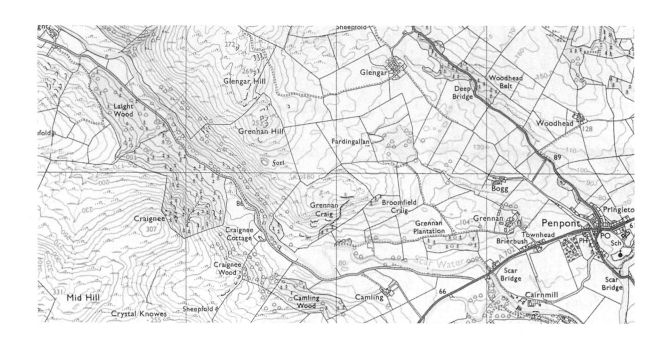

MONUMENTS

Terry Friedman

Goldsworthy's move to Penpont beside Scaur Water in Dumfriesshire in the Autumn of 1986 was a turning-point which brought with it the potential of a new and complementary way of working nature (which up to that moment had been for him to a great measure fugitive): that of making large-scale sculptures fixed permanently to the landscape. He has remarked that 'chance has always played a large part in choice of place to live. An advert for a cottage to rent seen in a local paper during a brief visit to Cumbria took me to Brough. Judith [my wife, who is also a sculptor] getting a job as a teacher at Carlisle took me to Langholm. The workshop brought me to Penpont. I do not research a place before I move there. All places have the potentials to take on meaning and a relationship develops. The common factor is that these places are my home ground ... Home is a place where ideas are gathered and understood. My work is a growing, strengthening well of understanding at the heart of which is the ephemeral work. This is the source which feeds everything else. Penpont is the home of that source ... It holds the most potential for learning. This is the place I know best ... I know what lies under the snow — I know the earth beneath — where the brightest cherry tree grows, the longest chestnut leaf stalks, where black thorns can be found'.[39]

The Scaur rises a dozen of so miles to the north-west of Penpont among spectacularly beautiful, ancient craigs, rushes down through rapids and rocky, sheep-grazing pastures past Glenwhargen, Hallscaur, Clanlockfoot, Druid Hill, Arkland and Auchenhessnane into Penpont, then twists and turns to meet the greater River Nith before venturing southward and emptying into the Solway Firth above Carlisle.[40] Goldsworthy has always favoured such remote and sparsely populated country for making small-scale temporary sculptures, and since this region shares qualities with previous working sites — Swindale Beck Wood, Helbeck Crag and Grizedale Forest in nearby Cumbria — he has continued to operate along the same lines. Permanent monumental sculptures have emerged more gradually out of the new experience.

His first Penpont works were characteristic: in September 1986 he made a continuous reed construction, cradling it gently in the delicate outer branches of an oak tree (the work surviving just long enough to be photographed).[41] In December of the same year he carved a group of slabs of frozen snow, standing them up on a wintery slope like tombstones in a graveyard.

But almost at once he became aware of Penpont's singularly special identity, recording on a sheet dated 8 January 1987 in Sketchbook 15: *This place is as if I have always been working up to coming here.* Three days earlier he had begun a series of outstanding and definitive ice works, which were made over eight consecutive days (5–12 January): *Ice star, Ice 'fish', Ice ball, Ice columns* and *Icicle points.* He has long been concerned with the potent strength of ice forms for sculpture: the first snowballs were made in 1979, at Bentham in Yorkshire, the first ice arch in 1982, at Brough in Cumbria.[42] His sketchbooks (twenty-six to date, the first begun in August 1980) — which record temporary sculptures just finished, accompanied by snappy, private observations on the daily out-of-doors operations (textual material which frequently finds its way into the poetic titles of his photographs) — reveal not only a remarkable continuity of ideas and themes in his work but an intensity of feeling for place, and in the recent sketchbooks a realisation of the extraordinary quality of Penpont.

Thus, at Helbeck in January 1985: *went to small pond below crags. — ice — thick enough to stand on — cracked — calm at first — broke ice after trying other things — it takes courage to break surface — began to stack ice — wanted to make construction — excited at getting 3 stories — then added another — and another — and another — — — Each time believing it might be last — however it was so cold the ice was freezing together making it strong enough to build tall. Turned what was a relatively uninteresting work in to something more special beautiful greyblue sky snowing* (Sketchbook 11: 15 January).

On Hampstead Heath in December 1985: *cold — frost but no ice on first ponds I came across some on viaduct pond though. thin ice — a lot already broken where dogs been in — refrozen — awkward lumps stuck to sheets — thought it would cause problems — took all day until 2.30. About $^1\!/_3$ way up thought it over ambitious &*

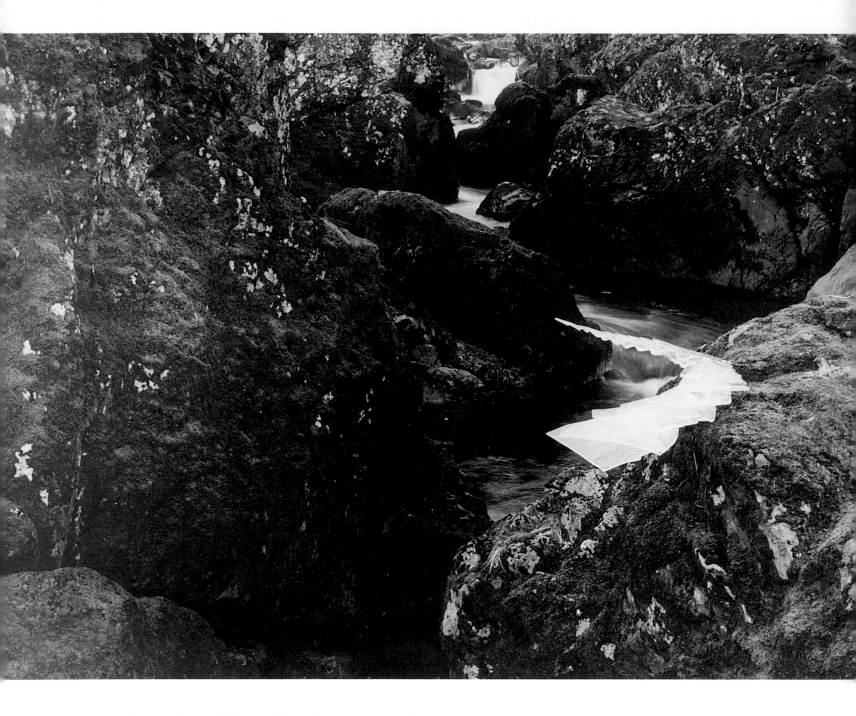

expected a collapse. *I like working that close ... It's funny — at first was unsure where to make it — but now so obvious. Looked great against viaduct arches ... tomorrow could be a brilliant sunny day. A few of what I thought were dangerous cracking noises but in fact was the noise of it freezing together — very solid work — so delicate.* He added: *Frustrating knowing that it will soon be smashed*; in fact, the ball was vandalised the following day (Sketchbook 13: 28 December 1985).

At Langholm in the eastern part of Dumfriesshire in 1986: *Decided to join one icicle to another meant breaking one so that thickness of join was about the same*; in the process the structure broke into three pieces by mistake — *Shock of break* — and only after further trials did he eventually manage to construct an ice spiral, which he regarded as *A good work. A good 2 days ... This work was only possible because of intense cold yesterday.* He realised *how much I could do in a really really cold*

144

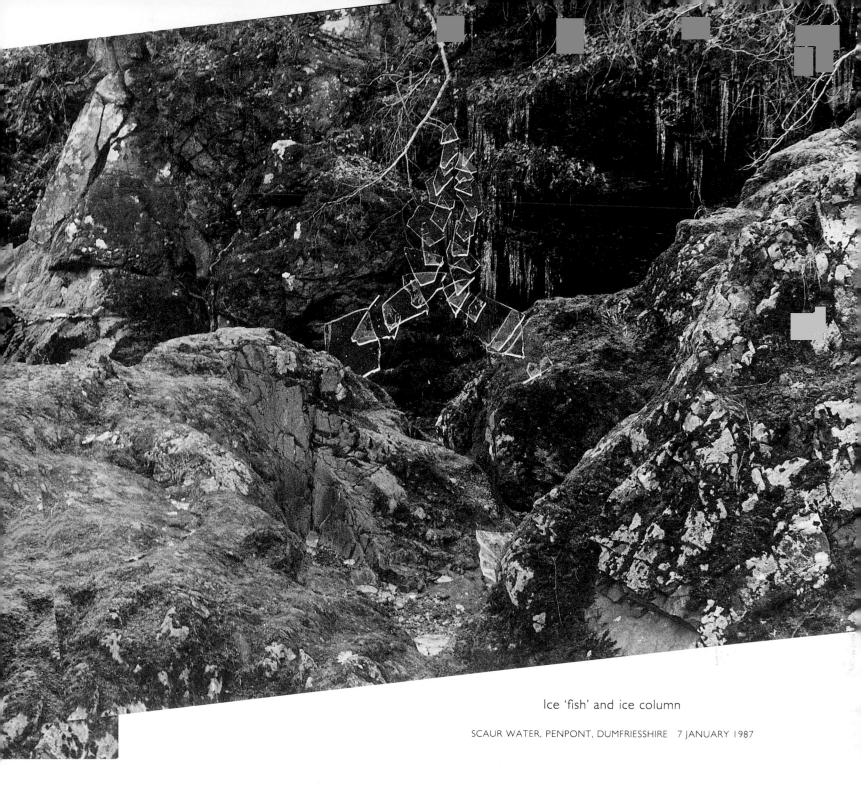

Ice 'fish' and ice column

SCAUR WATER, PENPONT, DUMFRIESSHIRE 7 JANUARY 1987

place and added that the *pressure is off now that I can move* (Sketchbook 13: 23 February) — as it happened, from Langholm to Penpont where, in the settled and confident arena offered by the 'outdoor' studios along a rugged and deeply beautiful stretch of the Scaur, these 'experiments' were finally resolved.

Though *unhappy* with the ice spiral constructed there on 5 January 1987 because it was *too showy — too obvious — imposed*, he recognised that the site was *a beautiful place for ice* (Sketchbook 15: 7 January) and the subsequent ice works were for him triumphs.

On 7 January, the *Coldest night so far — got up early — still dark — wanted to work with the cold of night — went to falls … incredible cold — ice sticking so well … so tense*. This resulted in a 'fish' made of flat, irregular, transparent sheets broken from the thinly-iced surface of the river and suspended on the edge of a moss-covered overhanging rock. At the same time and with the inten-

tion of keeping warm during the brief intervals one piece of ice froze against its neighbour, he constructed nearby a pair of *Ice columns*: vertical sheets taken for *a climb upwards — never meeting the gap between echoing the river through the falls. Intensely cold and calm — overcast. If it had been sunny the sun would have caught the columns* (Sketchbook 15).[43] The next day, 8 January — the day Andy confirmed Scaur Water's special significance for him — he made *Ice points*: two slender, horizontally confronting icicles frozen to rocks (temporarily supported by forked sticks), with tense, nearly touching tips, aptly described in an earlier version as *two icicles . . . pointing their frozen energies towards each other* (Sketchbook 8: 22 January 1983).[44] The roots of this work was a single icicle broken in two and welded with spit to either side of a rock, made at Swindale Beck Wood in 1982.[45] The final dual-arrangement was achieved at the same location but in the following year; significantly on that occasion the river's presence was overwhelming: *As I worked suddenly sound of river!! as if tide had rushed in — melted upstream & came shooting down breaking through ice as it came* (Sketchbook 8: 22 February 1983).

Finally, on 11 January 1987, a day of *Incredible cold beard freezing — river frozen for first time* (that year), the hollow *Ice ball*, and the *Ice star*. The first attempts at the *Ice star*, at Swindale Beck Wood, were unsuccessful: twice the fragile structure collapsed (Sketchbook 8: 10–11 February 1983) but at Scaur Water on 12 January 1987 the making was *Unbelievably quick — what would have taken days of cold — made in a single day — all day. This weather has been beautiful — a release of pent up feelings towards ice that have been in check by mild winters. This is a really good work one of the best* (Sketchbook 15).

The extreme beauty of the countryside and the uncommonly cold weather of that first Dumfriesshire winter have proved only part of Penpont's allure. Penpont is to be long-term. House and nearby studio (an eighteenth-century granary) have been purchased, while a few miles away a 2½ acre strip of wild woodland bordered by the steep bank of the Scaur on one side, with Laight Wood and the road on the other, which Goldsworthy has named Stone Wood, has been leased for

Swindale Beck Wood, Yorkshire

thirty-three years from the Buccleuch Estate, the local landowner. This offers the sort of protracted experience with a particular terrain which his previous peripatetic life had denied, and the chance to make a series of permanent outdoor sculptures almost for the first time. Here, through 1987–88, he built three such works in succession: *Slate stack*, *Slate hole* and *The Wall*.[46]

The middle — more modest and first built — sculpture underwent a transformation akin to some ancient and secret land ritual. A heap of earth was first covered with stones and a rowan sapling planted on top; the hole left by digging was then covered over with concentrically-placed slates to form an eliptical dome with a small hole carved into the top-most slab. The structure has been planted round with hazel which will eventually form a protective cage through which it will be possible to peer: 'Looking into a deep hole unnerves me. My concept of stability is questioned and I am made aware of the potent energies within the earth. The black is that energy made visible.'[47]

The work differs substantially from Goldsworthy's earlier earth holes made in London, Yorkshire, Cumbria

146

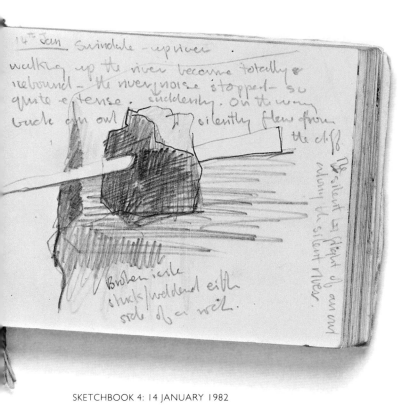

SKETCHBOOK 4: 14 JANUARY 1982

and Japan, which were ephemeral: covered by moorland grass stalks or surrounded by rowan leaves, foxglove leaves, dandelions, sticks, pebbles, frozen snow, ice. In each case the making was swift, single-dayed and often precarious, as the sketchbook entry for the Yorkshire Sculpture Park *Ice hole* reveals: *woke up about 2.00 in morning, a clear sky! half-moon — went out — cold but had problem — wanted to stick ice to stone parapet. wind causing thin ice to break off — struggled on — then had problems sticking ice against ice — the snow had made surface lumpy — not a good set — too dark to see. Half moon — worked with the moonlight. very strange intense light — but a band of clouds came over. went back to wall — collapsed again. A really bad night — finally made the ice hole — it had to come — but I am very pleased with it. Strangely I don't feel tired* (Sketchbook 16: 20 February 1987).[48]

Slate stack, by contrast, is an exclusively northern phenomena. Versions had been made at Little Langholm in Cumbria using rough quarried local stone stacked in contrasting directions to form a circle within a rectangle: *Slate — vertical and horizontal a long hard day solid almost too big to be made in one day!* (Sketchbook 19: 18

February 1988); then northward at Derwentwater, built of *good ice! about ³/₄″ thick Revisited at night in moonlight* (Sketchbook 19: 14 March 1988). Finally, the monument at Stone Wood, two weeks building in the summer of 1988 using old local roofing slates, again arranged in contrasting directions so that the shapes change with the progress of the sun or the movement of the viewer: light circle against darker wall, darker circle (seemingly an actual hole) against lighter wall. The special thinness of roofing slate allows for a more compact, intense layering which Goldsworthy has likened to drawing and, indeed, a similar effect is achieved in a recent series of large-scale, densely black-on-black graphite drawings where circle and rectangle are made manifest by the contrasting directions of the pencil strokes and the shifting fall of light. The Penpont *Slate stack* has taken on an additional potency through its intimacy with a nearby oak tree (described by Goldsworthy as 'a partnership'): the slate circle,[49] which is actually a deep cylinder integrated into the wall, reiterates the shape of the trunk, and because previously the tree had been burnt at its base and stripped of its lower limbs, the *stack* serves as a protective sentinel.[50]

The most ambitious of the Stone Wood works, a four foot high dry stone S-shaped wall with the ends open to form entrances, was constructed during winter 1988–89 by Joe Smith (an experienced waller from Crocketford near Dumfries) reusing carefully stacked stones retrieved from a nearby ancient but derelict wall. Located at one end of Stone Wood, *The Wall* was built to divide the two properties (the adjacent one being owned by a farmer), with one segment of the S overlapping on to Goldsworthy's land but accessible only from the pasture — serving as a sort of pen, its grasses kept manicured by frequent grazing; the other segment breaking into the pasture and open only from Stone Wood, its area left wild (the unexpected appearance of willow saplings superceding the sculptor's original idea of introducing a feature of his own). The elegant serpentine shape, therefore, is wholly tied to practical rather than ornamental functions.

Viewed from the top of Grenham Hill directly across the Scaur, *The Wall* possesses the powerful pres-

147

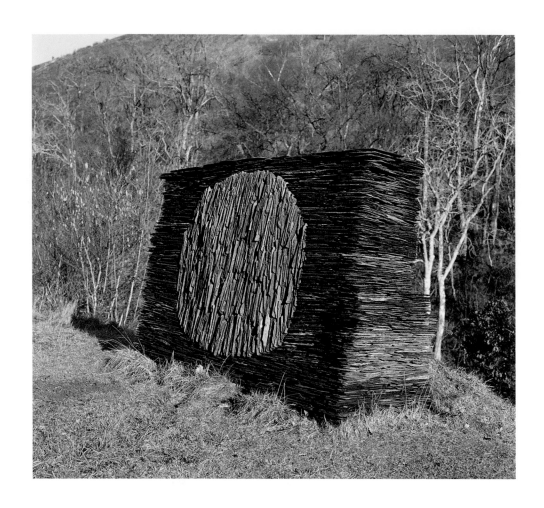

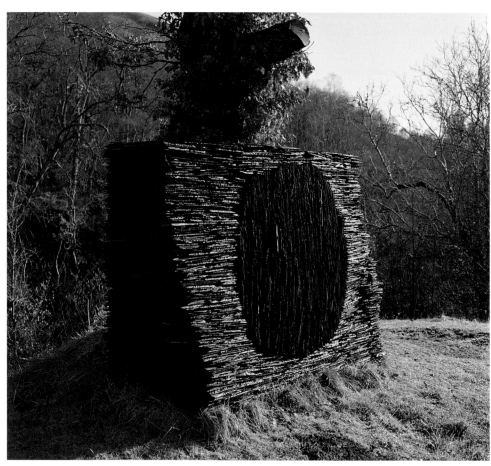

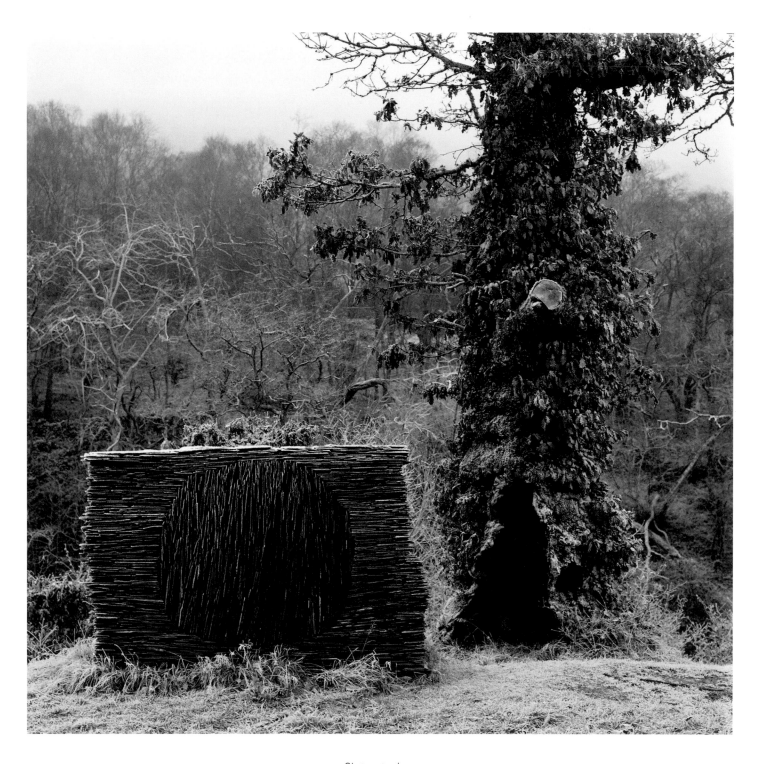

Slate stack

STONE WOOD, PENPONT, DUMFRIESSHIRE 1988

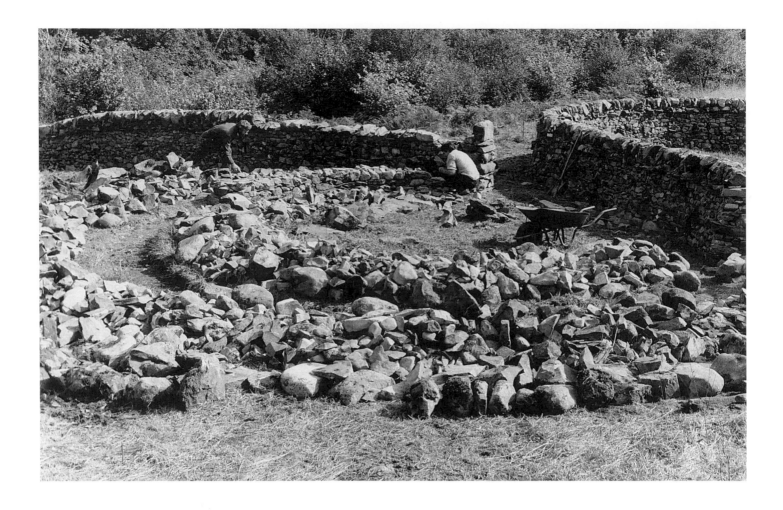

ence of some very ancient artefact. Dumfriesshire has been witness to many prehistoric settlements, hill stations, stone circles, standing stones and cairns. While Goldsworthy's art in no way pretends to imitate these early man-made structures, his progress through landscape has always involved making sculpture in close confraternity with wild and often mysterious locations: *climbed Helbeck craggs right to top — windy hail — difficult to stand or see — very beautiful came down a little made column with snow and stones* (Sketchbook 3: 28 November 1981). And he sees this sort of creative activity representing the most recent deposit in a continuous succession of human layering on the landscape:

Nature for me is the clearest path to discover — uncluttered by personalities or associations — it just is. A per- *fect lever. People like layers of leaves on a woodland floor — one generation after another — each layer adding a new level to human understanding and character* (Sketchbook 19: February 1988).[51]

I like touching stones touched many years ago Found a large plough horseshoe amongst the stone (Sketchbook 22: December 1988–17 February 1989).

In this sense, neither can his work be divorced from place: 'A rock is not independent of its surroundings. The way it sits tells how it came to be there. The energy and space around a rock are as important as the energy and space within. The weather — rain, sun, snow, hail, mist, calm — is that external space made visible. When I touch a rock, I am touching and working the space

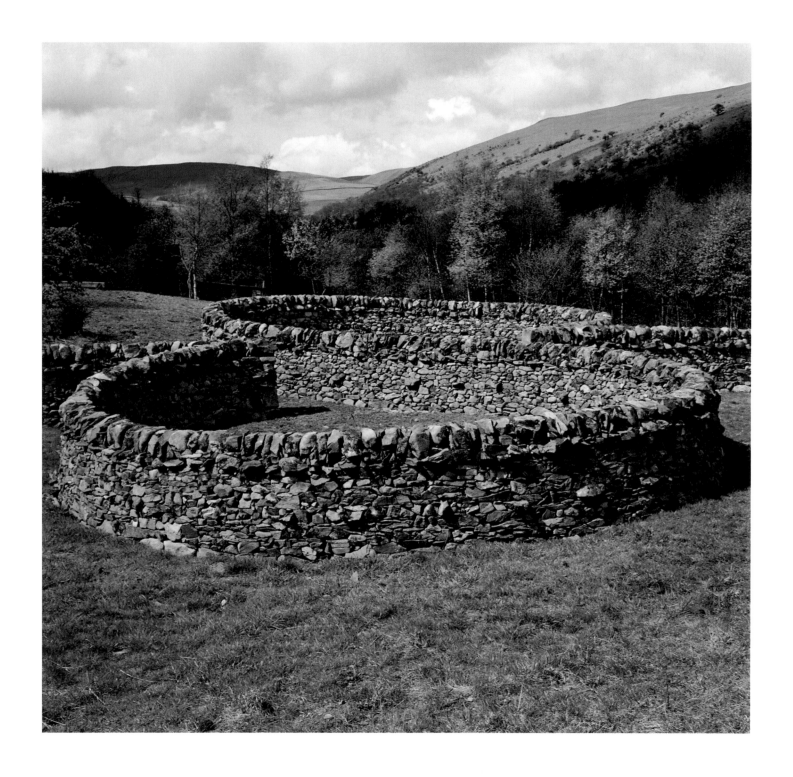

The Wall
stonework by Joe Smith

STONE WOOD, PENPONT, DUMFRIESSHIRE 1988–89

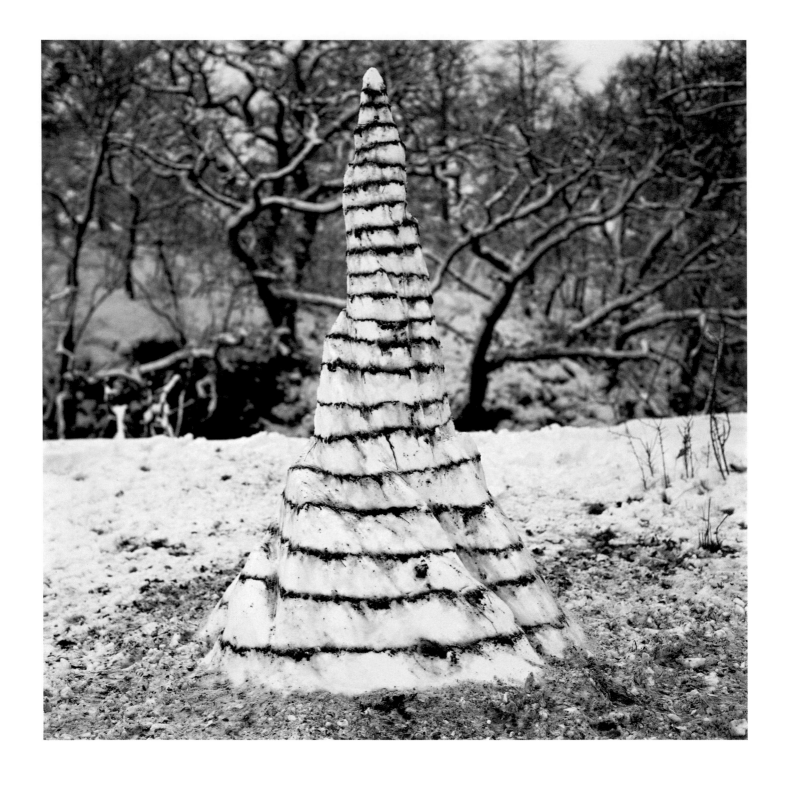

Snow and mud layers
melting during the day
freezing at night
two weeks

SCAUR WATER, PENPONT, DUMFRIESSHIRE 1987

around it. In an effort to understand why that rock is there and where it is going, I do not take it away from the area in which I found it'.[52]

On 8 March 1987, beside Scaur Water, he made a tapered column of alternating layers of snow and mud *as tall as I could reach*, finding the one material *So different after the hard, dry cold of the ice work This is a soft, wet cold*. The completed column rapidly thawed and in the process diminished and sagged, produced a *strange quality to [the] black lines* (Sketchbook 16). Eventually it melted, leaving an irregular concentric deposit of mud on the ground (which nevertheless retained a 'shadow' of the original structure), recalling in miniature some prehistoric earthwork. Indeed, this work coincidentally resembled the great ramparts of earth and fragmented stone walls of Tynron Doon (1st millennium BC–16th century AD) perched on the bald summit of a steep-sided

Stone Wood, though he had entertained such aspirations in earlier projects. Almost all these also used stone but proved short-lived and survive as photographs or sketchbook records or large-scale drawings, and more recently as studio-made stone maquettes which hint at more ambitious and enduring sculptures to come. 'The precedent for making large, more permanent works had begun in Grizedale whilst I was at Brough. What has evolved at Penpont is a need to make these works in my home place. This represents a deeper awareness of the meaning and implications of these works'.[54]

Since the earlier stone works were not meant to last, with the intention of allowing the ingredients to return to the land, their precariousness was not necessarily a source of undue concern: 'My sculpture can last for days or a few seconds — what is important for me is the experience of making. I leave all my work outside and

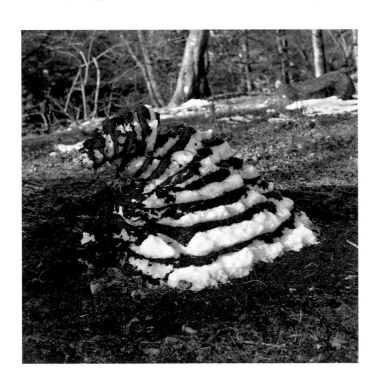

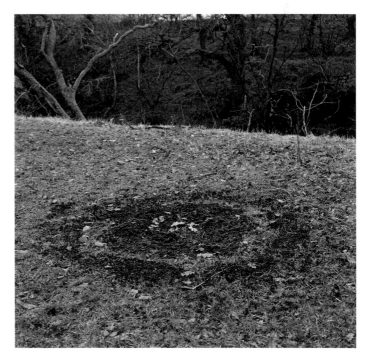

spur of Auchengibbert Hill, which overlooks Stone Wood and also dominates the north-west view from the windows of the Penpont studio, exerting a presence even when covered in mist.[53] Little wonder then that Goldsworthy's first truly permanent monuments, monoliths and serpentine sculptures in stone, were made at

often return to watch it decay'.[55] This natural cycle of growth and erosion often occupied Goldsworthy's thoughts when recording the day's achievements. For example, in Sketchbook 6, of a small and large rock column at Swindale Beck Wood: *I thought I had done well to get 12 rocks high but tried another & it stayed!*

Amazing. it is still there as I write this! (21 March 1982);
*RIVER STONES ... 3 slabs one large slab lots of
small enjoyed! Tense as I filled in cavity. Wobbled a bit
towards end* (25 September 1982); *boxed in round
stones. did three — didn't believe it could go higher — but
tried & worked! I have really enjoyed working with the
river stones it's solid yet fluid amazing combining mat-
erials* (26 September 1982); *Last one was a problem
whole thing wobbled felt at any time I would loose it all
but after much effort it stayed*, this by underpinning the
stones with slivers of rock (15 October 1982).[56]

The recent activity of monument-making has been
attended by vigorously rendered graphite drawings on
large sheets of paper worked-up in the studio. The
graphite drawings originated in Cumbria, at the same
time as the first slate stack. 'I found graphite lying on the
side of a mountain — remains of a mine. For me this was
a major discovery. I was no longer drawing with a mat-
erial bought from an art shop. I was drawing with the
mountain itself and although since then I have returned
to using refined graphite because of its blackness and
consistency, the connection with source has been made. I
am still drawing with earth'.[57] This progression pro-
duced a new, homogenous association between drawing
and sculpture which had previously hardly existed in his
work, though it is necessary to emphasise that the experi-
ence of making ultimately remains an exclusively outdoor
pursuit; with few exceptions this activity has not yielded
'gallery' pieces. Even in the case where working 'models'
are produced for mainly logistic purposes, the impact is
still heroic. *Sandstone Shelter | Staircase | Tower* of red
sandstone constructed in the studio in 1987 — which
shares features with a small spiral of broken pebbles
made at St Abbs, The Borders in 1985 and again at
Penpont in 1987 — is a version of a much larger structure
planned for a hilltop site, becoming an analogue for the
uniquely Scottish Iron Age round towers of drystone
masonry known as brochs.[58]

*In the evening went to small beach to work as the sun
went down — timing the completion of work with sun-
down — broken stones — cracked in two — not easy.
Scratched white around crack — made a sort of spiral*

*which suited this work — this is how forms such as spirals
circles balls appear — out of the making & not taken out
there to be imposed when I do that the work is stiff*
(Sketchbook 11: 1 June 1985).

Some monuments have roots in other places; for
example, the suspended stone over a hole originated at
Brough. Earlier, in 1982, at Blaenau Ffestiniog in Wales
(at the sculptor, David Nash's studio) Goldsworthy built
a simple structure comprising a pair of stacked stone
slabs rising in an inverted-V to just under six feet, which
he found *very-very difficult* because of the *strong wind*
and which *didn't hold for long* (Sketchbook 5: 16 May).
A sketchbook of the following year (No. 8: 2 May 1983)
includes two consecutive sheets recording closely related
projects for stone dolmen and cairn structures: (1) a
horizontal slab supported on four corner stones shel-
tering a ground hole (just as the Stone Wood *Slate stack*
was later to shield the blasted oak) (2) cairned-slabs sus-
pended over a hole (a variant of the Blaenau sculpture)
(3) a tepee-like structure buttressing a central slab sus-
pended over a hole, with its downward-pointed end
almost penetrating the void (4) schemes 1 and 3 com-
bined but with the dolmen repositioned as an under-
ground chamber protecting the hole. A large drawing of
1983 is a version of the third scheme developed into a
monumental and mysterious sculpture, well over life-
size: a work for the future, still to be realised.
Goldsworthy's intention is to site a sequence of monu-
ments in the Penpont region, spaced 'far enough apart so
they can be reached in a long, hard, single days run. If in
years to come a 5 monument fell run was established I
would be delighted. It would be in the tradition of the 3
peaks run. They are not called monuments in the tradi-
tional sense of the word. Not all will be permanent or
prominently sited. They are monuments to the land. *The
Wall* is a monument to walls. They are certainly not
monuments to me'.

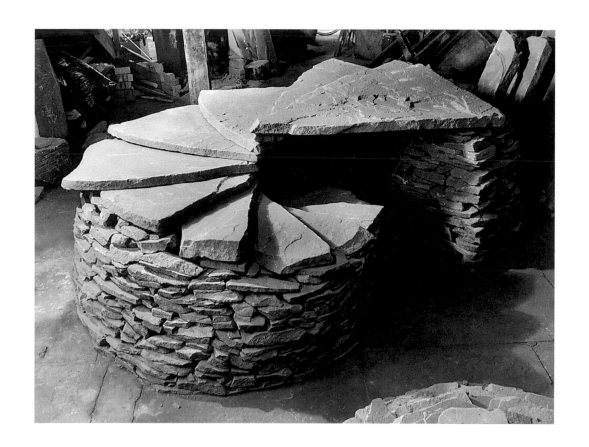

Sandstone Shelter/Staircase/Tower

PENPONT STUDIO, DUMFRIESSHIRE 1987

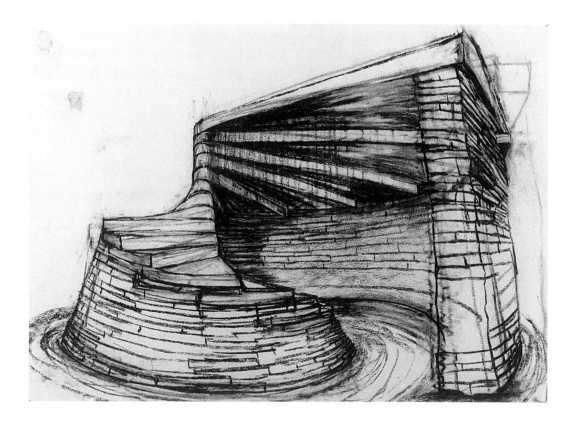

Proposal for a hilltop monument

1987

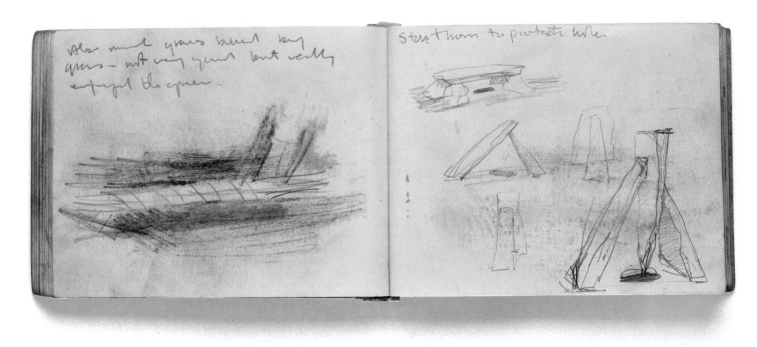

Working sketches for monuments

SKETCHBOOK 8: 2 MAY 1983

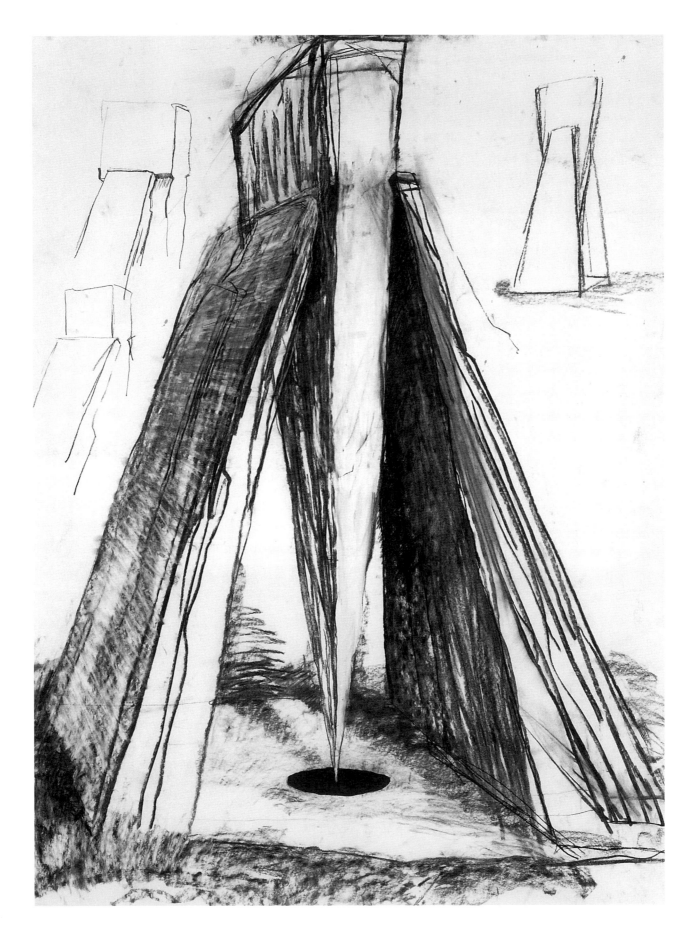

Proposal for a monument

1983

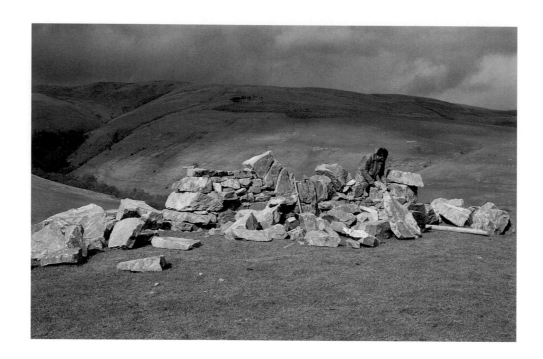

Stonework by Joe Smith

TOUCHSTONE NORTH
APRIL 1990

In February 1989, before going to the Arctic, Goldsworthy wrote:

'Work made abroad should have purpose in the place that I live. I want my experience in the Arctic to find form in my home land. A work will be made north of Penpont — a touchstone between Penpont and Pole. A landmark that will orientate north. North will be a part of its nature — possibly something that catches the north wind, or a work that casts a north shadow or a window to the north: a reminder that a stone turned in Penpont is a stone turned on the earth.'

'It feels right that when I make a work in Penpont to mark and orientate north that it should be made of stone. Snow is stone — it is a white stone. Snow is like sand, ice is like slate — snow is sand and ice is slate. I have always considered snow and ice to be one of the most ephemeral of materials that I have ever worked with, but here it has a feeling of permanence and it makes me realise how rhythms, cycles and seasons in nature are working at different speeds in different places. The earth as a whole is probably in these cycles, going through different speeds and changing. Understanding those cycles is understanding the processes of nature.'

Extract from Arctic Diary 8 April 1989,
in *Touching North Andy Goldsworthy*, 1989

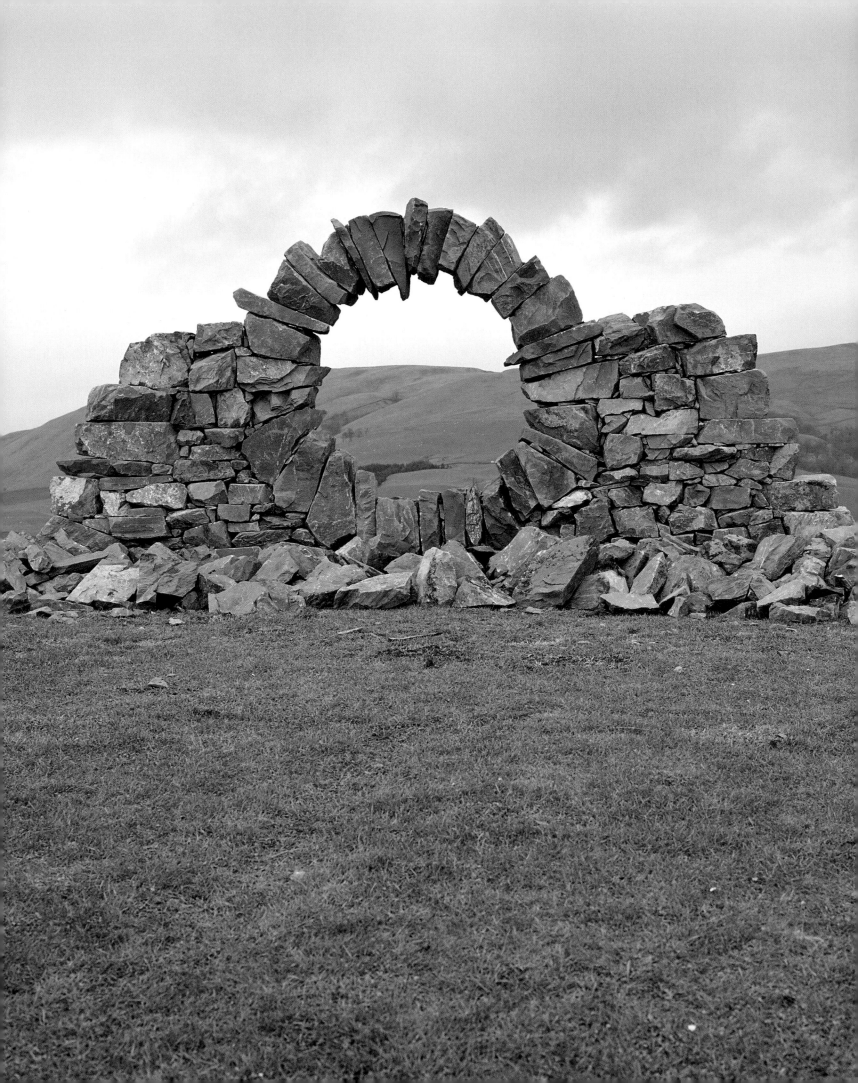

THREE CONVERSATIONS WITH
ANDY GOLDSWORTHY

John Fowles and
Andy Goldsworthy

Reprinted from *Winter Harvest*, produced by Fowles and Goldsworthy in 1987 as a unique, large, handmade table book and toured by The Scottish Arts Council to public galleries and libraries in Scotland.

When the Scottish Arts Council approached me with the idea of introducing this table-book, I leapt at the notion, since I had long been impressed by what I knew of Andy Goldsworthy's strange and subtle art. I supposed at first that this would entail an orthodox critical appreciation, full of long words and learned placing. This was before I sought the help of Andy himself, and had his answers. He told me at the time, by way of self-excuse, that 'I suffer when I write'. He may suffer, but I differ from him over the value of the results; I could offer nothing their equal in the orthodox line. What follows is therefore the artist and his beliefs, in his own words. I hope it will allow you to 'feel' him, and partly in the way that he feels nature, the earth, so sensitively himself.

Andy would in any case be difficult to place in terms of today's fashionable art movements. He is sui generis, *of his own kind alone. I would rather put him with a much older tradition in our culture, that of the nature mystic — if it were not that that suggests a dreamy remoteness from actual life. As you will see, the real and the practical are essential elements of his work. The end-product may sometimes seem casual and spontaneous, but it is very seldom so in fact. Not only the handling difficulties of his chosen material (nature itself) but his philosophy make that impossible.*

Andy, born in 1956, began taking his own road very early in adult life, from the moment he entered art college at Bradford. He met no serious opposition, either parental or from his teachers, but very soon discovered he was happier living on a farm than in a college studio. Of what opposition he did meet in student days, he says succinctly, 'They were wrong and I was wrong'. Since then, and his eventual degree in fine arts, he has achieved increasing recognition

for his work; its uniqueness is now widely appreciated, its genius for expressing complex and deep relationships both in and with nature. Andy has very recently moved with his wife to Scotland. He refuses to guess the future, but all augurs well.

Above all I hope viewers of this book will realise, however much they may — like most of us — associate 'art' with pencils and brushes and more conventional 'pictures', that they are here seeing the earth through the sensibility of one of the most gifted and intelligent young artists of our time. I have great sympathy for many of his views on both art and nature; but I first admired his work simply because it made me look at familiar things with fresh eyes. That is the rarest gift, in any period of art.

JF Much of your work is, like much of nature itself, very short-lived and transient by normal artistic standards. Does this worry you at all?

AG Working with nature means working on nature's terms. I cannot stop the rain falling or a stream running. If I did it would no longer be raining and the stream would dry up. Movement, change, light, growth and decay are the life-blood of nature, the energies that I try to tap through my work. I want to get under the surface. When I work with a leaf, rock, stick, it is not just that material in itself, it is an opening into the processes of life within and around it. When I leave it, these processes continue. At its most successful my 'touch' looks into the heart of nature: most days I don't even get close. These things are all part of the transient process that I cannot understand unless my touch is also transient — only so is the cycle unbroken, the process complete. I cannot explain the importance to me of being part of a place, its seasons and changes. Ten years ago I made a line of stones in Morecambe Bay. It is still there, buried under the sand, unseen. All my work still exists, in some form.

I have now worked with nature out of doors for about twelve years, a trail of work that marks my progress through

life and gives me a deep sense of satisfaction and an appetite for the future. In sum, my work is a growing body of feeling towards and understanding of the earth.

Of course there are opposites and conflicts in my work; uncomfortable but creative tensions, which I use to sharpen my relationship with nature. I refuse to resolve them prematurely, to make my own position easier. Discomfort is a sign of change. Every so often I feel as birds must before their first migration — a gut instinct that something is wrong where they are, a strong sense they must now go where they have never been before. The one contradiction I won't tolerate is having an art that binds me. Occasionally I work at extremes, forcing myself into a corner to provoke a reaction.

I once made too many ball shapes. That form obsessed me. Finally I made one with the last bit of snow high up on the moor, and brought it down into the valley with the intention of watching it slowly melt. Carrying a heavy, wet snowball a long way is hard work. I put it in a wood, then decided to go home and come back later. Just as I left I saw a passing man go out of his way to kick it down a gully into a stream. Something in me snapped.

The next day I made a work with a mixture of spring debris — bluebells, the pink cases of sycamore leaves . . . flat, against the ground, intimate, tiny, formless. I worked in that way for the next nine months, yet purposely avoided showing photographs of it. (You can expect only two or three works in such a period to be 'good'.) But what an important nine months that was for me!

Nowadays my work in response to places and materials is freer. The main source of tension is between the large-scale commissions and my day-to-day work. I keep the approaches to both kinds of work distinct. It feels sometimes like being two artists, arguing with each other.

JF Then reputation, how your work stands up against the past, is not a primary concern?

AG I have never been too concerned about measuring my work against the art of the past. It began in response to far more personally important issues: what to do with my life, my nature, the earth's nature. I felt an increasing concern for environmental issues, and a disillusionment with the kind of art I was then producing. I had to discover my own nature, and then a work process that would use my nature like a tool. Up until that time (my first year at art college) I had gone against my own grain. My art was literary and symbolic — a dumping-ground for half-

understood ideas. They'd have been simpler, more effective and honest, if they'd been written.

I'm not an artist born full of things I want to express. I'm empty, hungry, wanting to know more. That's my true self; and my art is a way of learning, in which instincts guide best. It is also very physical — I need the shock of touch, the resistance of place, materials and weather, the earth as my source. It is a collaboration, a meeting-point between my own and earth's nature. These are my personal reasons, not to be confused with my attitude in general towards art. I have never been against permanence in a work of art — far from it. Neither am I against the symbolic.

JF Do you have any strong specific political or religious feelings?

AG No, though I am sympathetic towards the Green Movement, ecological concern. I belong to no church.

JF You usually work on small or comparatively small scales — what do you feel about that, and gigantism in contemporary art?

AG I need to make on a wide range of scales, reflecting what I find in nature. I see my work growing both smaller and larger. Working small with grasses or leaves is a strain. A sudden gust, a hungry robin, even a worm can cause a work's collapse. I enjoy these delicate tensions; but it causes an occasional need to work large, physically hard. It functions both ways. One scale releases energy, and makes me more sensitive to the other.

I dislike gigantism for its own sake, but small works must grow into large. By this I don't mean a coarse scaling-up, but a maturing and development of forms and feelings — often in only one material, or rediscovered in another, changing during process. This is not planned, it happens over years.

For me, scale is usually determined by material and place. My largest works have come from commissions. They remain close to my basic feelings towards nature, but the way of making opens new ground. Obviously the people who commission me have to be taken into account as well as materials and place. In these larger works I usually have four or five people helping me.

JF Do you enjoy that: working with others, communally . . . working in public?

AG Such works are a meeting-point between earth and human nature; social events, social landmarks. Issues, personalities, problems and tensions are inevitable in this kind

of work, and drawn into it. For me they are an exploration of the two kinds of nature. But central to my art is the work done by myself. This is my source, where I get my energy. All my private work-places are public in the sense that I have to deal with farmers, land-owners, gamekeepers, walkers and so on, but I don't really enjoy making in public. I just recognize it as important for me to do it, from time to time.

JF How do you set about one of your works?

AG Looking, touching, material, place, making, the form and resulting work are integral — difficult to say where one stops and another begins. Place is found by walking, direction determined by weather and season. I am a hunter, I take the opportunities each day offers — if it is snowing, I work with snow, at leaf-fall it will be with leaves, a blown-over tree becomes a source of twigs and branches. I stop at a place or pick up a material by feeling that there is something to be discovered. Here is where I can learn. I might have walked past or worked there many previous times. There are places I return to over and over again, going deeper. A relationship with a place is made in layers over a long time. Staying in one place makes me more aware of change.

I might give up after a while. My perception of a place is often so frustratingly limited. The best of my work, sometimes the result of much struggle when made, appears so obvious that it is incredible I didn't see it before. It was there all the time.

My approach to larger, more permanent work is much more long-term. There is a process of familiarization with site through drawings that explore the site or space. This is the only time I use drawing to work through ideas; for me it represents a change in approach — a new way to work with nature. I often live with a site at the back of my mind for months — sometimes years. A target for energies and ideas. I also keep a sketchbook diary.

JF I was interested in the one you showed me, with its emphasis on humble, very elemental aspects of things. Are you in any sense a keen natural historian, an expert botanist or ornithologist?

AG No, I am not interested in categorising nature, the scientific approach. I have the countryman's basic general knowledge of it.

JF Could you give me an impression of what you would count a good day, in your own terms?

AG One at Loughborough, last September. I began working in an open grass field. An overcast grey sky. Tall, light dry grass stalks. I wove, drew stalks together in 'stooks', twisted at the top. Bent-over stalks reflecting the light — working the light. I made several touches, but the wind got stronger. I left it for another day.

I went to a pond, first time I have worked there. Found a beautiful dark, sheltered corner, overhanging trees dropping leaves, floating. Struggled for about an hour, trying things out, trying to work the pond surface, floating out leaves, but I didn't want something that hid the pond. I tore holes in leaves, pond showing through, horse chestnut leaves. I tore every other section, leaf, water, leaf; dark, light, dark, light . . . arrows — work taking on form and direction, determined by the negative and positive lines of the leaves. I saw unlooked-for qualities: muddy pond bottom, thick with black rotting leaves. Wading stirred up black clouds surrounding the work.

That was a good day, in which each touch led to the next. Mistakes were as important as successes. Most of the time I didn't know where I was going, it was always potentially a really bad day. Leaves across the pond became a way of exploring pond, place, season . . . even first working out in the open grass space was necessary, making me aware of the dark enclosed pond space. The resulting work stretched for about eight feet, pointing out from the dark corner.

During the next few days I revisited the pond, made other work there. I had pinned the occasional leaf with thorns to sticks in the pond bottom. Each leaf was stitched to another with a stalk or thorn. It lasted for the week I was there, changing, sinking with the water level. Gradually disappearing under other fallen leaves.

JF If I had any criticism of your work, it would be that the shapes are sometimes a little too consciously geometric. Doesn't this seem to contradict nature?

AG My approach to the earth began as a reaction against geometry. I used to think it an arrogance imposed upon nature, and still do. But I've also realised that it is arrogance to think man invented geometry. As regards my own work I'd like to think geometry has appeared in it to the same degree I have found it in nature.

All my work concentrates on a particular aspect of material or place. The grass stalk is hard, brittle, hollow and fractures at angles; the seed-head is supple, thin, strong, whippy. It takes many works to come to some understanding of 'stalk', let alone 'grass'; it will take many more. Should I ignore the fractures in grass stalks made by the

wind? All forms are to be found in nature. There are so many qualities within any material. By exploring them I hope to understand the whole. My work should include the loose and disordered as well as the tight and regular, within the nature of the material.

Having said all this I am always suspicious of geometry, cautious in using it. This last year saw my first use of the spiral. It's taken me a long time to come to terms with this form, so evident in nature. I still avoid the overblown spiral. I prefer that of the unfolding fern, which gives the impression of endless growth, or of the simple ammonite in stone.

JF What of the future?

AG Solutions to problems can be found only by doing and making. My work comes first, reasons for it follow. Any statement about the future must allow for freedom to develop and change. Any statements I made would only say how I would like things to happen. That is all. How things will be is what I shall make.

JF Most art critics I have read like what you are doing. How about ordinary people?

AG The most rewarding thing ever said to me was by a Dutch woman of a shape I had carved in sand. She said 'Thank you for showing me that was there'. That is what my work does for me myself, the discovering 'what was there'. If it does it for others, then so much the richer.

Fumio Nanjo and Andy Goldsworthy

An interview held at Kiinagashima-cho, Mie prefecture, 9 December 1987, reprinted, by kind permission of the authors, from *Andy Goldsworthy Mountain and Coast Autumn into Winter Japan 1987,* 1988.

FN What were your first impressions working with nature in Japan?

AG Working here has made me realise how British, or European my work has been in its basic approaches and in the ground rules which I have for working with nature. I have an understanding of the British landscape which allows ideas to flow quickly and I can work relatively fast as I know how to work the materials, but when I first came to Japan I found that I was working very slowly: it took most of the day to make one leaf-patch for example. On the first day I found ferns which I wanted to work with on the ground, but whereas an English wood floor has open, muddy spaces which I could press the leaves into, in Japan there was a lot of resistance: it was all stone and there was no earth. Then I decided to bend the ferns and looked for thorns, but there were no thorns! Everywhere I've worked in the past, in every country, there has been a thorn tree within a hundred yards, and this lack of fundamental materials made me aware of the enormous amount of control I had over my work in Britain.

FN Despite this, however, you have already made a great deal of work in a very short period.

AG Because I kept at it: when I'm faced with a problem like that it doesn't mean that the place is wrong or I must move, it just means that I must change, which is important and something I enjoy. I realised that here is a situation where I have got to change as an artist, as a person, to cope with the landscape. It takes a long time to build up a working relationship with a place, but I knew that there would be ways in, or keys to Japanese nature and those are what I look for.

For instance, the Japanese maple, when you see it from a distance, in the woods, or even from a few yards away, has a fantastic colour, a beautiful colour, but when you get up close it's gone. The colour is like a rainbow: elusive and always in the distance, partly because of the concentration of the leaf, but particularly because of the light. I could feel the colour and had to discover a way of unlocking it, of activating it, and I found that water was the way to bring the leaf to life. So, I started to work on the waterfalls, or laying the leaves in the water to bring out the colour. You wouldn't believe the effect of picking up a maple leaf that looks a little dull and then dropping it in the water where the colour becomes so intense. I began to understand the maple leaf through water, but that's only one way in, all materials have a way in to discovering their nature.

Similarly here, in Kiinagashima-cho, I got to the beach on the first day, looked around and there were lots of small, grey pebbles and I wondered what I could do. This is a difficult place and I was really quite worried; even in Britain the beaches are quite colourful with all shapes and sizes of rock. However, there was a fantastic view with the moun-

tains receding in layers, giving a very distinct sense of distance and space. So I found the bamboo and made a work which used the view: I put in a screen to see through, working with the mountains in the distance. That first day I felt I touched the heart of the place and that was incredible, getting so soon to something I felt was very important to this place.

FN What do you mean by the 'heart' of the place?

AG Not just the scenery, but the essence of the place, what makes it. In some places, like the mountains, it's all close to, concerned with what's in my hands, in the river or pool: very intimate and often very small, and I can feel closed in by nature. Here it's expansive, the islands define distance: misty, blue, just flat.

FN Is there no scenery like that in Scotland?

AG To a degree, but I can't think of a place where you can look across the sea onto so many mountains. I've worked in the Lake District where there is a similar sort of feel, but nothing as intense as here.

FN There is a tradition of incorporating the vista of distant mountains into the design of a garden called 'Shakkei'.

AG That's what I've done with the 'Woven Bamboo/ Hole' in the way it isolates and concentrates your view on what's in the hole. It wasn't just the view that made it though: on the beach there was a big ridge at the high water line which gave an abrupt start to the sea. It was very inviting to put things on as everything was in strongly defined layers.

FN Like a stage set?

AG Exactly, because I worked right on the edge of the beach, it created a kind of second horizon as well as the one in the distance, so I could bring the two places together in my work. I felt I had understood the place, I had learned.

FN Why and how did you start working with nature?

AG Because of days like that when I understand a place. I was less concerned with whether it was Art and how it fitted into the context of Art, more with what I wanted my art to do for me as a person. I have an art that teaches me very important things about nature, my nature, the land and my relationship to it. I don't mean that I learn in an academic sense; like getting a book and learning the names of plants, but something through which I try to understand the processes of growth and decay, of life in nature. Although it is often a practical and physical art, it is also an intensely spiritual affair that I have with nature: a relationship.

FN When you are walking in nature don't you feel that you are looking at it in terms of how you can use it?

AG It is very important that I have a direction: that's the difference between just going out for a walk and actually making something. For me it means that I have to look and work a lot harder: as I'm using all my senses, my perception has to be that much more acute. It is an accumulative, growing process. I have to continue searching for new forms, new ways of looking at nature, new ways of understanding, and this gives my relationship with nature a greater energy, a greater vigour.

FN It could be said that art and nature are at opposite poles; how would you react to that?

AG I am part of nature, I don't see myself as being in opposition, and I think it's a strange idea to see us as separate from nature. Our lives and what we do affect nature so closely that we cannot be separate from it.

FN But art is man-made, always touched and changed; isn't it against nature?

AG It is the way of nature to be used, worked and touched. All of nature here has been touched; the Japanese landscape by centuries of rice cultivation, these mountains by plantation and forestry, all are in some way affected, and my art doesn't hide the fact. We all touch nature and we are a part of this process of interaction and change, we rely on each other. This is a good thing if it's done well, with respect, and I celebrate this in my art: the act of touching and the way the landscape changes.

FN So, this is the big question: what is art for you?

AG What is art?

FN Are you conscious of creating art, or are you just making something which others call art?

AG I've been asked that all my life and I don't really care. I would defend what I do in terms of whether it is important and necessary for me as a person. These are questions of life rather than questions of art, which can lead to very long and academic discussions that tend to get a little bit away from life, and I've always tried to keep my definitions within the parameters of life.

FN There are certain landscape traditions in Britain; do you feel that your art can be linked to them?

AG It's too easy to say that, because the English landscape tradition comes out of our feelings towards nature not just in art, but in farming, in the way we have made parks, and it's like a way of life. You can't just isolate the art from a whole way of life, a way of seeing nature. Constable and

Turner's feelings towards nature are very much a part of ours, because they were feeding off the same source. It's the same when people see the work I've made here as very Japanese. We have talked about things I've felt about the Japanese landscape and you mentioned that they have been used here, in temple gardens for instance. That is because we are feeding from the same source, and the fact that we have come up with the same solutions to the landscape means that the solutions are right. I like it when that happens.

It would have been difficult for me to have made the things I've described had I been sight-seeing, or visited the gardens you mentioned. I wanted to discover the Japanese landscape for myself, to come here with clear eyes.

Terry Friedman and Andy Goldsworthy

An interview first broadcast on *The Third Ear*, BBC Radio, 30 June 1989.[59]

TF Andy Goldsworthy is fast becoming one of the most interesting and persuasive advocates for sculpture made in and with the landscape rather than in the studio. He was born in 1956 in Cheshire and grew up in Yorkshire, and now in his early thirties he lives with his wife, who is also a sculptor, and their son, in a Dumfriesshire village at the foot of the Scottish lowlands. His rapport with nature is a delicate and beautiful one, sometimes almost painfully so; but it is in no way tentative because he has recognised the strengths inherent in natural objects and uses them to striking effect: an icicle broken in two and welded to a rock with spit. A line of poppy petals seven feet long pressed end to end and hung vertically from a tree, a sculpture which lasts only until blown away by the early morning breeze. So the sculptures are made permanent by recording them as photographs which the artist takes himself and presents in large format, and these become the work of art. He often works under strenuous conditions, in isolated, harsh, wintry country, and he has just spent four weeks making sculptures in an Inuit Indian village of the high Arctic islands of the North-West territories of Canada, and then spent three days working on the North Pole. Andy Goldsworthy, why did you go there?

AG North has always held a fascination for me. It is a strong element in the landscape. For me going North was following feelings that I have discovered in working with snow and ice in the places where I live, and I wanted to follow North to its source. I wanted to go to the place that generated the cold that made winter. It was a way of understanding where I live. North made visible in the snow and ice of winter, but also the north side of a mountain is different to the south side. There is a 'northness' about that. Winter for me has always been, when I first started working outside, a test; a kind of test of my commitment to the landscape: whether I could manage to work all year round, and I wanted to work all year round because I wanted to have a complete understanding of the landscape, and that meant seeing it not only on the sunny, nice days but also the wet, snowy, cold days. Not only have I managed to work through the winter, but I find I need it; I need the stimulus of winter. I can't explain to you the first snowfall — the effect, the excitement of that snowfall, and going out and working with it. And the dark earth turning white: that was a very potent lesson for me. There is something there that is fundamental to the way the earth works. And it was following these feelings that the Arctic project originated.

TF On the Pole you constructed four, over life-size, upright circles using blocks of snow and then positioned them to form a large square area. This is, I think, the most formal piece of sculpture you have ever made. How did this come about?

AG It's a formality that I think was a response to the regular rhythm of the sun going round at the same height — the sun never went down, never went up, just stayed in the same place and just circled. There was this very strong sense of a circular motion. That was the strongest indication that you were at the North Pole. So the work had to be equal on all sides to work the equal light conditions up there. I have never used that before — the light for me has been always changing from whichever direction it has come from. So the formality, I think, came out of that. I also wanted to enclose an area up there so you felt you were at the centre of something, which you are up there at the North; and where all points from that place face south. To make a work that made you aware of looking out of and looking towards somewhere. These were the qualities that I was trying to work into the piece.

TF *In fact, when you stand in the middle of this square surrounded by the four great circles, whichever way, you are still looking south. This is an extraordinary phenomena which only happens on the North Pole.*

AG Yes. There was a strong sense of being at the North Pole which I didn't really expect. I was surprised by that, and the sun was the biggest indication of that.

TF *When you arrive at a spot, how do you begin the process of making a work?*

AG When I arrived at Grise Fiord I started working immediately. There was no acclimatising before I started work. There was no resting. I wanted all those problems to be worked out as I worked and to try and resolve those problems in work. Coming to terms with the cold: I wanted to do that whilst I was working and making things so that pieces become an expression of that. The best way I can come to terms with a new place is through my work; so I don't really know what I am going to make until I arrive. There are exceptions and the North Pole is one, to some extent. I like to go open-eyed and until I actually get there I don't know what I will make because I don't know what the materials are like. As soon as I stood on the snow I realised it was hard and I realised I could work with it, but until that moment I had no idea. It could have been very soft, powdery snow and that would have produced a very different work.

TF *The sort of snow you are used to working in Scotland or Japan?*

AG No. The snow that I am used to working with is a wet snow. The Arctic is very dry, the hardness is brought about by the wind, not by the wet snow that is frozen. So it is a totally different snow to what I have ever experienced before.

TF *So the process is very intuitive — on the spot. What part does drawing play in the creative process, or is it merely a record?*

AG I keep a diary, which is very important. I make a short, quick drawing of the work. But I began to look at, and feel about, some of the snow-works as drawings. The walls of snow that we made were like sheets of paper that I worked into each day. They were blank walls of snow. It is difficult to put drawing into a small category in my work. I have drawn lines on the sand and in snow.

TF *How did your interest in nature begin? Did it start when you were a child?*

AG The things I remember most in my childhood are those that are related to messing about in woods and such like. But I began working outside in the first year of my degree at Lancaster. I became very disillusioned with working inside; it didn't seem important. There is no meaning in that. Whereas when I began working outside I learnt about the weather, the materials. And through touching the materials and working the materials I think I get an understanding of those materials that you can only do through touch. And I understand snow and leaves and feathers and mud and sticks and stones a little bit like the way a carpenter will understand wood, because he's worked with it.

TF *You were a farm labourer when you were young. That must have opened up all sorts of possibilities.*

AG Working on the farm for me was far more important than art college. It gave me an understanding of how to work the land. How you can effect the land. And it gave me an ability to work physically quite hard and not to be afraid of often working on a large scale. It also made me very angry about the way industrial farmers abuse the land. So it did many things — from the techniques of walling, hedge-laying, sheep-shearing, all those kind of things, to driving tractors.

TF *I suppose that ecology is quite an important aspect of your thinking.*

AG I work outside. I want to take responsibility for what I take from the land. I think that makes me more aware of how I affect the land and I have a lot of sympathy for those issues. But I have a very personal approach; it is not in a political sense. For me ecological issues are very creative ones. I have found this a very exciting time to live, in a way, because we are reassessing our relationship to the land. For me it is not just doom and gloom; it is also a sort of celebration. It is a time when we can find a very personal way of establishing a relationship with the land.

TF *In 1988/89 you made a series of sculptures using various leaves in the garden of a museum in the South of France [Centre d'Art Contemporain, Castres]. Now, I find these works over-delicate, and you once said that sometimes a work is at its best when most threatened by the weather. Do you feel you work more successfully in hostile and cold environments?*

AG The works in France were made in this tiny garden in the middle of this small town surrounded by buildings and traffic; and in that garden I found such wilderness. On the surface it was probably one of the most difficult environments in which to work. It was a very small area. So that

was a challenge. But I feel a strong commitment to find richness in what appears to be very humble places. And in that garden, the first day I worked, there was this brilliant, intense sun. In the South of France the light is beautiful. When I first arrived there it was hazy and a little bit dull and it rained heavily; and the atmosphere cleared and there was a brilliant clarity in the light. And I had to work that light in a relatively dark situation where there were tall buildings around. And I found that the light hit certain trees two or three times a day. That garden had a kind of natural clock to it that regulated how I worked. And I began to hang leaves from these trees to catch the light, to work the light. I would get there before the sun had even got up and work in the cool, dark morning. I'd hang the work on the tree and wait, and then the sun would gradually come round and activate these leaves. And it was fantastic to see that happening. And then the sun would pass over them and then the work would be finished. So for me it was an extraordinary situation and in its way as extraordinary as going to the Arctic. I wouldn't like to think that I have to go to places like the Arctic to find extraordinary things. In many ways my trip to the Arctic emphasised my commitment to the small and the local. I went to the Arctic to follow and pursue things that I had felt very strongly in Scotland. I don't need to have these exotic trips. I am not an artist that can only work in that way. I like to have a wider view of the world that the trips give me, the places that I have worked in Japan and France: I have strong feeling of those within me, and I like to think of the trees I have worked there. But I think of them when I am working with a tree in Penpont. It gives me a feeling that a stone turned in Penpont is a stone turned on the world. I think that is very important to me.

TF Do you find that colour is an important aspect of your work when you move from continent to continent. I mean: is Japanese colour and nature different from English colour and nature?

AG When you first arrive at a place your perception of that place is very new. Your eyes are fresh in the way that sometimes you have a freshness at first seeing a place. When I arrived in the Arctic the thing that struck me most strongly was how deep blue the snow was. This thick blue. And any snow that was lifted up off the plain of snow was this brilliant white, by comparison. And that initial discovery dictated a lot of the work that I made there. And sometimes after being there for a long time I began to think of the snow as white again. Everybody thinks the snow is white, or the

grass is green, and that conception of colour sometimes blinds us to what that colour really is. And sometimes I have to kind of shake my eyes up and look again and realise it isn't white — it is many colours. Colour is very important and the colour in the Arctic is the sky. So I am working with the sky. When I work with the land I work with the sky. When I work with water I am working with the clouds. The colour in the Arctic is a kind of atmospheric colour. It is different to colour, say, in Japan, where the colour is embodied in the leaves, in the mountains. On the coast there was this atmospheric colour that I worked with, but that colour — red, the red of the Japanese maple — that colour held for me the spirit of that place. Understanding the colour was understanding that place. And touching that colour is what I try to do in my work, and touching something as elusive as colour is very difficult. When I saw those red trees up in the mountains and I walked up to them, by the time I reached them the colour had gone. It disappeared because the colour viewed from down in the valley I was seeing as a concentration of leaves lit up from behind by the sun, and it had gone. So I had to try and find that colour and I discovered that colour by putting the leaves in water. That was the key to discovering the energy of those leaves — the energy of that red. For me when I make a good piece of work it is like touching a rainbow, and try touching a rainbow — it moves, it is always moving, it is always elusive. Working in the Arctic in that cold it became a constant — it was like being able to touch a rainbow all the time.

TF So, are you saying that the atmosphere in Japan produced a particular type of work for you and the atmosphere in the Arctic produced a different sort of work? Is it the atmosphere that is the key to what is produced in your sculpture?

AG The atmosphere of any place produces a specific work. When I say atmosphere I think I mean many things, but in talking about the space that a material occupies, that space is made visible by the weather, the light; and it is that space that I am trying to understand. I am not just trying to understand a rock as if it has been delivered to my studio. I have to understand why it is there and the time it has spent there, the way it has effected that place. It is a window into processes that have gone on and around that rock, or leaf or stick. Those are the things I am trying to learn about. That is why I work with the materials in the place where they have come from — at their source. When I work with a leaf I am working with the sun and the rain and the growth of

The entries are arranged numerically 1–228, by date of work; each can include the following information:

Title or description of work

Location

Date

Edition

Number of frames

Number of photographs

Dimensions of photograph or photographs (centimetres/inches; height before width)*

Dimensions of frame

Secondary frame, with text (for example, no. 39)

Dimensions of frame

Bibliographical references to illustrations (abbreviated in chronological order, with full references in Bibliography, pp. 189–95). In *Parkland 1988*, *Mountain and Coast 1988*, *Garden Mountain 1989* and *Viking 1990*, photographs on unpaginated pages, some with variant titles, are identifiable by location and/or date.

Collection (public or corporate only)

*Because there may be variations in the sizes of the photographs and frames in the edition, the sizes given may not necessarily be those of the particular work in the cited collection.

1977

1

Five stones, about 4–5 feet high
SCAFELL PIKE, CUMBRIA
MAY 1977

1 frame
1 black and white photograph
49.6 × 33 (19½ × 13)
framed 76 × 56 (29⅞ × 22)
Hanson 1982 p. 110; *Leeds 1990* p. 22

2
Stone in hole
ILKLEY MOOR, YORKSHIRE
JUNE 1977

1 frame
1 Cibachrome photograph
24.2 × 16.2 (9½ × 6⅜)
framed 51.5 × 41.5 (20¼ × 16⅜)

3
Woodpigeon wing feathers | partly buried | laid around hole
LEEDS, YORKSHIRE
AUGUST 1977

1 frame
1 Cibachrome photograph
24.2 × 16.2 (9½ × 6⅜)
framed 51.6 × 41.5 (20¼ × 16⅜)
Rain 1985 p. 37; *Viking 1990*

4
Hole in sand
ABERSOCH, NORTH WALES
AUGUST 1977

1 frame
1 Cibachrome photograph
24.2 × 16.2 (9½ × 6⅜)
framed 51.6 × 41.5 (20¼ × 16⅜)

5
Sycamore leaves
LEEDS, YORKSHIRE
SEPTEMBER 1977

1 frame
1 Cibachrome photograph
16.5 × 24.1 (6½ × 9½)
framed 39 × 46 (15⅜ × 18⅛)
Mabey 1984 p. 81; *Rain 1985* p. 38; *Viking 1990*

6
Foxglove leaves | split down centre vein | laid around hole
HAREWOOD FOREST
NEAR LEEDS, YORKSHIRE
OCTOBER 1977

1 frame
1 Cibachrome photograph
24.2 × 16.2 (9½ × 6⅜)
framed 51.7 × 41.5 (20⅜ × 16⅜)
Rain 1985 p. 21; *Andreae 1987*
The Arts Council of Great Britain

7
Wet feathers | white wrapped around black
MORECAMBE BAY, LANCASHIRE
OCTOBER 1977

1 frame
1 Cibachrome photograph
18.5 × 16.5 (7¼ × 6½)
framed 46.3 × 41.5 (18¼ × 16⅜)

1978

8
Broken stones | scratched white
MORECAMBE BAY, LANCASHIRE
JANUARY 1978

1 frame
1 Cibachrome photograph
40.7 × 28 (16 × 11)
framed 65 × 49 (25⅝ × 19¼)
Beardsley 1984 p. 52; *Rain 1985* p. 36;
Towneley 1988 p. 28; *Viking 1990*

9
Icicle stack | about 8 inches in length
MORECAMBE BAY, LANCASHIRE
FEBRUARY 1978

1 frame
1 Cibachrome photograph
16.2 × 24.2 (6⅝ × 9½)
framed 44 × 49 (17⅜ × 19¼)
The Arts Council of Great Britain

10
Moss hole
ILKLEY MOOR, YORKSHIRE
MARCH 1978

1 frame
1 Cibachrome photograph
24.2 × 16.2 (9½ × 6⅜)
framed 51.6 × 41.5 (20¼ × 16⅜)
Newcastle Polytechnic Permanent Collection

11
Dock leaf bits
MORECAMBE, LANCASHIRE
1978

1 frame
1 Cibachrome photograph
16.5 × 24 (6½ × 9½)
framed 44 × 49 (17¼ × 19¼)
Leeds 1990 p. 102

12
Part stripped sycamore twigs
ILKLEY MOOR, YORKSHIRE
APRIL 1978

1 frame
1 Cibachrome photograph

24.1 × 16.5 (9½ × 6½)
framed 50.8 × 40.6 (20 × 16)
Causey 1980
The Arts Council of Great Britain

13
Reconstructed stone, about 1 foot high
**MORECAMBE BAY, LANCASHIRE
MAY 1978**

1 frame
1 Cibachrome photograph
16.2 × 24.2 (6⅜ × 9½)
framed 44 × 49.1 (17⅜ × 19⅜)

14
Balanced rocks
**MORECAMBE BAY, LANCASHIRE
MAY 1978**

1 frame
1 Cibachrome photograph
40.5 × 51 (16 × 20⅛)
framed 57.5 × 83 (22⅝ × 32⅝)
Hanson 1982 p. 108, *Leeds 1990* p. 10
The Arts Council of Great Britain; The British
Council; Carlisle Museum and Art Gallery

15
Four pieces of damp seaweed on a dry rock
**ABERSOCH, NORTH WALES
AUGUST 1978**

1 frame
1 Cibachrome photograph
24.1 × 16.5 (9½ × 6½)
framed 50.8 × 40.6 (20 × 16)
Causey 1980
The Arts Council of Great Britain

16
Oak leaves in holes
**ILKLEY MOOR, YORKSHIRE
1978**

1 frame
1 Cibachrome photograph
16 × 23 (6¼ × 9)
framed 39 × 46 (15⅜ × 18⅛)
Viking 1990
The Arts Council of Great Britain; Common
Ground, London

17
Elm leaves
**ILKLEY MOOR, YORKSHIRE
1978**

1 frame
1 Cibachrome photograph
24.2 × 16.2 (9½ × 6⅜)
framed 51.6 × 41.5 (20¼ × 16⅜)
Leeds 1990 p. 103

18
Rowan berries in grass
**ILKLEY, YORKSHIRE
SEPTEMBER 1978**

1 frame
1 Cibachrome photograph
14.9 × 11.4 (5⅞ × 4½)
framed 41.3 × 36.5 (16¼ × 14⅜)

19
Two forked branches and twig
**ILKLEY MOOR, YORKSHIRE
SEPTEMBER 1978**

1 frame
1 Cibachrome photograph
16.5 × 24 (6½ × 9½)
framed 44 × 49 (17¼ × 19¼)
The Arts Council of Great Britain

20
Forked branch and twig
**ILKLEY MOOR, YORKSHIRE
SEPTEMBER 1978**

1 frame
1 Cibachrome photograph
24.2 × 16.2 (9½ × 6⅜)
framed 51.7 × 41.5 (20⅜ × 16⅜)
Causey 1980
The Arts Council of Great Britain

21
Woven sticks
**ILKLEY MOOR, YORKSHIRE
SEPTEMBER 1978**

1 frame
1 Cibachrome photograph
16.5 × 24 (6½ × 9½)
framed 44 × 49 (17¼ × 19¼)

22
Balanced rock | about 2½ feet in height
**MORECAMBE BAY, LANCASHIRE
NOVEMBER 1978**

1 frame
1 Cibachrome photograph
24 × 16.5 (9½ × 6½)
framed 51.5 × 41.5 (20¼ × 16⅜)

1979

23
Snowball made from last remaining patch of
snow | left in the shadow of a tall hedge
**HIGH BENTHAM, YORKSHIRE
1979**

1 frame
1 Cibachrome photograph
24.5 × 38.2 (9⅝ × 15)
framed 58 × 69 (22⅞ × 27⅛)
Causey 1980 cover; *Rain 1985* p. 22; *Passes
1986* p. 39
The Arts Council of Great Britain

24
Snowball covered with mud | placed on
heavily frosted frozen pond | covered over
any footprints
**HIGH BENTHAM, YORKSHIRE
1979**

1 frame
1 Cibachrome photograph
24.5 × 38.2 (9⅝ × 15)
framed 58 × 69 (22⅞ × 27⅛)
Rain 1985 p. 23
The Arts Council of Great Britain

25
Brown icicles
**ILKLEY MOOR, YORKSHIRE
JANUARY 1979**

1 frame
1 Cibachrome photograph
16.5 × 24.1 (6½ × 9½)
framed 40.6 × 50.8 (16 × 20)
The Arts Council of Great Britain

26
Mud on ice
**HIGH BENTHAM, NORTH YORKSHIRE
FEBRUARY 1979**

1 frame
1 Cibachrome photograph
25.5 × 39.5 (10 × 15½)
framed 58.1 × 68.9 (22⅞ × 27⅛)

27
Forked sticks in water
**HIGH BENTHAM, NORTH YORKSHIRE
MARCH 1979**

1 frame
1 Cibachrome photograph
31.7 × 48.2 (12½ × 19)
framed 58.4 × 72.4 (23 × 28½)
The Arts Council of Great Britain

28
Small, earth lined hole in snow
**BENTHAM, NORTH YORKSHIRE
MARCH 1979**

1 frame
1 Cibachrome photograph
24.2 × 16.2 (9½ × 6⅝)
framed 51.7 × 41.5 (20⅜ × 16⅜)
The Arts Council of Great Britain

29
Twigs
**HIGH BENTHAM, NORTH YORKSHIRE
MAY 1979**

1 frame
1 Cibachrome photograph
33 × 48.2 (13 × 19)
framed 69.8 × 81.3 (27½ × 32)
The Arts Council of Great Britain

30
Grass stalks
**HIGH BENTHAM, YORKSHIRE
MAY 1979**

1 frame
1 Cibachrome photograph
24.2 × 16.2 (9½ × 6⅝)
framed 51.7 × 41.5 (20⅜ × 16⅜)
Causey 1980
The Arts Council of Great Britain

31
Balanced rock | misty, calm
**ROSSETT GHYLL, LANGDALE, CUMBRIA
JUNE 1979**

(not May 1977 as stated in *Viking*)
1 frame
1 Cibachrome photograph

25.5×39.5 ($10 \times 15\frac{1}{2}$)
framed 67.5×81.8 ($26\frac{1}{2} \times 32\frac{1}{4}$)
Viking 1990
Carlisle Museum and Art Gallery

32

Part scratched white slate
**ABERSOCH, NORTH WALES
AUGUST 1979**

1 frame
1 Cibachrome photograph
24.2×16.2 ($9\frac{1}{2} \times 6\frac{5}{8}$)
framed 51.6×41.5 ($20\frac{1}{4} \times 16\frac{3}{8}$)

33

Stones in water
**BENTHAM, NORTH YORKSHIRE
DECEMBER 1979**

1 frame
1 Cibachrome photograph
33×49.6 ($13 \times 19\frac{1}{2}$)
framed 68.8×82.4 ($27\frac{1}{4} \times 32\frac{3}{8}$)

1980

34

Grass stalk line through trees | thin end of
one pushed up wider hollow end of another
**BENTHAM, YORKSHIRE
JANUARY 1980**

1 frame
1 Cibachrome photograph
33×49.6 ($13 \times 19\frac{1}{2}$)
framed 58.4×72.4 ($23 \times 28\frac{1}{2}$)

35

Clapham hole
**CLAPHAM, YORKSHIRE
JANUARY 1980**

1 frame
1 Cibachrome photograph
34.3×48.2 ($13\frac{1}{2} \times 19$)
framed 71.1×83.8 (28×33)
Viking 1990

36

Grass stalk ends | thin end of one pushed up
wider hollow end of another
**BENTHAM, YORKSHIRE
JANUARY 1980**

1 frame
1 Cibachrome photograph
49.6×33 ($19\frac{1}{2} \times 13$)
framed 76×56 ($29\frac{7}{8} \times 22$)

37

Snowball in trees
**LOW BENTHAM, LANCASHIRE
FEBRUARY 1980**

1 frame
1 Cibachrome photograph
40.5×51 ($16 \times 20\frac{1}{8}$)
framed 74×83 ($29\frac{1}{8} \times 32\frac{5}{8}$)
Beardsley 1984 back end-papers; *Mabey 1984*
p. 82; *Cork 1985*; *Dobson 1986* p. 30; *Khan 1986*

p. 13; *Dobson 1987*; *Towneley 1988* p. 19;
Archibald February 1988; *Viking 1990*
The British Council

38

Hole in snow | lined with peat
**INGLEBOROUGH, YORKSHIRE
FEBRUARY 1980**

1 frame
1 Cibachrome photograph
49.6×33 ($19\frac{1}{2} \times 13$)
framed 76×56 ($29\frac{7}{8} \times 22$)

39

Stone stack
**BLAENAU FFESTINIOG, NORTH WALES
JUNE 1980**

1 frame
1 Cibachrome photograph
25.5×39.5 ($10 \times 15\frac{1}{2}$)
or 1 black and white photograph
33×49.6 ($13 \times 19\frac{1}{2}$)
framed 58.1×68.9 or 58.4×72.4
($22\frac{7}{8} \times 27\frac{1}{8}$ or $23 \times 28\frac{1}{2}$)

Re-presented in 1989
Primary frame:
1 Cibachrome photograph
60×91 ($23\frac{5}{8} \times 35\frac{7}{8}$)
framed 96.5×124.5 (38×49)
Secondary frame:
Text, location, artist's name, date only
framed 22×32 ($8\frac{5}{8} \times 12\frac{5}{8}$)
Viking 1990

40

Reed knot
**ILKLEY MOOR, YORKSHIRE
JULY 1980**

1 frame
1 Cibachrome photograph
24.2×16.2 ($9\frac{1}{2} \times 6\frac{5}{8}$)
framed 51.7×41.5 ($20\frac{3}{8} \times 16\frac{3}{8}$)

41

Hazel stick throws
**BANKS, CUMBRIA
10 JULY 1980**

Edition of 3
Individual photographs have been sold from one
copy of the edition
1 frame
9 black and white photographs
each 12.7×20.3 (5×8)
framed 25.4×213.3 (10×84)

Re-represented in 1988
3 primary frames:
each containing 3 black and white photographs
each 39×49.2 ($15\frac{3}{8} \times 19\frac{3}{8}$)
framed 73.5×196.5 ($27\frac{7}{8} \times 77\frac{3}{8}$)
Secondary frame:
Text, location, artist's name, date only
framed 22×32 ($8\frac{5}{8} \times 12\frac{5}{8}$)
Beardsley 1984 p. 53; *Rain 1985* p. 16;
Leeds 1990 pp. 44–45
LYC Museum and Art Gallery, Banks, Cumbria

42

Torn leaves | held to ground with a small
ball of mud
(sometimes called: Cracked line
through leaves)
**MIDDLETON WOODS, ILKLEY, YORKSHIRE
27 OCTOBER 1980**

1 frame
1 Cibachrome photograph
27×18.7 ($10\frac{5}{8} \times 7\frac{3}{8}$)
2 Cibachrome photographs
each 26×39.4 ($10\frac{1}{4} \times 15\frac{1}{2}$)
joined 27×74 ($10\frac{5}{8} \times 29\frac{1}{8}$)
framed 59.4×128.3 ($23\frac{3}{8} \times 50\frac{1}{2}$)
National Westminster Tower Art Collection

43

Dark elm patch
**MIDDLETON WOODS, ILKLEY, YORKSHIRE
4 NOVEMBER 1980**

1 frame
2 Cibachrome photographs
39×29 and 39×26
($15\frac{3}{8} \times 11\frac{3}{8}$ and $15\frac{3}{8} \times 10\frac{1}{4}$)
framed 74×92 ($29\frac{1}{8} \times 36\frac{1}{4}$)
St Martin's College, Lancaster
(this copy includes one photograph from nos. 43,
45 and 46 in one frame)

44

Moorland grass stalks over a woodland hole |
wind blew stalks into hole | had to fish them
out with a twig | knocked others in | forced to
start again
**MIDDLETON WOODS, YORKSHIRE
6 NOVEMBER 1980**

2 frames
Primary frame:
1 Cibachrome photograph
91×60.5 ($35\frac{7}{8} \times 23\frac{3}{4}$)
framed 127×94 (50×37)
Secondary frame:
Text, location, artist's name, date only
22×32 ($8\frac{5}{8} \times 12\frac{5}{8}$)
Rain 1985 p. 43; *Iizawa 1988* p. 46

45

Leaf patches | edges made by finding leaves
the same size | tearing one in two | spitting
underneath and pressing flat on to another
**MIDDLETON WOODS, ILKLEY, YORKSHIRE
YELLOW PATCH (ELM)
6 NOVEMBER 1980**

1 frame
2 Cibachrome photographs
39×29 and 39×26
($15\frac{3}{8} \times 11\frac{3}{8}$ and $15\frac{3}{8} \times 10\frac{1}{4}$)
framed 74×92 ($29\frac{1}{8} \times 36\frac{1}{4}$)
Rain 1985 p. 59; *Viking 1990*
St Martin's College, Lancaster
(see no. 43)

46

Leaf patches | edges made by finding leaves
the same size | tearing one in two | spitting
underneath and pressing flat on to another

MIDDLETON WOODS, ILKLEY, YORKSHIRE
GREEN PATCH (ELM)
7 NOVEMBER 1980

1 frame
2 Cibachrome photographs
39 × 29 and 39 × 26
(15⅜ × 11⅜ and 15⅜ × 10¼)
framed 74 × 92 (29⅛ × 36¼)
Rain 1985 p. 58; *Viking 1990*
St Martin's College, Lancaster
(see no. 43)

47

ROBERT HALL WOOD, LOW BENTHAM,
LANCASHIRE
1980

Unique
2 frames
2 Cibachrome photographs
each 185.5 × 124 (73 × 48⅞)
each framed 198 × 136.5 (78 × 53¾)
Camoflage 1988

1981

48

Oak leaves
MIDDLETON WOODS, ILKLEY, YORKSHIRE
JANUARY 1981

1 frame
2 Cibachrome photographs
each 39.5 × 25.5 (15½ × 10)
framed 61 × 81.3 (24 × 32)

49

Sycamore stick placed on snow | heavy
overnight rain | thaw | stripped bark from
stick following day
MIDDLETON WOODS, ILKLEY, YORKSHIRE
16–17 JANUARY 1981

1 frame
2 Cibachrome photographs
each 27.9 × 38.1 (11 × 15)
framed 63.5 × 116.8 (25 × 46)
Stathakos 1986 p. 11; *Viking 1990*

50

Sycamore leaf, found on cow dung —
peeled off and placed on dry, light leaves
NORTH YORKSHIRE
MARCH 1980

Sycamore leaf, bleached with age —
placed on roughed up damp leaves
WEST YORKSHIRE
30 JANUARY 1981

1 frame
2 Cibachrome photographs
each 24.1 × 19 (9½ × 7½)
framed 51.4 × 73.6 (20¼ × 29)
One work from the edition has been divided and
the two photographs sold separately
Viking 1990
The British Council

51

Leaf patches | edges made by finding leaves
the same size | tearing one in two | spitting
underneath and pressing flat on to another
MIDDLETON WOODS, ILKLEY, YORKSHIRE
WHITE PATCH (SYCAMORE)
9 FEBRUARY 1981

1 frame
2 Cibachrome photographs
39 × 29 and 39 × 26
(15⅜ × 11⅜ and 15⅜ × 10¼)
framed 74 × 92 (29⅛ × 36¼)
Rain 1985 p. 59; *Viking 1990*

52

Rainbow making | bright windy sunny days |
hitting the water with a large stick
ILKLEY MOOR, YORKSHIRE
28 OCTOBER 1980
RIVER WHARFE, YORKSHIRE
13 NOVEMBER 1980 (2)
RIVER WHARFE, YORKSHIRE
23 DECEMBER 1980
RIVER LUNE, LANCASHIRE
APRIL 1981

Edition of 3
1 frame
5 Cibachrome photographs
each 10.2 × 15.2 (4 × 6)
framed 40.6 × 114.3 (16 × 45)

Re-represented in 1988
4 primary frames:
each containing 3 Cibachrome photographs
each 31 × 46.7 (12¼ × 18⅜)
framed 65.3 × 191 (25¾ × 75⅛)
Secondary frame:
Text, locations, artist's name, dates only
framed 22 × 32 (8⅝ × 12⅝)
Rain 1985 p. 17; *Leeds 1990* pp. 50–51

53

Cracked line through rocks
(sometimes called: Crack line through
stones)
RIVER WHARFE, YORKSHIRE
5 APRIL 1981

1 frame
2 black and white photographs
each 27.9 × 40.3 (11 × 15⅞)
joined 28.6 × 76.2 (11¼ × 30)
1 black and white photograph
27.9 × 18.4 (11 × 7½)
framed 59.4 × 130.2 (23⅜ × 51¼)
National Westminster Tower Art Collection

54

Damp patch | river water on stones
ILKLEY, YORKSHIRE
APRIL 1981

1 frame
3 black and white photographs
each 19 × 25 (7½ × 9⅞)
framed 48.5 × 103.5 (19½ × 40¾)

55

Wood floor debris, Spring
ILKLEY, YORKSHIRE
1 MAY 1981

1 frame
2 Cibachrome photographs
24 × 16 and 16 × 24
(9½ × 6¼ and 6¼ × 9½)
framed 36 × 64 (14⅛ × 25¼)

56

Crow and seagull feathers | things pocketed
on the way | wood floor debris
MIDDLETON WOODS, ILKLEY, YORKSHIRE
4 AUGUST 1981

1 frame
2 Cibachrome photographs
each 16.2 × 24.2 (6⅝ × 9½)
framed 33 × 78.7 (13 × 31)

57

Wood | floor debris | Summer
ILKLEY, YORKSHIRE
9 AUGUST 1981

1 frame
2 Cibachrome photographs
each 16.5 × 22.8 (6½ × 9)
framed 33 × 78.7 (13 × 31)

58

Line to follow colour changes in ground
elder leaves
SWINDALE BECK WOOD, CUMBRIA
1 SEPTEMBER 1981

1 frame
2 Cibachrome photographs
each 39.5 × 25.5 (15½ × 10)
framed 64.8 × 83.8 (25½ × 33)
Viking 1990
Carlisle Museum and Art Gallery
(this copy incorporates one photograph from each
of nos. 58, 59, 60 and 62 in one frame); Leeds City
Art Galleries (this copy incorporates one
photograph from each of nos. 58, 59, 60 and 62,
and two others from no. 71, in one frame)

59

Line to follow colour changes in rosebay
willowherb leaves
SWINDALE BECK WOOD, CUMBRIA
25 SEPTEMBER 1981

(not October 1982 as stated in *Rain* and *Viking*)
1 frame
2 Cibachrome photographs
each 39.5 × 25.5 (15½ × 10)
framed 64.8 × 83.8 (25½ × 33)
Rain 1985 p. 55; *Steele 1988* pp. 8–9; *Viking 1990*
Carlisle Museum and Art Gallery (see no. 58);
Leeds City Art Galleries (see no. 58)

60

Line to follow colour changes in beech leaves
TOWARDS SWINDALE BECK WOOD, CUMBRIA
27 SEPTEMBER 1981

1 frame
2 Cibachrome photographs
38.1 × 26.7 and 26.7 × 38.1
(15 × 10½ and 10½ × 15)
framed 71.1 × 101.6 (28 × 40)
Carlisle Museum and Art Gallery (see no. 58);
Leeds City Art Galleries (see no. 58)

61

Trench | about two paces in length | cold damp earth | edged with grass stalks | revisited and photographed one week later

SWINDALE BECK WOOD, CUMBRIA
6 NOVEMBER 1981

1 frame
3 Cibachrome photographs
each 20 × 36.5 (7⅞ × 14⅜)
2 Cibachrome photographs
each 25.7 × 39 (10⅛ × 15⅜)
joined 29.5 × 69.5 (11⅝ × 27⅜)
framed 64 × 174 (25¼ × 68½)
Hanson 1982 p. 260; *Rain 1985* pp. 7–10;
Iizawa 1988 p. 47 bottom
Carlisle Museum and Art Gallery

62

Line to follow colour changes in elm leaves

BROUGH, CUMBRIA
12 NOVEMBER 1981

1 frame
2 Cibachrome photographs
each 39.5 × 25.5 (15½ × 10)
framed 64.8 × 83.8 (25½ × 33)
Carlisle Museum and Art Gallery (see no. 58);
Leeds City Art Galleries (see no. 58)

63

Ragwort and nettle stalks | thin end of one stuck up wider hollow end of another | wide ends joined with short thin piece | thin ends joined short thick piece | freezing cold day, calm | froze solid and remained for several days

BROUGH, CUMBRIA
15 DECEMBER 1981

1 frame
2 Cibachrome photographs
24.4 × 38.5 and 24.4 × 34
(9⅝ × 15⅛ and 9⅝ × 13⅜)
joined 25.9 × 66.1 (10⅛ × 26)
framed 63.5 × 100.3 (25 × 39½)
Rain 1985 pp. 12–13
Carlisle Museum and Art Gallery

1982

64

Icicle broken in two | frozen welded to a rock with spit and sucked icicles | freezing cold day | made in the shadow of a steep cliff face

SWINDALE BECK WOOD, CUMBRIA
14 JANUARY 1982

1 frame
2 Cibachrome photographs
each 25.4 × 38.1 (10 × 15)
framed 75.8 × 62.5 (29⅞ × 24⅝)
Hanson 1982 p. 106; *Rain 1985* p. 11
Carlisle Museum and Art Gallery

65

Grass stalks and damp elm leaves | torn down centre vein to make edge | about 21 inches in overall length | calm, heavily overcast day — a few dangerous showers

BROUGH, CUMBRIA
19 JANUARY 1982

Re-visited and photographed a week later

1 frame
1 Cibachrome photograph
37 × 24.6 (14½ × 9⅝)
2 Cibachrome photographs
each 24.6 × 37 (9⅝ × 14½)
framed 59 × 132 (23¼ × 52)
Hanson 1982 p. 107
Carlisle Museum and Art Gallery

66

Feathers plucked from dead heron | cut with sharp stone | stripped down one side | about three-and-a-half feet overall length | made over three calm days | cold mornings | frost | smell from heron becoming more pungent as each day warmed up

SWINDALE BECK WOOD, CUMBRIA
24–26 FEBRUARY 1982

1 frame
3 Cibachrome photographs
each 35.5 × 22.5 (14 × 8⅞)
2 Cibachrome photographs
each 25.7 × 39 (10⅛ × 15⅜)
joined 29.5 × 69.5 (11⅝ × 27⅜)
framed 64 × 174 (25¼ × 68½)
Beardsley 1984 p. 52; *Rain 1985* pp. 39–41;
Buchanan 1988 p. 77; *Viking 1990*
Carlisle Museum and Art Gallery

67

Rocks covered with mud | edged with split lengths of hogweed

BROUGH, CUMBRIA
7 MARCH 1982

1 frame
2 Cibachrome photographs
39.9 × 25.5 and 25.5 × 39.5
(15½ × 10 and 10 × 15½)
framed 57.3 × 90.4 (22½ × 35⅝)
Carlisle Museum and Art Gallery

68

Balanced column | calm | largest rock on top | soon collapsed

BROUGH, CUMBRIA
9 APRIL 1982

1 frame
1 Cibachrome photograph
39.5 × 25.5 (15½ × 10)
framed 65.1 × 48.9 (25⅝ × 19¼)

69

Feathers | plucked from shot crows | stripped down one side | held to the ground with thin slivers of bracken stalks

SWINDALE BECK WOOD, CUMBRIA
23 APRIL 1982

1 frame
2 Cibachrome photographs
each 38.1 × 25.4 (15 × 10)
framed 59.7 × 83.8 (23½ × 33)

70

Heavy slate arch | fourth attempt | two days trying | began to rain as I finished

BLAENAU FFESTINIOG, NORTH WALES
18 MAY 1982

(not September 1982 as stated in *Viking*)
1 frame
3 Cibachrome photographs
each 25.5 × 39.5 (10 × 15½)
framed 58.4 × 166.4 (23 × 65½)
Viking 1990
Presented to Harrogate Art Gallery
by The Contemporary Art Society

71

Line to follow colour changes in coltsfoot leaves

BROUGH, CUMBRIA
11 JULY 1982

1 frame
2 Cibachrome photographs
each 38.1 × 25.4 (15 × 10)
framed 64.8 × 83.8 (25½ × 33)
Rain 1985 p. 54
Leeds City Art Galleries (see no. 58)

72

Bracken fronds stripped down one side | pegged to the ground with thorns

SWINDALE BECK WOOD, CUMBRIA
5 SEPTEMBER 1982

1 frame
2 Cibachrome photographs
38.1 × 25.4 and 25.4 × 38.1
(15 × 10 and 10 × 15)
framed 63.5 × 94 (25 × 37)
Mabey 1984 p. 80; *Rain 1985* p. 35; *Sutton 1989*
p. 182

73

River stones supported by hazel sticks | collapsed several times | the last four or five stones being the most awkward | made across a path at the entrance to a glade

SWINDALE BECK WOOD, CUMBRIA
13 SEPTEMBER 1982

1 frame
2 Cibachrome photographs
each 25.4 × 39.4 (10 × 15½)
joined 25.4 × 78.8 (10 × 31)
framed 58.4 × 104.1 (23 × 41)
Rain 1985 p. 19
Newcastle Polytechnic Permanent Collection

74

Balanced river stones

SWINDALE BECK WOOD, CUMBRIA
24 SEPTEMBER 1982

1 frame
2 Cibachrome photographs
26.6 × 36.8 and 36.8 × 26.6
(10½ × 14½ and 14½ × 10½)
framed 61 × 86.3 (24 × 34)
Cumberland 1984; *Rain 1985* p. 48 top;
Viking 1990

75

Balanced river stones

SWINDALE BECK WOOD, CUMBRIA
15 OCTOBER 1982

1 frame
2 Cibachrome photographs
38.1 × 25.4 and 25.4 × 38.1
(15 × 10 and 10 × 15)
framed 61 × 86.3 (24 × 34)
Rain 1985 p. 48 bottom; *Steele 1988* p. 9

76
Stacked ice
BROUGH, CUMBRIA
15 NOVEMBER 1982

1 frame
1 Cibachrome photograph
33 × 48.2 (13 × 19)
framed 66 × 78.7 (26 × 31)
Mabey 1984 p. 82; *May 1987* pp. 38–39

77
Ice arch | left to freeze overnight | before
removing supporting pile of stones | (made
in a field of cows — a tense wait) pissed on
stones too frozen to come out | fourth attempt
successful | other three arches collapsed
or melted
BROUGH, CUMBRIA
1–2 DECEMBER 1982

1 frame
2 Cibachrome photographs
each 25.5 × 39.5 (10 × 15½)
framed 52 × 109 (20½ × 42⅞)
Mabey 1984 p. 81; *Rain 1985* p. 25; *City Limits*
1985 p. 69; *Burns 1986*; *Stathatos 1986* p. 10;
Earthlife 1986 contents; *Viking 1990*
Harrogate Art Gallery; Leeds City Art Galleries

1983

78
Shallow pond | frozen over with thin ice |
broke and removed a section | used pieces
with pointed ends, held upright in muddy
pond bottom | calm
HELBECK, CUMBRIA
23 JANUARY 1983

1 frame
2 Cibachrome photographs
49.6 × 33 and 33 × 49.6
(19½ × 13 and 13 × 19½)
framed 64 × 107 (25⅛ × 42⅛)
Rain 1985 pp. 46–47; *Oliver 1986* p. 5;
Buchanan 1988 p. 76
The British Council

79
Five standing stacks of sticks and branches
HELBECK, CUMBRIA
27 FEBRUARY–11 MARCH 1983

1 frame
1 Cibachrome photograph
33 × 48 (13 × 18⅞)
2 Cibachrome photographs
32 × 47 and 32 × 41
(12⅝ × 18½ and 12⅝ × 16⅛)
joined 35 × 88 (13¾ × 34⅝)
framed 61 × 170.2 (24 × 67)
Viking 1990

80
Line drawn in sand with a stick | early
morning | before sun appeared
ABERSOCH, NORTH WALES
14 AUGUST 1983

1 frame
2 Cibachrome photographs
each 31.7 × 45.5 (12½ × 17⅞)
joined 36 × 90 (14⅛ × 35⅜)
framed 64 × 114.5 (25⅛ × 45⅛)
Rain 1985 pp. 56–57

81
Sand brought to an edge to catch the early
morning light
ABERSOCH, NORTH WALES
14 AUGUST 1983

1 frame
3 Cibachrome photographs
49.6 × 33, 33 × 49.6, 33 × 49.6
(19½ × 13, 13 × 19½, 13 × 19½)
framed 63.7 × 164 (25⅛ × 64½)
Rain 1985 pp. 60–61

82
River stones scratched white | made in dried
up bed of Swindale Beck after a long hot
summer | overcast | began to rain steadily
just as I finished
SWINDALE BECK WOOD, CUMBRIA
27 AUGUST 1983

1 frame
2 Cibachrome photographs
20.3 × 19 and 27.3 × 19
(8 × 7½ and 10¾ × 7½)
2 Cibachrome photographs
each 29.5 × 19.7 (11⅝ × 7¾)
framed 60 × 84.1 (23⅝ × 33⅛)
Rain 1985 pp. 50–51

Nos. 83–84 were made during the *Sculpture
in the Open Air* symposium at the Yorkshire
Sculpture Park.

83
Continuous grass stalk line | each stalk
pushed into the wider hollow end of another
| two thin ends joined by pushing both ends
into a short length of thicker stalk | windy |
pegged to ground and tree with thorns
YORKSHIRE SCULPTURE PARK
SEPTEMBER 1983

Edition of 2
Primary frame:
9 black and white photographs
various irregular shapes and sizes
joined 110 × 154 (39⅜ × 60⅝)
framed 116 × 168 (45⅝ × 66⅛)
Secondary frame:
1 Cibachrome photograph
38.7 × 25.9 (15¼ × 10¼)
framed 72.7 × 58.5 (28⅝ × 23)
Rain 1985 p. 31; *Viking 1990*

84
Leaves collected from underneath trees
where starlings roosted | splashed white with
bird droppings | laid around hole

YORKSHIRE SCULPTURE PARK
SEPTEMBER 1983

1 frame
2 Cibachrome photographs
each 25.4 × 38.1 (10 × 15)
framed 58.4 × 86.3 (23 × 34)
Rain 1985 p. 24

84a
Earth crack line
YORKSHIRE SCULPTURE PARK
SEPTEMBER 1983

1 frame
1 black and white photograph
37.2 × 48 (14⅝ × 18⅞)
frame 54.9 × 65.1 (21⅝ × 25⅝)
Leeds 1990 p. 38

1984

85
Frozen patch of snow | each section carved
with a stick | carried about 150 paces, several
broken along the way | began to thaw as day
warmed up
HELBECK, CUMBRIA
MARCH 1984

1 frame
3 Cibachrome photographs
each 33 × 49.6 (13 × 19½)
framed 61 × 184.1 (24 × 72½)
Rain 1985 pp. 44–45; *Kent 1985* p. 34; *Currah*
1985 p. 92; *Artists Newsletter 1986* p. 6; *Hopkins*
1986 p. 7; *Lee 1986* p. 9; *Steel 1988* p. 8

85a
Continuous grass stalk lines | each stalk
pushed into the wider hollow end of another
| or two thin ends joined with a short length
of thick stalk | edging a hole
HELBECK, CUMBRIA
MAY 1984

Unique
1 frame
3 Cibachrome photographs; first two
photographs joined
17.8 × 24.8, 17.8 × 24.1, 25.1 × 17.5
(7 × 9¾, 7 × 9½, 9⅞ × 6⅞)
framed 41.9 × 85.7 (16½ × 33¾)
Viking 1990

Nos. 86–89 were made in the woods
belonging to the town of Haarlem, as part of
the Haarlemmerhout Symposium organised
by the Frans Hals Museum.

86
Carved sand
HAARLEMMERHOUT, HOLLAND
13 AUGUST 1984

1 frame
2 black and white photographs
each 26.6 × 39.4 (10½ × 15½)
framed 55.9 × 114.3 (22 × 45)
Leeds 1990 p. 52

87

Hard trodden-down sand | carved with a knife | a place where people with dogs meet | underneath large beech trees
HAARLEMMERHOUT, HOLLAND
23 AUGUST 1984

1 frame
1 black and white photograph
39.3 × 26.6 (15½ × 10½)
2 black and white photographs
each 26.6 × 39.3 (10½ × 15½)
framed 64.1 × 152.4 (25¼ × 60)
Rain 1985 pp. 52–53; *Buchanan 1988* p. 77

88

Horse chestnut leaf spire | hollow inside | supported by its own architecture | centre veins joined with thorns to make framework | leaves stitched with thin snowberry twigs | slightly breezy | soon went limp and fell over
HAARLEMMERHOUT, HOLLAND
25 AUGUST 1984

1 frame
2 Cibachrome photographs
each 38.1 × 25.4 (15 × 10)
framed 61 × 81.3 (24 × 32)
Rain 1985 pp. 28–29

89

Poppy petals | early morning, before breeze strengthened | each petal licked underneath and pressed to another | to make a line about seven feet long
HAARLEMMERHOUT, HOLLAND
27 AUGUST 1984

Edition of 3
Primary frame:
3 Cibachrome photographs
48.2 × 31.4, 48.9 × 31.7, 47.6 × 30.8
(19 × 12⅜, 19¼ × 12½, 18¾ × 12⅛)
joined 113.5 × 43.5 (44⅝ × 17⅛)
framed 149 × 64 (58⅝ × 25⅛)
Secondary frame:
1 Cibachrome photograph
39 × 26 (15⅜ × 10¼)
framed 60.2 × 51 (23⅝ × 20⅛)
Rain 1985 p. 62; *Earthlife 1986* p. 37;
Leeds 1990 p. 55
The British Council

90

Grass stalks | fractured at angles | joined together
SWINDALE BECK WOOD, CUMBRIA
OCTOBER 1984

1 frame
2 Cibachrome photographs
25.4 × 38.1 and 38.1 × 25.4
(10 × 15 and 15 × 10)
framed 61 × 104.1 (24 × 41)
The second (location) photograph is displayed in a secondary frame, with text and a drawing using grass stalks, thorns and mud on paper, in one edition of the work.
Rain 1985 p. 30

91

Sycamore leaves and stalks | well ripened after a hot summer | held to the ground with thorns
HELBECK, CUMBRIA
NOVEMBER 1984

1 frame
2 Cibachrome photographs
each 25.5 × 39.5 (10 × 15½)
framed 90 × 68 (35⅜ × 26¾)
Rain 1985 cover and p. 32; *Oakes 1989* p. 56

92

Sycamore stalks in grass | raining
HELBECK, CUMBRIA
NOVEMBER 1984

1 frame
2 Cibachrome photographs
25.4 × 38.1 and 38.1 × 25.4
(10 × 15 and 15 × 10)
framed 58.4 × 92.7 (23 × 36½)
Rain 1985 p. 33
The British Council

93

Floating hole | casting its own shadow | held underneath with thorns to a framework of dock stalks
HELBECK, CUMBRIA
NOVEMBER 1984

1 frame
1 Cibachrome photograph
38.1 × 38.4 (15 × 15⅛)
framed 63.5 × 60 (25 × 23⅝)
Rain 1985 p. 20

94

Leaf patches | edges made by finding leaves the same size | tearing one in two | spitting underneath and pressing flat on to one another
SWINDALE BECK WOOD, CUMBRIA
RED PATCH (CHERRY)
4 NOVEMBER 1984

1 frame
2 Cibachrome photographs
39 × 29 and 39 × 26
(15⅜ × 11⅜ and 15⅜ × 10¼)
framed 74 × 92 (29⅛ × 36¼)
Rain 1985 p. 59; *Viking 1990*
The British Council

95

Continuous grass stalk line | held to mud-covered rocks with thorns
SWINDALE BECK WOOD, CUMBRIA
10 DECEMBER 1984

1 frame
2 Cibachrome photographs
each 38.1 × 38.1 (15 × 15)
framed 68.6 × 116.6 (27 × 46)
Rain 1985 p. 42; *Hutchinson 1985* p. 84

Nos. 96–97 were commissioned by the Scottish Arts Council and Coracle Press, London

96

Carefully broken pebbles | scratched white with another stone
ST. ABB'S, THE BORDERS
1 JUNE 1985

1 frame
2 Cibachrome photographs
each 39.5 × 25.5 (15½ × 10)
framed 66 × 78 (26 × 30¾)
Unpainted Landscape 1987 p. 54; *Lee 1987* p. 75;
Viking 1990

97

Beach cairn | collected pebbles
ST. ABB'S, THE BORDERS
1 JUNE 1985

1 frame
1 Cibachrome photograph
49.6 × 33 (19½ × 13)
framed 76 × 56 (29⅞ × 22)
Unpainted Landscape 1987 p. 53; *Bishop 1987*
p. 681; *Viking 1990*
Arthur Andersen Collection

98

Dandelions flowers | pinned with thorns to rosebay willowherb stalks | held above the bluebells with bracken forks
HELBECK, CUMBRIA
8 JUNE 1985

Primary frame:
1 Cibachrome photograph
75.5 × 75.5 (29¾ × 29¾)
framed 110.5 × 109 (43½ × 42⅞)
Secondary frame:
Text, location, artist's name, date only
framed 22 × 32 (8⅝ × 12⅝)

99

Large fallen oak tree | used leaves with twigs still attached to make supporting structure inside ball | wind, cloud, sun, rain
JENNY NOBLE'S GILL,
LANGHOLM, DUMFRIESSHIRE
15 SEPTEMBER 1985

1 frame
2 Cibachrome photographs
each 49.3 × 31.5 (19⅜ × 12⅜)
framed 90 × 109 (35⅜ × 42⅞)

Re-presented in 1989
Primary frame:
1 Cibachrome photograph
90.6 × 60.3 (35⅝ × 23¾)
framed 127 × 94 (50 × 37)
Secondary frame:
1 Cibachrome photograph
23.5 × 16 (9¼ × 6¼)
framed 51.3 × 37.5 (20¼ × 14¾)
Unpainted Landscape 1987 p. 55; *Viking 1990*

100

Sycamore black spot | rain to begin with
**TOWARDS JENNY NOBLE'S GILL,
LANGHOLM, DUMFRIESSHIRE
OCTOBER 1985**

1 frame
2 Cibachrome photographs
each 22.8 × 16.5 (9 × 6½)
framed 55.9 × 66 (22 × 26)

Nos. 101–103 were produced from work
made during a six week residency on
Hampstead Heath, organised by Common
Ground and the Artangel Trust.

101

Bramble leaves turning brown | used whole |
strong wind — held to ground with thorns
**VIADUCT POND, HAMPSTEAD HEATH, LONDON
20 DECEMBER 1985**

1 frame
2 Cibachrome photographs
39 × 25.5 and 34 × 25.6
(15¾ × 10 and 13¾ × 10⅛)
joined 73.5 × 27.8 (28⅞ × 10⅞)
2 Cibachrome photographs
38.8 × 25.6 and 34.8 × 25.7
(15¼ × 10⅛ and 13⅝ × 10⅛)
joined 74 × 27.5 (29⅛ × 10¾)
framed 108.5 × 90.6 (42¾ × 35⅝)
Viking 1990

102

Beech line over pond
**HAMPSTEAD HEATH, LONDON
26 DECEMBER 1985**

1 frame
2 Cibachrome photographs
each 47 × 32.3 (18½ × 12¾)
joined 93.9 × 40 (37 × 15¾)
framed 119.3 × 58.4 (47 × 23)
Leeds 1990 p. 59

1986

103

Floating hole on the 'Temporary Pond' | Six
weeks on Hampstead Heath in collaboration
with Common Ground and the Artangel
Trust
**HAMPSTEAD HEATH, LONDON
16 JANUARY 1986**

1 frame
1 Cibachrome photograph
48.7 × 32.5 (19¼ × 12¾)
framed 78 × 60 (30¾ × 23⅝)
Common Ground, London

104

Lines walked through snow covered
heather | snowing heavily
**LANGHOLM, DUMFRIESSHIRE
FEBRUARY 1986**

1 frame
1 Cibachrome photograph

30.5 × 48.2 (12 × 19)
framed 71.1 × 86.3 (28 × 34)

105

Icicles, broken, reconstructed | welded with
spit and sucked snow-ice | made in the cold
of morning | worked until midday sun
reached work place | stored icicles in sheep
shelter to keep frozen until following day |
thawed on third day
**WHITE HILL QUARRY, LANGHOLM,
DUMFRIESSHIRE
22–23 FEBRUARY 1986**

1 frame
2 Cibachrome photographs
each 28.5 × 28.5 (11¼ × 11¼)
framed 56 × 86 (22 × 33⅞)
Viking 1990

106

Woven silver birch
**LANGHOLM, DUMFRIESSHIRE
1986**

1 frame
1 Cibachrome photograph
25.4 × 39.4 (10 × 15½)
framed 43.2 × 58.4 (17 × 23)
Turnbull 1987 p. 14 (similar work made on
Hampstead Heath illustrated in *The Times*,
18 December 1985); *Viking 1990*

107

Bulrush debris | blown to one side of the lake
| made an opening | laid stalks around its
edge | grey, overcast, damp
**WARWICK UNIVERSITY
5 MAY 1986**

1 frame
2 Cibachrome photographs
38.8 × 26 and 38.7 × 26
(15¼ × 10¼ and 15¼ × 10¼)
joined 77.5 × 27.3 (30½ × 10¾)
framed 116 × 62.6 (45⅝ × 24⅝)
University of Warwick, Coventry

108

Old bramble leaves | turning brown at the
edges | pressed on to a mound of mud and
sticks | prickles on the underside of leaves
securing them against the wind. Started as a
collaboration with a student in Newcastle
'84 | clouds, rain, bright sun
**WARWICK UNIVERSITY
MAY 1986**

1 frame
2 Cibachrome photographs
39.3 × 26.3 and 26.8 × 39.3
(15½ × 10⅜ and 10½ × 15½)
framed 65.3 × 96.1 (25¾ × 37⅞)
University of Warwick, Coventry

109

Hanging hole
**HOLBECK TRIANGLE, LEEDS
SPRING 1986**

1 frame
2 Cibachrome photographs

each 32.6 × 49.5 (12¹⁵⁄₁₆ × 9½)
unframed
Leeds City Art Galleries

110

Horse chestnut tree | torn hole | stitched
around the edge with grass stalks | moving in
the wind
**TRINITY COLLEGE ENTRANCE, CAMBRIDGE,
ENGLAND
24 JULY 1986**

Primary frame:
1 Cibachrome photograph
90.8 × 60.7 (35¾ × 23⅞)
framed 126.7 × 93.5 (49⅞ × 36¾)
Secondary frame:
1 Cibachrome photograph
24 × 16 (9⅜ × 6¼)
framed 50.2 × 32.7 (19¾ × 12⅞)
Viking 1990; *Leeds 1990* p. 26

111

Horse chestnut leaves | sections torn out |
pinned with thorns to sticks pushed into
pond bottom | muddy black clouds stirred
up around where I worked | over the week
the leaves began to fall and the pond rose
slightly | work gradually disappearing
**LOUGHBOROUGH, LEICESTERSHIRE
22 SEPTEMBER 1986**

Primary frame:
3 Cibachrome photographs
50.8 × 80.6, 50.8 × 83.8, 50.8 × 80
(20 × 31¾, 20 × 33, 20 × 31½)
joined 74.3 × 218.1 (29¼ × 85⅞)
framed 99.7 × 246.7 (39¼ × 97⅛)
Secondary frame:
1 Cibachrome photograph
23.5 × 15.7 (9¼ × 6⅛)
2 Cibachrome photographs
each 15.6 × 20.7 (6⅛ × 8⅛)
joined 20.8 × 43 (8⅛ × 16⅞)
framed 50.5 × 81 (19⅞ × 31⅞)
Buchanan 1988 p. 76; *Viking 1990*
Arnolfini Collection Trust, Bristol

Nos. 112–115 were commissioned by the
Collins Gallery, University of Strathclyde
and included in the exhibition *Perspectives:
Glasgow — A New Look* (a work listed in the
exhibition catalogue as being made on
3 November 1986 was photographed but
never printed).

112

Bright and sunny after the rain | leaves
stitched together with grass stalks | hung
from a tree | moving in the wind
**POLLOK PARK, GLASGOW
31 OCTOBER 1986**

Primary frame:
2 Cibachrome photographs
each 76.2 × 50.2 (30 × 19¾)
framed 111.8 × 139.7 (44 × 55)
Secondary frame:
Text, location, artist's name, date only
framed 22 × 32 (8⅝ × 12⅝)
Perspectives 1987 pp. 28–29; *Viking 1990*;
Leeds 1990 p. 67

113

Yellow and ruddy leaves | made edge by finding ruddy and yellow leaf the same size | tore yellow leaf in two, spat underneath one half | pressed it onto the ruddy leaf

POLLOK PARK, GLASGOW
1 NOVEMBER 1986

Primary frame:
3 Cibachrome photographs
each 32.3 × 25.5 (12¾ × 10)
joined 98 × 25.5 (38⅝ × 10)
framed 130.5 × 57 (51⅜ × 22⅜)
Secondary frame:
2 Cibachrome photographs
each 39 × 26 (15⅜ × 10¼)
joined 73.5 × 37.3 (28⅞ × 14⅝)
framed 105 × 69.5 (41⅜ × 27⅜)
Perspectives 1987 p. 25 top photograph
of work only; *Leeds 1990* p. 66
University of Strathclyde, Glasgow

114

Sycamore leaf sections | torn from between the veins | laid on a path | calm and overcast

GLASGOW GREEN
2 NOVEMBER 1986

1 frame
2 Cibachrome photographs
each 26 × 39 (10¼ × 15⅜)
joined 27 × 78 (10⅝ × 30¾)
framed 62 × 109 (24⅜ × 42⅞)

115

Leaf | crack | line
(sometimes called: Cracked line through leaves)

GLASGOW GREEN
2 NOVEMBER 1986

Edition of 3
Primary frame:
4 Cibachrome photographs
each 38 × 25 (15 × 9⅞)
joined 145 × 29 (57⅛ × 11⅜)
framed 172 × 55 (67¾ × 21⅝)
presented vertically or horizontally
Secondary frame:
1 Cibachrome photograph
24 × 16 (9⅜ × 6¼)
framed 52 × 37 (20½ × 14½)
Viking 1990
The Scottish Arts Council

1987

Nos. 116–121 were made in a nearby valley during a particularly cold winter, Goldsworthy's first after moving to Scotland, and were included in his first one-man show at Fabian Carlsson Gallery, London, in 1987.

116

Ice | each piece frozen to the next | occasionally letting go too soon | lost several good points in the river | instinctive attempts to catch falling ice often causing more damage | forced myself to let them fall | only a small amount of ice to work with

SCAUR WATER, PENPONT, DUMFRIESSHIRE
7 JANUARY 1987

Primary frame:
1 Cibachrome photograph
72.5 × 114 (28½ × 44⅞)
framed 108.5 × 147.6 (42¾ × 58¼)
Secondary frame:
2 Cibachrome photographs
each 23 × 16 (9 × 6¼)
framed 51 × 54 (20⅛ × 21¼)
Henry October 1987 pp. 218–19; *Britannica 1988*
p. 131; *Buchanan 1988* p. 77; *Laws 1988* p. 45;
Viking 1990; *Leeds 1990* p. 144
Bradford Art Galleries and Museums
Musée des Beaux-Arts André Malraux, le Harve

117

Hard overnight frost | out early to work the cold | calm | froze ice to ice | began to span between rocks | became more ambitious | arch turned into columns

SCAUR WATER, PENPONT, DUMFRIESSHIRE
7 JANUARY 1987

Primary frame:
1 Cibachrome photograph
75.5 × 75.5 (29¾ × 29¾)
framed 110.5 × 109 (43½ × 42⅞)
Secondary frame:
1 Cibachrome photograph
25 × 25 (9⅞ × 9⅞)
framed 51.3 × 42 (20¼ × 16½)
Howell 1987 p. 55; *Viking 1990*; *Leeds 1990* p. 145
Arthur Andersen Collection; Fukuyama Museum
of Art, Hiroshima

118

Just cold enough to freeze icicles to rock | took a long time | supported icicles with forked sticks

SCAUR WATER, PENPONT, DUMFRIESSHIRE
8 JANUARY 1987

Primary frame:
1 Cibachrome photograph
60 × 90 (23⅝ × 35⅜)
framed 96 × 125 (37¾ × 49¼)
Secondary frame:
Text, location, artist's name, date only
framed 22 × 32 (8⅝ × 12⅝)
Viking 1990

119

Carefully broken icicle | reconstructed with ice

SCAUR WATER, PENPONT, DUMFRIESSHIRE
10 JANUARY 1987

Primary frame:
1 Cibachrome photograph
49.5 × 76.2 (19½ × 30)
framed 86.3 × 109 (34 × 42⅞)
Secondary frame:
1 Cibachrome photograph
17 × 24 (6⅝ × 9⅜)
framed 46.5 × 42.6 (18¼ × 16¾)
Baginsky 1989 p. 27

120

Thin ice | made over two days | welded with water from dripping ice | hollow inside

SCAUR WATER, PENPONT, DUMFRIESSHIRE
11 JANUARY 1987

Primary frame:
1 Cibachrome photograph
75.5 × 75.5 (29¾ × 29¾)
framed 110.5 × 109 (43½ × 42⅞)
Secondary frame:
1 Cibachrome photograph
24 × 16 (9⅜ × 6¼)
framed 50.8 × 43.2 (20 × 17)
Viking 1990
Government Art Collection, London

121

Icicles | thick ends dipped in snow and water | held until frozen to the work | pouring on water until solid | occasionally using forked sticks as support until stuck | a tense moment when taking them away | breathing on the stick first to release it | sun catching the work for a dangerous half hour | but alway intensely cold

SCAUR WATER, PENPONT, DUMFRIESSHIRE
12 JANUARY 1987

Primary frame:
1 Cibachrome photograph
75.5 × 75.5 (29¾ × 29¾)
framed 110.5 × 109 (43½ × 42⅞)
Secondary frame:
1 Cibachrome photograph
24 × 16 (9⅜ × 6¼)
framed 51.3 × 42 (20¼ × 16½)
Turnbull 1987 p. 13; *Brown 1987*; *Januszczak 1987* p. 9; *Howell 1987* p. 55; *May 1987* p. 37; *Buchanan 1988* p. 77; *3i 1988*; *Steele 1988* p. 9; *Henry July 1988*; *Baginsky 1989* p. 27; *Viking 1990*
Government Art Collection, London

Nos. 122–124 were made during a winter visit to the Yorkshire Sculpture Park, the first of three made by Goldworthy in each of the seasons, at the invitation of the YSP.

122

Green sticks | partly scraped and rubbed

YORKSHIRE SCULPTURE PARK
10 FEBRUARY 1987

Primary frame:
1 Cibachrome photograph
49.6 × 50 (19½ × 19⅝)
framed 82.7 × 81.2 (32½ × 32)
Secondary frame:
Text, location, artist's name, date only
framed 22 × 32 (8⅝ × 12⅝)
Leeds 1990 p. 68

123

Rhododendron leaves | creased to catch the hazy to bright light | held to the ground with thorns

YORKSHIRE SCULPTURE PARK
11 FEBRUARY 1987

Primary frame:
1 Cibachrome photograph

75.5 × 75.5 (29¾ × 29¾)
framed 110.5 × 109 (43½ × 42⅞)
Secondary frame:
1 Cibachrome photograph
25 × 25 (9⅞ × 9⅞)
framed 51.3 × 42 (20¼ × 16¼)
Howell 1987 pp. 54–55; *Parkland 1988*; *Buchanan 1988* p. 75; *3i 1988*; *Viking 1990*

124

Blackberry leaves | splattered white with
bird droppings after a few days of little rain |
collected splashes | laid alongside a scraping |
occasional dangerous showers of rain
YORKSHIRE SCULPTURE PARK
23 FEBRUARY 1987

Primary frame:
1 Cibachrome photograph
75.5 × 75.5 (29¾ × 29¾)
framed 110.5 × 109 (43½ × 42⅞)
Secondary frame:
1 Cibachrome photograph
25 × 25 (9⅞ × 9⅞)
framed 51.3 × 42 (20¼ × 16½)
Parkland 1988

125

Stone | crack | line
(sometimes called: Cracked line through
stones)
SCAUR WATER, PENPONT, DUMFRIESSHIRE
12 APRIL 1987

Edition of 3
Primary frame:
4 Cibachrome photographs
each 38 × 25 (15 × 9⅞)
joined 144 × 29.6 (56⅝ × 11⅝)
framed 170 × 58 (66⅞ × 22⅞)
presented vertically or horizontally
Secondary frame:
1 Cibachrome photograph
24 × 16 (9⅜ × 6¼)
framed 52 × 37 (20½ × 14½)
Viking 1990

Nos. 126–131 were made during a spring
visit to the Yorkshire Sculpture Park.

126

Spring grass | fresh green blades | white
stems | laid around a hole
YORKSHIRE SCULPTURE PARK
25 APRIL 1987

Primary frame:
1 Cibachrome photograph
75.6 × 75.6 (29¾ × 29¾)
framed 111.8 × 109.2 (44 × 43)
Secondary frame:
1 Cibachrome photograph
25 × 25 (9⅞ × 9⅞)
framed 51.3 × 42 (20¼ × 16½)
Parkland 1988; *Buchanan 1988* p. 75;
Oakes 1989 p. 54

127

Dandelions | newly flowered | none as yet
turned to seed | undamaged by wind or rain |

a grass verge between dual carriageways | on
the way to Bretton
YORKSHIRE SCULPTURE PARK
28 APRIL 1987

Primary frame:
1 Cibachrome photograph
75.5 × 75.5 (29¾ × 29¾)
framed 110.5 × 109 (43½ × 42⅞)
Secondary frame:
Text, location, artist's name, date only
framed 22 × 32 (8⅝ × 12⅝)
Howell 1987 p. 54; *Parkland 1988*; *Oakes 1989*
p. 55; *Viking 1990*

128

Willow herb stalks | pushed into lake bottom
| shallow around the edge | sunny and calm
to begin with | as I finished the sky
darkened | breeze | ripples
YORKSHIRE SCULPTURE PARK
29 APRIL 1987

Primary frame:
1 Cibachrome photograph
75.5 × 75.5 (29¾ × 29¾)
framed 110.5 × 109 (43½ × 42⅞)
Secondary frame:
Text, location, artist's name, date only
framed 22 × 32 (8⅝ × 12⅝)
Parkland 1988; *Graydon 1989* p. 98;
Nesbitt 1990 p. 49

129

Dandelion flowers | pinned with thorns
to willowherb stalks | blown — grown bent
by the wind | laid in a ring | held above
bluebells with forked sticks
YORKSHIRE SCULPTURE PARK
1 MAY 1987

Primary frame:
1 Cibachrome photograph
58 × 76 (22⅞ × 29⅞)
framed 87.5 × 104.5 (34⅜ × 41⅛)
Secondary frame:
Text, location, artist's name, date only
framed 22 × 32 (8⅝ × 12⅝)
Steele 1988 p. 9

130

Two works made in the same place | sticks
and willow herb stalks | pushed into lake
bottom | shallow around the edge | both days
sunny and calm to begin with | as I finished
the sky darkened | breeze | ripples
YORKSHIRE SCULPTURE PARK
29 APRIL, 3 MAY 1987

Primary frame:
1 Cibachrome photograph
75.5 × 75.5 (29¾ × 29¾)
framed 110.5 × 109 (43½ × 42⅞)
Secondary frame:
1 Cibachrome photograph
25 × 25 (9⅞ × 9⅞)
framed 51.3 × 42 (20¼ × 16½)
Howell 1987 p. 54; *Parkland 1988*; *Buchanan
1988* p. 76; *Architects Journal 1988*, p. 83;
Lund 1989 cover and p. 180

131

Dandelions | collected along the way to
Bretton | threaded on to grass stalks | laid on
the water | end to end | bright, sunny
YORKSHIRE SCULPTURE PARK
4 MAY 1987

Primary frame:
2 Cibachrome photographs
56.8 × 54 and 58.4 × 54
(22⅜ × 21¼ and 23 × 21¼)
joined 115.2 × 60.3 (45⅜ × 23¾)
framed 147.3 × 90.2 (58⅜ × 35½)
Secondary frame:
Text, location, artist's name, date only
framed 22 × 32 (8⅝ × 12⅝)
Parkland 1988

Nos. 132–137 were made during a summer
visit to the Yorkshire Sculpture Park.

132

Sycamore leaf sections | torn out | smeared
with mud | laid alongside a trench
YORKSHIRE SCULPTURE PARK
1 AUGUST 1987

Primary frame:
2 Cibachrome photographs
60.2 × 59.7 and 59.7 × 59.7
(23¾ × 23½ and 23½ × 23½)
joined 112.2 × 61.7 (44⅛ × 24¼)
framed 148 × 91 (58¼ × 35¾)
Secondary frame:
1 Cibachrome photograph
25 × 25 (9⅞ × 9⅞)
framed 51.3 × 42 (20¼ × 16½)
Parkland 1988; *Graydon 1989* p. 98

133

Trench | dug over two days | earth brought
to an edge | clay supported with sticks | cold,
darkly overcast but no rain | a hot day would
have caused the clay to dry out | a wet day
would have washed the earth away
YORKSHIRE SCULPTURE PARK
6 AND 7 AUGUST 1987

Primary frame:
4 Cibachrome photographs
each 59 × 59 (23¼ × 23¼)
joined 227 × 98 (89⅜ × 38⅝)
framed 247 × 117 (97¼ × 46)
Secondary frame:
1 Cibachrome photograph
25 × 25 (9⅞ × 9⅞)
framed 52 × 42 (20½ × 16½)
Parkland 1988; *Viking 1990*; *Leeds 1990* p. 69

134

Sweet chestnut green horn | continuous
spiral | each leaf laid in the fold of another |
stitched with thorns
YORKSHIRE SCULPTURE PARK
9 AUGUST 1987

Primary frame:
1 Cibachrome photograph
49.6 × 49.6 (19½ × 19½)
framed 83.6 × 81.3 (32⅞ × 32)
Secondary frame:
Text, location, artist's name, date only

framed 22 × 32 (8⅝ × 12⅝)
Parkland 1988; *Laws 1988* p. 46; *Graydon 1989*
p. 99; *Oakes 1989* p. 52; *Viking 1990*

135
Calm overcast | laid iris blades on pond |
pinned together with thorns | filled in five
sections with rowan berries | fish attacking
from below | difficult to keep all the
berries in | nibbled at by ducks
YORKSHIRE SCULPTURE PARK
29 AUGUST 1987

Primary frame:
1 Cibachrome photograph
75.5 × 75.5 (29¾ × 29¾)
framed 110.5 × 109 (43½ × 42⅞)
Secondary frame:
1 Cibachrome photograph
25 × 25 (9⅞ × 9⅞)
framed 51.3 × 42.4 (20¼ × 16⅝)
Parkland 1988; *Buchanan 1988* cover and p. 75;
3i 1988; *Steele 1988* p. 9; *Actual 1988*; *Graydon*
1989 p. 97; *Oakes 1989* p. 54, *Viking 1990*

136
Sycamore leaf sections | torn along the veins
| smeared with mud | laid alongside channels
YORKSHIRE SCULPTURE PARK
31 AUGUST 1987

Primary frame:
1 Cibachrome photograph
75.5 × 75.5 (29¾ × 29¾)
framed 110.5 × 109 (43½ × 42⅞)
Secondary frame:
1 Cibachrome photograph
25 × 25 (9⅞ × 9⅞)
framed 51.3 × 42 (20¼ × 16½)
Parkland 1988; *Buchanan 1988* p. 75

137
Sycamore leaf box | supported by its own
architecture | stitched with thorns | moving
with the breeze | for David Nash
YORKSHIRE SCULPTURE PARK
4 SEPTEMBER 1987

Primary frame:
1 Cibachrome photograph
49.6 × 49.6 (19½ × 19½)
framed 83.6 × 81.3 (32⅞ × 32)
Secondary frame:
Text, location, artist's name, date only
framed 22 × 32 (8⅝ × 12⅝)
Parkland 1988

Nos. 138–144 were made during an autumn
visit to the Yorkshire Sculpture Park.

138
Leaves on leaves | pressed flat with spit |
windy | held to ground with stalks and
thorns | streak line to explore colour in
horse chestnut
YORKSHIRE SCULPTURE PARK
21 OCTOBER 1987

Primary frame:
4 Cibachrome photographs

each 32 × 48.6 (12⅝ × 19⅛)
joined 54 × 181.5 (21¼ × 71½)
framed 73.6 × 200.5 (29 × 78⅞)
presented horizontally or vertically
Secondary frame:
1 Cibachrome photograph
25 × 25 (9⅞ × 9⅞)
framed 51.3 × 42.4 (20¼ × 16⅝)
Parkland 1988

139
Leaves on leaves | pressed flat with spit |
windy | held to ground with stalks and
thorns | streak line to expore colour in
horse chestnut
YORKSHIRE SCULPTURE PARK
22 OCTOBER 1987

Primary frame:
4 Cibachrome photographs
each 32 × 48.6 (12⅝ × 19⅛)
joined 56 × 182.5 (22 × 71⅞)
framed 73.6 × 200.5 (29 × 78⅞)
presented horizontally or vertically
Secondary frame:
1 Cibachrome photograph
25 × 25 (9⅞ × 9⅞)
framed 51.3 × 42.4 (20¼ × 16⅝)
Parkland 1988; *Buchanan 1988* p. 76; *Viking 1990*

140
Leaves on leaves | pressed flat with spit |
windy | held to ground with stalks and
thorns | streak line to explore colour in
horse chestnut
YORKSHIRE SCULPTURE PARK
23 OCTOBER 1987

Primary frame:
4 Cibachrome photographs
each 32 × 48.6 (12⅝ × 19⅛)
joined 46 × 182.5 (18⅛ × 71⅞)
framed 73.6 × 200.5 (29 × 78⅞)
presented horizontally or vertically
Secondary frame:
1 Cibachrome photograph
25 × 25 (9⅞ × 9⅞)
framed 51.3 × 42.4 (20¼ × 16⅝)
Parkland 1988

141
Sycamore leaves | stitched together
with stalks | hung from a still green oak
YORKSHIRE SCULPTURE PARK
23 OCTOBER 1987

Primary frame:
1 Cibachrome photograph
75.5 × 75.5 (29¾ × 29¾)
framed 110.5 × 109 (43½ × 42⅞)
Secondary frame:
1 Cibachrome photograph
25 × 25 (9⅞ × 9⅞)
framed 51.5 × 42 (20¼ × 16½)
Parkland 1988; *Graydon 1989* p. 96

142
Horse chestnut patch | green to yellow |
torn leaves | with spit
YORKSHIRE SCULPTURE PARK
24 OCTOBER 1987

Primary frame:
1 Cibachrome photograph
49.6 × 49.6 (19½ × 19½)
framed 83.6 × 81.3 (32⅞ × 32)
Secondary frame:
1 Cibachrome photograph
25 × 25 (9⅞ × 9⅞)
framed 51.3 × 42 (20¼ × 16½)
Parkland 1988; *Buchanan 1988* p. 75;
Oakes 1989 p. 52

143
Rowan leaves laid around a hole | collecting
the last few leaves | nearly finished | dog ran
into hole | started again | made in the shadow
of a sunny day | windy | sheltered by
rhododendron bush
YORKSHIRE SCULPTURE PARK
25 OCTOBER 1987

Primary frame:
1 Cibachrome photograph
75.5 × 75.5 (29¾ × 29¾)
framed 110.5 × 109 (43½ × 42⅞)
Secondary frame:
1 Cibachrome photograph
25 × 25 (9⅞ × 9⅞)
framed 51.5 × 42.5 (20¼ × 16¾)
Parkland 1988; *Buchanan 1988* p. 75; *Steele 1988*
p. 9; *Actual 1988*; *Oakes 1989* p. 54; *Viking 1990*

144
Sweet chestnut | autumn horn
YORKSHIRE SCULPTURE PARK
28 OCTOBER 1987

Primary frame:
1 Cibachrome photograph
49.6 × 49.6 (19½ × 19½)
framed 83.6 × 81.3 (32⅞ × 32)
Secondary frame:
Text, location, artist's name, date only
framed 22 × 32 (8⅝ × 12⅝)
Parkland 1988; *Laws 1988* p. 46

Nos. 145–188 were made in three
contrasting areas of Japan, a project
organised by Gallery Takagi, Nagoya

145
Started climbing the mountain | collected
ferns | looked for a soft place to dig | so much
stone | very little earth | returned to valley |
managed a small hole | bent the ferns
around | stripped down one side | underside
up | wind | held to ground with thin twigs |
no thorns
OUCHIYAMA-MURA, JAPAN
13 NOVEMBER 1987

Primary frame:
1 Cibachrome photograph
50 × 50.5 (19⅝ × 19⅞)
framed 79.7 × 79.2 (31⅜ × 31⅛)
Secondary frame:
1 Cibachrome photograph
22 × 22 (8⅝ × 8⅝)
framed 51.3 × 42.6 (20⅛ × 16¾)
Nikkan Fukui 1987

146

Line to follow colour changes in kaede leaves | yellow the most difficult to find | calm, overcast

OUCHIYAMA-MURA, JAPAN
14 NOVEMBER 1987

Primary frame:
2 Cibachrome photographs
47.7 × 33.6 and 45.3 × 33.2
(18¾ × 13¼ and 17⅞ × 13⅛)
joined 92.6 × 50 (36⅜ × 19⅝)
framed 122.1 × 62.7 (48 × 24⅝)
Secondary frame:
1 Cibachrome photograph
24 × 26 (9⅜ × 10¼)
framed 51.5 × 42.6 (20¼ × 16¾)
Mountain 1988; *Nakamura 1988* p. 34;
Sinden 1988 p. 29; *Whole Earth 1989*.
Tochigi Prefectural Museum of Fine Arts, Tochigi; Nagoya City Art Museum, Nagoya

147

Kaede leaves around a hole | yellow to reds | afternoon | overcast | going dark

OUCHIYAMA-MURA, JAPAN
14 NOVEMBER 1987

Primary frame:
1 Cibachrome photograph
40.5 × 48.5 (15⅞ × 19⅛)
framed 70.1 × 76.5 (27⅝ × 30⅛)
Secondary frame:
1 Cibachrome photograph
25 × 22 (9⅞ × 8⅝)
framed 51.5 × 42.6 (20¼ × 16¾)
Mountain 1988; *Asahi Shimbun 18 January 1988*;
Mizutani March 1988 p. 163
Nagoya City Art Museum, Nagoya

148

Chestnut leaves | carefully torn sections | leaving the veins | laid over hole | cloudy to begin with | becoming sunny | had to keep the work shaded and wet | until the sun dropped behind the mountains

OUCHIYAMA-MURA, JAPAN
15 NOVEMBER 1987

Primary frame:
2 Cibachrome photographs
46.5 × 48.8 and 48.4 × 48.8
(18¼ × 19½ and 19 × 19½)
joined 95.2 × 48.5 (37½ × 19⅛)
framed 129.8 × 85.5 (51⅛ × 33⅝)
Secondary frame:
1 Cibachrome photograph
24 × 24 (9⅜ × 9⅜)
framed 51.5 × 42.6 (20¼ × 16¾)
Nagoya City Art Museum, Nagoya

149

Sticks | stacked in a dome | leaving a hole

OUCHIYAMA-MURA, JAPAN
16 NOVEMBER 1987

Primary frame:
1 Cibachrome photograph
76.7 × 75.3 (30⅛ × 29⅝)
framed 111.5 × 109 (43⅞ × 42⅞)
Secondary frame:
1 Cibachrome photograph

25 × 25 (9⅞ × 9⅞)
framed 51.5 × 42.6 (20¼ × 16¾)
Mountain 1988

150

Japanese maple | red and green leaves | laid on to vertical rock surface | running with water | going dark

OUCHIYAMA-MURA, JAPAN
16 NOVEMBER 1987

Primary frame:
1 Cibachrome photograph
50.5 × 50.5 (19⅞ × 19⅞)
framed 79.7 × 79.1 (31⅜ × 31¼)
Secondary frame:
1 Cibachrome photograph
25 × 25 (9⅞ × 9⅞)
framed 51.5 × 42.6 (20¼ × 16¾)
Mountain 1988; *Graydon 1989* p. 96

151

Overcast, occasional rain | followed wild pig path through riverside grasses | fresh growth on old | torn blades | stuck with spit | windy | but not enough to blow away | clouds began to break | sun | grass shrivelling | cracking

OUCHIYAMA-MURA, JAPAN
17 NOVEMBER 1987

Primary frame:
1 Cibachrome photograph
60.4 × 60.4 (23¾ × 23¾)
framed 94.9 × 93.7 (37⅜ × 36⅞)
Secondary frame:
1 Cibachrome photograph
25 × 25 (9⅞ × 9⅞)
framed 51.5 × 42.6 (20¼ × 16⅜)
Mountain 1988

152

Climbed mountain | following a stream | small waterfall | leaves suck to wet rocks | made lines | monkey

OUCHIYAMA-MURA, JAPAN
18 NOVEMBER 1987

Primary frame:
2 Cibachrome photographs
68.7 × 54 and 67.6 × 68.6
(27 × 21¼ and 26⅝ × 27)
joined 136.8 × 91.1 (53⅞ × 35⅞)
framed 165.3 × 114.8 (65 × 45⅛)
Secondary frame:
1 Cibachrome photograph
25 × 25 (9⅞ × 9⅞)
framed 51.5 × 42.6 (20¼ × 16⅜)
Nakamura 1988 p. 34

153

Grass | stripped down one side | floating on riverside pool

OUCHIYAMA-MURA, JAPAN
19 NOVEMBER 1987

Primary frame:
1 Cibachrome photograph
61 × 61 (24 × 24)
framed 95.6 × 94.2 (37⅝ × 37⅛)
Secondary frame:
1 Cibachrome photograph

25 × 25 (9⅞ × 9⅞)
framed 51.5 × 42.6 (20¼ × 16¾)

154

Bark | stacked in a dome | leaving a hole

OUCHIYAMA-MURA, JAPAN
19 NOVEMBER 1987

Primary frame:
1 Cibachrome photograph
75.8 × 75.8 (29⅞ × 29⅞)
framed 110.9 × 109.6 (43⅝ × 43⅛)
Secondary frame:
1 Cibachrome photograph
25 × 25 (9⅞ × 9⅞)
framed 51.5 × 42.6 (20¼ × 16¾)
Sakurai 1988 p. 33

155

Aoki leaves | stitched together with grass stalks | hung from a tree | catching the autumn light | from both sides

OUCHIYAMA-MURA, JAPAN
20 NOVEMBER 1987

Primary frame:
1 Cibachrome photograph
76 × 76.3 (29⅞ × 30)
framed 110.8 × 109.4 (43⅝ × 43)
Secondary frame:
1 Cibachrome photograph
24 × 16 (9⅜ × 6¼)
framed 51.3 × 37.5 (20⅛ × 14¾)
Mountain 1988; *Mizutani March 1988* p. 163;
Nikkei Trendy 1988 p. 80; *Sinden 1988* cover;
Law 1988 p. 47
Setagaya Art Museum, Tokyo

156

Japanese maple | each leaf stitched to the next with stem to make floating chain

OUCHIYAMA-MURA, JAPAN
21 NOVEMBER 1987

Primary frame:
2 Cibachrome photographs
67.5 × 68.6 and 62 × 68.6
(26⅝ × 27 and 24⅜ × 27)
joined 129.3 × 73.4 (50⅞ × 28⅞)
framed 163.6 × 97.7 (64⅜ × 38½)
Secondary frame:
Text, location, artist's name, date only
frame 22.2 × 32.5 (8¾ × 12¾)
Britannia 1988 p. 130; *Mountain 1988*; *Asahi Camera 1988*; *Sogetsu 1988* p. 81; *Graydon 1989*
p. 98 bottom section of work only; *Viking 1990*
Nagoya City Art Museum, Nagoya

157

Maple patch | difficult | yellow to orange hard to find | wind, sun | leaves drying out and blowing away

OUCHIYAMA-MURA, JAPAN
22 NOVEMBER 1987

Primary frame:
1 Cibachrome photograph
50.5 × 50.3 (19⅞ × 19¾)
framed 80.2 × 79.1 (31½ × 31⅛)
Secondary frame:
1 Cibachrome photograph

25.3 × 25.3 (10 × 10)
framed 51.5 × 42.6 (20¼ × 16¾)
Sogetsu 1988 p. 82; *Dumas 1988* p. 195;
Leeds 1990 p. 71

158

Hole in leaves | sinking | held underneath to
a woven briar ring | keeping it afloat
OUCHIYAMA-MURA, JAPAN
22 NOVEMBER 1987

Primary frame:
1 Cibachrome photograph
61 × 61 (24 × 24)
framed 95.6 × 94.3 (37⅝ × 37⅛)
Secondary frame:
1 Cibachrome photograph
24 × 16 (9⅜ × 6¼)
framed 51.5 × 37.5 (20¼ × 14¾)
Mountain 1988; Brutus 1988 p. 101; *Nikkei
Trendy 1988* p. 80; *Conoco World April 1988* p. 15;
Actuel 1988; Conoco World December 1988 p. 8;
Packer 1989 p. 29; *Nesbitt 1990* cover; *Viking 1990*

159

Stacked sticks | high up on a ledge
OUCHIYAMA-MURA, JAPAN
23 NOVEMBER 1987

Primary frame:
1 Cibachrome photograph
75.5 × 75.7 (29¾ × 29¾)
framed 110.7 × 109.5 (43⅝ × 43⅛)
Secondary frame:
1 Cibachrome photograph
26 × 23 (10¼ × 9)
framed 51.5 × 42.6 (20¼ × 16¾)

160

Leaves | folded and creased to catch the light
| pinned to ground with thin bamboo |
worked in the intense shadow of a sunny day
OUCHIYAMA-MURA, JAPAN
24 NOVEMBER 1987

Primary frame:
4 Cibachrome photographs
58.6 × 59.6, 59.2 × 59.2, 59 × 59.3, 59 × 59.2
(23 × 23½, 23¼ × 23¼, 23¼ × 23⅜,
23¼ × 23¼)
joined 65 × 211.5 (25⅝ × 83¼)
framed 104.8 × 235.3 (41¼ × 92⅝)
Secondary frame:
1 Cibachrome photograph
25.5 × 25.5 (10 × 10)
framed 51.5 × 42.6 (20¼ × 16¾)
Mountain 1988; Geijutsu Shimcho 1988 pp. 76–77;
Nakamura 1988 p. 34; *Laws 1988* pp. 46–47
Tochigi Prefectural Museum of Fine Arts, Tochigi

161

Woven bamboo
KIINAGASHIMA-CHO, JAPAN
27 NOVEMBER 1987

Primary frame:
1 Cibachrome photograph
75.6 × 76 (29¾ × 29⅞)
framed 110.7 × 109.4 (43⅝ × 43)
Secondary frame:
1 Cibachrome photograph

16 × 24 (6¼ × 9⅜)
framed 46.3 × 42.6 (18¼ × 16¾)
Mountain 1988; Asahi Shimbun 30 January 1988;
Nikkei Trendy 1988 p. 80; *Graydon 1989* p. 99

162

Old bamboo | soft in places | ends pushed
into bitten holes to make screen | going dark
| calm, warm, humid, raining, mosquitos
KIINAGASHIMA-CHO, JAPAN
27 NOVEMBER 1987

Primary frame:
2 Cibachrome photographs
65.5 × 62.8 and 65.6 × 65.2
(25¾ × 24¾ and 25⅞ × 25⅝)
joined 66 × 128.8 (26 × 50¾)
framed 102.7 × 162.8 (40⅜ × 64⅛)
Secondary frame:
Text, location, artist's name, date only
framed 22.3 × 32.5 (8¾ × 12¾)
Mountain 1988; Asahi Shimbun 30 January 1988;
Sogetsu 1988 p. 82; *Geijutsu Shincho 1988* p. 77;
Graham-Dixon 1988 p. 13; *Viking 1990*
Tochigi Prefectural Museum of Fine Arts,
Tochigi; Fukuyama Museum of Art, Hiroshima

163

Beach cairn
KIINAGASHIMA-CHO, JAPAN
28 NOVEMBER 1987

Primary frame:
1 Cibachrome photograph
48.2 × 48.1 (19 × 18⅞)
framed 77.9 × 76.6 (30⅝ × 30⅛)
Secondary frame:
Text, location, artist's name, date only
framed 22.3 × 32.5 (8¾ × 12¾)

164

Sticks | bleached by sun and sea | strong
wind | second attempt | tide came up
too high on first try
KIINAGASHIMA-CHO, JAPAN
29 NOVEMBER 1987

Primary frame:
1 Cibachrome photograph
75.8 × 75.8 (29⅞ × 29⅞)
framed 110.9 × 109.6 (43⅝ × 43⅛)
Secondary frame:
1 Cibachrome photograph
26 × 25 (10¼ × 9⅞)
framed 51.5 × 42.6 (20¼ × 16¾)
Mountain 1988; Nakamura 1988 p. 34;
Sinden 1988 p. 31; *Viking 1990*

165

Woven bamboo | windy | collapsed
just after I finished
KIINAGASHIMA-CHO, JAPAN
29 NOVEMBER 1987

Primary frame:
1 Cibachrome photograph
77.5 × 76.5 (30½ × 30⅛)
framed 110.9 × 109.3 (43⅝ × 43)
Secondary frame:
1 Cibachrome photograph
16 × 24 (6¼ × 9⅜)
framed 46.3 × 42.6 (18¼ × 16¾)

Mountain 1988; Mizutani January 1988;
Sogetsu 1988 p. 83; *Ishii 1988; Pia 1988* p. 225;
Martin 1988 p. 112; *Packer 1989* p. 30.
Nagoya City Art Museum, Nagoya

166

Stones | scratched white
KIINAGAHIMA-CHO, JAPAN
29 NOVEMBER 1987

Primary frame:
1 Cibachrome photograph
50.6 × 50.6 (19⅞ × 19⅞)
framed 80.4 × 79.1 (31⅝ × 31⅛)
Secondary frame:
1 Cibachrome photograph
25 × 25 (9⅞ × 9⅞)
framed 51.5 × 42.6 (20¼ × 16¾)
Mountain 1988; Nikkei Trendy 1988 p. 80;
Sinden 1988 p. 30
Nagoya City Art Museum, Nagoya

167

Cherry patch | yellow to red
KIINAGASHIMA-CHO, JAPAN
30 NOVEMBER 1987

Primary frame:
1 Cibachrome photograph
50.5 × 50.5 (19⅞ × 19⅞)
framed 80.4 × 79.1 (31⅝ × 31⅛)
Secondary frame:
1 Cibachrome photograph
25 × 25 (9⅞ × 9⅞)
framed 51.5 × 42.6 (20¼ × 16¾)
Mountain 1988; Geijutsu Shincho 1988 p. 76;
Sinden 1988 pp. 30–31

168

Broken line through pebbles
KIINAGASHIMA-CHO, JAPAN
2 DECEMBER 1987

Primary frame:
2 Cibachrome photographs
37.2 × 36.6 and 36.4 × 39 (14⅝ × 14⅜ and
14⅜ × 15 × 15⅜)
joined 76.5 × 37.5 (30⅛ × 14¾)
framed 105.9 × 66.8 (41⅝ × 26¼)
Secondary frame:
1 Cibachrome photograph
25.3 × 25.3 (10 × 10)
framed 51.5 × 42.6 (20¼ × 16¾)
Nagoya City Museum, Nagoya

169

Bamboo spires | calm to begin with | wind
becoming stronger
KIINAGASHIMA-CHO, JAPAN
4 DECEMBER 1987

Primary frame:
1 Cibachrome photograph
75.5 × 76 (29¾ × 29⅞)
framed 110.7 × 109.3 (43⅝ × 43)
Secondary frame:
1 Cibachrome photograph
25.5 × 25.5 (10 × 10)
framed 51.5 × 42.6 (20¼ × 16¾)
Nakamura 1988 p. 35

170

Bamboo | each end pushed into another
to make lines | calm
KIINAGASHIMA-CHO, JAPAN
5 DECEMBER 1987

Primary frame:
2 Cibachrome photographs
each 49.4 × 47.9 (19½ × 18⅞)
joined 49.5 × 95.5 (19½ × 37⅝)
framed 80.4 × 124.9 (31⅝ × 49⅛)
Secondary frame:
Text, location, artist's name, date only
framed 22.3 × 32.5 (8¾ × 12¾)

171

A good overnight fall of cherry leaves | on
the path to work | yellow on red | spit
and stalks
KIINAGASHIMA-CHO, JAPAN
6 DECEMBER 1987

Primary frame:
1 Cibachrome photograph
50.5 × 43.3 (19⅞ × 17)
framed 80.4 × 71.4 (31⅝ × 28⅛)
Secondary frame:
1 Cibachrome photograph
25 × 25.5 (9⅞ × 10)
framed 51.5 × 42.6 (20¼ × 16¾)
Mountain 1988; *Mizutani March 1988* p. 163
Nagoya City Art Museum, Nagoya

172

Sand brought to an edge to catch
the morning light | windy
KIINAGASHIMA-CHO, JAPAN
7 DECEMBER 1987

Primary frame:
1 Cibachrome photograph
75 × 75.3 (29½ × 29⅝)
framed 110.7 × 109.5 (43⅝ × 43⅛)
Secondary frame:
1 Cibachrome photograph
24 × 16 (9⅜ × 6¼)
framed 51.5 × 37.5 (20¼ × 14¾)
Mountain 1988

173

Pebbles around a hole | becoming cloudy
KIINAGASHIMA-CHO, JAPAN
7 DECEMBER 1987

Primary frame:
1 Cibachrome photograph
40.3 × 43.5 (15⅞ × 17⅛)
framed 70.3 × 71.6 (27⅝ × 28⅛)
Secondary frame:
1 Cibachrome photograph
25.5 × 25.5 (10 × 10)
framed 51.5 × 42.6 (20¼ × 16¾)
Mountain 1988; *Sogetsu 1988* p. 83; *Viking 1990*
Setagaya Art Museum, Tokyo; Tochigi
Prefectural Museum of Fine Arts, Tochigi

174

Raining | wet heavy snow ice |
hollow snowball | hole | splitting
IZUMI-MURA, JAPAN
18 DECEMBER 1987

Primary frame:
1 Cibachrome photograph

74.8 × 75 (29⅜ × 29½)
framed 110.7 × 109.3 (43⅝ × 43)
Secondary frame:
Text, location, artist's name, date only
framed 22.5 × 32.6 (8⅞ × 12⅞)

175

Carved into slab of snow
IZUMI-MURA, JAPAN
19 DECEMBER 1987

Primary frame:
1 Cibachrome photograph
74.8 × 74.8 (29¾ × 29⅜)
framed 110.8 × 109.4 (43⅝ × 43)
Secondary frame:
1 Cibachrome photograph
25.5 × 25.5 (10 × 10)
framed 51.5 × 42.6 (20¼ × 16¾)

176

Bright sunny morning | frozen snow | cut
slab | carried carefully | scraped snow away
with a stick | just short of breaking through |
becoming warmer | melting
IZUMI-MURA, JAPAN
19 DECEMBER 1987

Primary frame:
1 Cibachrome photograph
74.8 × 75 (29⅜ × 29½)
framed 110.7 × 109.5 (43⅝ × 43⅛)
Secondary frame:
1 Cibachrome photograph
24 × 16 (9⅜ × 6¼)
framed 51.8 × 37.5 (20⅜ × 14¾)
Mountain 1988; *Sogetsu 1988* p. 85; *Geijutsu
Shincho 1988* p. 76; *Mizutani March 1988* p. 162;
Laws 1988 p. 45; *Viking 1990*
Tochigi Prefectural Museum of Fine Arts,
Tochigi; Nagoya City Art Museum, Nagoya

177

Snow slab arch | second attempt | lasted
several days | melting
IZUMI-MURA, JAPAN
19 DECEMBER 1987

Primary frame:
1 Cibachrome photograph
75 × 74.8 (29½ × 29⅜)
framed 110.6 × 109.3 (43½ × 43)
Secondary frame:
Text, location, artist's name, date only
framed 22.5 × 32.6 (8⅞ × 12⅞)
Mountain 1988

178

Leaves torn between the veins | stitched
together with pine needles | hung from
a tree | raining, calm, cold
IZUMI-MURA, JAPAN
20 DECEMBER 1987

Primary frame:
1 Cibachrome photograph
50.2 × 50.2 (19¾ × 19¾)
framed 80.2 × 79 (31½ × 31⅛)
Secondary frame:
1 Cibachrome photograph
25 × 25 (9⅞ × 9⅞)
framed 51.5 × 42.6 (20¼ × 16¾)
Mountain 1988

179

Torn leaves | leaving the veins | hung
from a tree | cold, calm, damp
IZUMI-MURA, JAPAN
21 DECEMBER 1987

Primary frame:
1 Cibachrome photograph
50.3 × 50.2 (19¾ × 19¾)
framed 80 × 79 (31½ × 31⅛)
Secondary frame:
1 Cibachrome photograph
25.3 × 25 (10 × 9⅞)
framed 51.5 × 42.6 (20¼ × 16¾)
Sogetsu 1988 p. 85; *Viking 1990*

180

Willow leaf patch
IZUMI-MURA, JAPAN
23 DECEMBER 1987

Primary frame:
1 Cibachrome photograph
50.1 × 50.2 (19¾ × 19¾)
framed 80.3 × 78.8 (31⅝ × 31)
Secondary frame:
1 Cibachrome photograph
25 × 26.5 (9⅞ × 10⅜)
framed 51.5 × 42.6 (20¼ × 16¾)

181

Worked in the early morning cold shadow of
mountain | sun rising | almost finished | two
pieces suddenly collapsed | weakened by the
sun | managed to replace them | working
quickly
IZUMA-MURA, JAPAN
24 DECEMBER 1987

Primary frame:
2 Cibachrome photographs
each 69 × 70 (27⅛ × 27½)
joined 69.7 × 142 (27⅜ × 55⅞)
framed 108.9 × 169.4 (42⅞ × 66⅝)
Secondary frame:
1 Cibachrome photograph
15.5 × 23.5 (6⅛ × 9¼)
framed 46.5 × 42.6 (18¼ × 16¾)
Mountain 1988; *Sogetsu 1988* p. 84; *Nakamura
1988* pp. 32–35; *Art and Design 1989* pp. 47–48;
Packer 1989 p. 28; *Graydon 1989* p. 99 left
section of work only
Nagoya City Art Museum, Nagoya

182

Slabs of frozen snow | the next piece
caused a collapse
IZUMI-MURA, JAPAN
24 DECEMBER 1987

Primary frame:
1 Cibachrome photograph
74.7 × 74.8 (29⅜ × 29⅜)
framed 110.7 × 109.3 (43⅝ × 43)
Secondary frame:
1 Cibachrome photograph
18 × 24 (7⅛ × 9⅜)
framed 46.5 × 42.6 (18¼ × 16¾)

183

Out early to work in the cold | a wall of
frozen snow | carved with a stick | almost

through to the other side | collapsed
in the sunlight
IZUMI-MURA, JAPAN
25 DECEMBER 1987

Primary frame:
1 Cibachrome photograph
74.8 × 75 (29⅜ × 29½)
framed 110.7 × 109.4 (43⅝ × 43)
Secondary frame:
1 Cibachrome photograph
23.3 × 15.5 (9⅛ × 6⅛)
framed 51.8 × 37.5 (20⅜ × 14¾)
Mountain 1988; *Viking 1990*; *Leeds 1990* p. 70

184
Flat frozen snow slab arch |
collected from around cherry trees
IZUMI-MURA, JAPAN
25 DECEMBER 1987

Primary frame:
2 Cibachrome photographs
each 59.7 × 59.6 (23½ × 23½)
framed 90.5 × 157.9 (35⅝ × 62⅛)
Secondary frame:
1 Cibachrome photograph
17 × 24 (6⅝ × 9⅜)
framed 46.5 × 42.6 (18¼ × 16¾)

185
Foggy | sun breaking through
just as I finished
IZUMI-MURA, JAPAN
27 DECEMBER 1987

Primary frame:
1 Cibachrome photograph
74.8 × 74.8 (29⅜ × 29⅜)
framed 110.7 × 109.7 (43⅝ × 43⅛)
Secondary frame:
1 Cibachrome photograph
24 × 16 (9⅜ × 6¼)
framed 51.8 × 37.5 (20⅜ × 14¾)
Mountain 1988; *Viking 1990*

186
Frozen snow | brought to a dome | leaving a
hole | second attempt | slipped and fell into
the first try | not a good moment
IZUMI-MURA, JAPAN
28 DECEMBER 1987

Primary frame:
1 Cibachrome photograph
75 × 75 (29½ × 29½)
framed 110.6 × 109.5 (43½ × 43⅛)
Secondary frame:
1 Cibachrome photograph
24 × 24 (9⅜ × 9⅜)
framed 51 × 42.5 (20 × 16¾)
Mountain 1988

187
Snow going | made a mountain snowball |
drove 2½ hours to the coast | warm and
sunny | no snow | left on tidal edge
IZUMI-MURA, JAPAN
28 DECEMBER 1987

Primary frame:
1 Cibachrome photograph

74.7 × 74.6 (29⅜ × 29⅜)
framed 110.6 × 109.5 (43½ × 43⅛)
Secondary frame:
1 Cibachrome photograph
25 × 25 (9⅞ × 9⅞)
framed 51.5 × 42.6 (20¼ × 16¾)
Mountain 1988

188
Balanced rocks | raining heavily |
strengthening wind
IZUMI-MURA, JAPAN
30 DECEMBER 1987

Primary frame:
1 Cibachrome photograph
74.8 × 74.9 (29⅜ × 29½)
framed 110.8 × 109.5 (43⅝ × 43⅛)
Secondary frame:
Text, location, artist's name, date only
framed 22.5 × 32.7 (8⅞ × 12⅞)
Mountain 1988; *Sogetsu 1988* p. 85; *Nakamura 1988* p. 35; *Packer 1989* p. 29; *Viking 1990*

1988

Nos. 189–195 were made in the Lake
District, a commission which was part of the
Artists in National Parks project organised
by the Department of the Environment
and Conoco (UK) Limited.

189
Bracken stalks | brought to a dome |
leaving a hole | raining
BORROWDALE, CUMBRIA
13 FEBRUARY 1988

Edition of 3
Primary frame:
75.5 × 75.5 (29¾ × 29¾)
framed 108.7 × 107.5 (42¾ × 42⅜)
Secondary frame:
1 Cibachrome photograph
25 × 25 (9⅞ × 9⅞)
framed 45 × 41.2 (17¾ × 16¼)
Lake District Guardian 1988 p. 24; *Viking 1990*
Conoco (UK) Limited

190
Clouds clear of the peaks | carved snow |
melting in the sun | windy | soon blown over
BLENCATHRA MOUNTAIN, CUMBRIA
15 FEBRUARY 1988

Edition of 3
Primary frame:
2 black and white photographs
each 36.8 × 58.4 (14½ × 23)
joined 40.6 × 101.6 (16 × 40)
framed 76.2 × 142.2 (30 × 56)
Secondary frame:
Text, location, artist's name, date only
framed 22 × 32 (8⅝ × 12⅝)
Department of the Environment

191
Slate throws
BLENCATHRA MOUNTAIN, CUMBRIA
19 FEBRUARY 1988

Edition of 3
5 frames
4 primary frames:
each containing 3 black and white photographs
each 31.7 × 48.2 (12½ × 19)
framed 60.9 × 195.6 (24 × 77)
Secondary frame:
Text, location, artist's name, date only
framed 22.9 × 31.7 (9 × 12½)
Leeds 1990 pp. 46–47
Department of the Environment; Whitworth Art
Gallery, University of Manchester

192
Calm | knotted seaweed stalks | stuck into
muddy lake bottom | ends pushed into
hollow stems to make screen
DERWENT WATER, CUMBRIA
20 FEBRUARY 1988

Edition of 3
Primary frame:
2 Cibachrome photographs
each 72.4 × 72.4 (28½ × 28½)
joined 74 × 140 (29⅛ × 55⅛)
framed 110 × 177 (43¼ × 69⅝)
Secondary frame:
1 Cibachrome photograph
16.5 × 24.1 (6½ × 9½)
framed 41.9 × 40.6 (16½ × 16)
Artists in National Parks 1988 p. 9; *Lake District
Guardian 1988* p. 24; *Redhead 1989* pp. 12–13;
Viking 1990
Conoco (UK) Limited

193
Slate | crack | hole | line
LITTLE LANGDALE, CUMBRIA
2 MARCH 1988

(not February 1988 as stated in *Viking*)
Edition of 3
Primary frame:
3 black and white photographs
each 71.1 × 45.7 (28 × 18)
joined 206.2 × 70.8 (81⅛ × 27⅞)
framed 236.2 × 83.8 (93 × 33)
Secondary frame:
Text, location, artist's name, date only
framed 22.9 × 31.7 (9 × 12½)
Aperto 88 p. 262; *Nesbitt Alba 1989* p. 56;
Viking 1990
Department of the Environment

194
Out early to work the morning calm |
knotweed stalks | half a hole | made complete
by its own reflection | second attempt |
became windy on the first try
DERWENT WATER, CUMBRIA
8 MARCH 1988

Edition of 3
Primary frame:
1 Cibachrome photograph
73.6 × 73.6 (29 × 29)
framed 110.5 × 110.5 (43½ × 43½)

Secondary frame:
1 Cibachrome photograph
16.5 × 24.1 (6½ × 9½)
framed 41.9 × 40.6 (16½ × 16)
Britannica 1988 p. 128; *Artists in National Parks
1988* cover; *Countryside Commission News 1988*;
Redhead 1989 cover; *Brown 1989* p. 97; *Alberge
1989* p. 43; *Viking 1990*
Department of the Environment

195
Early morning | calm | knotted stalks | began
to rain just after I finished
**DERWENT WATER, CUMBRIA
9 MARCH 1988**

Edition of 3
Primary frame:
2 Cibachrome photographs
each 69 × 69.5 (27⅛ × 27⅜)
joined 72 × 131.5 (28⅜ × 51¾)
framed 110.5 × 178 (40 × 70⅛)
Secondary frame:
1 Cibachrome photograph
16 × 24 (6¼ × 9½)
framed 46.5 × 42.5 (18¼ × 16¾)
Laws 1988 pp. 42–43; *Barbican 1989* p. 164;
Viking 1990
The Countryside Commission

Nos. 196–200 were made in the overgrown
garden of Centre d'Art Contemporain,
Castres, France.

196
Leaves | polished to catch the light | creased
and folded | pinned with thorns
**CENTRE D'ART CONTEMPORAIN, CASTRES
18 OCTOBER 1988**

Edition of 3
Primry frame:
1 Cibachrome photograph
50.5 × 50.5 (19⅞ × 19⅞)
framed 83.5 × 81 (32⅞ × 31⅞)
Secondary frame:
1 Cibachrome photograph
25 × 25 (9⅞ × 9⅞)
framed 52 × 47 (20½ × 18½)
Garden Mountain 1989; *Withers 1989*

197
Iris blades | pinned with thorns | hung from
a tree | second attempt
**CENTRE D'ART CONTEMPORAIN, CASTRES
21, 22 OCTOBER 1988**

Edition of 3
Primary frame:
1 Cibachrome photograph
75.9 × 75.9 (29⅞ × 29⅞)
framed 111.7 × 109.2 (44 × 43)
Secondary frame:
1 Cibachrome photograph
24.8 × 25.8 (9¾ × 10⅛)
framed 52 × 47 (20½ × 18½)
Garden Mountain 1989

198
Out early | reworked iris blades | catching
the first light to reach into the garden

**CENTRE D'ART CONTEMPORAIN, CASTRES
23 OCTOBER 1988**

Edition of 3
Primary frame:
1 Cibachrome photograph
75.5 × 75.5 (29¾ × 29¾)
framed 111.7 × 109 (44 × 42⅞)
Secondary frame:
1 Cibachrome photograph
25 × 25 (9⅞ × 9⅞)
framed 52 × 47 (20½ × 18½)
Garden Mountain 1989; *Viking 1990*

199
Two leaves thick | leaving a gap of single
leaves | stitched with thorns
**CENTRE D'ART CONTEMPORAIN, CASTRES
25 OCTOBER 1988**

Edition of 3
1 frame
2 Cibachrome photographs
59.3 × 41.8 and 58.4 × 41.8
(23⅜ × 16½ and 23 × 16½)
joined 114.5 × 41.8 (45⅛ × 16½)
framed 150.8 × 74.9 (59⅜ × 29½)
Garden Mountain 1989; *Viking 1990*

200
Plane leaves | doubled up with one
section removed
**CENTRE D'ART CONTEMPORAIN, CASTRES
26 OCTOBER 1988**

Edition of 3
1 frame
2 Cibachrome photographs
each 61 × 49 (24 × 19½)
joined 113.4 × 49 (45 × 19½)
framed 149.9 × 82.5 (59 × 32½)
Garden Mountain 1989

1989

201
Leaf throws
**BLAIRGOWRIE, TAYSIDE
3 JANUARY 1989**

4 primary frames
each containing 3 black and white photographs
each 32.5 × 49 (12¾ × 19¼)
framed 68.5 × 201.9 (27 × 79½)
Secondary frame:
Text, location, artist's name, date only
framed 22 × 32 (8⅝ × 12⅝)
Leeds 1990 pp. 48–49

Nos. 202–222 were made in the Arctic,
a project organised by Fabian Carlsson
Gallery, London.

202
Blocks of snow | carved and stacked |
occasional collapse | feeling the cold
**GRISE FIORD, ELLESMERE ISLAND
23 MARCH 1989**

1 frame
1 Cibachrome photograph

90 × 90 (35⅜ × 35⅜)
framed 125.5 × 124.5 (49⅜ × 49)
Touching North 1989; *Lewis 1989* p. 13;
Juncosa 1989 p. 61; *Ikebana Ryusei 1990* p. 19.

203
Balanced snow | becoming too heavy in
places | collapsing and rebuilding | overcast |
revisited the following day | sunny
**GRISE FIORD, ELLESMERE ISLAND
24, 25 MARCH 1989**

2 primary frames:
each containing 2 Cibachrome photographs
each 48 × 87 (19 × 34¼)
joined 48 × 169.5 (19 × 66¾)
framed 83 × 204 (32⅝ × 80¼)
Secondary frame:
2 Cibachrome photographs
each 16 × 24 (6¼ × 9½)
framed 61.5 × 41 (24¼ × 16⅛)
Touching North 1989; *Howell 1989* p. 158;
Juncosa 1989 pp. 62–63; *Ikebana Ryusei 1990*
p. 19

204
Drifting snow | carved into snow | in the
direction of the wind | becoming calm
as I finished
**GRISE FIORD, ELLESMERE ISLAND
26 MARCH 1989**

Primary frame:
1 Cibachrome photograph
56.5 × 121 (22¼ × 47⅝)
framed 90 × 150 (35⅜ × 59)
Secondary frame:
1 Cibachrome photograph
16 × 24 (6¼ × 9½)
framed 41 × 41 (16⅛ × 16⅛)
Touching North 1989

205
Stacked snow | made as tall as I could reach |
below cliffs where gulls nest in summer |
soon collapsed
**GRISE FIORD, ELLESMERE ISLAND
28 MARCH 1989**

1 frame
1 Cibachrome photograph
73 × 99.5 (28¾ × 39⅛)
framed 108 × 133 (42½ × 52⅜)
Touching North 1989; *Ikebana Ryusei 1990* p. 20

206
Snow brought to an edge
**GRISE FIORD, ELLESMERE ISLAND
29 MARCH 1989**

1 frame
1 Cibachrome photograph
90 × 90 (35⅜ × 35⅜)
framed 125 × 124.5 (49¼ × 49)
Touching North 1989; *Ikebana Ryusei 1990* p. 20

207
Snow slabs | stood on end | for the wind
**GRISE FIORD, ELLESMERE ISLAND
30 MARCH 1989**

1 frame
1 Cibachrome photograph

52 × 100 (20½ × 39⅜)
framed 86 × 135 (33⅞ × 53⅛)
Touching North 1989; *L'Autre Journal 1989*
pp. 88–89; *Viking 1990*

208
Stacked snow | hollow inside
GRISE FIORD, ELLESMERE ISLAND
30, 31 MARCH 1989

Primary frame:
1 Cibachrome photograph
101 × 75.5 (39¾ × 29¾)
framed 136 × 109 (53½ × 42⅞)
Secondary frame:
1 Cibachrome photograph
16 × 24 (6¼ × 9½)
framed 41 × 41 (16⅛ × 16⅛)
Graham-Dixon June 1989 p. 48; *Watkins 1989*
p. 71; *Ikebana Ryusei 1990* p. 21

209
Snow | stood on end | facing south |
for the sun
GRISE FIORD, ELLESMERE ISLAND
31 MARCH 1989

1 frame
4 Cibachrome photographs
each 30.5 × 49.5 (12 × 19½)
joined 30.5 × 188 (12 × 74)
framed 66 × 228.5 (26 × 90)
Touching North 1989

210
Snow wall | cut into | not quite reaching
the other side | becoming translucent
GRISE FIORD, ELLESMERE ISLAND
2 APRIL 1989

Primary frame:
1 Cibachrome photograph
75 × 75 (29½ × 29½)
framed 110 × 109 (43¼ × 42⅞)
Secondary frame:
1 Cibachrome photograph
16 × 24 (6¼ × 9½)
framed 41 × 41 (16⅛ × 16⅛)
Touching North 1989; *Nesbitt 1990* p. 50;
Ikebana Ryusei 1990 p. 21

211
Five arches | used blocks of snow as steps to
reach up | bent over by the wind during the
following two weeks
GRISE FIORD, ELLESMERE ISLAND
3 APRIL 1989

Primary frame:
1 Cibachrome photograph
98 × 73 (38⅝ × 28¾)
framed 133 × 107 (52⅜ × 42⅛)
Secondary frame:
1 Cibachrome photograph
16 × 24 (6¼ × 9½)
framed 41 × 41 (16⅛ × 16⅛)
Touching North 1989; *Beaumont 1989* p. 545;
L'Autre Journal 1989 p. 88; *Ikebana Ryusei*
1990 p. 21

212
Eight slabs of snow | made into a wall |
marked into towards the sun

GRISE FIORD, ELLESMERE ISLAND
3 APRIL 1989

Primary frame:
1 Cibachrome photograph
75 × 75 (29½ × 29½)
framed 110 × 109 (43¼ × 42⅞)
Secondary frame:
1 Cibachrome photograph
16 × 24 (6¼ × 9½)
framed 41 × 41 (16⅛ × 16⅛)

213
Cold wind | work partly collapsed |
difficult day | Looty encouraging me on
GRISE FIORD, ELLESMERE ISLAND
5 APRIL 1989

1 frame
1 Cibachrome photograph
75 × 75 (29½ × 29½)
framed 110 × 109 (43¼ × 42⅞)
Touching North 1989; *Juncosa 1989* p. 61;
Christie's 1989 p. 137 additional secondary
Cibachrome; *Ikebana Ryusei 1990* p. 22

214
Snow drift | carved into | waiting
for the wind
GRISE FIORD, ELLESMERE ISLAND
5 APRIL 1989

1 frame
1 Cibachrome photograph
100 × 77.5 (39⅜ × 30½)
framed 136 × 109 (53½ × 42⅞)
Touching North 1989

215
Began working out in the Fiord | too windy |
snow wall blew down | moved nearer cliffs |
more sheltered but snow not as strong | icy,
crumbly | sunny | became overcast | gave up |
sun breaking through | finished the work |
just catching the sun before it went down
behind | cloud and mountain
GRISE FIORD, ELLESMERE ISLAND
5 APRIL 1989

1 frame
1 Cibachrome photograph
100.5 × 75.5 (39½ × 29¾)
framed 136 × 109 (53½ × 42⅞)
Touching North 1989

216
Soft snow | brought to an edge | hand packed |
froze hand | remaining until winds came |
covered by drifting snow
GRISE FIORD, ELLESMERE ISLAND
11, 12 APRIL 1989

Primary frame:
2 Cibachrome photographs
each 74 × 50 (29⅛ × 19⅝)
joined 154.8 × 82 (60⅞ × 32¼)
framed 184 × 104 (72⅜ × 40⅞)
Secondary frame:
2 Cibachrome photographs
each 16 × 24 (6¼ × 9½)
framed 40 × 70 (15¾ × 27½)
Touching North 1989

217
Carved snow
GRISE FIORD, ELLESMERE ISLAND
12 APRIL 1989

Primary frame:
2 Cibachrome photographs
each 58 × 59.5 (22⅞ × 23⅜)
joined 58 × 118.5 (22⅞ × 46⅝)
framed 92.5 × 152.5 (36⅜ × 60)
Secondary frame:
1 Cibachrome photograph
16 × 24 (6¼ × 9½)
framed 41 × 41 (16⅛ × 16⅛)
Touching North 1989

218
In the direction of the wind
GRISE FIORD, ELLESMERE ISLAND
13 APRIL 1989

Primary frame:
1 Cibachrome photograph
77.5 × 100.5 (30½ × 39½)
framed 110 × 134.5 (43¼ × 53)
Secondary frame:
1 Cibachrome photograph
16 × 24 (6¼ × 9½)
framed 41 × 41 (16⅛ × 16⅛)
Touching North 1989; *Graham-Dixon*
June 1989 p. 48

219
Snow spires | used blocks of snow as steps
to reach the tip | started in the morning
finished in the evening | marking
the journey of four
GRISE FIORD, ELLESMERE ISLAND
14, 15 APRIL 1989

Primary frame:
2 Cibachrome photographs
each 58 × 86 (22⅞ × 33⅞)
framed 93 × 216 (36⅝ × 85)
Secondary frame:
1 Cibachrome photograph
24 × 16 (9½ × 6¼)
framed 49 × 33 (19¼ × 13)
Touching North 1989; *Shulman 1989* p. 424;
Graham-Dixon June 1989 p. 49; *Lee 1989*;
L'Autre Journal 1989 p. 90; *Viking 1990*

220
Slits in snow | catching the sun and wind |
blown down by a strong gust
GRISE FIORD, ELLESMERE ISLAND
15 APRIL 1989

Primary frame:
2 Cibachrome photographs
each 48.5 × 76.2 (19⅛ × 30)
joined 48.5 × 136.5 (19⅛ × 53¾)
Secondary frame:
2 Cibachrome photographs
each 16 × 24 (6¼ × 9½)
framed 41 × 71 (16⅛ × 28)
Touching North 1989; *Graham-Dixon June 1989*
p. 49; *L'Autre Journal 1989* pp. 90–91

221

Stacked snow cone | sunny all day | storm blowing up on the horizon as I finished | becoming windy and overcast on the way back

GRISE FIORD, ELLESMERE ISLAND
16 APRIL 1989

Primary frame:
1 Cibachrome photograph
98.5 × 73 (38¾ × 28¾)
framed 133 × 107 (52⅜ × 42⅛)
Secondary frame:
1 Cibachrome photograph
24 × 16 (9½ × 6¼)
framed 49 × 33 (19¼ × 13)
Touching North 1989; *Howell 1989* p. 157; *Henry 1989* p. 14; *Juncosa 1989* p. 60; *L'Autre Journal 1989* p. 91; *Watkins 1989* pp. 69, 71; *Nesbitt 1990* p. 51

222

Touching North

NORTH POLE
22, 23, 24 APRIL 1989

Edition of 10
4 primary frames:
4 Cibachrome photographs
each 83.7 × 118.7 (33 × 46¾)
each framed 116.2 × 147.5 (45¾ × 58)
Secondary frame:
1 Cibachrome photograph
26.3 × 39.1 (6¼ × 9½)
framed 51 × 56 (20⅛ × 22)
Touching North 1989; *Graham-Dixon June 1989* pp. 46–47; *Business 1989* p. 22; *BBC Wildlife 1989* p. 475; *Howell 1989* p. 158; *Juncosa 1989* p. 61; *Watkins 1989* p. 71; *Ikebana Ryusei 1990* p. 16; *Viking 1990*; *Leeds 1990* pp. 74–75

Nos. 223–227 were made in the Sidobre, an area of hilly and wooded parkland some 15 kilometres from Castres, France.

223

Beech leaves | torn in two | pressed onto poppy petals | leaving a gap

SIDOBRE
1 JUNE 1989

Edition of 3
Primary frame:
4 Cibachrome photographs
each 24 × 15.6 (9⅜ × 6⅛)
joined 86 × 17.5 (33⅞ × 6⅞)
framed 117.4 × 44.4 (46¼ × 17½)
Garden Mountain 1989

224

Grass blades | pinned with thorns to a raft of stalks | floating on a slow moving river pool

SIDOBRE
2 JUNE 1989

Edition of 3
Primary frame:
1 Cibachrome photograph
60.3 × 60.3 (23¾ × 23¾)
framed 96 × 94 (37¾ × 37)
Secondary frame:
1 Cibachrome photograph
25 × 25 (9⅞ × 9⅞)
framed 52 × 47 (20½ × 18½)
Garden Mountain 1989

225

Stacked sticks | dark overcast raining

SIDOBRE
3 JUNE 1989

Edition of 3
1 frame
1 Cibachrome photograph
90.8 × 90.8 (35¾ × 35¾)
framed 126.8 × 124 (49⅞ × 48¾)
Garden Mountain 1989

226

Overcast cold | upturned leaves | laid in a line on bracken

SIDOBRE
4 JUNE 1989

Edition of 3
1 frame
2 Cibachrome photographs
each 74 × 75.8 (29¼ × 29⅞)
joined 146 × 75.8 (57½ × 29⅞)
framed 183.5 × 109 (72¼ × 42⅞)
Garden Mountain 1989; *Singular Vision 1989* p. 6

227

Poppy petals | wrapped around a granite boulder | held with water

SIDOBRE
6 JUNE 1989

Edition of 3
Primary frame:
1 Cibachrome photograph
92 × 60.8 (36¼ × 23⅞)
framed 127 × 94 (50 × 37)
Secondary frame:
1 Cibachrome photograph
24 × 15.8 (9⅜ × 6¼)
framed 51 × 38 (20¼ × 15¼)
Garden Mountain 1989; *Viking 1990*

228

JARDIN MASSEY, TARBES
AUGUST 1989

Edition of 3
Primary frame:
1 Cibachrome photograph
50.5 × 50.5 (19⅞ × 19⅞)
framed 83.5 × 81 (32⅞ × 31⅞)
Secondary frame:
1 Cibachrome photograph
25 × 25 (9⅞ × 9⅞)
framed 52 × 47 (20½ × 18½)
Garden Mountain 1989 cover; *Viking 1990*

Errata
Nos. 202–221 were made in an edition of 7.

Notes

Cat no. refers to works in the Catalogue Raisonne of Photographs 1977–1989 (pp. 169–87).

1. Quoted in *Laws 1988*, p. 44.
2. Quoted in *Aspects 1986*.
3. Quoted in *Causey 1980*.
4. Quoted in *Rain 1985*, p. 4.
5. Quoted in *Sinden 1988*, p. 28.
6. Quoted in *Baginsky 1989*.
7. Quotations, except where indicated, are from conversations with the artist, September 1989–January 1990.
8. A test then taken by English children at the age of eleven to determine what type of secondary school they might enter.
9. *Rain 1985*, p. 4.
10. An artificial earthwork in the form of a spiral built out into the Great Salt Lake at Rozel Point, Utah, in 1970 (R. Hobbs, *Robert Smithson: Sculpture*, 1981, pp. 191–97).
11. Goldsworthy saw illustrations of both the Smithson and Beuys works in G. Muller, *The New Avant Garde*, 1972.
12. 'Image' is not the correct word, since, unless we are speaking of the photograph only, it is emphatically not an image of anything; but configurations, which would be more precise, I find inelegant.
13. For instance, *cat. no.* 161.
14. *Beeldhouwerssymposium in de Haarlemmerhout*, Frans Hals Museum, Haarlem, 1986. See *cat. nos.* 86–89 for the Haarlemmerhout works.
15. *Rain 1985*, pp. 6–7.
16. Artist's statement, March 1987.
17. Goldsworthy was filmed making these works by Howard Perks, a producer for BBC's 'Art Exchange', for BBC South West.
18. From *Morland 1988*, pp. 40–47.
19. Sketchbook 13. Goldsworthy comments on the project in *Sinden 1988*, pp. 28–29. The exhibition *Between Trains* was held in May 1986 at St Paul's Gallery, Leeds. A photograph (*cat. no.* 109), a leafwork, drawings and documentary photographs for the project are in The Henry Moore Centre for the Study of Sculpture.
20. Unpublished notes.
21. Unpublished notes.
22. Quoted in *Leaves Andy Goldsworthy*, 1989, p. 18. This publication, which illustrates twenty-two of the permanent leafworks exhibited at The Natural History Museum, London, includes a discussion by Nesbitt (pp. 8–16) on the properties of leaves and Goldsworthy's use of them. Other leafworks discussed in the present essay are illustrated in *Rain 1985*, *Parkland 1988*, *Mountain and Coast 1988*, *Garden Mountain 1989*. For uniformity, the editors have given the common names of plants in lower case only, though a botanist would prefer the use of upper and lower case.
23. Unless otherwise indicated, quotations in the present essay are from previously unpublished conversations with the artist.
24. *Cat. no.* 88.
25. *Nesbitt 1988*, pp. 24–25.
26. This image was published as a card by Common Ground to record his residency there.
27. Leeds City Art Galleries collection.
28. *Fowles 1987*, end-plate.
29. *Cat. no.* 160.
30. Reprinted from *Andy Goldsworthy Snowballs in Summer Installation*, 1989.
31. Quoted in *Davies 1984*, p. 151.
32. D. H. Lawrence, *The Rainbow*, 1959, p. 98.
33. Richard Long talking to Martina Griezen, in *Richard Long in Conversation*, 1986, part 2, p. 7.
34. Andy Goldsworthy, unpublished notes, December 1988.
35. See H. Moore, 'Sculpture in the Open Air', 1955, in P. James, ed., *Henry Moore on Sculpture*, 1966, p. 99.
36. Carl Andre in *Avalanche*, 1, Fall, 1970.
37. Quoted in D. Bourdon, 'The Razed Sites of Carl Andre', *Artforum*, 2 October 1966.
38. Quoted by C. Hussey in the introduction to D. Stroud, *Capability Brown*, 1975, p. 31.
39. Parts of this essay are based on conversations with the artist at Penpont during 1988, 1989 and 1990, as well as two undated letters written in February 1990 (The Henry Moore Centre for the Study of Sculpture archives).
40. Ordnance Surveys: Sanquhar Sheet NS60/70 (Pathfinder 493) and Thornhill Sheet NX89/90 (Pathfinder 505).
41. This work, like some astrologer's diagram of the movements of heavenly bodies, recalls the continuous grass stalk line held to mud-covered rocks with thorns, made at Swindale Beck Wood, 10 December 1984 (*cat. no.* 95) and a similar work, lodged within a clipped-hedge niche on the formal terrace of the Yorkshire Sculpture Park, March 1987.
42. *Cat. nos.* 23, 24, 77.
43. The formidable role of light in Goldsworthy's outdoor sculptures is evident from the following entry: *Bright, cold, sunny a jewel of a day. Bitterly disappointed at ice ball being smashed overnight by some body I don't mind things going once they have reached their peak but today's atmosphere and light would have turned a good work into a fantastic one* (Hampstead Heath, Sketchbook 13: 29 December 1985).
44. This and some other photographs described in the present essay are also reproduced in *Viking 1990*.
45. *Cat. no.* 64. The text reads: *Swindale — up river — walked up the river became totally icebound — the river suddenly noises stopped — so quiet & tense. On the way back an owl silently flew from the cliff. The silent flight of an owl along the silent river. Broken icicles stuck welded either side of a rock* (Sketchbook 4: 14 January 1982).
46. Descriptions of these sculptures are based on texts accompanying three of a special set of seven photographs issued

annually between 1987 and 1991 to the subscribers invited by Common Ground in 1987 to fund the building of *Stone Wall* (Sue Clifford and Angela King, Common Ground, Fabian Carlsson, John Fowles, Terry Friedman, Ann Hartree, Rupert and Liz Nabarro, Colin Renfrew, Jenny Wilson, Angus Wolfe-Murray).

47. *Rain 1985*, p. 5.

48. *Parkland 1988*, dated 20 February 1987.

49. Evident in photographs taken during construction (*Nesbitt 1989*, p. 55).

50. 'The wall . . . has a practical, spiritual and social purpose . . . I no longer do residencies or teach. If I have social needs then it has shifted to be worked out in my art itself.' Goldsworthy had earlier considered laying a large slab punctured by a hole against the crippled trunk of the oak (Sketchbook 19). Another scheme calls for a formal entrance to Stone Wood in the shape of a stone-walled, serpentine passage *leading to the major burnt oak possibly [with] trees planted in each corner* (Sketchbook 19: February–April 1988).

51. Just as Dr Pococke, visiting nearby Drumlanrig on 17 July 1750, 'passed by a mount to the left [of the Nith], much like a Danish fort, now planted by the duke [of Buccleuch]', in J. J. Cartwright, ed., *The Travels Through England of Dr. Richard Pococke, Successively Bishop of Meath and Ossory, During 1750, 1751, and Later Years*, The Publications of the Camden Society, 1889, I, p. 25. Goldsworthy writes that the Monuments represent a 'realisation of time in nature progressing at many levels. Different materials have different time scales — the time scale for a leaf is different to that of a rock. I want to make work that reflects these movements in time. The land has been laid in layers over thousands of years — of growth, people, animals . . . The land is an expression of its past — the past is invariably drawn into my work through the materials I use and the places I work in. I am not trying to recreate the past — the monuments are not follies — they are of today but are affected by what has gone before. I have fed off these layers and I feel a deep need to put something back.'

52. *Rain 1985*, p. 4.

53. G. Stell, *Exploring Scotland's Heritage: Dumfries and Galloway*, 1986, pp. 122–23, no. 47.

54. Two permanent sculptures, *Tree Spires* and *Sidewinder*, were made in Grizedale Forest in 1984–85 (see essay by Causey).

55. *Rain 1985*, p. 4.

56. *Cat. nos.* 74, 75; *Rain 1985*, pp. 48–49. Goldsworthy returned to this theme in 1988 at Penpont (Sketchbook 20).

57. *went to collect graphite — amazing to see it lying on the side of a mountain in its raw state but good enough to draw with* (Borrowdale, Cumbria; Sketchbook 19: 3 March 1988). 'A development/progression is emerging where I make discoveries, often away from home and on my return pursuing and intensifying that discovery. Drawings done with blood and snow in the Arctic are now developing into drawings made with snow

and berries and earth. Where the snow is collected is important — a recent snowfall left Tynron Doon white — I climbed up — gathered snow — brought it back and mixed with elder berries collected the previous autumn. The snow ball will melt into a sheet of paper. These drawing do not just represent the place — they *are* that place.' The above drawing is illustrated on the title page of the present publication.

58. For example, Dun Garloway on the western isle of Lewis, which incorporates an integral staircase (G. Daniel and P. Bahn, *Ancient Places: The prehistoric and Celtic sites of Britain*, 1987, pp. 74–75).

59. The transcript, kindly supplied by the BBC, has had minor grammatical adjustments for purposes of clarity.

Bibliography

The Henry Moore Centre for the Study of Sculpture holds copies of the published writings by and on Andy Goldsworthy.

1980

A. Causey, *Nature as Material* (Arts Council of Great Britain) 1980

1981

M. Strickland-Constable, *Summer Shows 1981*, 1 (Serpentine Gallery, London) 1981

1982

N. Hanson, ed., *Presence of Nature* (Carlisle Museum and Art Gallery) 1982

1984

J. Beardsley, *Earthworks and Beyond: Contemporary Art in the Landscape*, 1984, pp. 50–53, 134 (expanded 1989)

P. Davies and T. Knipe, eds., *A Sense of Place: Sculpture in Landscape*, 1984, pp. 150–51

R. Mabey, ed., *Second Nature*, 1984

Subscribe (MN8, Press Noordwijk) 1984

'£4,000 Bursary for Sculptor', *Cumberland and Westmorland Herald*, 7 January 1984

A. McGill, 'Portrait of the artist as a bent twig', *The London Standard*, 22 January 1984

1985

P. Buchanan, *Spirits of the Forest*, 1985

Rain sun snow hail mist calm: Photoworks by Andy Goldsworthy (The Henry Moore Centre for the Study of Sculpture, Leeds City Art Gallery and Northern Centre for Contemporary Art, Sunderland) 1985

Impulse 8 (Galerie Lohrl, Monchengladbach) 1985

City Limits, 2–8 August 1985, p. 69

'Bisen und Bierflaschen', *Rhein Post*, 24 October 1985

R. Cork, 'Paying the price', *The Listener Guide*, 9 December 1985

M. Hutchinson, 'So follow him, follow him, down to the hollow', *The Hampstead and Highgate Express*, 13 December 1985

1986

S. Kent, 'Art selections and reviews', *Time Out*, 19 December 1985–1 January 1986

M. Currah, 'Visual Arts', *City Limits*, 20 December 1985–2 January 1986, p. 92

Land Matters (Blackfriars Arts Centre, Lincoln) 1986

Beeldhouwerssymposium in de Haarlemmerhout (Frans Hals Museum, Haarlem) 1986

W. Januszczak, 'The Heath Robinson', *The Guardian*, 5 January 1986

M. Dobson, 'Breath of fresh air', *The New Statesman*, 10 January 1986

D. Lee, 'Photography', *Arts Review*, 17 January 1986, pp. 8–9

A. Burns, 'Art', *Lam*, 21 January 1986

M. Garlake, 'Andy Goldsworthy', *Art Monthly*, No. 93, February 1986, p. 19

W. T. Oliver, 'A natural at work', *The Yorkshire Post*, 24 February 1986

B. Hopkins, 'Andy Goldsworthy', *Leeds Student*, March 1986

N. Khan, 'Beating nature', *Arts Express*, No. 25, March 1986, pp. 12–13

J. Stathatos, 'Andy Goldsworthy's Evidences', *Creative Camera*, No. 255, March 1986, pp. 10–11

Artists Newsletter, April 1986, p. 6

'Andy Goldsworthy Hampstead Heath', *Aspects*, No. 23, Spring 1986

Earthlife News, No. 5, Summer 1986

J. Morland, 'New Milestone Project', *Link*, May–June 1986

J. Partridge, 'Forest Work', *Craft*, No. 81, July–August 1986, pp. 16–23

T. Passes, 'Rain sun snow hail mist calm', *Venue Magazine*, 29 August–11 September 1986, p. 39

1987

The Unpainted Landscape (Scottish Arts Council, Coracle Press, Graeme Murray Galley) 1987

Perspectives: Glasgow — A New Look (Collins Gallery, University of Strathclyde) 1987

A. Goldsworthy and J. Fowles, *Winter Harvest* (The Scottish Arts Council) 1987

C. Turnbull, 'Beautiful Behaviour: The photoworks of Andy Goldsworthy', *The Green Book*, Vol. 2, No. 6, 1987, pp. 14–16

M. Dobson, 'Shared sentiments', *BBC Wildlife*, January 1987

W. Bishop, 'A Corporate Collection', *The British Journal of Photography*, 12 June 1987, p. 681

S. Howell, 'Kingdom of the Ice Man', *Observer Magazine*, 28 June 1987, p. 55

C. Brown, 'Natural Arts', *The Magazine*, July 1987

J. Norrie, 'Andy Goldsworthy', *Arts Review*, 3 July 1987, p. 453

W. Januszczak, 'The magic of ice works', *Arts Guardian*, 7 July 1987

W. Packer, 'Sculpture from the countryside', *The Financial Times*, 7 July 1987

C. Henry, 'A style with natural life', *The Glasgow Herald*, 21 August 1987

D. Lee, 'Great art of the outdoors', *Country Life*, 27 August 1987, p. 75

C. Andreae, 'Art shaped by the weather', *The Christian Science Monitor*, 21–27 September 1987

C. Henry, 'Lumps of the landscape', *The World of Interiors*, October 1987, pp. 218–21

J. May, 'Landscape Fired by Ice', *Landscape*, December 1987, pp. 38–39

'Investigate the beauty of nature with ice and snow in Fukui', *Nikkan Fukui*, 20 December 1987

1988

J. Morland, *New Milestones: Sculpture, Community and the Land* (Common Ground) 1988, pp. 40–47

C. Grenier, F. Cohen, L. Cooke and F. Mirotchnikoff, *Britannia. Trent Ans de Sculpture* (Musée des Beaux-Arts André Malraux, Le Harve) 1988, pp. 128–31, 252

Parkland Andy Goldsworthy (Yorkshire Sculpture Park) 1988

S. Oshima, T. Friedman and F. Nanjo, *Andy Goldsworthy Mountain and Coast Autumn into Winter Japan 1987* (Gallery Takagi, Nagoya) 1988

La Biennale di Venezia, Aperto 88, 1988

Camoflage (Scottish Arts Council) 1988

Lancashire South of the Sands: The Contemporary Landscape (Towneley Hall Art Gallery and Museums) 1988

Artists in National Parks (Department of the Environment and Conoco (UK) Ltd.) 1988

'Andy's commission bound for V&A', *Lake District Guardian*, 1988, p. 24

T. Sakurai, 'Here comes the gold light', *Ikebana Ryusei*, No. 10, January 1988, pp. 32–35

'Joyful art from nature: Mr Goldsworthy from Scotland', *Fukui Shimbun*, 10 January 1988, p. 12

'Conversation with nature', *Asahi Shimbun*, No. 3, 18 January 1988

'Creation in nature with nature', *Chunichi Shimbun*, 28 January 1988

T. Mizutani, 'Close relation with nature', *Mainichi Shimbun* (evening edition), 29 January 1988

'Andy Goldsworthy at Gallery Takagi, Nagoya', *Asahi Shimbun*, No. 17 (evening edition), 30 January 1988

'Art with the landscape', *Asahi Shimbun*, No. 18 (evening edition), 30 January 1988

P. Buchanan, 'The Nature of Goldsworthy', *The Architectural Review*, February 1988, p. 74

T. Sakurai, 'Goldsworthy with snow', *Ikebana Ryusei*, February 1988, pp. 16–19

'Nature is all', *Asahi Camera*, No. 12, February 1988, p. 10

'Canvas is the earth', *Hi Fashion*, February 1988, p. 157

'Artist changing himself with the change of nature', *Sogetsu*, Vol. 176, February 1988, pp. 81–85

Y. Ishii, 'Creating beauty from nature', *Chubu Yomiuri Shimbun*, No. 21, 2 February 1988

K. Matsui, 'Column People', *Ashai Shimbun*, 3 February 1988

D. Archibald, 'Andy's unique view of nature takes him round the world', *The Dumfries and Galloway Standard*, 3 February 1988

'Making art with the nature of Japan', *Pia*, No. 21, 5 February 1988, p. 225

L. Talbot, 'Fleeting beauty from the elements forger', *The Hampstead and Highgate Express*, 12 February 1988

'Conversation with nature', *Brutus*, No. 14, 15 February 1988, p. 101

T. Mizutani, 'Conversation with nature', *Bijutsu Techo*, March 1988, pp. 162–63

'Andy Goldsworthy', *Nikkei Trendy*, March 1988, p. 80

K. Iizawa, 'Earth Work', *Studio Voice*, March 1988, pp. 46–47

Materials are the snow, flower, wind: Goldsworthy', *Geijutsu Shincho*, March 1988, pp. 76–77

A. Graham-Dixon, 'Turning over an old leaf', *The Independent*, 1 March 1988

H. Nakamura, 'Andy Goldsworthy and Anthony Green', *Ikebana Ryusei*, No. 38, April 1988, pp. 32–35

'Timeless images from ice and leaves', *Conoco World*, April 1988, p. 15

A. Dumas, 'Andy Goldsworthy at Fabian Carlsson Gallery', *Art in America*, May 1988, pp. 194–95

'An artist for all Seasons: In touch with Environment', *3i's House Magazine*, No. 10, May 1988

R. Martin, 'Andy Goldsworthy at Fabian Carlsson Gallery, London', *Flash Art*, May-June 1988, p. 112

J. Steele, 'In a Natural Mould', *Farmers Weekly*, 13 May 1988, pp. 8–9

'Des tableaux bio-dégradables: gardez bien la photo', *Actual*, Nos. 109–10, June–July 1988

E. Hilliard, 'In tribute to the wild bunch', *The Independent*, 22 June 1988

N. Sinden, 'Interview: Art in Nature Andy Goldsworthy', *Resurgence*, No. 129, July–August 1988, pp. 28–31

G. Hughes, 'Artists in Parks', *Arts Review*, 15 July 1988, p. 504

C. Henry, 'Artist in Love with Nature Puts Down Roots', *The Glasgow Herald*, 19 July 1988

'Parks art goes on tour', *Countryside Commission News*, No. 33, September–October 1988

'Leafing Through works of art', *The Yorkshire Post*, 8 September 1988

C. Henry, 'Goldsworthy at Work or Paving the Way', *Artline*, Vol. 14, No. 33, October–November 1988

B. Laws, 'Where Art and Nature Meet', *The Telegraph Weekly Magazine*, 12 November 1988, pp. 42–47

D. Archibald, 'Art forms fashioned with the help of Mother Nature', *The Dumfries and Galloway Standard*, 18 November 1988

'Parkland', *Architects Journal*, 30 November 1988, p. 83

'Natural elements highlight artist's work', *Conoco World*, Vol. 11, No. 12, December 1988, p. 8

1989

'40 Under 40: The New Generation in Britain', *Art & Design*, Vol. 5, Nos. 3–4, 1989

The Coracle (Coracle Press Gallery 1975–87) 1989

B. Redhead, *The Inspiration of Landscape*, 1989

P. Nesbitt and A. Goldsworthy, *Leaves Andy Goldsworthy* (Common Ground: The Natural History Museum, London) 1989

Touching North Andy Goldsworthy, including transcripts of 'Audio tapes recorded Grise Fiord, March 1989' (Fabian Carlsson and Graeme Murray, with special edition of 50 copies containing an original drawing) 1989

A. Goldsworthy, *Snowballs in Summer Installation* (Old Museum of Transport, Glasgow) 1989

Garden Mountain Andy Goldsworthy (Centre d'Art Contemporain, Castres and Galerie Aline Vidal, Paris) 1989

The Inspiration of Landscape: Artists in National Parks, 1989

Singular Vision: Recent Landscapes by Five Artists (Mead Gallery, University of Warwick) 1989, pp. 6, 12

G. Badger and J. Benton-Harris, eds., *Through the Looking Glass: Photographic Art in Britain 1945–1989*, Barbican Art Gallery, 1989, p. 180

'Images of paradise', *Christie's*, 1989, p. 137

Y. Baginsky, 'Sculptor for whom success snowballs', *Scotland on Sunday*, 15 January 1989

D. Brown, 'New British Sculpture in Normandy', *Arts Review*, 10 February 1989, p. 97

D. Alberge, 'Making an impression with the elements', *Weekend Independent*, 18 February 1989

P. Nesbitt, 'At Home with Nature: Andy Goldsworthy in Scotland', *Alba*, Spring 1989, pp. 55–57

N. Shulman, 'Monday at the North Pole', *Arts Review*, 2 June 1989, pp. 424–25

M. Bailey, 'Carve a name in ice', *The Observer*, 11 June 1989

A. Graham-Dixon, 'Cutting Ice', *The Independent Magazine*, 24 June 1989, pp. 46–49

D. Lee, 'Pure, ephemeral spires', *The Times*, 26 June 1989

W. Packer, 'Andy Goldsworthy's Transient Touch', *Sculpture*, July–August 1989, pp. 28–30

'Reviews', *BBC Wildlife*, Vol. 7, No. 7, July 1989, p. 475

'Iceman winneth', *Business*, July 1989, p. 22

G. Lewis, 'No sculpture like snow sculpture', *This is London*, No. 1709, 7 July 1989

M. R. Beaumont, 'Andy Goldsworthy', *Arts Review*, 14 July 1989, p. 545

S. Howell, 'Goldsworthy: the ice-man cometh', *The World of Interiors*, July–August 1989, p. 158

C. Henry, 'Melting moments', *The Glasgow Herald*, 28 July 1989

A. Graham-Dixon, 'An Artist Does The Strand', *The Independent*, 5 August 1989

N. Graydon, 'Magic in the field', *Ritz*, No. 133, 1989, pp. 96–99

Whole Earth Review, No. 64, Fall 1989

M. Drabble, 'Andy Goldsworthy', *Modern Painters*, Vol. 2, No. 3, Autumn 1989, pp. 97–98

E. Juncosa, 'Landscape as Experience', *Lapiz*, No. 61, October 1989, pp. 60–63

'Le grand Nord', *L'Autre Journal*, November 1989, pp. 88–89

P. Oakes, 'The Incomparable Andy Goldsworthy', *Country Living*, No. 48, December 1989, pp. 52–57

A. Lund, 'Landskab og skultur' and G. K. Sutton, 'Land Art', *Landskab*, December 1989

K. Withers, 'Is it art?', *Venue*, December 1989

J. Watkins, 'Andy Goldsworthy Touching North', *Art International*, Winter 1989, p. 71

1990

Andy Goldsworthy (Viking Penguin Books; Harry N. Abrams, Inc. Publishers, New York; Editions Anthese, Paris) 1990

T. Friedman and A. Goldsworthy, eds., *Hand to Earth Andy Goldsworthy Sculpture 1976–1990* (The Henry Moore Centre for the Study of Sculpture) 1990

P. Nesbitt, 'A Landscape touched by Gold', *Arts Review Yearbook 1990*, pp. 48–50

'Touching North', *Ikebana Ryusei*, No. 357, January 1990, pp. 16–23

V. Rigney and H. Stevenson, eds., *Glasgow's Great British Art Exhibition* (Glasgow Museum and Art Galleries) 1990, pp. 64–65

British Art Now: A Subjective View (Asahi Shimbun, Tokyo) 1990–91

Photographic Acknowledgements

Clive Adams pp. 84, 89

Geoff Allen pp. 30 top, 42, 94–95, 109, 130, 132, 134, 138 top, 157

Julian Calder pp. 74–75, 98

Common Ground p. 79

Iain Crafer pp. 32–33

David Ding p. 16

Andy Goldsworthy back cover, pp. 10, 12–15, 18, 20–23, 26–27, 29, 30 bottom, 31, 34–36, 38 top, 39–41, 52, 55, 59, 60, 62–64, 68–69, 71–72, 77, 81, 83, 85–88, 90–93, 96–97, 100–07, 110–13, 120–24, 126–29, 133, 144–45, 148–49, 151–53, 158–59

Judith Goldsworthy front cover, pp. 38 bottom, 44–51, 56, 65–67, 73, 76, 78, 114–15, 117, 150, 196

Barry Gregson p. 28

Kiku p. 70

Larkfield Photography, Brighouse title page, pp. 146–47, 156

Brian Mills p. 17

Joanna Morland p. 61

Ordnance Survey p. 142

Phil Owen pp. 37, 80, 82, 138 bottom, 139, 141 bottom, 155

R. G. Peakin p. 135

Thijs Quispel p. 24

Glyn Satterley p. 118

Miranda Strickland-Constable p. 25

Notes on Contributors

CLIVE ADAMS was formerly gallery co-ordinator at Arnolfini, Bristol (1974-79), director of Mostyn Art Gallery (1979-85) and managing director of Fabian Carlsson Gallery, London – the gallery that helped develop Goldsworthy's career with projects in Japan and the North Pole. Since 1989 he has been an independent curator, co-ordinating a major exhibition on the history of British landscape painting for Japan, 1992, and acting as a commissioner for the Kangju Biennale, Korea, 1995. He has been involved in several exhibitions which explore our relationship to nature and, most recently, was consultant curator for *The Impossible View?* at The Lowry, in Salford, in the north of England, which was nominated for a Museums and Heritage Award. He is currently working to establish the Centre for Contemporary Art and the Natural World at a location near Exeter in south-west England.

PROFESSOR ANDREW CAUSEY is Professor of Modern Art History at Manchester University. He has published widely on twentieth-century British art, including acclaimed studies on Edward Burra, Peter Lanyon and Paul Nash. His book, *Sculpture since 1945*, was published by Oxford University Press in 1998. Goldsworthy was included in his Arts Council exhibition, *Nature as Material*, 1980.

SUE CLIFFORD and ANGELA KING are founder directors of Common Ground. They have been at the forefront of cultural campaigning in the environmental movement and environmental awareness raising in the arts, initiating many projects, exhibitions and publications, from *Second Nature* in 1984 to *The Common Ground Book of Orchards* in 2001. They are now working on *England in Particular* – a book (Hodder & Stoughton 2005) about local distinctiveness, an idea they have pioneered. They co-organised *Andy Goldsworthy on Hampstead Heath* in 1985 and *Leaves* by Andy Goldsworthy at London's Natural History Museum in 1989-90. Common Ground, now based in Shaftesbury, Dorset, plays a unique role in linking nature and culture, working to inspire, inform and involve all people in learning about, enjoying and taking more responsibility for their own locality. See www.commonground.org.uk and www.england-in-particular.info.

JOHN FOWLES is the author of *The Collector*, *The Magus*, *The French Lieutenant's Woman* and other celebrated novels. His major private interest has long been the relationship between nature, the arts and society. He is a champion of conservation and its movements, such as Common Ground, and was for many years President of a trust for maintaining the island nature reserve of Steepholm, in the Bristol Channel. In 1987 he collaborated with Andy Goldsworthy in making *Winter Harvest*, a unique book, which was toured by The Scottish Arts Council.

DR TERRY FRIEDMAN, formerly Principal Keeper of Leeds City Art Gallery and The Henry Moore Centre for the Study of Sculpture, studied art history at the University of Michigan and the Courtauld Institute of Art, London University. He has written widely on various aspects of British art and organised major exhibitions devoted to Jacob Epstein, Henry Moore and Claes Oldenburg, among others. He was co-organiser, with Tony Knipe, of *Rain sun snow hail mist calm: Photoworks by Andy Goldsworthy* in 1985, before the retrospective in Leeds, and has since contributed an introduction to Goldsworthy's *Wood* (1996) and an extensive chronology to *Time* (2000).

FUMIO NANJO was organiser of the exhibition *Andy Goldsworthy Mountain and Coast Autumn into Winter Japan 1987*, held at Nagoya, Tokyo and Osaka in 1988, in his capacity as Director of the Tokyo Office of the Institute of Contemporary Art (ICA) at Nagoya. As one of the selectors at the Venice Biennale, he invited Goldsworthy to show in the Aperto section in 1988.

PAUL NESBITT is Director and Curator of Exhibitions at Inverleith House in The Royal Botanic Garden Edinburgh. There he has curated many significant solo exhibitions by artists, including Carl Andre, Lothar Baumgarten, Chris Drury, Agnes Martin, Rory McEwen, John McLaughlin, Ed Ruscha, Julian Schnabel, Myron Stout, Richard Tuttle, Cy Twombly, Ruth Vollmer, herman de vries, Lawrence Weiner and Franz West, as well as Andy Goldsworthy about whose early career he has written widely. As an artist and plant ecologist he has developed a unique programme that explores the relationships between art and science, and their roles in our appreciation and understanding of the natural world.

MIRANDA STRICKLAND-CONSTABLE trained at the Courtauld Institute of Art, London University. As Keeper of Leeds City Art Gallery (1966-85), she was an advocate of modern British art and organised a number of exhibitions including, from 1966, a series devoted to work by holders of the Gregory Fellowship in Painting and Sculpture at Leeds University. She is the author of *Leeds' Paintings: 20th century British art from Leeds City Art Gallery*, 1980, and *Artist and Camera*, 1982. In 1981 she was invited by the Arts Council to select for the *Serpentine Summer Show I*, marking Goldsworthy's first public appearance in London.

HANS VOGELS is curator of the Stedelijke Musea in Gouda, Holland, a collection of both historical and modern art, and has organised several exhibitions on modern British art, among them, *Prints and Drawings by Barry Flanagan* (1983), *Whistling in the Dark, Peter Randall Page* (1998), and *Small Bronzes by Barbara Hepworth* (2003). For some years he has been working on a thesis about Raymond Duchamp-Villon (1876-1918).

Andy Goldsworthy

Born 1956 Cheshire, England
1963 Moved to Leeds, Yorkshire
1974–75 Bradford Art College, Yorkshire
1975–78 Preston Polytechnic, Lancashire Annex
 (BA Fine Art)
1979 North West Arts Award
 Moved to Bentham, Yorkshire
1980 Moved to Ilkley, Yorkshire
 Yorkshire Arts Award
1981 Moved to Brough, Cumbria
 Northern Arts Award
1982 Northern Arts Award
1983 Northern Arts Bursary
1984 *Seven Spires*, Grizedale Forest, Cumbria
 Residency, Haarlemmerhout Symposium,
 Haarlem, Holland
1985 *Sidewinder*, Grizedale Forest, Cumbria
 Moved to Langholm, Dumfriesshire
1986 Association with Fabian Carlsson Gallery, London
 Moved to Penpont, Dumfriesshire
 Entrance, Hooke Park Wood, Dorset
1987 Established Stone Wood, Penpont
 Scottish Arts Council Award
 Residency, Yorkshire Sculpture Park (a visit
 in each season)
 Residency, Japan
1988 Artist in Lake District National Park
 Residency, Centre d'Art Contemporain,
 Castres, France
 Lambton Earthwork, Lambton, County Durham
 Invited artist at the Aperto, Venice Biennale
1989 *Maze*, Leadgate, County Durham
 Working at Grise Fiord, Ellesmere Island and
 on the North Pole
 Working at Sidobre, France
 Northern Electricity Arts Award

One-man* and group exhibitions

1980 LYC Museum and Art Gallery, Banks, Cumbria*
 Nature as Material, Arts Council of Great Britain
 (touring exhibition)
1981 Serpentine Summer Shows, 1, Serpentine Gallery,
 London*
 St Paul's Gallery, Leeds (with John Aiken)
 Royal Northern College of Music, Manchester*

New Sculpture, Midland Group Gallery,
Nottingham
1982 LYC Museum and Art Gallery, Banks, Cumbria*
 Presence of Nature, Carlisle Museum and Art
 Gallery, Cumbria (touring exhibition)
 Sculpture for a Garden, Tatton Park, Cheshire
 British Drawings, Hayward Gallery, London
1983 *Art and the Land*, Rochdale Art Gallery, Lancashire
 Place, Gimpel Fils Summer Show, London
 Sculpture in the Open Air, Yorkshire
 Sculpture Park
 Photographs of Outdoor Work, Altrincham Library,
 Cheshire*
1984 *Haarlemmerhout Symposium*, Frans Hals Museum,
 Haarlem, Holland
 Preston X, Harris Art Gallery and Musum,
 Preston, Lancashire
 Discovery of the Lake District, Victoria and Albert
 Museum, London
 Salon d'Automne, Serpentine Gallery, London
 Second Nature, Newlyn Orion, Penzance,
 Cornwall (Common Ground touring exhibition)
 Essentials, Kent County Council (touring
 exhibition)
 A Sense of Place, Ceolfrith Gallery, Sunderland
 Arts Centre (touring exhibition)
1985 *Evidence*, Coracle Press Gallery, London*
 Rain sun snow hail mist calm, The Henry Moore
 Centre for the Study of Sculpture, Leeds City Art
 Gallery and Northern Centre for Contemporary
 Art, Sunderland (touring exhibition)*
 Abbot Hall, Kendall, Cumbria*
 City Thoughts (organised by Frank Gribbling,
 Amsterdam)
 Looking at Landscape, Drumcroon, Wigan
 Education Art Centre, Wigan, Lancashire
1985–86 Hampstead Heath, Common Ground and
 Artangel Trust (residency)
1986 The Barn, Lincoln*
 Between Trains (Holbeck Triangle Trust),
 St Paul's Gallery, Leeds
 Galerie Löhrl, Mönchengladbach
 Land Matters, Lincolnshire and Humberside Arts
 (touring exhibition)
 St Louis Arts Festival, St Louis, Missouri, USA
 (residency)

1987 *Winter Harvest* (book exhibition with
 John Fowles), Scottish Arts Council*
 Fabian Carlsson Gallery, London*
 Quay Arts Centre, Newport, Isle of Wight
 (residency)
 Prescote Art and Design, Edinburgh*
 Yorkshire Sculpture Park (residency)
 Perspectives: Glasgow — A New Look, Collins
 Gallery, University of Strathclyde, Glasgow
 (touring exhibition)
 Landscape and Sculpture, Axiom Centre for the
 Arts, Cheltenham (touring exhibition)
 The Unpainted Landscape, Scottish Arts Council
 (touring exhibition)
 Revelation for the Hands, Leeds City Art Gallery
 (residency)
1987–88 *The Possibilities of Space: Fifty Years of British
 Sculptor's Drawings*, Musée des Beaux-Arts de
 Besançon (Kirklees Museums touring exhibition)
1988 *Lancashire South of the Sands: The Contemporary
 Landscape*, Towneley Hall Art Gallery and
 Museum, Burnley (touring exhibition)
 Gallery Takagi, Nagoya, Japan*
 Yurakucho Asahi Gallery, Tokyo and Osaka, Japan*
 Britannica. Trente Ans de Sculpture, Musée des
 Beaux-Arts André Malraux, Le Havre (touring
 exhibition)
 *Mountain and Coast Autumn into Winter Japan
 1987*, Fabian Carlsson Gallery, London*
 Ruskin Gallery, Sheffield*
 Artists in National Parks, The Victoria and
 Albert Museum, London
 With an Eye to the East, Scottish Arts Council
 (touring exhibition)
 Distant Thunder (recent work by Andy
 Goldsworthy and Vincent Woropay), Bluecoat
 Gallery, Liverpool
 Camoflage, Scottish Arts Council (touring
 exhibition)
 Food, Odette Gilbert Gallery, London
 Touching on Nature, Doorstep Gallery,
 Arts in Fife
 Venice Biennale
1989 *Touching North*, Anne Berthoud Gallery, London
 and Graeme Murray Gallery, Edinburgh*
 Black in Black, Fabian Carlsson Gallery, London*
 Snowballs in Summer, Old Museum of Transport,
 Glasgow*
 Andy Goldsworthy, The Rozelle Galleries, Ayr*

 Landscape Now, City Museum and Art Gallery,
 Stoke-on-Trent
 British Sculpture 1960–1988, Museum van
 Hedendaagse, Kunst Antwerpen
 Language of Landscape Part I, Anderson O'Day
 Gallery, London
 *Thomas Joshua Cooper, Andy Goldsworthy, David
 Nash*, L.A. Louver Gallery, Venice, California
 Natural Art, Dundee Art Galleries and Museums
 Out of the Wood: The Tree as Image and Symbol,
 Craft Council/Common Ground, London (touring
 exhibition)
 *Through the Looking Glass: Photographic Art in
 Britain, 1945–1989*, Barbican Art Gallery, London
 *Singular Vision: Recent Landscapes by Five
 Artists*, Mead Gallery, University of Warwick
 (touring exhibition)
 Photo-Sculpture, Watershed Media Gallery, Bristol
 (touring exhibition)
 Leaves, The Natural History Museum, London
 (organised by Common Ground)*
1990 *Garden Mountain*, Galerie Aline Vidal, Paris
 (touring exhibition)*
 Photography as Sculpture, Ffotogallery, Cardiff*
 Glasgow's Great British Art Exhibition, McLellan
 Gallery
 *Hand to Earth Andy Goldsworthy Sculpture 1976–
 1990*, Leeds City Art Gallery (touring exhibition)*
 Drumcroon, Wigan Education Art Centre, Wigan,
 Lancashire*
1990–91 *British Art Now: A Subjective View*, Asahi
 Shimbun in connection with the Setagaya Museum,
 Tokyo and The British Council, London (touring
 exhibition)

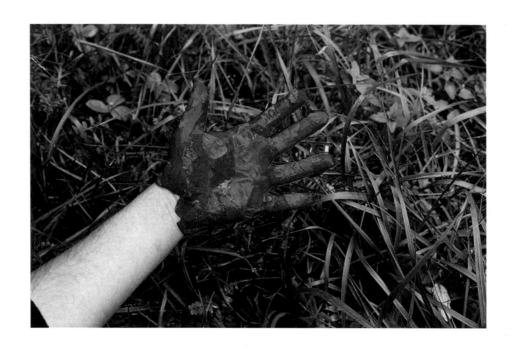

Coquelicots